D0202925

THE PRINCETON SERIES IN

NINETEENTH-CENTURY ART, CULTURE,

AND SOCIETY

WITHDRAWN
UTSA Libraries

WITHDRAWN
UTSA Libraries

ART AND THE FRENCH COMMUNE

ART AND THE FRENCH COMMUNE

IMAGINING PARIS AFTER WAR AND REVOLUTION

BY

ALBERT BOIME

PRINCETON UNIVERSITY PRESS

Copyright ©1995 by Princeton University Press
Published by Princeton University Press, 41 William Street,
Princeton, New Jersey 08540
In the United Kingdom: Princeton University Press, Chichester, West Sussex

All Rights Reserved

Library of Congress Cataloging-in-Publication Data

Boime, Albert.
Art and the French commune: imagining Paris after war and revolution /
by Albert Boime.
p. cm. — (The Princeton series in nineteenth-century art, culture, and society)
Includes bibliographical references and index.
ISBN 0-691-02962-8 (CL)
1. Art—Political aspects—France—Paris. 2. Art and the state—France—Paris.
3. Impressionism (Art)—France—Paris. 4. Paris (France)—Intellectual life—19th century.
5. Paris (France)— History—Commune, 1871. I. Title. II. Series.
N6850.B64 1995
701'.03—dc20 94-5324

This book has been composed in Linotron Trump
by The Composing Room of Michigan, Inc.

Princeton University Press books are printed on acid-free paper and meet the guidelines
for permanence and durability of the Committee on Production Guidelines for
Book Longevity of the Council on Library Resources

Printed in the United States of America

10 9 8 7 6 5 4 3 2 1

EDITED BY TIMOTHY WARDELL

DESIGNED BY LAURY A. EGAN

Library
University of Texas
at San Antonio

For
Anna and David Rabinowitz

KEEPERS OF THE FLAME

Contents

LIST OF ILLUSTRATIONS

ACKNOWLEDGMENTS

I OWE SO MUCH to my colleagues and students over the years for their work and unfailing encouragement that it is impossible to do them all justice in the short space allotted for acknowledgments. But I would especially like to express gratitude to Sanda Agalidi, Wayne V. Andersen, Edward Berenson, Jerry Boime, Myra Boime, Elizabeth Broun, Petra Chu, Timothy J. Clark, Carrol F. Coates, Carol Duncan, Madeleine Fidell-Beaufort, Lois Fink, Michael Fried, Carlo Ginsburg, George Gurney, Nicos Hadjinicolaou, Robert L. Herbert, Klaus Herding, Patricia Hills, Seymour Howard, Kenneth L. Lindsay, David Lubin, Patricia Mainardi, Linda Nochlin, Fred Orton, Vincent Pecora, Theodore Reff, John Rewald, Robert Rosenblum, Meyer Schapiro, Richard Shiff, Debora Silverman, Clare Spark, Paul Tucker, Paul Von Blum, Alan Wallach, and Gabriel Weisberg. These are my spiritual and scholarly soul-mates whose work and thought have guided and informed my own, and if I have on occasion improperly neglected, misunderstood, or misrepresented their ideas they have knowingly or not accompanied me on my solitary intellectual vigil under the starlit sky. Finally, special thanks are due to Elizabeth Powers for her encouragement of the project, and to Timothy Wardell for expertly shepherding the manuscript through to realization.

ART AND THE FRENCH COMMUNE

1. INTRODUCTION

IT HAS BECOME somewhat of a cliché to state that avant-garde painting began with the modernization of Paris. T. J. Clark shrewdly rephrased it in ideological terms: "It seems that only when the city has been systematically occupied by the bourgeoisie, and made quite ruthlessly to represent that class's rule, can it be taken by painters to be an appropriate and purely visual subject for their art."[1] Yet what is left out of his analysis and that of others who have otherwise made important contributions to our understanding of this period is the fact that modernism is wrought out of the unexpected dislodging of that bourgeoisie and the replacement of its rule—if ever so brief—of Paris by that of another class: the proletariat and its political expression in the Commune. Although that other "class's rule" was short-lived, its shocking hold on the apparatus of the city forced an extreme reaction in which every weapon in the bourgeoisie's political, social, and cultural arsenal was mobilized to bring Paris back and up to the point where the middle class had "systematically occupied" it.

The influential Marxist art historian Arnold Hauser made the astonishing claim that, "1871 is of merely passing significance in the history of France."[2] Of course, art historians are hardly to be blamed for the suppression of knowledge of the Commune's influence on the institutional and cultural life of France, for even modern liberal social scientists such as Edward Mason wrote that when it disappeared it left "scarcely a trace" on the development of the nation. He argued that it had been rescued from insignificance only by international socialism and communism seeking historical legitimation. Although it is true that Lenin, who wrote tirelessly on the Commune, emphasized its importance as a momentous event in the history of socialism and as the first step in the development of "the Dictatorship of the Proletariat," it is more likely that this association and Cold War politics did much more harm in predisposing bourgeois scholars to avoid looking more deeply into the Commune's contribution to French culture. My own researches into the art of this period have revealed the unmistakable impact of this event on the cultural life of the capital. It will be the task of my book to define this "other" moment of modernity, which lasted only from 18 March to 28 May 1871. The Paris Commune sprang from a complex set of historical circumstances: irritation and disgust at the loss of the war with Prussia, the misery of the four-month siege of Paris, the struggle of republicanism against dynastic rule, the working class reaction to the moderates' fear of socialist desires and aspirations, all of

which combined explosively into revolutionary action. Despite its brevity, however, the Commune was the largest urban insurrection in modern European history until the Warsaw uprisings of 1943–1944: somewhere between 25,000–30,000 men, women, and children lost their lives in the street massacres of the Commune's last days. In addition, the more than 50,000 sentences meted out to prisoners taken during and after the Commune, including over 4,000 deportations to the islands of New Caledonia in the South Pacific, made it the most extensive judicial repression in the nineteenth century. Not only did it destabilize social relations and disrupt the infant Third Republic's claim to democratic rule, but it engendered such violent counter-reactions in its aftermath that it left a permanent scar on the French body politic. By threatening the conservatives and moderates alike in their attachment to property, the event profoundly affected art, literature, and politics in its aftermath. Even liberal intellectuals, who had persistently attacked the materialism of the Second Empire and were bound in sympathy to the working classes' suffering and infuriated by their social disadvantages, moved to the right in their revulsion from the excesses of the "mob."

For the first time in French history, a municipal government counted more members from the working class (artisans, factory workers, small shopkeepers) than members from either the aristocracy or the bourgeoisie. Women too played an unprecedented role in the Commune, first in neutralizing the troops when they entered Paris to appropriate the cannons of the National Guard, then in organizing the *Union des femmes* in support of the Commune's projected social reforms as well as its ambulance stations, canteens, and barricades, and finally, in building and defending the barricades shoulder to shoulder with the men during Bloody Week. The new social relations engendered by the Commune aroused a mood of euphoria and a heady sense of utopian possibilities. This promise could still be tapped a century later, when members of the French left-wing sect known as the Situationist International—who made decisive contributions to the political and philosophical preparation of the May-June 1968 rebellion —looked to the Commune as a source of inspiration:

> The Commune was the greatest *fête* [festival, celebration] of the 19th century. On a fundamental level, the rebels seemed to feel they had become the masters of their own history, not so much on the level of "governmental" political decisions as on the level of daily life in that Spring of 1871 (note how everyone *played* with their weapons; which means: playing with power). This is *also* the sense in which we must understand Marx: "The greatest social measure of the Commune was its own working existence."[3]

This sense of proletarian self-mastery, the joy of at last feeling like a participant in, and responsible for, the decisions that affect and transform daily life—in short, all the rhetorical shibboleths of the bourgeois dream—meant that "modernity" had been usurped for antihierarchical purposes.

For this the rebels were to pay dearly. The day after the penetration of Paris through an undefended gate on 21 May, Thiers reported to the National Assembly that the "expiation" of the Communards would be complete. During the next six days the

Communards fought Thiers' systematic and methodical advance, with such daring and determination that even their enemies were forced to admire them. The urban sites the rebels commandeered had to be systematically defended by a cross-section of the entire population of Paris, *quartier* by *quartier*, street by street, house by house, barricade by barricade. But their inexperienced courage was no match for the regular army's professionalism and maddened desire to compensate for the humiliating defeat so recently sustained at the hands of the Prussians.

Although the civil war ended on 28 May, the killing continued unabated. People were shot on the lamest pretext, and anyone accused of being a communard, or who resembled a communard leader, or sheltered an insurgent, or anyone with blackened hands, which could only have been caused by a certain type of rifle, was in immediate danger. In the two days following 28 May over 2,000 Parisians were summarily executed. Those taken prisoner and trundled off to Versailles fared little better; confined to squalid cells and denied appropriate food and water, many died of suffocation as well as from starvation and disease. An accurate accounting of the death toll is probably impossible, but a clue to its enormity is seen in the government's subsequent admission that the Paris Municipality paid for the disposal of 17,000 corpses. More French were killed during "Bloody Week" (May 21–28) than during the Reign of Terror or the Prussian siege.

As the Communards withdrew from their urban stations, they set official buildings on fire to cover their retreat. Ironically, it had been the work of "Haussmannization" to eradicate the threat of insurrection, and now this very "modernity" was being turned inside out. When it was all over and the last barricade destroyed, Paris lay in ruins. For the bourgeoisie the working class—previously evicted from its old place in the city's center to make room for progress—had reclaimed Paris only to wreak vengeance on the new society and its monuments. The work of the bourgeoisie was not only to restore the look (as it existed in memory) of the hated Second Empire, but to make sure that the last remaining vestiges of the Commune and its social relations disappeared from the urban view.

In *The Civil War in France*, Karl Marx sets out a justification for the Communards' use of fire to cover their retreat, since the government of Versailles had stigmatized the burning of buildings as a crime against the state and proceeded to hunt down its enemies as suspect of professional incendiarism. Noting that in war, "fire is an arm as legitimate as any," he declared:

> To be burned down has always been the inevitable fate of all buildings situated in the front of battle of all the regular armies of the world. But in the war of the enslaved against their enslavers, the only justifiable war in history, this is by no means to hold good! The Commune used fire strictly as a means of defense. They used it to stop up to the Versailles troops those long, straight avenues which Haussmann had expressly opened to artillery-fire; they used it to cover their retreat, in the same way as the Versaillese, in their advance, used their shells which destroyed at least as many buildings as the fire of the Commune.

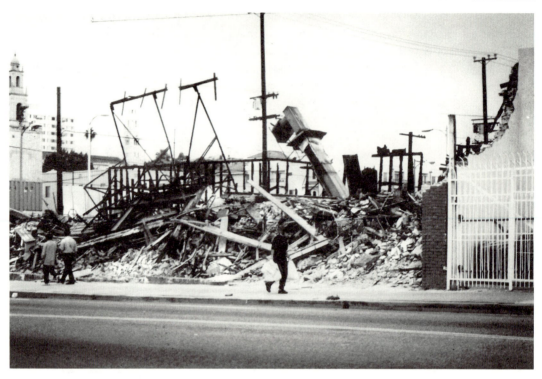

1. Photograph of Burned Out Building in South Central Los Angeles, 1992.

After emphasizing that the Communards understood that their opponents cared less for the lives of Parisians than for Paris buildings, Marx elaborated:

> If the acts of the Paris working men were vandalism, it was the vandalism of defense in despair, not the vandalism of triumph, like that which the Christians perpetrated upon the really priceless art treasures of heathen antiquity; and even that vandalism has been justified by the historian as an unavoidable and comparatively trifling concomitant to the titanic struggle between a new society arising and an old one breaking down.[4]

The significance of these texts came home to me most vividly just after experiencing the grim street warfare in South Central Los Angeles in the spring of 1992, described by Mike Davis as a "firestorm of rage and desperation."[5] It was history once more repeating itself not as farce but as high tragedy, seen most vividly in the empty hulks of burned out buildings eerily recalling the ruins of the Commune (figs. 1–6). During the early TV coverage, the participants were pilloried as looters, thugs, and crack-crazed arsonists expressing "black rage," with the burning characterized as a random spree of vandalism. Unreported went the economic violence of poverty, the psychological and physical torture meted out by the police, unemployment, welfare, and collapsing

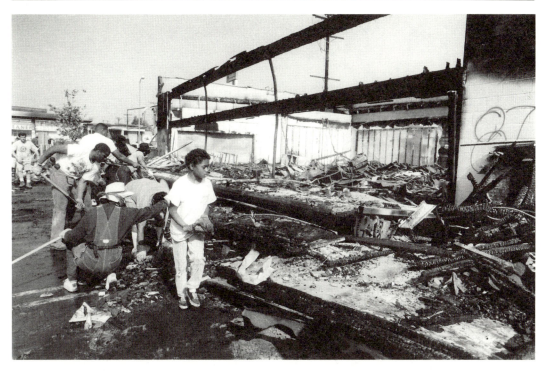

2. Photograph of Burned Out Building in South Central Los Angeles, 1992.

school systems that fueled the uprising. The burning and the looting were consigned to a specific category of non-citizens, so that the rest of the population could breathe easy knowing that the LAPD and the National Guard were dealing with the criminal under-class. Talk of deportation of undocumented Latino workers sounded suspiciously like the Commune as well, and of course, everyone caught in the new riot zone risked being characterized as "criminal riffraff" and being treated, according to the local joke, "as a [Rodney] King." Finally, Peter Ueberroth's corporate rebuilders were anxious to get Los Angeles back in shape and delete the ruinous signs of class contradictions akin to Thiers and Company 122 years ago.

The formation of the Impressionists in the years 1871–1874 brackets the critical period of rebuilding Paris following the brutal hammer blows of the Franco-Prussian War and the Commune—"l'année terrible" of Victor Hugo. The Impressionists— moderate republicans—descended into the public sphere to reclaim symbolically its sullied turf for the bourgeoisie. Caught up in the flow of energies released by the exor-cism of the twin demons of the Prussians and Communards, they developed into inno-vative and daring creators whose work still appeals to large numbers of their social counterparts in the present. But their aesthetic purposes are inseparable from their

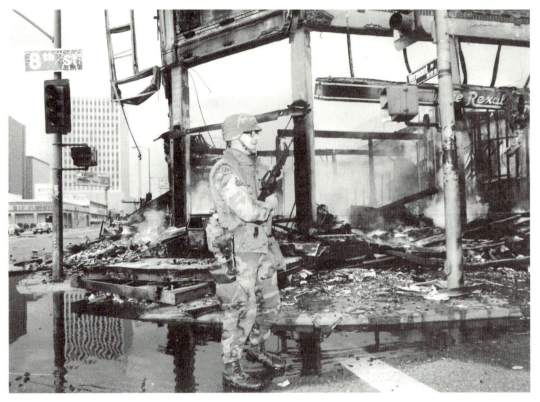

3. Photograph of Burned Out Building in South Central Los Angeles, 1992

participation in the political and cultural reclamation of Paris. The moment of the suppression of the dissident community constituted their opportunity for economic and artistic liberation. It is this stage in the process of modernization that forms the core of the present study.

The eight French men (Manet, Degas, Pissarro, Monet, Renoir, Sisley, Bazille, and Cézanne) and lone French woman (Berthe Morisot) whose work is generally considered to constitute the nucleus of Impressionism were all born between 1832 and 1841, and thus reached maturity and at least quasi-professional status by the time of the Commune. Except for Bazille (who was killed in the Franco-Prussian war), they had a stake in the rebuilding of Paris and seized the moment to establish their careers. The next generation of painters, the Post-Impressionists or those who rejected Impressionism, were almost all youngsters during the time of the Commune for whom it was a childhood trauma. Their lives were violently disrupted either by flight or the destruction of their neighborhoods, and their memories were permeated with terrifying images. As adults, they revived the quest for monumental utopias and social schemes that promise order and harmony. Their mature art was the first to renounce the illusion of reality on principle and to express its ideological outlook by the deliberate deformation of the

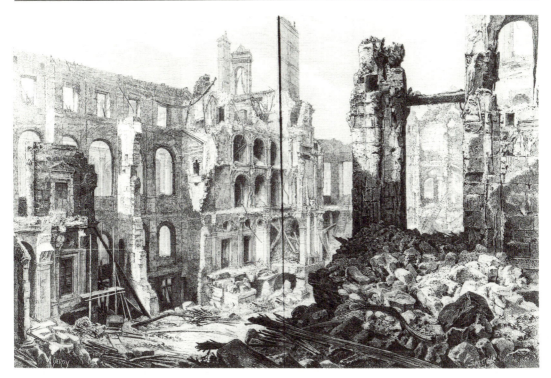

4. Wood engraving of Building Burned During the Commune, 1871.

natural world. This deformation was part of their metaphorical enterprise to reconstitute it as a totality, subject to a controlling impulse. For this reason I have added as an epilogue to my work on Impressionism an analysis of Seurat's *Sunday Afternoon on the Isle of the Grande-Jatte*; it will serve as a control study to help position the work and mindset of the older generation.

Once the voices of its main participants were silenced, the Commune could be represented by its triumphant enemies everywhere in the world as a violent revolutionary insurrection, and its supporters, the ordinary people of Paris, as a bloodthirsty, destructive rabble. With this reaction in mind I have added an appendix on the testimony of an American eyewitness to the events of the Commune as a gloss on its cultural impact on the French and a corrective to the official line. A sculptor who stayed in Paris during the entire period of the short-lived regime, he was shocked after returning to his native land to learn how grossly the press had maligned the Communards and distorted their political aspirations. Warner's is an especially interesting case since there is scant evidence of a passionate democratic impulse in his art, and he is hardly an innovator like the Impressionists. Hence, although it cannot be said that the Commune directly affected the character of his work, his account has the ring of authenticity and stands as a warning against the traditional notion that innovation in art is necessarily a concomitant of advanced political thought.

ÉTAT ACTUEL DE LA GARE DU CHEMIN DE FER, A AUTEUIL.

église, qui toutes ont défié la fureur des révoltés. Paris, capitale du monde, existe encore ! Disparues, il est vrai, les Tuileries, ce palais par excellence de la monarchie française, ce palais qui, depuis près de trois siècles, avait vu passer tous les souverains, et qui fut le sanglant théâtre du 10

août, la première journée où le peuple affolé, foulant aux pieds les traditions du respect, soufflette la souveraineté, se vautre dans la demeure des rois et s'y impose en maître ; — disparu le Palais-Royal, de mémoire lascive et de libertinage princier, qui, après avoir été le Palais-Cardinal, de-

vint, sous la République, le Palais-Egalité, puis Palais du Tribunat sous le premier empire, pour servir tout naturellement, dans ces derniers temps, d'habitation au prince Napoléon, digne hôte de la maison qui avait abrité jadis le duc d'Orléans ! — Disparues ces belles constructions du quai d'Or-

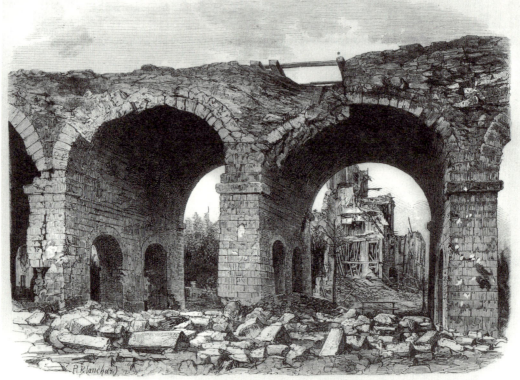

LE VIADUC DU POINT-DU-JOUR. — D'après les photographies de M. Franck.

5. Wood engraving of Buildings Burned During the Commune, 1871.

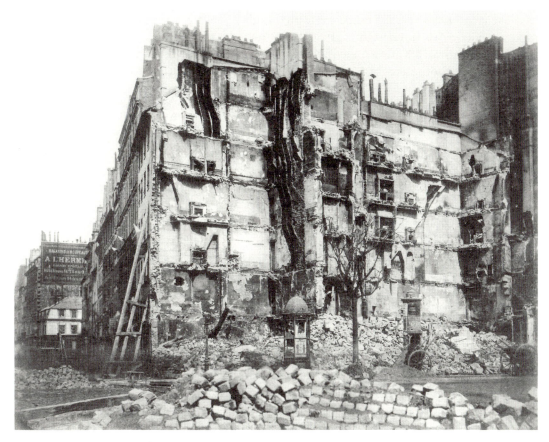

6. Photograph of Building Burned During the Commune, 1871.

Surprisingly no one has yet undertaken a systematic investigation of the possible influence of the Franco-Prussian War and the Commune on the actual content of the Impressionist group and its reception at the inaugural exhibition on 15 April 1874. The Commune is inevitably mentioned in monographic studies, but mainly as something that the artist had to get around, avoid, or somehow elide to survive. In this book, I hope to problematize the content of the painters in order to open up the possibility of a connection and, at the same time, attempt to deal with the inherent contradiction of their avant-garde position and what I will characterize as their Third Republic compromise. I will insist, contrary to most previous scholarship, that the Impressionists preeminently politicized their creations by reimagining and reconstructing symbolically their partially destroyed country and disrupted social hierarchy.[6]

Although the diverse individuals who would organize as the Impressionists were painting modern-life subjects in the late 1860s, their breakthrough techniques emerged after the Commune. There is a real threshold effect in their development from

the last year of the Second Empire and their subsequent production. That this thresh-
old coincided with the period of the Commune is perhaps telling, suggesting an accel-
eration of innovation encouraged by the political transformations. It is in this sense
that I believe their success was made possible by the reaction to the civil war, and
despite the initial hostility in some quarters to their experimentation it was overall
the positive reception on the part of the moderate Republicans that fueled their sus-
tained experimentation.

My study covers roughly the ten-year period 1870–1880, at the end of which am-
nesty allowed the Communards to return to France and a full-fledged Republic with a
parliamentary majority was in place. The emergence of the conservative Republic at
the end of the Commune—the notorious "republic without republicans"—was ac-
cepted by the monarchist and Bonapartist Right by default and only when it estab-
lished its credentials by rooting out the supporters of the insurrection. It comprises
four clear-cut regimes: 1) Thiers' presidency until May 1873; 2) MacMahon's *septennat*
of November 1873, by which he was to be head of state for seven years; 3) MacMahon's
desperate *coup de seize Mai* (1877) which dissolved a predominantly republican Cham-
ber and threw the issue of the Republic's survival into question; and 4) the failure of
the monarchists in the new elections of 1877 and the establishment of an authentic
republican regime between the years 1877 and 1881. Although the ruling personnel, as
well as the policy of the new Republic, were cautious and conservative, the incremen-
tal political changes they introduced made a difference in regenerating civic idealism.
Until 1879 the government refused to recognize either the *Marseillais* as the nation's
anthem or Bastille Day as the anniversary of the Republic. The government continued
to sit at Versailles until 1879, as if to emphasize its authoritarian underpinnings. Re-
publicans in the early 1880s also permitted public and electoral meetings, which had
been carefully monitored and brutally suppressed in the previous decade. The law of
28 July 1881 gave the press—even the left-wing press—a wider latitude for publishing.
If the program offered mainly token gestures to the workers, the heat had been lifted
and life could begin all over again for the exiles and outcasts. The proposal for full
amnesty (a partial amnesty had been granted in spring 1879) anticipated the elections
due in 1881, for which the republicans hoped to consolidate their organization by re-
moving from the political agenda an issue that sharply divided them.

Théodore Duret, patron, friend, and historian of the Impressionists and Edouard
Manet's biographer, wrote that the painter had entered Paris just before the end of the
Commune and witnessed the bloody repression in the streets. And he noted somewhat
tersely: "Il a comme synthétisé, dans une lithographie, la *Guerre civile*, l'horreur de
cette lutte et de la répression qui la suivit" (fig. 7).[7] We shall return to this work later,
but for now it should be recalled that Duret himself had been implicated in the Com-
mune, came within a hair's breadth of being summarily shot, and later wrote an histor-
ical account of the short-lived government. This is a measure of the effect of the
Commune on the thought of contemporary intellectuals—whether pro or con—and
their work.

Duret, a well-to-do cognac producer and moderate republican, also clues us into the
political sources of Impressionist inspiration.[8] With few exceptions, the painters, their

7. Edouard Manet, *Guerre civile*, 1871. Lithograph. National Gallery of Art, Washington, D. C. Rosenwald Collection.

patrons, and their contemporary apologists belonged to the moderate republican faction. This meant that they rejected the Commune principle (despite their admiration for Courbet), but condemned the brutal repression and generally supported amnesty for the exiled and imprisoned—the precise position of Manet. A classic example is the engraver Félix Bracquemond, one of the prominent exhibitors in the show of 1874. An active member of the republican opposition during the late years of the Second Empire, he bitterly resented the actions of the Commune and refused his appointment to the Comité de la Fédération des Artistes.[9] He and his colleagues were more at home with Thiers than with MacMahon, and rejoiced with the center-left wing of republicans known as the Opportunists and their allies when they seized the reins of government in the early 1880s. Meanwhile, they supported the early Third Republic's agenda to return to order, whose overriding aim was to cleanse the national memory of Second Empire decadence, catastrophic military defeat, and bitter civil and class war.

The decisive impact of the Commune on both the content and the reception of the

month-long exhibition of the Impressionists in 1874 has never been given the scholarly attention it merits.[10] Indeed, it is one of the curious gaps in modernist historiography generally. This is all the more surprising when we consider that the subject of Impressionism has been treated in recent times by some of the most engaged scholars in the art historical profession. Neither Meyer Schapiro nor his younger disciples T. J. Clark and Robert L. Herbert ever devote more than a scant few lines and mainly passing references to the Commune—often tucked away in footnotes—in their otherwise sustained meditation on the politics of Impressionist aesthetics.[11] Herbert makes important connections between Impressionist painting and the post-Commune period, but his references for the most part remain on the level of generality and speculation.[12] Other recent writers on Impressionism such as Griselda Pollock, Richard Shiff, Kermit Champa, Richard Brettell, and John House seem loathe to mention it. Most recently, in Stephen Eisenman's *Nineteenth-Century Art: A Critical History*, where Marx is quoted throughout and the author promises to disclose "a new historical and critical consciousness of society and culture," the Commune is mentioned only in passing in two places.[13] Even more surprising, the 1994 blockbuster show of Paris and New York, "The Origins of Impressionism," sidestepped the problem entirely by cleverly confining the discussion to the Second Empire—surely, a limited conceptualization of the movement's "origins."[14] Only in shorter studies by Marilyn R. Brown and Paul Tucker, and in the recent monograph on Monet by Virginia Spate, has there been some effort to make the connection, but although groundbreaking, they are limited in scope. Brown's critical study focused on Manet's images of the Commune, albeit in an effort "to raise the larger issue of the effect of the Commune on a significant shift in the definition of 'avant-garde' and of modernism as a whole."[15] Tucker's equally important essay in the catalogue *The New Painting* treated the Commune as central to the dynamic of the first Impressionist exhibition in April 1874.[16] But there he was more concerned with contextualizing the event within the post-Commune climate than with showing how it may have played out in specific Impressionist thematics, their allegorical and narrative structures. Spate's provocative pages on the relationship of Monet to the Commune stress his work at Argenteuil, for example, as "reparative," and at one point perceptively notes that he and other avant-garde realists made "their expression of a harmonious, uncontradictory social order more intense and exclusive than before, as if to demonstrate that the events of 1870–1 were, in Zola's words, 'a bad dream.'" But if more specific than either Brown or Tucker in connecting one artist's style and subjects with the post-Commune period, Spate neglects to pinpoint those sites occupied by the Commune that Monet depicts with what she calls the "rhetoric of the new."[17] Despite these reservations, the contributions of Brown, Tucker, and Spate have decisively advanced our understanding of avant-garde activity in the post-Commune era and have laid the groundwork for my own study of the specific relations between the activity and reception of the movement and the politically charged period. My discussion differs from the previous scholarship in attempting to specify the intersections between the historical event and the themes and locales of Impressionist production.

This systematic neglect of what I consider a key to understanding the curious contradiction of the "Sunday in the Country" content of Impressionism, and its generally

hostile reception in 1874, is all the more surprising given the recent privileging in scholarly studies of the social relations between modernist practice and the myths of modernity shaped in the rehabilitated Paris of the Second Empire. The discovery of the city as the implacable environment where one encounters and wrestles with the new and impermanent has given the art historical study of Impressionism a vigor and interdisciplinary focus it lacked in prior years. We may pause for just a moment to recall all of the recent references to Zola's *Au bonheur des dames* in the context of nineteenth-century industrial culture as it took form in Paris, and the extrapolation of the representation of sociological and gender issues, commodity fetishism, and the kaleidoscope of urban public space where the *flâneur* and the *flâneuse*[18] level their "gaze" and the consumerist spectacle unfolds. All of this is now grist as well for the art historical mill.

Clark concludes his searching account in *The Painting of Modern Life* with his central theme that the Impressionists failed to "find a way to picture class adequately" and ultimately to forge an authentic iconography of modern life. He sees the Impressionists bound by the major myths of representing Paris as a site of recreation, leisure, and pleasure, a world of nature to be enjoyed on weekend excursions. By so doing, they fudge class relations and suggest their fluidity in the public spaces of entertainment. Although Griselda Pollock specifically faults Clark's analysis for its incapacity to embrace a female-experienced modernity, both would agree that what structured the terrain of Manet and his followers was the hierarchy of class and gender during the Third Republic that regulated the unequal exchange between men and women in the urban spaces.[19]

In one of his rare but trenchant allusions to the Commune, Clark includes in a footnote a quotation from a Communard that speaks of the retaking of central Paris by "the true Parisians" who had heretofore been relegated either to the peripheries or to ghettoized communities by Haussmannization. These "true Parisians" were the working classes segregated in outlying *quartiers*, essentially rendered invisible and incapable of organized protest by Second Empire gerrymandering. This is a clue to the unmistakable impact of the Commune on the structuring of social relations in its aftermath. What is notable about the Commune is its temporary inversion of class relations and then the total disruption of class relations in the eradication by the Versaillais—soon to assume the reins of government—of a sizable portion of the laboring population.

For what is most remarkable about the short-lived Commune is its picturing of modern life in all of its social potential and its uniting of people across the bounds of nationality, sex, and class. Its very absence of a traditional party-apparatus and rejection of various hierarchical possibilites created a mood of social informality throughout the heretofore rigid class structure. This is most strikingly revealed in the group photographs of the participants by the "true reporter of the Commune," Auguste Braquehais (figs. 8, 9).[20]

I suspect that these photographs were done for, and preserved by, people sympathetic to the Commune, and many of them show neighborhood barricades guarded by those who made them and who were prepared to defend them. The photographs often display

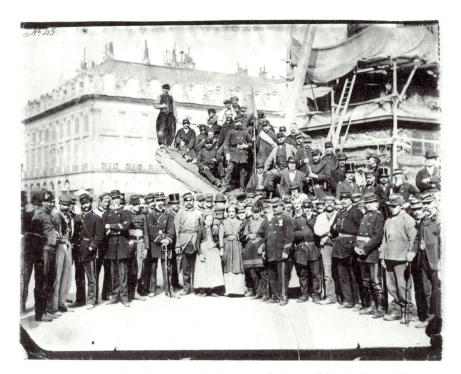

8. Auguste B. Braquehais, Communards Posing at the Base of the Vendôme Column, 1871. Photograph. Collection Daniel Wolf, New York City.

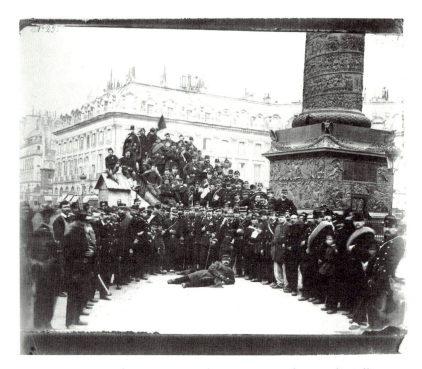

9. Auguste B. Braquehais, Communards Posing, 1871. Photograph. Collection Daniel Wolf, New York City.

a cross-section of Communard society including members of the working class not shown at their regular occupations. Usually, photographers posed laborers in their specific work-aday activities and particular costume establishing an updated version of the picturesque social types so familiar in popular imagery. Braquehais, however, shows them emancipated from their assigned niche in the social hierarchy and proudly manifesting their amplified potential in the more egalitarian space established under the Commune.

In the several group photographs taken at the base of the soon-to-be demolished Vendôme Column, we see working-class men and women posed analogously to ceremonious occasions heretofore reserved for the privileged classes. Yet within the formal grouping individuals strike their own idiosyncratic attitude, disrupting the formality and attesting to their newfound freedom.[21] One worker, balancing himself on the edge of an upraised cushion destined to absorb the shock of the falling debris, places his hand across his abdomen in mock imitation of the famous Napoleonic gesture, while in another example a Federal in full-dress uniform sprawls on the ground in the front ranks of his more decorously poised colleagues. Such deviations from the formal group photograph attest to the sense of liberation and newly won confidence experienced by the previously socially disadvantaged participants.[22] It is noteworthy that the reactionary caricaturist, Cham, mocked the defeated exCommunards by depicting them restored to their customary working-class niche in the social hierarchy dreaming of their previous moment of glory under the Commune (fig. 10).

The Commune tried to carve out a democratic public space where people of all classes could meet and interact on a plane of equality and participate in the critical decisions that affected their daily lives. I would not wish to over-idealize the flawed efforts of Communard leaders, but only point out that the opening they created inspired a whole host of novel social possibilities. Much of their innovation had its roots in the new organizational forms generated out of the transformation of Paris and the liberalization of the Second Empire in its final years.[23] Courbet, for example, wrote home at the height of Commune optimism on 30 April 1871: "Paris is a true paradise! No police, no nonsense, no exaction of any kind, no arguments! Everything in Paris rolls along like clockwork. If only it could stay like this forever. In short, it is a beautiful dream. All the government bodies are organized federally and run themselves."[24] Despite their fumbling and differences, the Communards shared a hope of maximizing the freedom and autonomy the city offered and of making these available to all classes and groups. The cessation of normal work and trade during the brief Commune period granted a rare opportunity to working-class men and women to promenade along the boulevards and in the parks and to mingle with other classes during weekdays. Workers and bourgeois queued up in the same lines and argued with one another on the streets. Upper-class and working-class women organized together on behalf of their mutual needs, and artisans in the uniform of the National Guard protected the boulevards and the municipal buildings. Together representatives of every class and station helped build barricades and keep a lookout for sneak attacks by the Versaillais. Not only did the Communards reclaim the streets they also renamed them in honor of the Commune.[25]

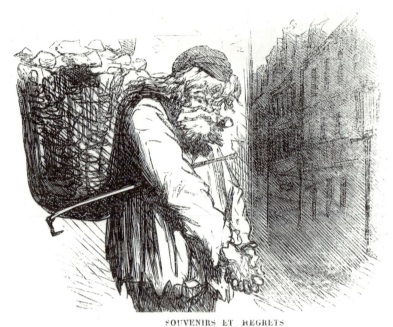

SOUVENIRS ET REGRETS
— 18 mars! Il y a un an, j'étais fonctionnaire public!

10. Cham, *Souvenirs et regrets.—18 Mars! Il y a un an, j'étais fonctionnaire public!"* Wood engraving reproduced in *Le Monde illustré*, 6 April 1872.

Communards rejected the "official" public city created by Napoleon III and Haussmann and took up what had been considered the marginalized, fragmented aspects of Parisian street life. Thus they shifted the trivial and marginal to center stage and in the process incurred the detestation and fear of ruling governments everywhere. Not surprisingly, the mainstream Western press vilified the Communards as unspeakable monsters and savages who had to be suppressed at any cost (see appendix). Above all, the ill-fated Commune failed to inspire in its immediate aftermath a body of images corresponding to its glimpse of the possibility of a new set of social relations.

The pattern of attack went this way: first, the Versaillais pulled out of Paris and allowed the Communards to take over the city and consolidate their position, thus allowing a coherent and identifiable presence that could easily be targeted for reprisal. Thiers literally disowned one segment of civil society within a certain topographical sphere, and by so doing acknowledged a loss of authority over the abandoned terrain. By contracting territory formerly under the jurisdiction of the government, the Versaillais recapitulated in the domestic realm the loss of territory in the recent Franco-Prussian War. This may explain the terrible vengeance the enraged Versaillais wreaked on the Communards, bent, as it were, on exorcizing the double humiliation.

Yet those left in Paris were wholly within their right to organize control of the institutional structures, and did so through the democratic process. The Communards

were in fact a much more representative body of the populace than their counterparts at Versailles. At this moment, the working class and their bourgeois allies created an historical coalition that totally transformed both power and gender relations. External pressures forced them to develop new identities and mutual bonds: women, for example, advanced in this environment, forming clubs and actively participating in the decision-making process. Their presence on the barricades during Bloody Week made them infamous in the international press which especially singled out the women for the most barbed assaults. The temporary suspension of the traditional hierarchy posed the threat of a positive role model of the kind that Noam Chomsky once claimed sealed the doom of Nicaragua in more recent times.

The frantic suppression of the Commune and the enormous swell of literature devoted to justification of this suppression is proof of this. It is certain, moreover, that the conservative form the early Third Republic assumed in the aftermath was decisively shaped by the Commune. The ruthless extermination of thousands of Communards and the mass deportation of thousands of others abruptly destroyed the left and created a vacuum in the class structure. The loss of such a large segment of skilled workers recalled the time of the Revocation of the Edict of Nantes, when the pursuit of the Huguenots led to a massive transfer of talent from France to the rest of the world. In the later period as well, the politically motivated working classes were not merely politically invisible but physically absent, although the new French government persuaded a part of the peasant population to migrate to Paris to replace them. The city that the Impressionists now confronted was one systematically bombarded and ravaged by Prussian and Versaillais bombs and Communard covering fires, and one depleted of its artisanate class. It was this absent but indexical body of militant manual workers, both male and female, and a physically present but psychologically intimidated bourgeoisie, that populated the environment of early modernist visual practice.[26] Thus the fluidity of class relations and the gender inequality inevitably shaping the subjective construction of the modern may owe a significant debt to the Commune.

The problem for the conservatives and their fearful moderate allies was how to preserve the semblance of what in fact had been realized in part by their avowed enemy, since the Communards practiced in actuality what had mainly been uttered rhetorically by the Versailles government. Here the new role of the public space in modern life was indispensable, in providing an opportunity for the mingling of the classes in the streets while yet masking their social and spiritual dissonances. The authentic republic—the Commune—had to be demonized to make a space for the inauthentic Third Republic and its democratic pretense. Here it could mobilize the power to generate glamorous spectacles and luxuries close enough for all to see and even to touch (if not to buy), an outward show so dazzling that it could conceal the dark contradictions within.

In this book, I will argue specific connections between the Commune and early modernist painting that reveal the Impressionists' essentially moderate point of view and at the same time try to clarify the occultation of the Commune in the abundant literature on Impressionism. Part of this occultation emanates from the social sciences

directly: both the Left and the Right camps took up the episode for their own purposes, integrating it with and interpreting it according to their own mythologies. It was the elevation of the Commune into suprahistorical drama that obsessed them. Hence the current neglect among the younger generation of art historians indicates their suspicion of the mythologies and their natural caution against being lured into a *Zeitgeist* formulation, and their concomitant attempt to get beyond the conventional adulation of the Impressionists by carefully sifting the empirical evidence for specific motifs. Further, the disastrous consequences of the Commune would give anyone pause in selecting it as a source for the purpose of understanding avant-garde activity. Finally, it must have been the heroic place of the Commune in the mythology of both the socialist movement and the Communist Party that stood in the way of a fair assessment of its influence on French intellectual and cultural history. Although Marx's watershed analysis of the Commune pointed out that its ragtag components could not measure up to the classical Marxist paradigm of scientific socialism, it nevertheless constructed the 18th of March as a proletarian and therefore socialist revolution. For Engels, as well as later for Lenin and Trotsky, the Commune gave flesh and blood to the phrase the "dictatorship of the proletariat." Even without the Cold War, the cherished role of the revolution of 1871 in the Communist literature and anniversary celebrations would have made it an unpalatable object of study in relation to avant-garde art for scholars in late capitalist societies.

I believe it is the peculiar circumstances of my own chronological and intellectual development that grants me a peculiar insight into this scholarly neglect of the Commune's influence on culture. Born in the decade prior to World War II, I was socialized into the Rooseveltian rhetoric of optimism and patriotism that expressed itself concretely in the surmounting of the Great Depression and in military victory. During the 1950s I remained profoundly imbued with patriotic devotion and loyalty—even to the point of volunteering for service in the U. S. Army. Although my first conscious political act was in distributing leaflets in front of the New York Public Library in protest against the execution of the Rosenbergs in 1953, this had less to do with my understanding of Cold War politics than with my sympathy for them as persecuted individuals in the early post-Holocaust period.

My political awakening occurred in the 1960s, coinciding with the beginnings of my late-blooming academic career. At that moment Western ideological and political hegemony was disrupted, and this disruption took the form of a symbolic occupation of the streets and institutional structures in the advanced industrial countries. Both the student and civil rights movements quickly translated into struggles for urban space. Indeed, the rhetoric of community control soon became the property of diverse social movements and lived on through the next decades.[27] Even the radical feminist goal to end male supremacy in all areas of social and economic life could be seen as an attempt to contest the public as well as private spaces of everyday life. As in the case of the Commune, the issue of decentralizing institutional control and distributing power more widely among the entire citizenry was hotly debated in the name of democracy. Groups renamed themselves and reconstituted themselves as subjects on the basis of race, ethnicity, and gender, and new dress and cultural codes undermined traditional

class signs. This wrenching revelatory experience growing out of participation in the debates over positions during the Civil Rights Movement and the anti-Vietnam protest generated an enthusiasm on my part way out of synch with most of my generation. Despite the fact that I could be classified among the untrustworthy folks "over thirty," I now redirected my previous optimism and nationalist devotion towards what I perceived to be more "authentic" democratic ideals as I saw them unfold in the dynamic interaction of the radical social movements. What was powerful for me in these movements was their convergence on the social and institutional spaces where it could be immediately seen that the promise of mobility and inclusion was a long way off from being fulfilled for large numbers of "my fellow Americans."

At the same time (chalk it off to my perennial naiveté) having gained these insights later in life than the militant students, I did not readily yield to discouragement or disillusionment as so many did in the predominantly Republican era that followed. In academia, this discouragement took the form of new intellectual currents which (narrowly construing Althusserian formulations) often used post-structuralist concepts and the term "theory" to mask the poverty of, or fear of, substantial insights into social practice. If the study of language has opened fresh possibilities for an understanding of social history and the laws of how a society functions, it should not stand in the way of a scientific analysis of history and the subject. My "unapologetic" participation in, and affection for, the sixties has allowed me to confront the Commune as one instance of the constant mutation of social structures constituted by forces that are in conflict. Lest I be accused of trying too hard to be "politically correct," I hasten to add that I do not see this perspective as possessing a special or superior moral virtue but rather I mean it to clarify what I believe governs my particular take on the historical conditions in France during the aftermath of the Commune.

I will suggest that the post-Commune era, in which Impressionism unfolded, was a construction as much of the fledgling Third Republic as of the scattered remnants of the radical formations whose historical memory cherished it ever after as a foretaste of the millennium. Although the crushing defeat and relentless prosecution of the Communards helped the conservative Third Republic survive by proving to the monarchical majority in the National Assembly that it could control the insurgent poor and their allies, social reform was postponed for over a decade and the participation of the working classes in the political struggles was permanently affected. As Edmond de Goncourt wrote with a personal vengeance three days after the end of Bloody Week:

> It is good that there was neither conciliation nor bargain. The solution was brutal. It was by pure force. The solution has held people back from cowardly compromises. The solution has restored confidence to the army, which learned in the blood of the Communards that it was still able to fight. Finally, the bloodletting was a bleeding white; such a purge, by killing off the combative part of the population, defers the next revolution by a whole generation. The old society has twenty years of quiet ahead of it, if the powers that be dare all that they may dare at this time.[28]

No single institution—indeed, no corner of everyday life in France—escaped the impact of the Commune and the reaction. There can be little doubt that the characteristic right-wing activist response to the Commune profoundly colored both speech and action during the early years of the republic. With rare exception, the moderate liberal intellectuals of France and everywhere else identified with the conservative position. The articulate Right was haunted by the Commune and any expression of radicalism was equated with insurrection. Indeed, any sign of dissent or difference was immediately suspect for years, both in the family and in collective life. We must recollect that the core of the artisanate was either ruthlessly exterminated or thrown into exile, making everyday life a little emptier and a little quieter. The Parisian class structure had to be entirely reorganized, as the voices of the underprivileged went unheard without its leadership. Although Gambetta was prepared as early as July 1871 to cooperate in restoring Thiers' "moral order," even his speeches caused consternation in an environment excited by an outpouring of pamphlets on the secret societies and cabals of Jews and Freemasons fomenting another Commune whose ruins continued to smolder. It was not until partial amnesty in 1879 and full amnesty in 1880 that there was a fresh influx of the working class, and the beginnings of organized labor activity. By this time, however, the Third Republic government had gained sufficient support and confidence to feel able to manage it. It is altogether unsurprising to find that by 1879 formerly hostile critics began to temper their commentary on the Impressionists and even admit to rare ability among the "intransigeants." By the end of the 1880s, the critics even wax apologetic about ever having suspected them of harboring revolutionary designs.[29]

The devastation that struck Paris in this period gives rise in the aftermath to the reigning metaphors of regeneration and restoration, both visually and textually (fig. 11). Little by little, one commentator observed, Paris regained its old appearance [*physionomie*], "that is, its appearance prior to the Commune, the siege and the National Guard."[30] Another critic, writing for the same journal, sighed: "Before the war, before the Commune! Here are the words that crop up again and again so often beneath the pen of the chronicler; one is able only gradually, and by a series of painful examples, to give an idea of the perturbation that these lugubrious events have caused."[31] In July 1871 newspapers reported with delight that the civil engineer Alphand, a crucial player in Second Empire Haussmannization, was already putting his talents to work restoring "to its original state . . . the lawns of the Trocadéro!"[32]

The municipal government of Paris undertook a massive effort to rehabilitate the ravaged public spaces and shattered institutional infrastructure. High on the list of its priorities was the reconstitution of its public squares and parks. Significantly, even plans for the reorganization of the teaching of fine arts were figured with the post-Commune rhetoric of regeneration.[33] But perhaps the Third Republic's obsession with effacing the traces of the Communard presence is best seen in its unexpected outrage at the toppling of the Vendôme Column—the beloved symbol of none other than the Bonapartists. Yet this identification became less important to the monarchists and moderate republicans than the fact that its destruction was wrought by the Commune. Its symbolic restoration is seen in the fact that the refurbished statue of Napoleon was hoisted to the pinnacle on the same day that the remains of generals Lecomte and

11. Edmond Morin, *Après la tourmente*. Wood engraving reproduced in *Le Monde illustré*, 3 June 1871.

Thomas were transplanted from Montmartre to the Père Lachaise cemetery and honored in a highly publicized ceremony.[34] Both events signaled the government's dedication to rectifying and redeeming the actions of the detested Communards. The rare dramatic exception to the drive for socialist cleansing were the ruins of the Tuileries, left standing for want of tactical concensus among the political parties about how to handle the monument. Meanwhile, its persistent presence was justified in the official rhetoric as a symbolic negation of Communard barbarism.

An entire cottage industry cropped up devoted to the documentation of the defeat of the Commune and the gutted buildings and burned rooftops left in its wake. Photograph albums of the destroyed facades of once-beautiful buildings served as memorials to the destructive effects of political radicalism. The widespread devastation is remarked upon by all the writers of the period, and images in the popular illustrated journals all pointed to the ruined landscape that once boasted some of the most spectacular topography in Europe. The lavish quarters and parks built under Haussmann had been reduced to charred timbers and piles of rubble. Despite the frightful appearance of Paris in June 1871, however, the thoughts of Goncourt and his friend, the art critic and moderate republican Philippe Burty, turned to the possibilities of renewal: "We speak of the sad state of things and we see no resurrection for France except through her admirable capacity for hard work, through the ability to work day and night which other countries do not have."[35] Is it a coincidence that Burty, soon to

become one of the leading apologists for the Impressionists, commends the artists in his review of the second Impressionist exhibition of 1876 for being "hard-working," and lauds their efforts in the first show of 1874 for clarity, freshness, and the "virginal" rendering of the general aspect of the landscape?[36] What I hope to show is that the scenes of the Impressionists are complicit with the subsequent intensive campaign to rebuild Paris and its beautiful suburbs, coinciding with the official line of the period. It was not by chance that Monet exited Paris at the end of 1871 to reestablish his career in the suburb of Argenteuil, or that 1871 is often taken as the starting date for the formal emergence of Impressionism and even Manet's incipient break with the past. Recalling his moves just after the suppression, Renoir stated: "When order was restored to Paris, I rented an atelier on rue Notre-Dame-des-Champs."[37] When Armand Silvestre set out to justify the inclusion of Sisley, Monet, and Pissarro in Durand-Ruel's catalogue of prints in 1873 and to counter criticism of their stylistic similarities, he asserted that "nobody really knows who will insert, in its proper place, that stone which each of them contributes to the great edifice [of French art]."[38]

Key patrons of Impressionist scenes such as their dealer Paul Durand-Ruel, Jean-Baptiste Faure, Théodore Duret, Gustave Caillebotte, Ernest Hoschedé, Victor Choc-quet, Henri Rouart, Georges Charpentier, Edmond Maître, and Georges de Bellio also rejected the Commune principle.[39] Ironically, the Impressionists continued the direc-tion of their work of the late 1860s, forging a continuity with the Second Empire analo-gous to Thiers' government undertaking the rebuilding of Paris in the form Napoleon III shaped it. This is not to say that they desired a return to an imperial status quo ante, but that they wanted to restore the material embodiment of an idealized Paris as it still existed in memory. But merely reclaiming the space physically was insufficient for the victorious, they had to also reclaim it symbolically in representation. Here it should be emphasized that the breakthrough techniques of the Impressionists occurred after 1870, pointing to the decisive stimulus of the Commune-influenced epoch. Once the military and political work was accomplished, the urban and intraurban sites trans-gressed by the Communards needed to be reinvested and reappropriated once again for bourgeois culture. The Communards constructed a new identity for themselves and in the process gave that urban space a new identity. What made the Commune insurrec-tion unique was not its seizure of the means of production, but its seizure and transfor-mation of a particular sector of civil society. Although the city center in the modern epoch is inevitably the site of popular insurgency, the worker-Communards, victims of Haussmann's architectural and social reorganization, descended into the center to re-claim the public space from which they had been evicted, to reoccupy streets they formerly inhabited.[40] Their dismantling and transformation of that social and physical space, however, differed from changes made by previous governing bodies only in its class perspective.

Throughout French history, as royal pageants, entries, and coronations demonstrate, new ruling regimes carved out zones of control as an act of legitimation and to promote a narrowly conceived class identity. Often, this implied recapturing the symbolic space of a previous regime and deleting and replacing its signs of authority. This was seen during Bloody Week when the red flags were removed from the public spaces and re-placed with the tri-color, as in the case of the highly publicized feat of one Versaillais

TAKING DOWN THE RED FLAG FROM THE GRAND OPERA HOUSE.

12. *Taking Down the Red Flag from the Grand Opera House.* Wood engraving reproduced in the *The London Illustrated News,* 17 June 1871.

veteran who climbed the lofty Opéra to remove an immense red banner that fluttered from the gilt lyre of the bronze Apollo crowning its sloping roof (fig. 12). There is a wonderful passage in George Sala's *Paris Herself Again in 1878–9*—the title explicitly referring to France's recovery from humiliating defeat and civil war—that instances another visual transition connected with the same building:

Just eight years ago I was staying at the Grand Hôtel, in a room overlooking the Place de l'Opéra; and on the morrow of the Revolution of the 4th of September, 1870, I was lying grievously sick in bed. From the angle of the apartment in which my bed was placed I had a capital view of the façade of the Opéra; and with peculiar curiosity did I watch the proceedings of a journeyman painter in a blouse, who, perched on a tall scaffolding, was occupied in erasing from the inscription 'Académie Impériale de Musique' the adjective 'Imperiale,' and substituting for it the word 'Nationale.' He took such pains over his work that I got an opera-glass to peer at him the more narrowly. The labor to him was manifestly one of love. He licked his lips, so to speak, over the upstrokes and the downstrokes; and his whole Republican soul seemed to pour forth when he came to the great round O. Instinctively as I ascended the *perron* [steps] a week since did I glance upwards at the inscription; and in the flaming gaslight 'Nationale' seemed to me to have a newer coarser sheen than

the rest of the legend. There had been a wound, and this was the scar. Ah, if all the other hurts of France could cicatrise so quickly as this has done![41]

Sala's elevated perspective from his Grand Hôtel room overlooking the Place de l'Opéra might easily have been that of an Impressionist, and his class and political bias show through his condescending commentary on the description of the painter and the qualities of the replaced text. But he is quick to acknowledge the transformation in the public sphere as metaphorically projected in the substitution and to reclaim it symbolically as a "healing" process. Even this modest remaking of the social signage required the talents and skills of art producers to create the required trappings, to retrace the route to power and then to recreate history. The Impressionists entered the scene to mop up and blunt the "coarser" elements within their privileged purview to conceal the "scars" on the landscape and render the historical transition visually seamless. Like Sala—whether unconsciously or not—they recovered the Parisian territory from the *canaille* who had rejected the privileged organization of that space, and reinvested it with bourgeois sensibility and symbolic value.

There is a telling testimony by the critic Armand Silvestre who hung out with the Impressionists in their favorite haunts in the period just prior to the opening of their first group venture. Remembering the vibrant spectacle of Montmartre and the lively encounters in the Café Guerbois, he declared:

> I was attracted to the area shortly after the war by the combination of its material and intellectual advantages. Paris, still breathing from the final convulsions of civil war, had a deep yearning for quietude and forgetfulness of the past. Flowers were already beginning to grow from the blackened ruins, and to show themselves from among the blood-stained cobbles. Inanimate matter, no more than men, is not made to suffer protracted grief. It is true that one thought a bit about those who had been proscribed by the government, but youth, infatuated with sunshine and spring, had reasserted its rights. Only deep thinkers wondered how long the shock of this recent jolt would last. Because beneath these surfaces, so rapidly calmed, like those of great lakes after a storm, there seethed a dark pool of hate and anger, and, in these mysterious depths, bubbled crazy desires for revenge and expiation. What was to become of the mind condemned to live amid such currents? Would French art and its sacred precincts survive for long after this catastrophe? We experienced anxiety about all this in the face of the apparent indifference of a crowd whose revolts had been too high-pitched to be so suddenly appeased.[42]

Silvestre suggests here the psychological motivation for Impressionist activity in the wake of the recent upheavals, activity sparked as much by the preoccupation with the political conditions as with the future of French art. This is a group distanced from the crowd (*la foule*) yet yearning to appease it. Significantly, when Silvestre reviewed the first exhibition of the Impressionists he praised "their pleasant colors and charming subjects" whose influence he felt would extend to all contemporary art by reinvigorating the range of pictorial possibilities.

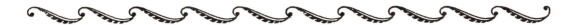

2. THE CRITICAL RECEPTION

T RYING to persuade Tissot—living in London since the end of the Commune—to
join with him and his colleagues in the first Impressionist exhibition, Degas ex-
horted his friend to put aside all commercial concerns and think patriotically: "So
forget the money side for a moment. Exhibit. Be of your country and with your
friends."[1] This appeal to nationalism on the part of one of the key organizers of the
show leads us to a critical examination of the curious mixed reception of the Impres-
sionists at their inaugural exhibition in 1874, one that ran the gamut from muted
praise to bitter invective. (It is also true that even some of the most abusive reviewers
found something positive to say about the qualities of individual works.) Almost all
complained about the incompleteness of the efforts and lack of clear definition of the
forms, despite the praise for the look of freshness and "elements of renewal and prog-
ress" produced by the sketchy technique. But the label of radicalism so often leveled at
the participants stigmatized the show as a subversive political act. We may well in-
quire just why it is, given their qualities of escapism and unconstrained freedom that
we so much admire today, that the Impressionists were perceived as inimical to the
state's interests in 1874. The answer lies in the overdetermination of their reception in
light of the experience of the Commune. Their group formation, experimental diver-
sity, look of difference, and antihierarchical content and technique made them suspect
to conservative spectators still influenced and threatened by the bitter memories of
the outrageous actions of the Commune.[2] Emile Cardon, for example, writing for *La
Presse*, entitled his caustic appraisal "L'Exposition des révoltés."[3] Another commonly
used term to describe the group was "intransigeants," a specific political allusion to
the extreme left-wing of Spanish radicalism in 1873.[4] In actuality, this period of hos-
tile reception lasted for only a short time and by the last years of the decade they
were more accurately understood as representatives of the post-Commune and anti-
Commune era.

The context in which they launched their movement was still seething with social
tension caused by the experience of the Commune. The conservative commentator
Ernest Daudet, already anticipating the aftermath, catches the conflicting positions of
his contemporaries in this bristling passage:

> The uprising is vanquished. The valor of the army had a proper mission: that
> is good. But it would be illusory to believe that all that is left for us to do is to

rebuild our material ruins, to return to our daily business and to our pleasures, and to forget the past. On the contrary, it is necessary to remember, because this insurrection has demonstrated the power of a revolutionary idea, sent out purposefully to the corrupted or bewildered masses, as well as the existence of a formidable conspiracy organized from below to crush all that which is noble, respectable, great: our families, our fortunes, our traditions![5]

Daudet wished to cling to the memory of the Commune to shape a conservative program for the future government (for him the "Republic" saved France in May 1871), while many of his contemporaries harboring more mixed feelings just wanted to get on with their lives.

This conflict is played out in the contradictory signals communicated by the critics during the reception of the Impressionists, particularly evident in a review by Zola of the independents in 1876. He claims that Monet's pictures communicate to him, "une impression de jeunesse, de belles croyances, de foi hardie et enflammée." This is the utopian, restorative side that Zola shared with the Impressionists in the wake of the Commune, but at the same time he characterizes Monet, Pissarro, and their colleagues as "revolutionaries" whom he predicts are destined to transform the French school in twenty years.[6] Zola at once clarifies the qualities that endeared them to a younger generation of art collectors, and at the same time helps us understand the anxiety they evoked in 1874.[7]

Perhaps one of the most telling reviews in this respect is one by the republican feminist Maria Deraismes—Pissarro's neighbor at Pontoise—who was writing in outrage over the rejection of Eva Gonzalès, a former disciple of Manet, by the Salon jury of 1874. Deraismes claimed that it was Gonzalès' affiliation with the realist Manet that led to the rejection of her picture, *The Loge*, and that for the conservatives the realist is to painting what the "radical is to politics." She went further in relating this kind of thinking to the current wave of reaction: "Manet is a realist, but so was Courbet. Therefore from realism to the Commune, there is but one short step. In this case, it is not just a question of a school, but a question of general security. Oh, the depth of politics!"[8] Deraismes goes on to contrast the differing attitudes of the realists whom she characterizes as the "*sincères,*" and the conservatives whom she describes as the "*non-sincères,*" emphasizing the explicit links between aesthetic principles and political ideologies. Written less than two months after the closing of the first Impressionist exhibition, Deraismes further clarifies the wellsprings of contemporary hostility towards the newcomers.

Deraismes was a leader of the bourgeois feminist movement in France, and the resistance to this movement in the early years of the Third Republic provides an intriguing parallel to that of the independent artists in the period. Deraismes belonged to the moderate, antisuffrage wing of French feminism which threw its support behind the liberal republic. Her position coincided with that of center-left politicans like Edouard de Laboulaye, Edouard Lockroy, Victor Hugo, and Louis Blanc who in turn supported her brand of French feminism. Like them she deplored the conduct of the Communards, but also advocated amnesty for prisoners and condemned the harshness of the retaliation and discriminatory verdicts rendered against the so-called *pétroleuses*. In

1873 she published *France et progrès*, a tract defending French culture in the face of defeat and meeting its accusers on their own ground, condemning the excesses of the Commune and ridiculing bourgeois fears of socialism, rejecting repression and opting in favor of "solidarity" of class, gender, and race, extolling republican patriotism, and anticipating a national rebound from the recent disasters.[9] In other articles of the period she discussed the "regeneration" of France, calling for a mental healing rather than a resort to discipline and the forging of arms, and admonished the intellectuals to remain optimistic. Either the "mind worker" (the intellectual) believes in infinite progress and works with "une ardeur invincible," or lapses into despair and routine. The routinization of French society—a tempting route to take in view of the twin shocks to the system—would guarantee that anything out of the ordinary would be perceived as a danger to the state. She especially demanded the recognition of women's civil rights and the release of feminine energies as the basis for the progress of the battered state.[10]

Despite her moderate proposals, Deraismes and her peers were highly suspect in the reactionary climate of the immediate post-Commune period. In March 1873, M. de Goulard, Thiers' Minister of Interior, refused to authorize Olympe Audouard's public lecture on "La question des femmes," citing female conferences "as only a pretext for the gathering of numerous *over-emancipated* [*trop-émancipées*] females," and condemning Audouard's theories as "subversive, dangerous, and immoral."[11] Clearly, the recent events had politicized the context in which bourgeois French feminism was struggling. The massive, extraordinary, momentous participation of women in the Commune proved such a threat to French patriarchy that conservatives attempted to stigmatize the participants as viragos and criminals. The legacy of the Commune for women was the image of the female incendiary—a frightening image of uncontrollable and therefore "subversive" women.[12] As in the case of the Impressionists and the academicians, women were divided into two categories: the savage *pétroleuses* who go beserk under stress, and the angelic females who remain at home or perform social nurturing like nursing. French society yearned for stability after the double trauma of war and civil disorder, and women's emancipation in the aftermath was viewed by conservatives and moderates alike as potentially disruptive of that stability. The feminist movement after 1871 would be bourgeois and liberal, but even this was considered threatening in the heated political climate.

By the late 1870s, however, both the Impressionists and the liberal feminists could make claims to public legitimation and respectability. In 1878 the republic seemed stable enough for the feminists to organize the first French Congress for Women's Rights, articulating a moderate program wholly acceptable to the future Opportunists of the early 1880s. Although the Impressionists' second exhibition in 1876 continued to arouse intense controversy, it did so because the work now had legitimate claim to a niche in the Parisian art world. This parallels the evolution of the general public attitude towards the Communards in the 1870s. Whereas from 1871 to around 1874 Communards were lumped together indiscriminately as thugs, gradually public opinion softened and participants were individualized as honest reformers, innocent dupes, and hard-core offenders. By 1876–1877, the controversial issue of amnesty could enter the public domain as people could now state openly that some Communards

deserved pardon while still others merited the public's sympathy. As Philippe Burty, a republican with close ties to the Opportunists, wrote about the second exhibition:

> This present attempt has been much better received by the public than the first, and this is not merely the impression of one who, as I do, personally sympathises with the feelings that prompt these artists as a body, but that of a paper also which is the organ of the purest academical doctrines, *La Chronique des Arts et de la Curiosité*, a weekly fly-leaf of the *Gazette des Beaux-Arts*. The step is considerable, and was for many reasons to be foreseen. The public are fired with a kind of tender interest in this group of honest earnest-minded, hard-working, original young artists, men yearly victimised by the majority who bear tyrannous rule over the official Salon, its entrance, and its awards. They regard this exhibition with favourable eyes, as being both a tribute to their judgment and to men chiefly poor, who, in a country, in a society, that has no notion of the advantages of material or moral co-operation, have succeeded in forming an association among themselves, for their mutual benefit.[13]

It is a tribute to their success that distinguished critics of the leading journals now descended into the arena to take their measure. The most vehement of all was the review by Albert Wolff in *Le Figaro*, which compared the artists to mental patients in a madhouse, conjuring up once again the specter of the lunatic Communard arsonist. When the critic of *Le Rappel*, a radical newpaper, praised their work, an anonymous reporter in the official *Le Moniteur universel* wrote: "The Intransigents in art holding hands with the Intransigents in politics, nothing could be more natural." One reviewer, comparing them to the Spanish Intransigents—from whence the term derived—noted that the anarchist wing of the Spanish Federalist Party admitted neither compromise nor concession, that the "terrain on which they intend to build their edifice must be a tabla rasa." Similarly, the Intransigents in art wanted also to begin with a fresh slate, unencumbered by academic formulae. Although referring to an aesthetic discourse, I believe he caught hold of a certain truth about the early Impressionist agenda. The violently anti-Communard paper *Le Gaulois*, whose tirades against the insurgents fired up the Versaillais pending their invasion of Paris and remained staunchly opposed to amnesty, was surprisingly sympathetic to the Impressionists from the start.[14] Its reviewer had kind words to say for the entire group including Cézanne, and concluded by apologizing for his lack of space to discuss the painters in detail because, "nous serions très heureux de voir réussir les artistes de cette nouvelle société." He declared that their efforts deserve to be encouraged, because with slight resources they are making a valiant attempt that promises a bright future.[15] In 1876, another reviewer for the same paper confronted the accusations of aesthetic subversion as coded references to political subversion and asked for public understanding:

> Are these artists who for a second time are appealing directly to the public revolutionaries as some love to repeat, when they are not being treated idiot-

ically as communards? No, of course not. They are dissidents at most, associated and organized for the purpose of showing the ensemble of their work under optimal conditions unavailable in the Salon.

He admonished the public not to judge them too hastily, and that it not be put off by some "inevitable exaggerations at the dawn of a new school whose disciples possess not only the qualities of youth, but also the general defects that go with it. . . . It should consider only one thing, the new idea, the fertile renewal of the French school, the affirmation in a word, of an art principle whose results could be considerable." He then admonished his readers to momentarily step outside the range of aesthetic discourse, and rhetorically inquired: "Isn't it consoling, in the aftermath of our disasters, to witness a young generation, full of life and vigor, willing to forego for the sake of a noble conviction an easy success in another genre, to sustain often unjust criticism, sometimes even discomfort, in order to uphold an idea it has made an article of faith?"[16] Finally, Silvestre could deploy an analogy with music to underscore his related response: "As for me, I find here the mildness of a perfect concord after an avalanche of dissonances. It is not an orchestra, it is a diapason."[17] What counts for Silvestre and the reviewers of the *Gaulois* are the implications in their work of regeneration and renewal, and these overshadow the technical flaws inherent in their experimental and youthful exuberance.

Victor Cherbuliez, reviewing the Salon of 1876 for the conservative *Revue des deux mondes*, strove for a balanced account of the Impressionists, whom he referred to (somewhat tongue-in-cheek) as the "school of the future." For him they were the "sharpshooters, the Garibaldians of painting, those who call themselves the *intransigents* or the *impressionists*." He characterized the new school as a lively bunch with the devotion of a religious sect, trying to convert the insensitive bourgeoisie to the love of the sketch, the vague, and the unfinished. "Did the artist wish to paint a god or a wash-basin?," he rhetorically asked. It was up to the bourgeois spectator to guess.[18] But it was precisely this look of incompleteness and its peculiar charms that enabled Impressionism to be encoded as a category of high art. In his own popular book on aesthetics, *L'Art et la nature*, Cherbuliez declared that his choice of great art inevitably displayed the personal stamp of the author rooted in the first impression: "Nothing is more personal than our impressions, and every work worthy of the name is born of an impression vividly experienced and sincerely rendered." Every profession had its peculiar merits, "perfect sincerity" is the professional virtue of the artist. Although the definitive project had to be developed and refined, the most fugitive sensation was grist for the artists' mill. Whether the poet-artist be Christian, Jewish, Muslim, Protestant or Catholic, devout or free-thinking, liberal or absolutist, royalist or republican, "if the Muse orders it, he will scandalize the sectarians by his generous inconsistencies." Hence the creative artist cuts across political, religious, and class divisions with the tenuous individual impression which is ultimately independent of all these social affiliations.[19]

It was surely in response to such unexpected serious appraisal from diverse conservative quarters and its curious parallel in other areas of cultural experience in 1876 that

prompted the bourgeois feminist, Maria Deraismes, to warn republican liberals that the anti-Republican forces—Bonapartists, clerics, monarchists and legitimists—were calculatingly stealing the agenda of socially progressive groups to revive their sagging popularity. They were, for example, plagiarizing the ideas of the feminist movement to gain the support of "one half of the population," while plotting the destruction of the republic. She protested that the attempt of the reactionaries to canonize Joan of Arc and convert her "essentially national heroism into Catholic heroism," was an act of the highest effrontery on the part of those who would have persecuted and assassinated her. Then she noted that the same group is in the process of infiltrating the realist movement—here specifically denominating Courbet, Manet, Caillebotte, and company—whose canvases are so conspicuously lacking in mystical and religious tendencies and themes of saintly sacrifice. She blames the republicans for their lukewarm support of the new school for giving the opportunity to the conservatives to identify themselves with the young artists (whom she classifies as advanced republicans) and mask their program with forward-looking appeal. In such troubled economic times, and evidently discontented with the lack of appreciation on the part of their kindred political allies, the appeal of a well-timed commission and flattering praise will not be unwelcomed by the young artists. Deraismes' article, coinciding with the year of the second exhibition, attests to the changing climate of reception of both the feminist movement and Impressionism, and the convergence of differing political agendas on the issues raised by modernity.[20]

The year of the second show also marked the watershed publication of Duranty's *La nouvelle peinture*, defining the new art and exploring its origins. Duranty, like every reviewer of the Impressionist shows, acknowledged their failure to go beyond the sketch, but emphasized the originality and fresh ideas of the movement.[21] His simile could have applied to cultural politics in the wake of the Franco-Prussian war and Commune: "A new branch emerges on the trunk of the old tree of art. Will it bear leaves, flowers, and fruit? Will it spread its shade over future generations? I hope so." Duranty's pamphlet is a sort of Impressionist manifesto, and as such merits close scrutiny. Although professing a democratic tone, Duranty expresses a privileged position constructed in opposition to the debris of the Commune. He stresses the need for the painter to depict the modern individual in an indigenous modern environment—"in his clothing, in social situations, at home, or on the street." Duranty is especially keen to study people in relationship to their environment and the influence of their profession on them, as reflected in the gestures they make. And he continues:

> A back should reveal temperament, age, and social position, a pair of hands should reveal the magistrate or the merchant, and a gesture should reveal an entire range of feelings. Physiognomy will tell us with certainty that one man is dry, orderly, and meticulous, while another is the epitome of carelessness and disorder.

Duranty's comments resemble the program of the conservatives to identify the potential misfits and dissenters among the laboring classes held responsible for the disorders of the Commune. Duranty's pamphlet in fact reveals sharpening class antagonisms in the 1870s; while he excuses the poorly defined shapes in Impressionist painting, in

reality he wants strict definition of class identities and their baggage. But he knows that "lives take place in rooms and in streets, and rooms and streets have their own special laws of light and visual language." This means that the logic of color and drawing in these representations depend on the time and season and the place in which the subjects are seen. When he speaks of interiors, his descriptions clearly refer to privileged masculinist environments. Surrounding the person are the furniture, fireplaces, curtains, and walls that indicate his financial position, class, and profession. The new painters, he states a little later, "have tried to render the walk, movement, and hustle and bustle of passersby, just as they have tried to render the trembling of leaves, the shimmer of water, and the vibration of sun-drenched air."

Duranty opens his novelette, *La Statue de M. de Montceaux*, with a view of the active urban life seen from a window or balcony where, "one could have counted numerous black dots [*points noir*]. . . . These black dots were passersby, strollers singularly preoccupied with business affairs."[22] Moving from the panorama of street life to the human drama soon to unfold around the inauguration of a statue of a local hero, Duranty delineates the class character of each of the protagonists. But what is curious is that even in the long view, Duranty is at pains to show that the "black dots" that dominate the street constitute a specifically bourgeois—if blurred—vision. His perception of the black dots of class identification reconfigure what other critics, not so close to the Impressionists, chose to characterize with some malice as "black tongue lickings."[23]

Duranty confessed that early on he imagined painting as charting "a vast series about society people, priests, soldiers, workers, and merchants." Although they would differ in their individual roles, they would be linked to a common public space, especially scenes of marriages, baptisms, births, successions, celebrations, and family scenes. Like the social space of modernism in capitalist society, class identities mingle without touching and preserve their social differences. In the main his argument is a special plea for liberal bourgeois supremacy on the eve of casting out the last remnants of the monarchist coalition and setting up the republican Third Republic. He attacked the painter of North African subjects, Fromentin, who celebrated the heroic character of Bedouin horsemen, "for hindering the colonization of Algeria." The politics of sketching have now been usurped by the bourgeoisie who crushed the Communards. The improvised surfaces of Impressionist painting, initially perceived as anarchistic expressions, later gained almost universal respectability as a liberal response to the dual demands for order and institutional change.

Burty, for example, supported "the general idea" of Impressionism because it had "a very close connexion [sic] with the movement that we must support unceasingly if we would escape plunging into the tyranny of formulas such as prevailed under the First Empire and the Restoration."[24] In this clever subterfuge, Burty uses a text about aesthetics to praise individual freedom under moderate republicanism while damning authoritarian Bonapartism and monarchism—twin evils still fending off the full-fledged Republic. The young upstarts despise the "filching" of figures from engravings "or ransacking the Musée des Copies" (a conservative republican innovation), fleeing from the artifices of the Academy and the lure of official awards.

In 1880 Charpentier published Burty's novel entitled *Grave imprudence*, whose

hero is the painter Brissot, "chef du mouvement impressionniste." The protagonist searches "without an agenda (sans parti pris) a virile conception, a modern style, something that would display or celebrate the distinction of the young society, the aspirations of the rising classes, the radiant ideal towards which the entire country was heading." He establishes himself in Paris near the Parc Monceau, and then seeks class-based motifs in the countryside and the city, searching "the fields for the peasants, the factory for the worker, the street for the passer-by, the boulevard for the bourgeois and the tourist, the Bois [de Boulogne] for the wealthy."[25]

Burty thus agrees with Duranty's perception of the class bias of the new realists. He is delighted that the Impressionists eschew "social or human" features in their representations, depending more on "elements of interest strictly aesthetic . . . lightness of colouring, boldness of masses, blunt naturalness of impression." He admits to being "quite won over to this doctrine," although he could understand that from "the governmental point of view, it is heretical, worthy of the dungeon, the torture and the stake"—again, conjuring up despotic associations with authoritarian regimes. He shifts to the metaphor of freedom they present in their likeness to "a band of artists floating down a rapid river, drinking in the intoxicating effects of the sun, the shade, the verdure, the freshness, the perfumes that wander over the water and the banks, and never casting anchor or bringing their bark to land." He agrees with the critics who decry their want of finish and solidity, but suggests that in this they merely display "the faults of youth," as in the suburban studies of Monet, Sisley, and Pissarro, "when they suppress not only the human race, but also what the human race is accustomed to see there, that is, trunks of trees modelled according to the light that falls upon them; branches with well-defined knots, and the joints visible; houses square or oblong." Nevertheless, despite these repressions there remains "a singular illusion of light and freshness; the masterly harmonising of ground and verdure with the blue sky and the white clouds; shadows or reflections exquisitely fleeting."[26]

Burty's defense of the Impressionists is motivated in large part by ideological desire, and harks back to his thoughts expressed in the conversation with Edmond de Goncourt on the rebuilding of the French nation. The purification of the landscape—both urban and suburban—meant first removing from it the souvenirs of the recent catastrophes and then reinvesting it symbolically through the new aesthetic formulation. He delighted in the "aimiable" look of their sites and their "virginal" representation.[27] What counts operationally is neither the presence of the "human race" nor the physicality of property, but the "illusion of light and freshness" and "the masterly harmonising" of all the elements in nature. The potential threat to this harmony—the disruptive "human race" or "mob"—is suitably repressed. Yet the "harmony" in reality can only be achieved at the expense of "hard-working" French laborers and symbolically represented by the Impressionist *go-aheads* (Burty's English) such as Monet, Sisley, and Pissarro. The aesthetic and intellectual "workers" of the bourgeoisie need to be recruited to metaphorically contain the threat of the working classes who in principle have access to the same spaces of leisure in the landscape.

Thus the Impressionists recode the remaining places and traces marking the previous dissolution of hierarchical structures. They cannot, however, give a negative spin

on democratic ideals, but attempt to convey them by concentrating on the public sphere under conditions of flux and transition. Their technique homogenizes space and abolishes old heterogeneities, but expresses them technically in the metaphorical equivalent of exclusion. The sensuous pigment and emphasis on radiant color are keyed more to the elegant and fastidious taste of the refined bourgeoisie bent on the rare and exquisite object than to the plebeian seeking a representation of self for a sense of place in the new order. The Impressionist surface is a recoding of the public sphere for the privileged even while representing a space theoretically accessible to all. This visualization of the public space is analogous to the consumer spectacle of the department store, where the poor may look but not touch.

This is how I interpret Mallarmé's essay on Manet and the Impressionists, whom he describes as "workers" who "paint wondrously alike." Monet, Sisley, and Pissarro "endeavor to suppress individuality for the benefit of nature." This has a marvellous effect on the spectator who proceeds

> from this first impression, which is quite right as a synthesis, to perceiving that each artist has some favourite piece of execution analogous to the subject accepted rather than chosen by him, and this acceptation fostered by reason of the country of his birth or residence, for these artists as a rule find their subjects close to home, within an easy walk, or in their own gardens.

In other words, as workers the Impressionists' generality suppresses their own individuality and recreate for the bourgeois viewer a "harmonious" slice of property relations that alone constitutes modern-moderate living. They represent "the transition from the old imaginative artist and dreamer to the energetic modern worker," and together with their other colleagues merit all honor for having, "brought to the service of art an extraordinary and quasi-original newness of vision, undeterred by a confused and hesitating age."[28]

Like his friend Burty, Mallarmé praises their "workman"-like earnestness and dedication but in a way that subordinates their labor to the needs and aspirations of the dominant classes. It is true that Mallarmé pays lip-service to the "participation of a hitherto ignored people in the political life of France" whose cultural parallel is found in the new movement, "dubbed, from its first appearance, Intransigeant [sic], which in political language means radical and democratic." (This is actually inaccurate, they were dubbed "Impressionists" long before being called "Intransigents"—the latter, to stigmatize their efforts as political.) The Impressionists constitute the new breed of "impersonal men placed directly in communion with the sentiment of their time, analogous to the future political newcomers who will consent to be an unknown unit in the mighty numbers of universal suffrage." And yet what is the artist's function in the face of "the massive and tangible solidity" of this new political and market-oriented world? It is to convey "that which only exists by the will of Idea, yet constitutes in my domain the only authentic and certain merit of nature—the Aspect."[29] Here Mallarmé again agrees with Burty, both perceiving the mission of the Impressionists—who recreate "nature touch by touch"—to veil and mystify the new social relations sanctioned by law under the Third Republic.

Mallarmé's life and work are a testament to his own attempt to flee from the exigencies of the political and social pressures of his time, although he knew well how to publicize and market his work and that of his friends by implicating it in the modern. For Mallarmé's irrationalistic and spiritualistic approach flies in the face of naturalistic and materialistic Impressionism, seeking ever fainter and evaporating imagery. Even in his voluminous correspondence it is rare to come across even passing references to the political events and social upheavals. It is hardly surprising to find that he despised the Commune, waiting in Avignon until after it had been crushed before returning to Paris and even seriously trying to efface its existence in memory.[30] Both his life and his poetry are a testament to his deliberate avoidance of direct involvement with the social realities of his time, and this explains his support of the young Impressionists in the post-Commune period. They gave ordinary empirical reality some of the qualities of an ideal, timeless arcadia that he longed for in his Platonic dream. Burty wrote in his French review: "Here is a young battalion who will make its mark. It has already conquered—and this is the crucial point—those who love painting for itself."[31] Finally, Mallarmé shared with his dear friend and collaborator Catulle Mendès—who resolutely condemned the Commune[32]—the idea that "pure art" is the goal and possession of an aristocratic "elite" in the democratic age.

Nevertheless, the timing of their entry ensured a controversial reception for their positivist solutions. Tucker insightfully interpreted Monet's *Impression, soleil levant* (*Impression, sunrise*) as a possible "vision of a new day dawning" for France.[33] Yet less than a year before he painted the picture, Louise Michel, the revolutionary feminist, wrote a poem during her deportation to New Caledonia for her participation in the Commune with the lines: "L'avenir grandira superbe / Sous le rouge soleil levant" (The future will swell superbly / Under the red sunrise).[34] It should be recalled that there remained Communard prisoners who were still being tried, deported, and executed at the time the exhibition of the independents opened on 15 April 1874.[35] The fact that the drama of the Commune was still unfolding preserved the ascendance of the conservatives who kept up the pressure on left-leaning politics. Both in their organization and in their venue the Impressionists implicated themselves in the current radical political discourse. Organized as an artist's cooperative, the group appeared as a dissident and independent collective aimed at undermining the authority of the official system. Their novel technical recipes—striking many spectators as bordering on decorative and industrial design—gave an artisanal cast to the look of the exhibition. Thus, they were indirectly identified with the Fédération des artistes de Paris, the Commune's organization for artists, presided over by Courbet who grouped decorative and industrial artists with the fine artists to create ties with the artisanate. In fact, there were grounds for this association, since three of the exhibitors, Bracquemond, Auguste Ottin, and his son Léon (actually listed by the Commune as "artiste industriel") had been elected to the Fédération.[36] Louis Leroy, who coined the term Impressionism, claimed that wallpaper in its primal state was more developed than Monet's *Impression, soleil levant*, and even Philippe Burty and Armand Silvestre, early apologists for the group, associated the independents with the "*décorative*." Etienne Carjat claimed that in this case a "worker . . . could replace the artist," and warned that they could end up as "sign painters working for coal dealers and moving men." In the cir-

cumstances of 1874, such sympathies identified by the critics implied an ambiguous and even benevolent attitude towards the Commune and suspicion of the government.

It has not yet been previously noted, but the fact that they chose to exhibit in the photographer Nadar's former studio at 35 Boulevard des Capucines already surrounded their collective debut with a radical political aura. First of all, the street was the scene of heavy fighting during Bloody Week, when the Versaillais, advancing down the Rue Caumartin, attacked the barricade of the Rue Neuve des Capucines at the boulevard's entrance.[37] Although Nadar personally disapproved of the moment of the Commune and predicted that its poor timing would lead to inevitable massacre, his reputation for supporting left-wing causes gave rise to rumors about his arrest in early June 1871. He also concealed in his rooms prominent escapees of the Commune, Félix Pyat and Jules Bergeret, and persuaded Thiers (who imagined Nadar to have been shot) to give Bergeret and his wife a safe conduct and false papers.[38] Burty went out of his way to identify the location as the house of "the famous photographer Nadar, compared in his youth from his long fiery red hair, and the swiftness of his walk, to a wandering comet"—a not-so-subtle hint at the photographer's politics.[39] Thus Nadar's old signboard left on the vacated premises of the Boulevard des Capucines already implicated the first Impressionist exhibition in the memories of the insurrection.

At the same time, the hostile critics were not totally off the mark in reading the novel forms of Impressionism as a counter aesthetic discourse. To reclaim the space of Paris the Impressionists had to recode the concept of everyday life to give the illusion that the utopia envisioned by the Communards had in fact been realized within bourgeois society. This fiction was presented through the elevated perspectives that grasped the traffic of pedestrians and carriages on the boulevard as an anonymous crowd comprising all classes treated equally, as Ernest Chesneau put it in reference to Monet's *Boulevard des Capucines*, as an "indecipherable chaos of palette scrapings" (fig. 13). Although the elevated vantage point (socially expressed through the top-hatted observers on the balcony at the right) and absorption in the everyday content of public spaces is itself a giveaway of the artist's class position, the result is the antithesis of the monumental and historical and thus of conventional hierarchy. In this sense, the memory of the Commune forces the painters to affirm the relative identity of the social spaces they depict and give up the idea of their immutability. The shared memory of the disrupted infrastructure impinges powerfully on their imagination as they seek to heal the social wounds (fig. 14). The continually changing space they study is a social product shaped anew every day and is antihierarchical in time and space.

Further, the notion of swarming humanity had always struck conservatives like Thiers as the threatening tidal wave ready to engulf the dominant class. The blurry "black tongue-lickings" down in the street were always only one step away from the mob, the demonstration, the insurrection. The anonymous brush gestures may be faceless and stripped of their individual objectivity, but this was true also of the ghosts of the recently crushed rebellion threatening at any time to be reincarnated in the floating mass of people. The anti-democratic formulator of "crowd psychology," Gustave Le Bon, whose ideas were decisively shaped by his experiences during the siege of Paris and the Commune, noted that crowd-pleasing images evoked by such words as "democracy, socialism, equality, liberty, etc.," are "the most ill-defined" and

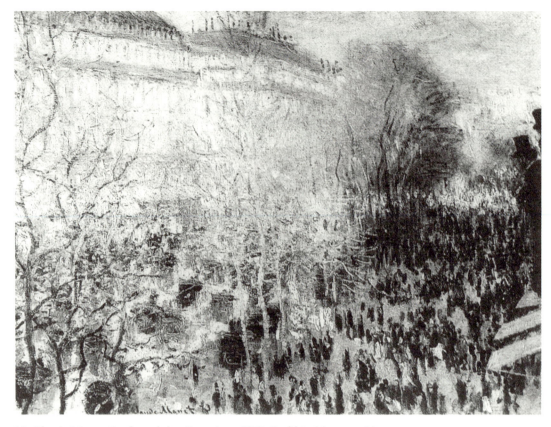

13. Claude Monet, *Boulevard des Capucines*, 1873. Pushkin Museum, Moscow.

"vague" and lend themselves to manipulation.[40] Analogously, the "ill-defined" impression of an anonymous multitude in the exhibition could be just as easily read as the movement of the swarming mob. Thus the Commune's threat to authority could still be conjured up in the reception of the scenes of the Impressionists and explains in part the venomous response of some conservative critics.

Berthe Morisot's academic teacher was shocked to see her work exhibited with the "les fous" at Nadar's in 1874. His explanation for some of the paintings on view was "madness," a similar kind of answer proffered to explain the actions of the Communards. Guichard wrote to Morisot's mother about her works on display: "If Mlle Berthe is set on doing something violent she should pour petrol on these things and set them alight rather than destroy all she has done so far."[41] Here Guichard makes allusion to the bloodthirsty, inebriated image of the Communard woman constructed by the conservatives as a *pétroleuse*. This image of the unsexed female pouring kerosene on buildings and setting them on fire could be exploited to execute hundreds of women and adolescent females and import thousands more to New Caledonia and Cayenne. As we have seen in the first chapter, Marx wrote regarding the *pétroleuse* that the "story is one of the most abominable schemes that has ever been invented in a civilized country."

THE RUINS OF PARIS: PORTE MAILLOT AND THE AVENUE DE LA GRANDE ARMÉE.

14. *The Ruins of Paris: Porte Maillot and the Avenue de l Grande Armée*. Wood engraving reproduced in *The Illustrated London News*, 24 June 1871.

The right like the left often symbolized the Commune as a militant female, but for the right she brought fiery destruction rather than social justice. Although women participating in the defense of Paris during the Prussian siege were praised for their courage and patriotism, these same attributes were downplayed when displayed by the female activists of the Commune (fig. 15).[42] The issue of gender did not come up until women fought for social justice. Then the mythical *pétroleuse*, the female incendiary who flouted her true nature, provided the Versaillais with a demonized image of the Commune's warrior maid (fig. 16). Bertall's wild and roughly attired female—a satire of Delacroix's *Liberty Leading the People*—on the barricade waving a red flag was typical (fig. 17). As seen in Dubois' malevolent caricature, her emblems are not the liberty cap or the level of equality, but the petrol can and the torch. Even more telling is Girard's sketch of a wild-eyed incendiary captioned, "La femme émancipée répandant la lumière sur le monde" (figs. 18, 19). Yet the Versaillais propaganda so frightened Parisians that they bricked up their cellar windows and kept all low windows shut in the period following the civil war—an action seized upon by the contemporary cartoonists (fig. 20).

The basic contradiction of the conservative Third Republic is that it springs from protest against the Second Empire and Bonapartism and yet is forced by the Commune

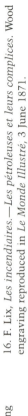

15. Edmond Morin, *Les femmes de Paris pendant le siège*. Wood engraving reproduced in *Le Monde Illustré*, 11 February 1871.

16. F. Lix, *Les incendiaires.—Les pétroleuses et leurs complices*. Wood engraving reproduced in *Le Monde Illustré*, 3 June 1871.

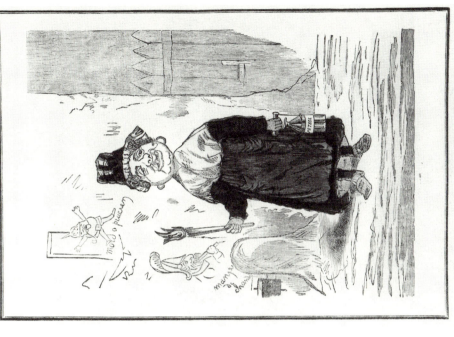

TYPES DE LA COMMUNE

LA BARRICADE

UNE PÉTROLEUSE

Ah! si son homme la voyait.

18. Dubois, *Une pétroleuse*, 1871. Lithograph reproduced in Paris sous la Commune.

17. Bertall, *La Barricade*, 1871. Colored lithograph reproduced in *Les Communeux 1871*, No. 37.

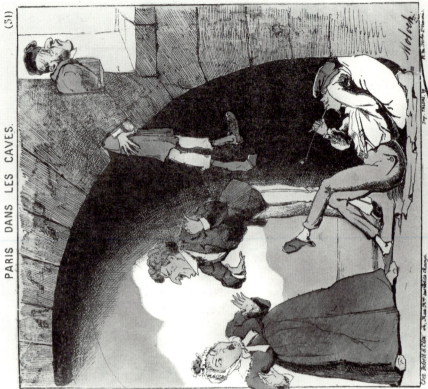

20. Moloch, *Ciel! Mon mari . . . !*, from *Paris dans les caves*, 1871, pl. 31.

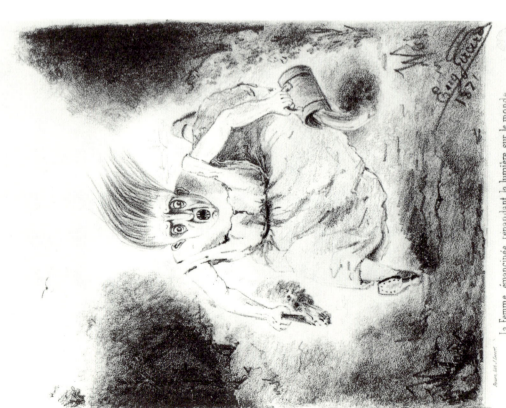

19. Eugène Girard, *La femme émancipée répandant la lumière sur le monde*, 1871. Lithograph reproduced in Series J. Lecerf, No. 4. Musée Carnavalet, Paris.

to reconstitute them in their cultural guise. The acute pain of bourgeois Parisians in the face of the abrupt end of prosperity and the rebuilding of Paris is seen most dramatically in the publication of Victor Fournel's *Paris et ses ruines en Mai 1871* (fig. 21). The former cynical critic of Haussmannization before 1870 changed his tune when confronted with the devastation of the Commune. He fulminated against the vandals who lay waste to the "splendor" of the monuments and boulevards created by the Second Empire. He saw the irony of Shakespearian tragedy in the destruction of the "Haussmannienne epic" by three successive plagues of bombardment, siege, and civil war. Although firmly convinced that Bismarck and Moltke had aimed at the start at destroying Haussmann's Paris, he saved the nastier part of his diatribe for the "depraved professors of civil war and anarchy" who brought Paris to its catastrophic finale with the "now dishonored name of the *Commune.*" After retracing the glory that was Paris, he lauds the administration of Thiers for rebuilding even Bonapartist monuments like the Vendôme Column (fig. 22). Glimpsing the stirrings of a marvellous resurrection, he adds: "Now it remains only to wash away the blood, to erase the traces of battle, to dress the wounded, to bury the dead, to raise up the ruins, to bring about a rebirth of order, security, work, to repair the disasters of the two sieges."[43]

The work of Zola, the contemporary and early defender of the Impressionists, may be seen as prototypical of the group's response to the Commune.[44] He published the first book of the Rougon-Macquart series in 1871 shortly after the Commune and the year of the origin of the Impressionist movement. *La Débâcle*, the nineteenth and last but one of the series of novels, brings to a thundering near-finale the great saga of the natural and social history of a family during the Second Empire, while the final novel, *Le Docteur Pascal*, ends with a vision of the brave new world of science and progress about to be born. *La Débâcle* concludes obsessively on a note of rebuilding, with Jean Macquart walking "into the future to set about the great, laborious task of building a new France." Paris, destroyed by fire, is compared to "the field ploughed up and cleansed so that the idyll of a new golden age might spring up into life." Zola's equivocation here seems to correspond to the ambiguous position of the Impressionists: as the fire and smoke from the buildings billow upward, a great clamor could be heard, "maybe the last death-cries of the shot victims in the Lobau barracks, or perhaps happy women and happy children eating out of doors after a nice walk or sitting in outside cafés." In other words, the Impressionist vision insinuates itself ambiguously in place of, and alongside of, the horrors of civil war.

Out of the welter of these mingled impressions, Jean, having just undergone a series of traumatic shocks, experiences an extraordinary sensation:

> It seemed to him, as day was slowly dying over this burning city, that a new dawn was already breaking. Yet it was the end of everything, fate pursuing its relentless course in a series of disasters greater than any nation had ever undergone: continual defeats, provinces lost, milliards to pay, the blood-bath of the most dreadful of civil wars, whole districts full of ruins and dead, no money left, no honour left, a whole world to build up again. . . . And yet, beyond the still roaring furnace, undying hope was reviving up in that great calm sky so supremely limpid. It was the sure renewal of eternal nature, the

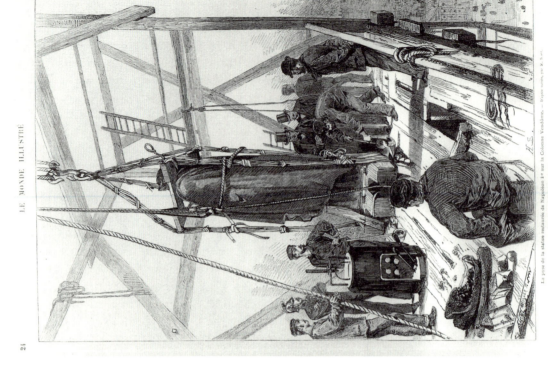

La pose de la statue restaurée de Napoléon Ier sur la Colonne Vendôme. — Dessin entre, par A. Scott.

22. Scott, *La pose de statue restaurée de Napoléon Ier sur la Colonne Vendôme*. Wood engraving reproduced in *Le Monde Illustré*, 8 January 1876.

PARIS
ET SES RUINES

EN MAI 1871

PRÉCÉDÉ D'UN COUP-D'ŒIL SUR PARIS, DE 1860 A 1870

ET D'UNE INTRODUCTION HISTORIQUE

MONUMENTS, VUES, SCÈNES HISTORIQUES, DESCRIPTIONS, HISTOIRE

DESSINS ET LITHOGRAPHIES

PAR MM. SABATIER, PHILIPPE BENOIST, JULES DAVID, EUGÈNE CICÉRI, BACHELIER, FÉLIX BENOIST, A. ADAM, JULES GAILDEAU

TEXTE PAR M. VICTOR FOURNEL

Collaborateurs à Paris dans sa Splendeur, visiter de Théâtre au vieux Paris, de Ce qu'on voit dans les Rues de Paris, de Paris nouveau et Paris futur, etc.

——

TROISIÈME ÉDITION

Publié par

HENRI CHARPENTIER, ÉDITEUR

PARIS, QUAI DES GRANDS-AUGUSTINS, 55. — ÉTABLISSEMENT A NANTES, RUE DE LA FOSSE, 34

M DCCC LXXIV

21. Titlepage of V. Fournel, *Paris et ses ruines*, 1872.

renewal promised to all who hope and toil, the tree throwing up a strong new shoot after the dead branch, whose poisonous sap had yellowed the leaves, had been cut away.

Here is precious testimony from a writer who had been close to Manet and his followers, and stated in retrospect as if had been thought for the first time. Zola was writing history as he recalled it and as he had lived it, and the "great calm sky so supremely limpid" could only have been a metaphor resonating with his memories of the past. This corresponds exactly to the sentiment of a letter written by Zola to Cézanne in July 1871, soon after the streets of Paris had been cleared of the debris of war and Communard bodies and the month Zola launched the Rougon-Macquart series in print: "I have never been more hopeful or desirous of working. Paris is being reborn. As I have often told you, our reign has begun!"[45]

This was the mandate to the Impressionists during a period of conservative political backlash. Impressionism retraces the damaged sites of the Commune, urban intersections, parks, and streets and represents them as bright, flourishing spaces. It glosses the ruins and minimizes the tension of the postwar culture, promoting the official political ideology with unofficial aesthetic effects. It strategizes in behalf of a pre-civil war idyll and privileges "a return-to-normal" exuberance that extends Haussmannization into the present. Impressionism deals with this contradiction by depicting its motifs from increasingly weird angles and points of view, blurry outlines, spectral objects, and hidden and disguised features of the landscape sites. Impressionists had to find a way of appearing modern, advanced, positivist, and yet return to pre-War cultural ideals of leisure and pleasure. They continued to represent recreation, resort life, the private garden and park, but by revealing it as transient and ephemeral they rid their imagery of nostalgia. In this way, they managed to keep up the pretense that it was the same old Paris (of fond memory), and still link their activities to the positivism and materialism of modern life expressed in Third Republic science, entrepreneurialism, and colonialism.

But they used the positivism, which was invisible to the public for the first couple of years, for the purpose of glorifying the recuperation by stressing the spectacle, landscape, bridges, parks, and places of leisure now made clear by the studies of Clark and Herbert. The Impressionists seized the sites where barricades once stood and restored them to their pristine urban glory, establishing visual parallels and metaphors for the actual rehabilitation of Third Republic France and reassured a still frightened bourgeoisie. It is possible that the initial view of these canvases struck observers more like the perestroika projected by the Communards, but by the mid-1870s the restoration of the ruinous neigborhoods and the scientific model went hand in hand. By the next decade, social engineering was in order and a younger generation of painters could build on their example for a newly projected urban utopia. In this sense, it may be claimed that the Commune's aura worked positively for the Impressionists, first in surrounding them with the initial publicity necessary to launch them in the public sphere and then in guaranteeing them success once the hostility abated and awareness set in.

3. THE DISLOCATING IMPACT OF
THE COMMUNE ON THE IMPRESSIONISTS

FIRST, it is necessary to examine the situation of the various members of the French avant-garde at the time of the establishment of the Commune and their response to it. This in turn cannot be discussed independently of the Franco-Prussian war which immediately preceded the Commune and with which it is inescapably attached. The presence of Prussian soldiers on the outskirts of Paris during the formation of the Commune, the release of French prisoners to the government of Versailles, and the complicity of the Versaillais and the Prussians, generally dictated the tragic outcome of that short-lived experiment in authentic self-government. These events forced the dispersal of the young Impressionists and their colleagues, disrupting their lives and careers and profoundly affecting their physical and mental health.

Manet experienced creative paralysis and nervous exhaustion in the aftermath, leading to deep depression for several months. He was unique among the Impressionists in depicting the civil war and even in witnessing it; most of the others had fled Paris earlier to escape involvement in the Franco-Prussian war. Manet, like his brothers Eugène and Gustave and his friend Degas, enrolled in the National Guard as volunteer gunners during the siege of Paris. Although neither Manet nor Degas saw much action (Manet quit the artillery to join the officer staff because the duty "was too harsh"), their collaboration with the predominantly working class members of the battalions probably predisposed them to sympathize with the Commune organized in large measure around the National Guard. This model followed a local administrative scheme which proved invaluable in establishing and administering the Commune. Indeed, the concept of its federal system derived from the essentially democratic organization of the National Guard during the siege.

Two weeks after the armistice of 27 January 1871, Manet rejoined his family in southwest France. There he stayed until the Commune had been proclaimed, subsequently made an effort to enter Paris but changed his mind, and then either returned to Paris during Bloody Week (22–28 May) or just after. A letter of 10 June to Berthe Morisot states that he has been back in Paris for "several days," presumably less than a week, suggesting that he may have retreated from Paris again to wait out Bloody Week.

During the interval between his encounter with Tiburce Morisot on 5 June (see below) and the 10 June letter, the denunciations and summary executions of Communard prisoners continued unabated and even foreign papers heretofore supportive of the Versaillese condemned the ruthless and vindictive nature of the extermination. Manet's memorable watercolor and two lithographs devoted to the civil war refer to this wholesale massacre which lasted through 13 June. So haphazard were the arrests, on the slightest of suspicions (of nearly 400,000 denunciations by informers only a tiny fraction were signed) that it may never be possible to estimate the number of arbitrarily seized victims. These "legal" shootings by the Versaillais were far more terrible than the slaughter during the battle, and went on day and night. In a letter of 5 June 1871, Berthe Morisot's mother informed her that her brother Tiburce, a lieutenant in the Versailles army (to whom Manet inscribed a proof of one of his lithographs), had "met two Communards, at this moment when they are all being shot . . . Manet and Degas! Even at this stage they are condemning the drastic measures used to repress them. I think they are insane, don't you?"[1]

Since neither Manet nor Degas supported the insurrection but probably condemned the harsh measures meted out to the Communards, this exasperated comment from the mother of one of the future Impressionists reflects the overdetermined circumstances created in part by the Versaillais propaganda and fed by the deep antagonism of conservatives towards the radicals. If either Manet or Degas had actually been suspected of being Communards it is unlikely that they would have been in a position to openly criticize the Versaillais. Neither had any sympathy for the insurgency as such, and their class bias predisposed them to look unfavorably on its participants. Degas spent the period of the Commune at the country estate of his wealthy friend, Paul Valpinçon, at Ménil-Hubert, in Normandy, ostensibly to recuperate from the siege of Paris.[2] A picture that he probably sketched in this period and completed slightly later, *At the Races in the Country*, depicts the serene countryside surrounding his friend's estate as the setting for the leisure activities of the local gentry (fig. 23). Not only is there no sign here of the turmoil embroiling all of France, but Degas locates his wealthy friend in top hat at the apex of the composition casting a protective glance at mother, child, and wet-nurse as if to represent symbolically the traditional hierarchy as constitutive of the surrounding order and stability.

Manet had written to his friend Bracquemond from Arcachon on 21 March roundly attacking the executions of the two generals on Montmartre and, although elected to the Comité de la Fédération des Artistes—the democratic body chosen to organize the Commune's arts program—he never took part.[3] Philip Nord, moreover, has recently shown that Manet was "never a Communard, nor a visionary of the working class." He sees the painter excluding from his political orbit the Communard left and socialist revolution, yet assuming the trappings of a radical bourgeois who eschewed the moderate republicanism of a Jules Ferry.[4] Nord claims that Manet "traveled in radical political circles, painted canvases with charged and explicit political content, and lent critical support to politically motivated efforts to democratize the salon system."[5] This claim would position the painter somewhat to the left of the Impressionists, but

omits to inquire why the painter refused to join the Impressionists in their organizing venture—an act far more radical then sticking with the Salon system and trying to reform it from within.

Although Manet was never a left-wing radical in the formal sense of party politics, the profound impact of the Commune on Manet's thought and his many contacts with it should not be disregarded. Manet was linked to the Commune through his brother Gustave, a lawyer who joined the Ligue d'Union républicaine des droits de Paris during the Commune. This group attempted to mediate a conciliation between the Communards and the Versaillais, favoring neither entirely and hoping to get the two bodies to dissolve themselves and together set up a provisional government pending the election of a constituent assembly.[6] The leader of the League, Arthur Ranc, had actually been elected a member of the Commune and was a close friend of Georges Clemenceau and many others in Manet's circle.[7] It was thanks in part to Clemenceau's patronage that Gustave Manet was elected to municipal office in the eighteenth arrondissement in 1876 and 1878. Not fortuitously, Gustave pledged himself in 1878 to the cause of amnesty for exiled Communards. Thus Manet and his brother fit the political pattern that I have previously proposed for the Impressionists and their allies.

Manet's good friend and biographer, and pioneer historian of the Impressionists, Théodore Duret, had edited the pro-republican newspaper, *La Tribune française*, for

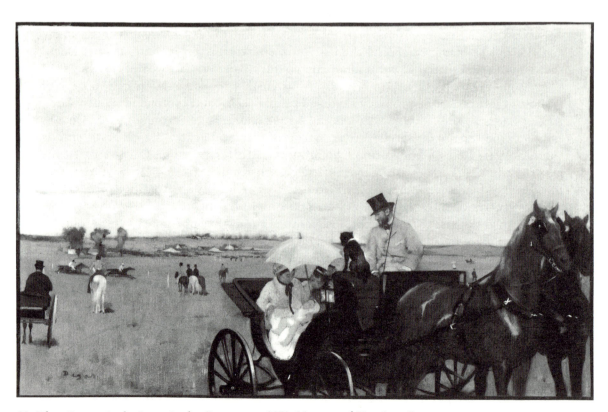

23. Edgar Degas, *At the Races in the Country*, ca. 1872. Museum of Fine Arts, Boston.

which he was indicted by the Second Empire government in the late 1860s for press offenses. He subsequently joined the staff of Henri Cernuschi's *Le Siècle*, one of three major pro-conciliation journals operating during the Commune. He and Cernuschi, whom he would later help organize a celebrated collection of Asian art, were arrested during Bloody Week and led to a cul-de-sac to face a firing squad.. They were lined up against a wall at the foot of which lay several corpses in a pool of blood, and were spared only at the last minute when a deputy in the officer's escort recognized them.[8] This kind of intense experience of so many friends and colleagues made Manet's "brush" with the Commune decisive for his subsequent career.

Pissarro, whose radical political convictions were in the process of unfolding, may have been predisposed to support the Commune but he had been away in England awaiting the outcome of the Franco-Prussian war. Aged forty, Pissarro had had no desire to fight for a regime he loathed. His wife Julie was pregnant, and the Prussian advance forced them to flee to a friend's farm in Brittany, leaving behind most of their belongings, including over a thousand of his paintings. Yet when the Prussians completed the encirclement of Paris on 19 September, threatening the Republic established two weeks previously, Pissarro felt the need to enlist in defense of the fledgling government. His mother then admonished him not to enter the fray, claiming her own need for protection and playing on his guilt feelings.[9] The death of his two-week-old baby, however, settled the matter by taking the fight out of him and prompting a desire to reunite with his mother and his brother's family who had sought refuge in England.

During his stay in England, the Prussians occupied his house in Louveciennes and destroyed hundreds of his paintings—a major part of his life's work. The news of this catastrophe devastated him, compounded by the report of the capitulation of Paris and then the ruthless suppression of the Commune. Pissarro shared the outrage of his friends at the behavior of the Versailles government;[10] until his death he preserved a personal chronicle of one of the Fédérés, those killed and arrested for being Communards. In 1887, when two letters of his idol Millet were published in *Le Figaro* denouncing and blaming the Commune for the destruction of Paris, Pissarro angrily and disappointingly wrote his son Lucien that "these letters show the painter in a very peculiar light and clearly indicate the petty side of this talented man."[11] The trauma of the years 1870–1871 rushed again upon him, recalling the reorientation of his life and career. It may not be coincidental that he finally married Julie, pregnant again, on 14 June at the very end of the reprisals of the Versaillais against the Communards. It was a way of giving some order to their lives after the destabilizing effects of the Franco-Prussian war and the civil war.

Like Pissarro, Sisley lost most of his possessions, including paintings, during the Franco-Prussian War when it was likely that Prussian troops occupied his rental house at Bougival. A small riverside suburb and favorite resort for weekending Parisians, Bougival lay outside the French fortifications and sustained terrible damage. Athough Sisley took refuge in Paris, nothing is known of his experiences during the Commune. In a letter dated 3 June 1871, Sisley's patron, Edmond Maître, gave him an account of what he considered the real tragedy of the Commune: "I mourn above all else the loss of the Hôtel de Ville which contained two marvels, the ceilings by Ingres and Delacroix,

and the fire at the Cour des Comptes that housed the *Justinian* [by Delacroix]."[12] Nevertheless, the impact of this period on Sisley's career is demonstrated by the fact that there is a virtual absence of work between the time of the two sieges and 1872.[13]

Cézanne's response to the Franco-Prussian War was to go into hiding in southern France, fearful of any military or political entanglement, and he spent the duration of the war and the Commune in L'Estaque, near Aix. Here he was close to insurgent Marseille, which set up its own short-lived Commune that was bloodily repressed. While Cézanne's correspondence of this period has been lost, his close relationship with Zola in this period suggests a shared response to the events. Although Cézanne expressed loathing of Thiers and his henchmen for the slaughter of the Communards, he is mute on the position of the Communards themselves. His letter to Pissarro of 6 July 1876 in which he hopes to see Dufaure—infamous for his murderous treatment of the Communards while serving as Minister of Justice under Thiers—get "knocked out" of the Senate, seems more designed to ingratiate himself with his mentor than to express sympathy for the insurgents.[14] He seems to have shared the contempt for the Communards expressed in Zola's *La débâcle*, viewing the destruction of that short-lived experiment as a cleansing action ridding France of the corruption ultimately traceable to the Second Empire.

Yet whatever Cézanne's own attitude to the Commune at the time, it must have been subsequently modified by his relationship with Pissarro and his art dealer Père Tanguy, an ex-Communard who barely escaped deportation. Tanguy managed to return from exile in the mid-1870s and open an art supply house. Too poor before the war to afford a shop, he had peddled his colors on foot; now in his desperation to put the recent past behind him he became an art dealer appealing to a second clientele as well. Tanguy was not only one of the first to show an interest in Cézanne, his favorite painter, but in the work of the Impressionists generally. During the later 1870s, his small paint shop and gallery on the rue Clauzel was the only place where Cézanne's work could be viewed.

Monet, like Pissarro, spent this period in England. His sole recorded comment on the Commune comes in a hasty note to Pissarro concerning a mistaken report on the execution of Courbet: "You have doubtless learned of the death of poor Courbet shot without a trial. What shameful conduct, that of Versailles, it is frightful and makes me ill. I don't have a heart for anything. It's all heartbreaking." Monet's pathetic confession tells us that he sympathized with Courbet's position and condemned the vengeful reaction of the Versailles. Monet's paralysis over the conflict suggests his emotional and intellectual dependence on some notion of social justice, but this was never expressed in the form of radical politics. When he arrived in Paris in the fall of 1871 one of his first actions was to visit Courbet, who had been temporarily moved from his cell in Saint-Pélagie jail to a nursing home. The older artist, already shrunk in both body and spirit, would soon be excluded from the official Salon of 1872 for his activities in the Commune by a cabal of vindictive artists led by Meissonier. Monet, Pissarro, and Sisley did not even bother to submit to the Salon that year and Renoir, who did, was rejected. Here the heavy hand of the Commune struck at their professional interests. Although Manet's *Le Bon Bock* was accepted, it was a modest effort whose conven-

tional rendering and obvious ties to 17th-century Dutch art could appeal even to the conservatives.

Renoir had been drafted during the hostilities with Prussia and served in a regiment of light cavalry (*chasseurs à cheval*).[15] Although Renoir claims to have rejected the advantage of a cushy position offered by a friend in the military (perhaps Prince Bibesco), he seems to have been exceptionally skilled at networking. He was first assigned to Bordeaux and then sent to Tarbès, where he groomed horses. All told, he served little over four months in the army and never saw any combat. His letter of 1 March 1871 to his friend Charles Le Coeur, written shortly before his discharge, testifies to his comfortable station and declares that he was "bored to death." He also enjoyed plentiful food and admits to feelings of guilt over his Parisian friends starving during the siege.[16] As if to atone for his situation, he claims to have "treated" himself to dysentery which nearly killed him. He describes his fears and relief of having survived the war intact, and notes in an ironic and detached mode the cost of human lives and the destructive impact of the war on the mental health of civilians.

He returned to Paris early in March but the outbreak of the Commune dislocated him and clashed with his conservative disposition. According to Coquiot, who knew him personally, Renoir had no desire to get mixed up with the Communards and in his own words the Federals were fanatical and stupid.[17] He braved the dangers in leaving the encircled city from time to time and entering the ground occupied by the Versaillais. He managed to survive the civil war but at one point had almost been shot as a spy for the Versaillais. He evidently went back to Paris near the end of the civil war for he sketched a Communard being executed. He knew Raoul Rigault by chance, the notorious Communard *procureur* at the Prefecture of Police under the Commune— brutally shot in the streets by the Versaillais—who provided the painter with a "laissez-passer" to leave Paris to rejoin his parents at Louveciennes and sketch landscapes unmolested. But the Commune seems to have left him bewildered, and he wandered around the outskirts of the capital penniless and depressed. He was evidently stopped at one point by the Versaillais, but was rescued by the intervention of Prince Bibesco, an ordinance officer of old Romanian stock who served under General du Barail of the Versailles army.[18] It is reasonable to assume that Bibesco accompanied du Barail when he led his cavalry division against the Communards during Bloody Week. This is important to consider when we recall that Bibesco and his Romanian protégé Georges de Bellio were both important patrons of Renoir.

Thus it was unavoidable that Renoir and his colleagues experienced the brunt of the tumultuous social struggle of the Commune, its resistance and defeat, all of the killings and the deportations, the immense toll of human suffering, and the total destruction of the short-lived proletarian organizations. And, as proper bourgeois, it was inevitable that they participated in the erasing of its memory.

Metaphorical allusions, whether textual or visual, to convalescence, purification, restoration, and regeneration are signifiers for the early Impressionist era. Conversely, it was the emblematic image of ugly ruins that was used to stigmatize the horrors of the insurrection, as in the case of the witty caricature by Cham that parodied Courbet's exhibits at the Vienna Exposition of 1873 as burned-out buildings (fig. 24). Themes

EXPOSITION DE VIENNE

M. Courbet et ses associés envoyant leurs produits
l'Exposition de Vienne.

24. Cham, *M. Courbet et ses associés envoyant leurs produits à l'Expo-
sition de Vienne*. Wood engraving reproduced in *Le Monde Illustré*,
5 April 1873.

of rehabilitation, on the other hand, identified the bourgeois recovery from the savage
vandalism. The *Illustrated London News*, closely monitoring events in France, pub-
lished an image of birds cooperating in the restoration of a previous year's nest, while
in the background we see the ravaged grounds and château of a wealthy estate enve-
loped in scaffolding (fig. 25). The accompanying article is "narrated" by a French rook
who establishes the blackened ruin as the work of "cowardly Prussians" angered at the
refusal of the owner to accede to their demands. The narrator states: "Both men and
birds are at the same work, that of *rebuilding*."[19] Although published the month be-
fore the suppression of the Commune, the image catches the predominant metaphor of
the French social mood.

By year's end, *L'Illustration* could publish a cartoon showing a bed-ridden France
being attended to by a pair of physicians each grasping one of her wrists and uttering
their pronouncements (fig. 26). The pessimistic "Docteur Tant-Pis" (Doctor Much
Worse) and the optimistic "Docteur Tant-Mieux" (Doctor Much Better) fill out this
attitude in the wake of the hammer-like blows of the two sieges. Doctor Much Worse
intones: "The crisis has been terrible! So much the worse! Such a crisis will inevitably
be followed by others. Lost health, debilitating infirmities, foreseeable disorganiza-
tion, shock to the moral system, sick brain, lack of energy, beliefs destroyed, deplorable
symptoms; everything must be changed, everything to be redone, little hope." But

26. Bertall, *Le Docteur Tant-Pis et le Docteur Tant-Mieux*, 1871. Wood engraving reproduced in *L'Illustration*, 1871.

25. *Rebuilding.* Wood engraving reproduced in *The Illustrated London News*, 8 April 1871.

Doctor Much Better delivers the benign diagnosis: "The crisis has been serious! So much the better! henceforth, her health can only improve. Forewarned by the past, she will follow a wise diet; she will avoid imprudent actions, deviations, and mistakes; a little reflection, plenty of work, and everthing will be restored to normal."[20] The need to find a visual solution to the mutilation of the national entity and the loss of its members Alsace-Lorraine led one satirist to adjust the new contours to the torso of the Venus de Milo (fig. 27). The text beneath the image suggests that the nation, like the sculpture, remains an "admirable masterpiece" despite their shared mutilations: "Akin to this artistic marvel, France has fallen into the hands of the barbarians, who, without respect for its beauty, have tested on her the temper of their swords; but no matter, the body remains splendid, and, as always, earns, and will earn the admiration of the entire world."

Degas internalized this psychological state in the immediate aftermath of the two sieges, escaping to the United States in the autumn of 1872 at the suggestion of his brother René to recover and reorder his priorities. Americans were for Degas a "new people" who had forgotten more of "their English origins" than he expected. After a short stay in New York, he made his way to New Orleans where his mother's family lived, and his brothers Achille and René worked in the cotton trade owned by their uncle. The uncle, Michel Musson, was a wealthy cotton broker and exporter of cotton to France and England. Coincidentally, Degas arrived at a time when Louisiana and, indeed, the entire South itself were still recovering from the devastating effects of the Civil War and trying to find its way through the chaos of Reconstruction. Thiers himself had likened the Communards to the southern Confederacy, and perceived himself as a sort of French Lincoln.[21] Degas' family had been pro-slavery and had joined other brokers in encouraging French intervention in the Civil War in favor of the Confederacy. In punishment, Major General Butler—the ruthless Union officer charged with the occupation of New Orleans after its capture—taxed Musson's firm (along with the others who joined the boycott) to help relieve the city's starving populace.[22] Degas' correspondence demonstrates that he shared his family's racist position, attesting as well to his conservative social bias. He seemed genuinely amused to learn that the Louisiana press deigned "to give Mr. Thiers expert advice on republicanism." He delighted in seeing blacks still serving whites, especially the women "of all shades," and responded warmly to the "contrast between the business offices with their bustle and order and the immense, black animal vitality."[23]

"I am thirsty for order" (J'ai soif d'ordre), Degas writes to his friend and patron Henri Rouart on 5 December 1872. And he closes with a show of pride in his brothers' success: "They will make a great fortune."[24] The novelty and possibilities of the United States fascinates him, and at the same time he feels a need to discipline himself to emulate the business success of his brothers. His mind is teeming with fresh ideas ("that would take . . . ten years to realize") and he plans a series of sketches later to be reworked in Paris. A subsequent letter of 18 February 1873 to his friend James Tissot in London likens his valuable mental assets to an insurable cotton bale, and expresses the wish that there were insurance companies who dealt in his particular brand of assets.[25] Here Degas consciously conceives of his ideas as commodities to be disposed of as

27. Cover of *Le Journal Amusant*,
4 May 1872.

those of his brothers, thus declaring himself as an emerging entrepreneur in his own
right.

It is no coincidence that in this same letter Degas announces to Tissot that he is in
the process of completing a major picture provisionally called *Intérieur d'un bureau
d'acheteurs de coton à Nlle. Orléans, Cotton Buyers' Office* (fig. 28). He stated that it
was "destined for Agnew," and that it should be sold in Manchester, "to any cotton
spinner" particularly desirous of having a fine representation of his trade. He even
knew that in Manchester there was "a wealthy spinner, who has a famous collection. A
fellow like that would suit me perfectly, and Agnew even better. But let's be cautious
about it, and not count our chickens too soon." Despite the cautionary note, it is clear
that Degas has exploited his brothers' business both as subject matter and as conduit to
an expected Manchester buyer—who is both purchaser of the family's cotton and a
collector of art! The painter used his time in America to launch a new entrepreneurial
venture and carefully selected the content with an eye to the client.[26] As he wrote to
Tissot on 19 November 1872, "Here I have acquired the taste for money, and once back

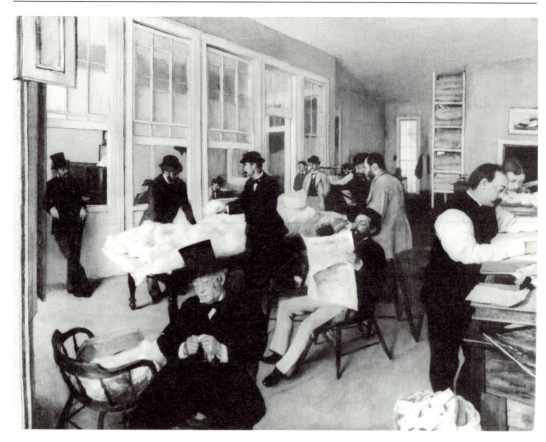

28. Edgar Degas, *Portraits in an Office, New Orleans*, 1873. Musée municipal, Pau.

I shall know how to earn some. I promise you."[27]Akin to Monet and Renoir, the dis-
location and economic hardship caused by the Franco-Prussian War and the Commune
predisposed Degas to begin his career afresh from the ground floor up. He had origi-
nally planned to take the work directly to London, and at Tissot's prompting he even
considered settling in London where his friends were already selling their work at high
prices. He makes the cryptic remark that if he did go there he would first have "to
sweep the said place a little, and clean it by hand."[28]

I would argue that the remark, like the painting itself, is a displaced metaphor of his
own desires for a "reconstructed" life in post-Commune Paris. Degas described his
image of the interior of a cotton-broker's office as a "picture of the locality if ever there
were one," with about fifteen figures energetically grouped around a table covered with
cotton samples. The picture, completed in 1873 but not exhibited until the second
Impressionist show of 1876, gives us a rare insight into the briskness of new urban
industry recovering from the onslaught of civil war. It represents the Degas family
enterprise in full force: his uncle is seated in the foreground carefully inspecting a

cotton sample, his brother René is seen scanning the New Orleans *Daily Picayune* for the current market report, his brother Achille leans against an open window at the left while awaiting the outcome of a transaction, while others examine the cotton at the central table, wait for an appointment, look at ledgers at a desk, or engage in miscellaneous clerical tasks behind the cashier's window. Although not everyone is busily at work, what struck critics was the sense of bristling energy coming through the unusual depiction of the office. This sense of activated space is accomplished by two powerful axes established by the figures, one moving laterally across the picture through the isocephalic positioning of the heads, and the other by the sharp diagonal intersecting this movement launched by the seated uncle and brother behind him. The figures appear, however, unrelated compositionally, randomly scattered throughout the scene and falling into casual poses that seemed both peculiarly American and bourgeois at the same time.

Degas' picture is a clinical case study of how an Impressionist deals close-up with the motif of work in the public sphere, when not viewing social relations from an elevated and distanced standpoint. The picture is as much allegorical as it is realist, informed as it is by a Thomas Nast cartoon and other reportorial illustration, as Zola himself recognized.[29] Degas shrewdly analyzes the specialized functions in an office space, devoted to coordinating, accounting for, and organizing the distribution of the multifarious activities involved in a vast enterprise essentially dependent on back-breaking labor. What we see, then, is a glimpse of a bourgeois world as a signifier of all the labor involved, but whose actual signs allow for only a narrow band of the work hierarchy—that encompassing the owners, managers, and clerks. Behind this white-collar team, the blue-collar labor force is occluded if not entirely erased (the cotton samples function there as metonymic awareness).[30] Nevertheless, Degas still wants to show this bourgeois realm as democratic and egalitarian by commingling managers and clerks, and suggesting the possibilities for advancement. Musson's partner, John E. Livaudais, is seen at the right in shirtsleeves examining ledgers just like one of his clerks. In bourgeois business you may work up from the bottom and aspire to the boss' position. Thus Degas evacuates the potential of class opposition by concentrating exclusively on white-collar signifiers in a bureaucratic space, attesting to how shrewdly Impressionist realism could neutralize the kind of disruptive social messages in Courbet's realism and Manet's naturalism.

Degas' bourgeois work realm is exclusively male, and it is noteworthy that his only images of the proletariat are female. In the 1876 show he exhibited four studies of laundresses, much more sketchily executed than the *Portraits in an Office* (figs. 29, 30). Ironically, he was homesick for laundresses while in New Orleans, and wrote Tissot: "Everything is beautiful in this world of the people. But one Parisian laundry girl, with bare arms, is worth it all for such a pronounced Parisian as I am."[31] Traditionally, the laundress was represented as a coquettish, sexual being, a lower-class woman vulnerably exposed to the better-off males whose clothes she washed and ironed.[32] Thus Degas' proletariat signifier, the sexualized female, symbolized the labor force reduced to subjugated status. It is no coincidence that laundresses were among those identified as *pétroleuses* during the Commune, including the notorious Eugénie Suetens, who

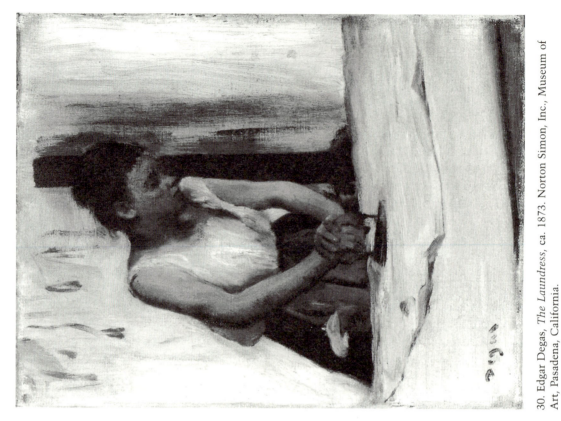

30. Edgar Degas, *The Laundress*, ca. 1873. Norton Simon, Inc., Museum of Art, Pasadena, California.

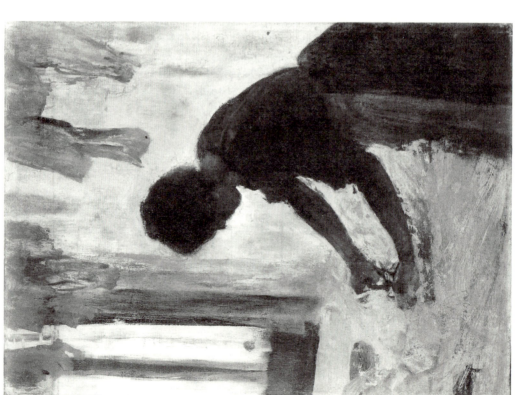

29. Edgar Degas, *A Woman Ironing*, ca. 1874. Metropolitan Museum of Art, New York. Bequest of Mrs. H. O. Havemeyer, 1929. The H. O. Havemeyer Collection.

brought food and water to the Communards, tended to the wounded, and participated in the building of the barricades.[33] By sexualizing sweated labor and submerging it in a dazzling network of open brushwork and daring colorism, Degas constructed an image of dominated labor whose lightness of execution belies the laboriousness of working women and, by extension, men as well. Impressionist disembodiment (whether conscious or unconscious) served the purpose of occluding an uncomfortable and contradictory reality.[34]

By the late 1870s, the reading of modernism could shift from a radical social emphasis to that of a primarily technical and decorative interpretation, where emphasis was placed on its originality and liveliness in opposition to the dry formalism and conventionality of academic production. It is no coincidence that Degas' *Portraits in an Office* became the first Impressionist work to be purchased by a major museum, the Pau Musée des Beaux-Arts in 1878. The town of Pau was then undergoing the throes of extensive urban renewal, with a republican mayor organizing streets, promenades, sidewalks, expanded gardens, and greenbelts, thus stimulating an economic boom and land speculation, in which American investment played an important role.[35]

One critic observed that the scattered and detached figures reminded him of "a wholesaler's shop on the rue du Sentier"—the Parisian garment district.[36] This allusion to the frenetic activity of the rue du Sentier thus suggests a larger frame of reference for Degas' picture. It is located in the second arrondissement not far from the Bourse, or stock exchange, the financial heart of the capital. It is bounded on the north by the grands boulevards and on the east by the Boulevard de Sébastopol. During the Commune, the Bourse was cordoned off by the National Guard and the neighborhood sealed off except to inhabitants and shop owners. Its strategic location brought down heavy fighting all around it in the final days of May, especially in the vicinity of the barricaded zones on Sébastopol and rue Montmartre.[37] Almost all retail and wholesale commerce had ceased during the Commune, decisively affecting one of the Impressionists' major patrons, Ernest Hoschedé, a textile merchant who owned a shop on the rue du Sentier and was a potential purchaser of Degas' painting.[38] Although set in the United States, Degas' scene exploits American alacrity and diligence as a model for a French regeneration, and its many traits of self-identification attest to his own desire for an entrepreneurial jump-start. It is in this sense that we may understand his active role in the organization of the first Impressionist exhibition, a cooperative business enterprise legally authorized under the rubric Société anonyme des artistes peintres, sculpteurs, graveurs, etc. He and his colleagues were embarking on a commercial venture with brand new "commodities" targeted for a middle-class clientele. This was their collective participation in the rebuilding and healing process, for themselves as well as for the nation.

Although lacking a willing dynastic head, the conservatives expressed their position through a call for a revival of the *monarchie chrétienne*. Everywhere in France pilgrimages were organized to famous shrines and the Church preached a vertiable crusade. The Assembly, dominated by monarchists, voted on 24 July 1873 to erect a great basilica of the Sacred Heart (*Sacré Coeur*) on Montmartre—the site of the Commune's origins—to expiate the sins of the nation and the crimes of the Communards. France

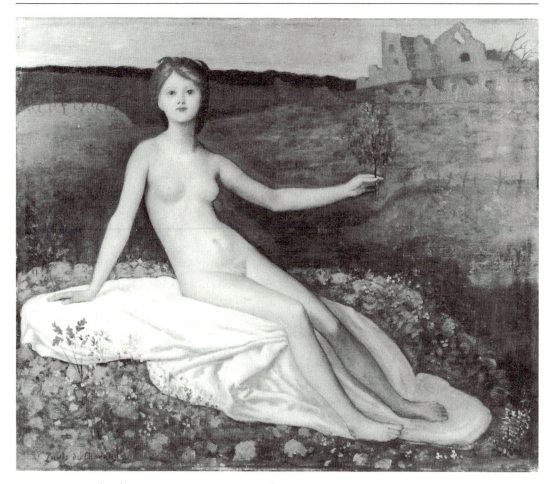

31. Pierre Puvis de Chavannes, *Hope*, 1872. Musée d'Orsay, Paris.

had to atone for the frivolity of the Second Empire, the modern Babylon whose disorders brought down the fires of heaven.

Zola observed the ethereal qualities of Puvis de Chavannes' *L'Espérance* in the Salon of 1872, a sort of compromise image of the period striding both official and avant-garde camps (fig. 31). Puvis' picture tries to counter the negative stereotypes of a prostrate Paris then circulating in popular illustration, but is itself steeped in the visual rhetoric of these allegories (fig. 32). He deployed conventional allegorical language to make the point about the recent travails, a pubescent girl whose immediate space is surrounded by signs of regenerative springtime holds an olive branch as token of peace against a backdrop of low-keyed emblems of waste and ruin. It may not be a coincidence that one of the earliest patrons of the Impressionists, Henri Rouart, owned a replica of this work whose original title was *Hope Blossoming on the Ruins*.[39] It was sold to him by Durand-Ruel and was praised by Armand Silvestre in his preface to an album of prints of the paintings in the dealer's gallery including the young Impressionists. Silvestre's

*DC
289
C54h
v.1

HISTOIRE

DE LA

RÉVOLUTION DE 1870-71

Par JULES CLARETIE

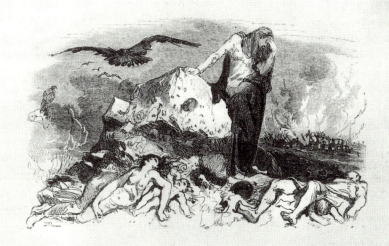

PRÉFACE

Je dédie ce livre à la France nouvelle, dont je suis, et qui n'ayant rien commis des impardonnables fautes qui ont amené notre décadence, en a cependant plus douloureusement que les générations ses aînées et plus durement qu'elles supporté le poids accablant.

Je dédie ce livre au peuple qui, généreux, donnant en prodigue l'enthousiasme de son âme et le sang de ses veines, mais se payant trop souvent de mots, doit à présent être avide de connaître des faits et d'apprendre comment, et jusqu'à quel gouffre il a pu être conduit par une de ces mains impérialement cruelles, à qui le sort, disait un grand orateur, ne semble avoir délégué la puissance que pour prouver aux hommes le peu de cas qu'il en fait.

Je dédie ce livre à tous ceux qui osent et veulent regarder en face la Vérité. Ce livre est vrai. Il sera vrai pour tous. Amis et ennemis y trouveront compté le total des responsabilités qui leur incombent dans les effroyables malheurs de la patrie.

L'*Histoire de la Révolution de* 1870-71, quelle histoire!

Je ne crois pas qu'on puisse trouver dans la succession des siècles beaucoup d'épisodes aussi dramatiques que ceux dont la patrie a vu le lugubre spectacle et des années plus remplies que les deux sombres années que notre malheureux pays vient de traverser. Quel entassement prodigieux d'événements, quels chocs épouvantables et quels jeux amers d'une ironique destinée! La France, prospère et redoutée, tombant tout à coup jusqu'à la défaite et jusqu'à la pitié des nations dont elle était jadis la protectrice et la vengeresse. Tout un vain échafaudage de fausse puissance s'écroulant avec fracas. Qui s'attendait à ce dénoûment sinistre? « Le couronnement de l'édifice » était un drapeau prussien.

Mais aussi, pourquoi la nation tout entière abdiquait-elle entre les mains d'un maître? Pourquoi, fière de sembler redoutable à l'extérieur, subissait-elle à l'intérieur un joug qui la courbait

1ʳᵉ LIV.

32. Titlepage of J. Claretie, *Histoire de la Révolution 1870–1871*, 1871.

interpretation of the young girl as a "flower hanging on the lone green branch in this ravaged sector, flower drooping towards the earth, flower of the sweet soil of the Nation," recalls his metaphorical comments on the budding Impressionists gathering their forces as summer blossoms began shooting up from the cobblestones stained with the blood of the Commune.[40]

In this painting Mother Nature has been replaced by her nymphet daughter, awaiting impregnation and the conception of a revivified nation. A Parisian daughter substitutes for a virgin nymph, playing on the traditionally feminine characterization of nature and opposing the wild, uncontrollable nature of the female Communards so conspicuous in the right-wing imagery of the period. Disordered nature in the form of the female participants had to be dominated, but devastated French manhood in the period required something gentle and vulnerable like Puvis' *Hope*. Her turned-in feet and delicate gesture suggest passivity and incapacity to act aggressively as did the Communard women: less a nurturing mother than a consoling angel, she soothes the anxieties of a distraught male populace needing to restore their lost manhood.

Zola commented on the Salon of 1872 that military pictures either ignored or played down the disasters of 1870–1871, the largest one recalling a glorious moment in the expedition to the Crimea. Alsace personified or pictures of homage bestowed on the statue of Strasbourg in the Place de la Concorde also momentarily caught his attention. But what moved him the most was the sight of the burned out Tuileries in a downpouring rain as he left the Palais de l'Industrie, with its "gaping windows" against the "nasty yellow of the sky."[41]

The ruins of the Tuileries were surprisingly the subject of another major official painter of the period, Meissonier, who led the opposition to Courbet's entry in the Salon of 1872 for his participation in the Commune (fig. 33). Akin to the reactionary photographers discussed earlier, Meissonier could represent the ruins from a conservative position as a warning and as an example of what French society had to surmount (figs. 34, 35).[42] (He himself associated this work with his *Barricade—Souvenir de guerre civile* of 1848 that carried a similar message.) He chose a spectacular perspective through the burned out windows of the Salle des Maréchaux, fixing on the distant quadriga atop the Arc de triomphe du Carrousel—once the threshhold of the Tuileries Palace. The far doorway through which we view the triumphal arch is flanked by two decorative shields commemorating the glorious Napoleonic victories of Marengo and Austerlitz. For Meissonier "the two words shine in history, just as they shone over the ruins of the palace." Although the quadriga is seen from the rear as if leaving the scene—the painter lamented, "Victory turns away on her chariot, she abandons us!"— it nevertheless produces the illusion that it is rising above the ruins and riding triumphantly into the future. This interpretation is confirmed by the Latin text Meissonier affixed to the bottom: "The glory of the ancients remains beyond the flames—May, 1871."[43]

Meissonier's pictorial fetishization of the Napoleonic moment of glory amidst the squalorous wreckage of the Commune was hardly unique in the period, and explains the outrage of even the conservatives over the destruction of the Vendôme Column. Photographs and popular illustration in this period focus on the Salle des Maréchaux as

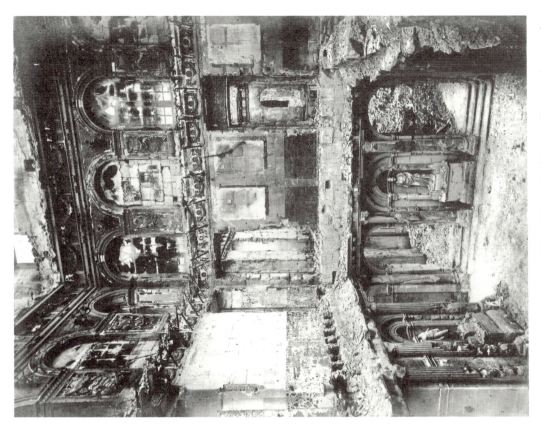

34. Alphonse Liebert, *Interior of the Salle des Maréchaux*, albumen photograph of the ruins of the Tuileries, 1871.

33. Jean-Louis-Ernest Meissonier, *Ruins of the Tuileries, May 1871*, 1871. Musée d'Orsay, Paris.

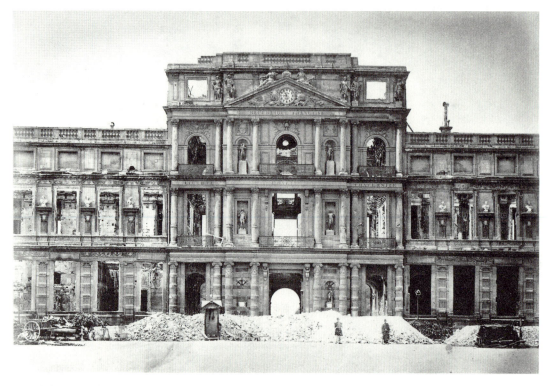

35. Alphonse Liebert, *Pavilion de l'Horloge*, albumen photograph of the ruins of the Tuileries, 1871.

an emblem of the heroic past (fig. 36). One writer noted that amid the ashes and scorched walls he could make out a decorative shield with the ineffaceable inscription "Jena"—the battleground of Napoleon's decisive victory over the Prussians in 1806—which he admonished Parisians to preserve as a precious souvenir of the "great nation."[44]

The Tuileries ruins were to stand untouched for twelve years both as a sign of Communard crimes against the nation and as a warning against future revolution, an exhibition in its own right.[45] As Deraismes had grasped, the personification of this outlook for the elite was Joan of Arc, symbol of both the militant church and the martyred victim. While she became the darling of the right wing, she could embody for all factions their longing for social stability, unanimity, and reconciliation. She represented the conservative Third Republic's answer to Carpeaux's male genius of the *Danse*, and certainly to the failed male hero at Sedan. She also represents the Christianized version of the female warrior of the Commune, a depraved prostitute and virago. A striking example of this attitude in poetry is Victor de Laparade's "A Jeanne d'Arc," which captures the mood of the conservatives in the wake of foreign and domestic upheaval. It addresses itself to French women—"sisters of Joan"—admonishing them to raise a new generation of males devoted to France and ready to engage in illustrious combats

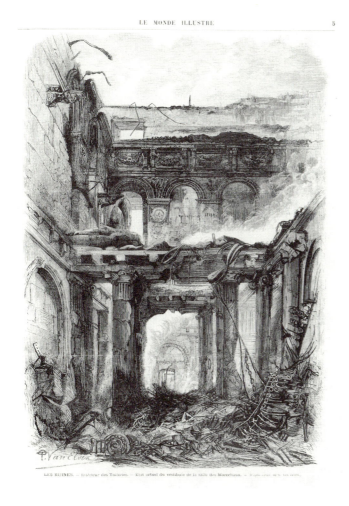

36. M. Van Elven, *Les ruines.
Intérieur des Tuileries.—Etat
actuel du vestibule de la Salle
des Maréchaux.* Wood engraving
reproduced in *Le Monde illustré*,
1 July 1871.

in their mothers' honor. The conventional sexism of the poem explains the rush to celebrate Joan: the threat of actual women voting and soldiering in the wake of the Commune (in which they were particularly active) needed to be neutralized and displaced onto a transcendental sign which essentially safeguarded the male hierarchy. At the very moment when Joan was championed, real women's rights and feminist agitation for those rights were aggressively squelched.

During the 1870s images of Joan of Arc could be seen everywhere in Paris. The most celebrated of all was the equestrian version by the sculptor Emmanuel Frémiet inaugurated on 20 February 1874, little less than two months before the opening of the first Impressionist exhibition (fig. 37). Depicting Joan as the militant Christian, it soon became a cult object; in 1878 Bishop Dupanloup of Orléans—hero of the fusionist party and hostile enemy of the Commune—suggested that Catholic women should assemble and lay flowers at the foot of the statue as a reply to the impending hundredth anniversary of Voltaire's death (fig. 38). (Moderate republicans gained increasing con-

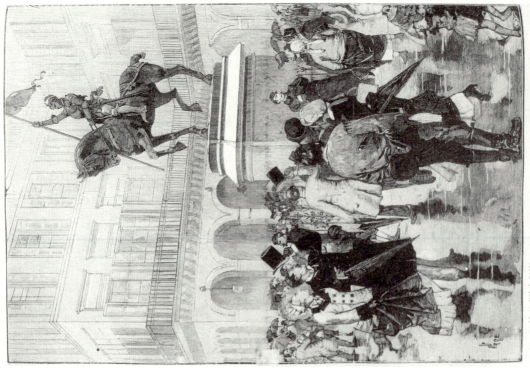

LE 30 MAI A PARIS. — Démonstration muette du Public, devant la Statue de Jeanne d'Arc, place des Pyramides.

(Dessin de M. Vierge.)

38. Daniel Urrabieta Ortiz y Vierge, *Le 30 Mai à Paris*. Wood engraving reproduced in *Le Monde illustré*, 8 June 1878.

37. Emmanuel Frémiet, *Joan of Arc on Horseback*, 1874. Bronze, 1899. Place des Pyramides, Paris.

trol of the Assembly and voted a national celebration of the centenary, and disgruntled conservatives organized a counterdemonstration at the base of Frémiet's statue.)

Erected on the Place des Pyramides near the site where the heroine was wounded during a battle against English invaders, the Joan of Arc was a highly charged political statement from the moment of its unveiling. The crowd included several outspoken revanchists like Paul Déroulède who bewailed the loss of the Alsace Lorraine provinces. Indeed, the desire for the recovery of Alsace Lorraine after 1870 was one of the main props of French patriotism in this period and immediately politicized Joan of Arc, whose native region was Lorraine. At the same time, memories of the Provisional Republic's poor handling of the defense of Orléans during the Prussian siege of Paris also caused ill feeling at the time of the inauguration, especially since the suspicion that the Government of Defense had sold them down the river fueled popular support for the Commune.

The other side of Frémiet's production are his wild beasts, the flip side of his fascination for medieval heroes and saints. From the moment of its sensational appearance in the Salon in 1887, Fremiet's *Gorilla Carrying off a Human Female* conjured up not only the "savage" of colonialized territories, but a vision "of the lowest side of human nature" (fig. 39). The appeal of Fremiet's work to the conservatives lay in its encoding of the "terrible past" now given its true identity. More than one anti-Commune writer classified the Communards with wild beasts and monsters; in an outburst of rage, Gautier wrote: "Des cages ouvertes, s'élancent les hyènes de 93 et les gorilles de la Commune."[46] Taine conjured up stampeding beasts including bloodthirsty baboons, while Zola's *Germinal* casts the crowd in the form of a salivating monster in heat.[47] As early as 8 June 1871, Villemessant, the reactionary publisher of *Le Figaro*, combined both the purgatorial and bestial metaphors in an editorial:

> There remains an important task for M. Thiers, that of purging Paris. Never has a better opportunity presented iteself for curing Paris of its moral gangrene that has been consuming it for twenty years. . . . What is a republican? A savage beast. Come on, honest people, a swift bold stroke to finish once and for all the vermin, both democratic and international. . . . We must track them down in their lairs like wild animals.[48]

The metaphorical representations of the crusading Joan of Arc and the rampaging Big Ape map the limits of the conservative visual regime in the post-Commune era.

A useful starting point for examining the independents' complicity in post-Commune reconstruction is the work *Place des Pyramides* by Giuseppe de Nittis, a Neapolitan painter who exhibited with the Impressionists in their first joint venture in 1874 (fig. 40). De Nittis suffered from his expatriate status, and this sensitivity perhaps explains his conspicuous appeal to French patriotism. In the background, a building burned by the Communards four years earlier is under scaffolding. Scaffolding was a pervasive sight during the building campaign that followed the devastation of the Commune, and especially associated with the official buildings and monuments of Paris (figs. 41, 42). That the scaffolding in the De Nittis scene constitutes a metonym for Paris reborn is seen in its juxtaposition with another triumphant emblem of French

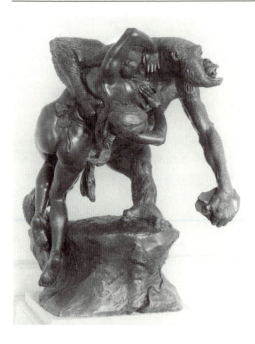

39. Emmanuel Frémiet, *Gorilla carrying Off a Human Female*, plaster, 1887. Musée des Beaux-Arts, Nantes.

nationalism, Frémiet's equestrian statue of Joan of Arc. The militant Joan of Arc strides in the direction of the burnt out Tuileries, a symbol of the triumph of the French government over the forces of anarchy. The monument shows the heroine, one commentator declared just after the unveiling, "lance in hand, at the moment of taking the enemy's measure, and when she calls Parisians to their liberation."[49]

To juxtapose this image with Monet's painting of the *Tuileries* of c. 1876 may seem to be stretching it, but bear with me for a moment (fig. 43). In one of four views of the gardens he depicted in this period from the window of his patron Victor Chocquet on the Rue de Rivoli, Monet clearly avoided displaying the ruins by relegating them to a remote corner and focusing on the vast garden area between the old palace and the place de la Concorde.[50] His strategic placement is immediately apparent from contemporary photographic views of the ruins (figs. 44, 45). The garden areas of the Tuileries still evoked pleasant memories of the previous regime, especially because the emperor opened them to the public. During the Commune, the Tuileries had been transformed into an artillery emplacement that profoundly upset the park strollers and nursemaids of the well-to-do (fig. 46). That springtime, when the leaves of the chestnut trees began to bloom, upper-class mothers wondered if their children could frolic in the shaded lanes of the gardens. As one reviewer noted, "In seeing all of that military hardware [attirail], that cluster of engines of destruction, those crude wooden barracks, they despair in thinking that the torrid season will have shone with all its rays before the garden of the Tuileries will be divested of the gunners and their artillery."[51] But the author concluded that this would soon pass, "a scrape of the rake and it will all disappear."

Monet's task, like that of the gardener, was to rake over the traces of the hated insurgents. At the same time, he avoided the implications of the political controversy

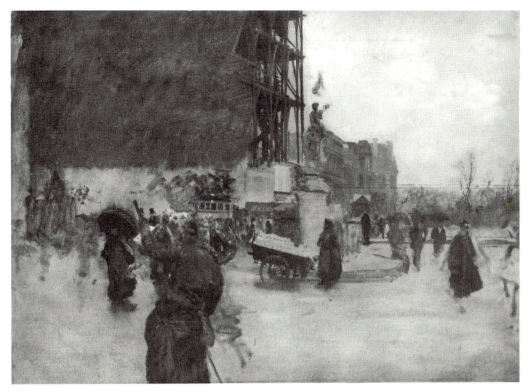

40. Giuseppe de Nittis, *Place des Pyramides*, c. 1875. Civica Galleria d'Arte Moderna, Milan.

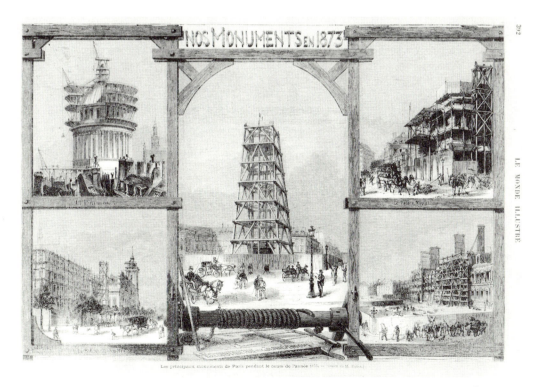

41. Karl Fichot, *Les principaux monuments de Paris pendant le cours de l'année 1873*. Wood engraving reproduced in *Le Monde Illustré*, 20 December 1873.

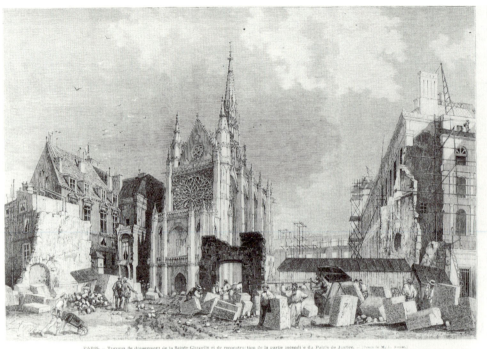

PARIS. — Travaux de dégagement de la Sainte-Chapelle et de reconstruction de la partie incendiée du Palais de Justice. — [Dessin de M. L. Avenet.]

42. L. Avenet, *Travaux de dégagement de la Sainte-Chapelle et de reconstruction de la partie incendie du Palais de Justice.* Wood engraving reproduced in *Le Monde Illustré*, 1873.

43. Claude Monet, *The Tuileries*, 1876. Musée Marmottan, Paris.

44. Photograph of the Burned
Out Tuileries, 1871.

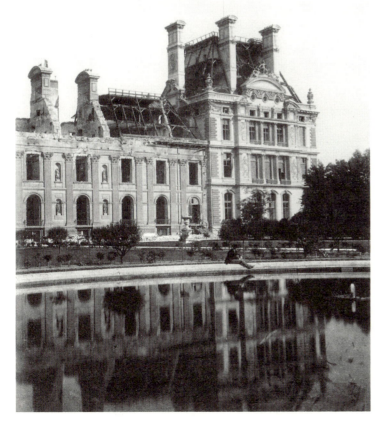

45. Photograph of the Burned
Out Tuileries, 1871.

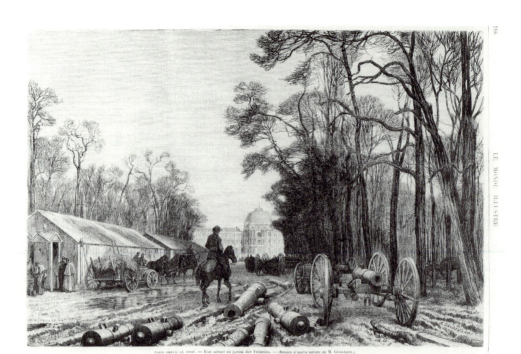

PARIS DEPUIS LE SIÈGE. — État actuel du jardin des Tuileries. — (Dessin d'après nature de M. Grandsire.)

46. E. Grandsire, *Paris depuis le Siège. Etat actuel du jardin des Tuileries*. Wood engraving reproduced in *Le Monde illustré*, 8 April 1871.

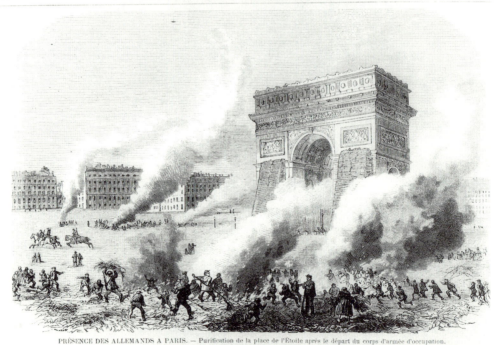

PRÉSENCE DES ALLEMANDS A PARIS. — Purification de la place de l'Étoile après le départ du corps d'armée d'occupation.

47. *Présence des Allemands à Paris. Purification de la Place de l'Etoile, après le départ du corps d'occupation*. Wood engraving reproduced in *La Guerre illustrée*, 1871, p. 533.

then raging over the remains of the palace, whether or not to preserve them in the form of a memorial or to raze them entirely. Monet's solution is to incorporate them into the middle zone as if still in the same state as they had been during the Second Empire. In this way, the continuity of French life is represented in an Edenic-like environment. Such an image would have appealed to Chocquet, given the proximity of his apartment to the Tuileries Palace whose infernesque appearance in May 1871 must have been a threatening sight glimpsed through the same window. Like Puvis' *Hope*, Monet's scene suggests a flourishing environment that overshadows the tragic landmarks of the past. He shares with de Nittis the manipulation of Parisian topography to fit the ideological proclivities of the early Third Republic.

Monet's avoidance of the political symbols may be contrasted with an example of the next generation's preoccupation with a restructured environment. Georges Seurat and his Post-Impressionist colleagues were children at the time of the Franco-Prussian war and Commune and traumatized by the devastation. If they managed to get out of Paris during the bombardment and final massacre, they returned to Paris only to see the streets in ruins and houses gutted by fire. They move in the direction of utopian planning and anarchist doctrine. Unlike Monet, Seurat confronted the ruins of the Commune with a sense of reconstruction (see Epilogue). His study of the remnant of the Tuileries in 1882 gives it a stateliness and order that would have been anathema to Fournel and the Impressionists. The older generation wished to restore and forget and get on with their lives, while the younger generation wanted to aid in the formation of a new social structure on the ruins of the past. In his most ambitious picture, *La Grande-Jatte*, a park devastated by the shelling of the Versaillais during the Commune, he reconfigures the landscape to conform to a geometric grid.

The attitude of the older generation in the 1870s (keeping in mind that they too underwent a change of direction in the decade of the 1880s) was simply that of getting on with the house-cleaning necessary to reestablish order. In this they shared the general need to see the traces of national humiliation and devastation come to an end. All French citizens, regardless of their political affiliation, were scarred by the brutality and civil carnage of 1870–1871. Symbolic of the popular mood was the reaction to the triumphal entry of the Prussians into Paris on 1 March, a concession made by the Government of National Defense in return for retention of the fortress of Belfort. This was taken as a direct insult to the honor of the capital, as well as a threat to its security, and was the occasion of serious disorders and a rapid decline in the credibility and authority of the government. Immediately after the exit of the Prussian occupation, scores of men, women, and children gathered and piled up hay all around the Arc de Triomphe which they set on fire (fig. 47). "Le feu purifie tout," claimed one reporter to describe this rite in the place de l'Etoile, and he probably choked on his words during the last days of the Commune. Purification first of the traces of the Prussian presence and then of the Communard presence by symbolic representation lies at the heart of Impressionist practice.

Both the Prussians and the Communards invested Paris and suburban Parisian topography with their bodies and their equipment, thereby, out of necessity or by design, laying waste to the environment. No landmark, particularly in Paris, seemed to have

Artilleriſten-Frühſtück vor Paris.

48. *The Artillerymen's Breakfast Outside Paris.* Wood engraving reproduced in *Illustrierte Geschichte des Krieges 1870/71,* Stuttgart, 1871, p. 292.

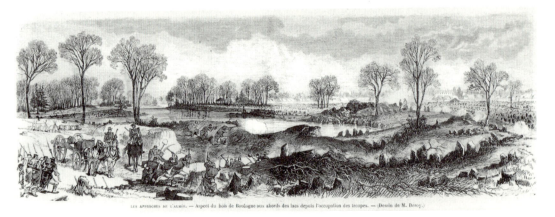

LES APPROCHES DE L'ARMÉE. — Aspect du bois de Boulogne aux abords des lacs depuis l'occupation des troupes. — (Dessin de M. Deroy.)

49. Deroy, *Les approches de l'Armée.—Aspect du bois de Bouilogne aux abords des lacs depuis l'occupation des troupes.* Wood engraving reproduced in *Le Monde Illustré,* 20 May 1871.

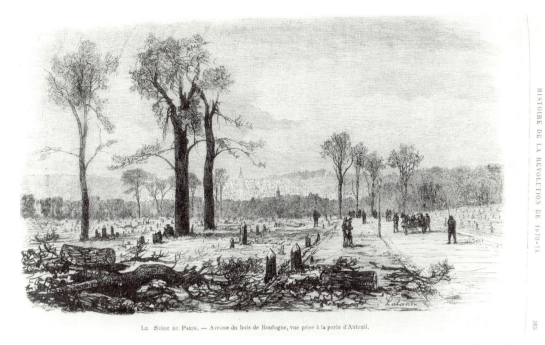

LE SIÈGE DE PARIS. — Avenue du bois de Boulogne, vue prise à la porte d'Auteuil.

50. Lalanne, *Le siège de Paris.—Avenue du bois de Boulogne, vue prise à la porte d'Auteuil*. Wood engraving reproduced in J. Claretie, *Histoire de la révolution de 1870–1871*, p. 365.

LAKE IN THE BOIS DE BOULOGNE, PARIS.
(SKETCH BY BALLOON POST).

51. *Lake in the Bois de Boulogne, Paris*. Wood engraving published in *The Illustrated London News*, 28 January 1871.

AU BOIS DE BOULOGNE.

— Allons, bon ! voilà qu'ils ont reculé le bois au diable ! il faudra maintenant faire une lieue pour aller au lac.
— On ne l'a pas reculé, grosse bébête ! Cet espace que tu vois nu, c'est la zone militaire qu'on a découverte.
— Bon ! mais ce n'était pas une raison pour reculer le bois.

52. Gilbert Randon, *Au Bois de Boulogne*, *Le Journal Amusant*, 15 July 1871.

escaped the war or the Commune unscathed. Pissarro and other artists were traumatized by the vandalism wrought by the occupying Prussians on their paintings, but the Prussians themselves acknowledged such acts as part of the vagaries of warfare (fig. 48). Bridges in and around the capital had been demolished, homes and monuments bombarded, prominent parks were places to bivouac or to mobilize or, worse, execution sites for Communard prisoners, and toward the end such a site as Longchamps could be transformed into an assembly ground for Prussian and then French troops, who suppressed the Commune, to pass in review. The radiant ecological triumph of Haussmann, the Bois de Boulogne, had been systematically stripped of its trees for firewood and charcoal, and everywhere one could see the damaging effects of shrapnel and bullets (figs. 49–51). The damage to the self-image of French people was perhaps even more incalculable, with the memory of the humiliation of the Prussian occupation and the wholesale massacres of the civil war leaving a searing scar on the national psyche. Gilbert Randon, the cartoonist for *Le Journal Amusante*, tried to find humor in the devastated site of the Bois by depicting a well-dressed couple taking their usual Sunday stroll in the park (fig.52). The woman exclaims, "What's going on? They have pushed the park back like the devil! Now we will have to walk much further to the lake." Her partner smiles at her naivete and replies, "They haven't pushed the park, Big Baby! The empty space that you see is only the clearing that was made for the military zone." But the woman has the last word: "Alright, but that's still not a reason for pushing back the park." Her ability to imagine the park as having receded rather than ruthlessly cut away is analogous to the adjustments performed by the Impressionists.

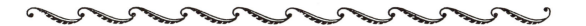

4. THE IMPRESSIONIST AGENDA

I WANT to begin this chapter with the case study of Gustave Caillebotte, both patron of, and participant in, the Impressionist collective. He was the youngest (born 1848) and most well off of the group, and the most conservative in style and content. His major works attest to a thorough assimilation of the rhetoric of the fledgling Republic trying to define itself in the wake of the Commune and in opposition to the formidable monarchist bloc. Although listed as a potential member for the first show, he joined the group for their second exhibition held at Durand-Ruel's gallery, 11 rue Le Peletier. Independently wealthy, he not only amassed an extraordinary collection of Impressionist works that he eventually bequeathed to the Louvre but he also paid for or otherwise subsidized the painters' later exhibitions. A vivid pictorial souvenir of Caillebotte's milieu is the painting by Jean Béraud, *Une soirée dans l'hôtel Caillebotte*, exhibited at the Salon of 1878, which conveys the luxurious surroundings and haute-bourgeoisie circle of the family that includes diplomats, aristocrats, high-ranking military officers, and bankers (fig. 53).

This is not a group that harbored sympathetic feelings for the Commune. Indeed, the family, of old Norman stock, had a long history of counter-revolutionary activity dating from the French Revolution of 1789.[1] Caillebotte's father expanded the fortune of the family's textile business by supplying bedding to the imperial army of Napoleon III. During the Franco-Prussian War, Caillebotte served in the Garde Mobile de la Seine for nine months, a privileged and conservative bastion for the sons of the well-to-do.[2] Soon after his discharge, he entered the studio of Léon Bonnat, who would become one of the favorite official artists of the Third Republic. Bonnat's political sympathies were with the moderate republicans, and following the termination of the war with Prussia he traveled to Spain to wait out the period of the Commune.[3]

Bonnat could be singled out from most academic painters by his ardent realism and coarser execution, although his subjects, other than portraits, fit the traditional mould. Nevertheless, he spawned a younger generation of painters whom I have previously classified as the *juste milieu* of the Third Republic, including Jean Béraud and Gustave Caillebotte, who rendered the Impressionist thematics with a more methodical technique. There was always a close connection between *juste milieu* aesthetics and moderate politics, and Béraud's painting of the elegant ball at the Caillebotte residence not only attests to the close association of the two painters but also portrays the same haute-bourgeois network that provided Bonnat with his commissions and allies.[4]

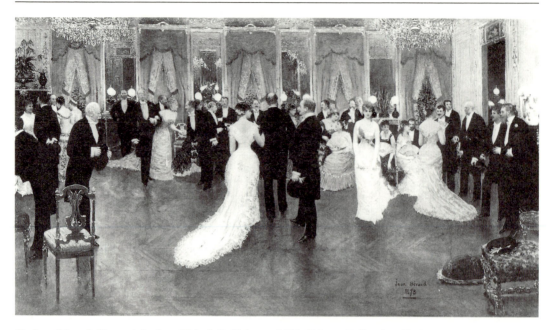

53. Jean Béraud, *Une soirée dans l'hôtel Caillebotte*, 1878. Private Collection, Paris.

Bonnat's *Portrait of Thiers*, begun in 1876 and shown in the Salon of the following year, was not simply the product of a paid commission but a monument to a particular brand of politics (fig. 54). Clad in a severe grey-coat and seen frontally in three-quarter length, the stern, unblinking elder statesman is portrayed as a pillar of strength and indomitable leader. The anecdotal accounts of the evolution of the portrait suggest an exchange among social equals, and the portrait itself immediately became the favorite of the antagonists of the Commune. Jules Claretie, for example, who lavished upon it extravagant praise, claimed that Bonnat's vision of Thiers would be the one that would be transmitted to future memory, interpreting for later generations "all the valour of this statesman, French to the core, who will be remembered . . . to posterity as the *liberator of the territory*." Bonnat presumably inscribed all the patriotic anxieties on Thiers' physiognomy, registering the travails of the man who, still standing bravely in the face of defeat like the Gallic cock, "rendered France free after having made it independent, and assuring his country the security of the morrow, after having emancipated it from the inquietude of yesterday."[5] Although Thiers' short-lived participation in the campaign against MacMahon in 1877 predisposed liberal Paris to turn his funeral into a massive republican demonstration, the Left never forgave him and the Right emphasized his heroic suppression of the Commune. A conservative journal that covered Thiers' funeral procession in September 1877 used the same language as Claretie, devoting a special issue to the "vanquisher of the Commune and the liberator of the territory." Not surprisingly, it included a double-page reproduction of Bonnat's portrait as the best existing likeness of the statesman.[6]

Bonnat's politics were those of the Caillebotte family, and the affiliation of teacher

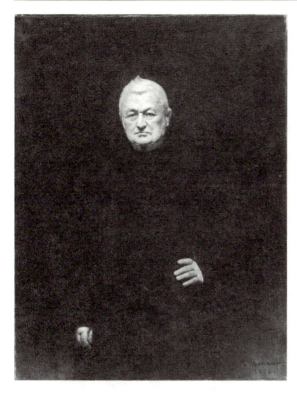

54. Léon Bonnat, *Portrait de M. Thiers*, 1876. Musée d'Orsay, Paris.

and student was more than a pedagogical accident. Caillebotte's modernity may have had an independent edge in his formal association with the Impressionists and in his topical themes, but he began in the conservative mode of his teacher. He submitted work to the Salon jury in 1875 that was refused, and its rejection prompted him to throw in with the "intransigents."[7] Thereafter he became known as the "millionaire who paints in his spare time," and critics loved to single him out as the best of the Impressionists for his tighter draftmanship and careful finish.[8] Although his *Raboteurs de parquet* (Floor-Scrapers) was considered vulgar by some critics in 1876, the critics confessed to admiring his technical know-how and constructed him in opposition to his fellow Impressionists.

This canvas brought Caillebotte instant attention when exhibited, and it has remained his "signature" piece (fig. 55). It depicts three artisans nude to the waist scraping the floor of a spacious apartment; although the scene is traditionally accepted as the upper floor of a family home, the kind of work carried out is more closely associated with the adjustment of problems caused by new building construction.[9] The perspective is highly unusual, with the raised horizon line and floor tilting dramatically toward the viewer who seems to be looking down on the workers. The rapidly plunging perspective and pictorial void gives the illusion of an exaggerated expanse of floor that needs to be covered by the floor scrapers. A stream of resplendent golden light pours through the grilled window in the rear, forming a radiant path along the receding floor-

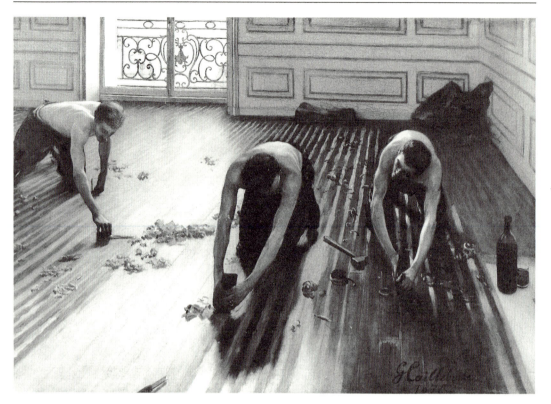

55. Gustave Caillebotte, *Floor-Scrapers*, 1875. Musée d'Orsay, Paris.

boards and picking out the nude torsos of the artisans in a triangulated pattern of luminous patches.

The three workers are totally absorbed in their labor and function as a team moving in tandem with each other's rhythm. This sense of mechanical movement is reinforced by the frontal symmetries of the two closest workers and the right-angle position of the third which align them with the geometry of the composition. The figures of the joiners are integrated into the architectural elements, an appearance sustained by the wedge-like shape they collectively form and the pattern of light falling on their backs. In effect, their bodily movements are conditioned by the environment and the tools they deploy for the job, tools conspicuously located in the composition so as to repeat the triangulated, wedge-like structure of the artisanal task.

This unusual depiction of urban workers surprised some reviewers at the time, but they not only quickly recovered their composure but went on to praise the novel attempt. The remarks of the critics are fascinating, more revealing perhaps in the case of Caillebotte than for any other artist in the 1876 exhibition. They underscore the importance of the subject in the rehabilitation of Paris in the early years of that fateful decade. Here are artisans—the same class devastated by both the halt to the Second Empire construction and the ruthless suppression of the Commune—regimented for

the sake of work in an affluent bourgeois milieu. The peculiar viewpoint and upraised horizon subordinates them not only to the exigencies of the architectural space but to the gaze of the viewer who owns it.

Caillebotte's eccentric upturned treatment of a traditional one-point perspectival scheme is expressed as surface, consistent with Impressionist formalism that absorbs space and reduces the look of the visual field to two dimensions. This reduction to surface is reinforced by the dazzling play of reflected light and illuminated shadows. Caillebotte's work is a key to unraveling Impressionist ideology: it represents the rehabilitation of a privileged space by workers who thereby guarantee their own exclusion. Even though occupied by laborers the scene is metaphorically represented as a site of luxury—a place where only the very rich belong. Thus the sumptuous color, texture, and surface design betray a space where only one class can reside, the interior counterpart of the recoded view of the boulevards from the window.

What I am saying is that the *Raboteurs de parquet* was a metaphorical representation of the reconstitution of Paris, both in its physical and human components. This is clear from the remarks of the critics, despite the occasional reservation about the unidealized presentation of the workers. Burty, who emphasized the need for hard work and long hours to restore the nation to its former glory, had this to say about the originality of Caillebotte's pictures generally, and the *Raboteurs* in particular:

> These pictures would create a scandal in an official Salon amid the false and sinewless figures of the school, and we applaud the juries for their wisdom in keeping them out. Here it is a different matter. Their success is fair and honest and due to their faithful representation of life as it expresses itself in the working functions, and of the members as they come to look when modified by the constant pursuit of some one particular occupation.[10]

Here is Burty delighting in seeing representations of urban laborers subsumed to the task of restoring the city and especially appearing in their peculiar occupational guise. As opposed to the worker under the Commune who presumed to engage in functions normally reserved for an educated elite, Caillebotte's joiners know their place and vividly show it. Louis Enault, writing for the moderate republican journal *Le Constitutionnel*, seconded these remarks: "All those who have had the pleasure or the bother of having a house built know the way these robust fellows work, unabashedly putting aside any encumbering outfit, leaving only the most indispensable clothing, and thus offering to the artist who wants to make a study of the nude, a torso and a bust that other trades do not expose as freely."[11] Akin to Burty, Enault appeals for understanding of Caillebotte's picture to a bourgeois audience (i.e., those "who have had the pleasure or the bother of having a house built") and categorizes a certain class of workers with their own intrinsic characteristics.

The following year Burty repeated this thought when he opined that "Monsieur Caillebotte made himself known last year by *Floor-Scrapers*, which demonstrated a curiosity, rare these days, about strictly professional types and occupations."[12] Burty then mentioned another work in this connection, Caillebotte's *Peintres en bâtiment* (The House-Painters), which showed in the Impressionist exhibition of 1877 (fig. 56).

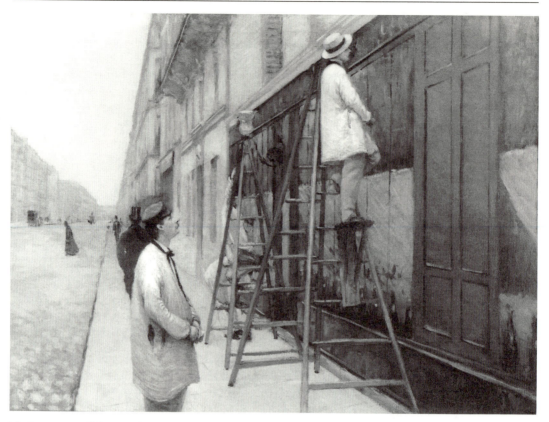

56. Gustave Caillebotte, *The House-Painters*, 1877. Private Collection, Paris.

Representing artisans in their easily identifiable occupational smocks once again re-
stored urban laborers to their "rightful" niche in the bourgeois social order. Addi-
tionally, the refurbishing of the facades on the broad thoroughfares was a familar sight
in the aftermath of the Franco-Prussian War and the Commune, and the painter privi-
leges the locale by emphasizing the vast space of the street and its seemingly endless
row of buildings. Finally, the house-painter is a witty allusion to Caillebotte's own
professional role as a painter who participates in the movement to reinvest the urban
space with a symbolic freshness.

Akin to Degas in his *Portraits in an Office (New Orleans)*, which also hung in the
same show, Caillebotte realizes the call of Duranty and Burty for a class-based modern-
ism that secures the prerogatives of the bourgeosie while conveying the illusion of a
shared public space. Nowhere is this more apparent than in *Le pont de l'Europe*, one of
three major Parisian street scenes that Caillebotte showed in the Impressionist exhibi-
tion of 1877 (fig. 57). Here Caillebotte focuses on the new Paris, choosing a monumen-
tal vista constructed under the Second Empire and the locale of heavy fighting during
the Commune (fig. 58).[13] Part of the new network of boulevards that reorganized the
flow of people and commodities, this juncture of six intersections inevitably became

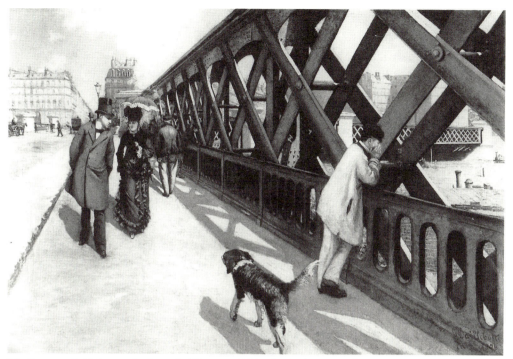

57. Gustave Caillebotte, *Le Pont de l'Europe*, 1876. Musée du Petit Palais, Geneva.

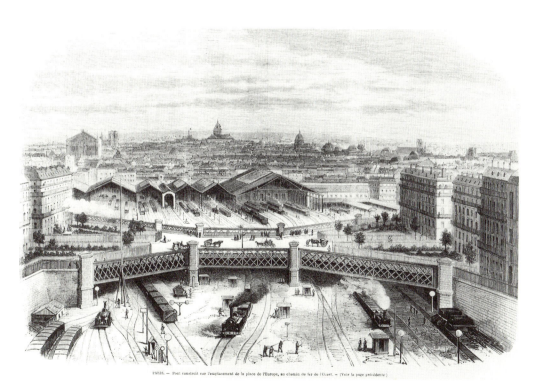

FARIS. — Pont construit sur l'emplacement de la place de l'Europe, au chemin de fer de l'Ouest. — (Voir la page précédente.)

58. A. Lamy, *The Pont de l'Europe and the Gare Saint-Lazare*. Wood engraving reproduced in *L'Illustration*, 11 April 1868.

an important strategic site for the Communards.[14] Victor Fournel, weeping over the destruction of Haussmann's Paris and railing against the wicked Communards, tried to recover the pristine memory and magisterial importance of the site:

> The Place *de L'Europe* is perhaps one of a kind; at its central core is a bridge of cast iron one hundred meters wide that spans innumerable junctions of the Chemin de Fer de l'Ouest: three thousand five hundred kilograms of cast iron were used in the arches of this monumental bridge. At the Place de l'Europe the streets of Vienna, Madrid, Constantinople, Saint-Petersburg, Berlin and London all converge.[15]

Fournel's work aimed at a restorative policy, but such a policy had to be predicated on never forgetting the "Communard executioners" always waiting in the wings for their opening. Caillebotte responds to this agenda by setting out the modern metropolis with all of its remarkable engineering feats to now function as awesome spectacle overwhelming its potential dissidents.

In the painting we are looking down the rue de Vienne, with the place de l'Europe at the left and the railroad yard at the lower right. Gazing contemplatively into the yard below is a young worker in a smock, who casually leans on the iron parapet of the recently constructed Pont de l'Europe. Moving toward the spectator at a brisk pace along the sidewalk is a bourgeois couple, conversing and strolling in a spacious ambience that suggests freedom of action. Although the perspective lines converge on the couple, the worker is positioned so prominently in the foreground that he sets up a visual opposition to them. As Herbert suggests, this opposition between bourgeois and worker is seen in the other figures as well, with the laborers on the inside of the walkway captivated by the metal trusswork—a metonym for industrial practice—and the upper-class types on the outside distanced from this realm and uninhibitedly engaging in a flirtatious exchange.[16] Thus although present in the same space as the bourgeoisie, the potentially unruly classes are shown as totally absorbed in their own world of industry and work and allow their social superiors to go about their business free from disturbance.

Caillebotte's plunging perspective again conveys the dynamic rhythm of the city restored to its functions. The conspicuous metallic girding that commands the composition expresses the industrial potential of the new Paris. If it disrupts the picturesque look of the old city, it provides a visual metaphor for both the mixing and separation of the classes in a modern urban and industrial space. This is all the more persuasive when we learn that the smartly dressed stroller accompanying the elegant woman is Caillebotte himself, and that the scene is in a neighborhood that adjoined his own: the Quartier de l'Europe, a new residential district so-called because several of its streets were named after the capitals of Europe. Hence Caillebotte's self-representation in the industrial zone signifies his own personalized desire for the emblematic opposition and fusion of the classes in a neighborhood close to his own. His career unfolds in the context of the signifiers of contemporary urban life, but he also maintains a distance consistent with the lifestyle of the privileged bourgeoisie and surrounds himself with a safety-net. It is in this sense that the painter meshes his work with the ideological proclivities of the moderate Republican regime.

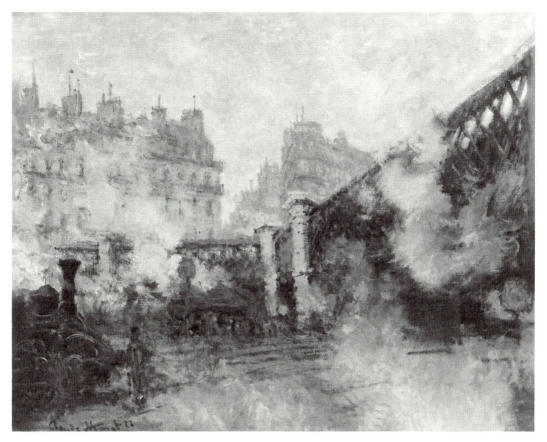

59. Claude Monet, *Le Pont de l'Europe*, 1877. Musée Marmottan, Paris.

The iron trellises of the Pont de l'Europe fascinated other Impressionists in the 1870s, showing up in important canvases of Monet and Manet (figs. 59, 60). Monet's *Le Pont de l'Europe*, one of several of his contemporary views depicting the Gare Saint-Lazare, would seem to be at the opposite pole of the political spectrum by taking us down into the trenches, into the infernesque realm of the railroad yards and their denizens. We look up from the edge of the suburban quai to the imposing metallic bridge dramatically crossing over to the rue de Rome, one of the six streets that converged on the immense construction that spanned the yards of the railway station. At the left is a puffing locomotive attended by two railway workers, who stand facing it as if transfixed by the technical marvel. The spectator looks on the scene from a slightly higher level, so that it appears as if the trainmen are on a lower level. The entire scene is shrouded in puffing clouds of smoke and steam that rise to the top of the picture and blend with the atmospheric conditions of the sky.

Almost all of the critics commented on the near-indecipherability of this and the other six views of the station exhibited in 1877. Typical is the remark of *Le Gaulois*'s critic Louis de Fourcade, who, while appreciating the picture's merit, claimed that all the vapor made it "look like an illegible scrawl."[17] One of the most sympathetic re-

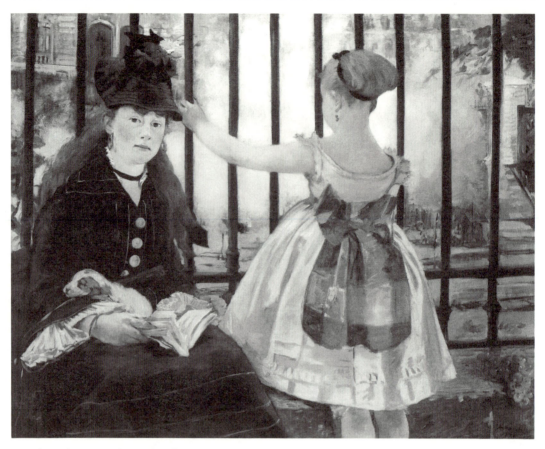

60. Edouard Manet, *The Railroad (Gare Saint-Lazare)*, 1873. National Gallery, Washington, D. C.

views of the railroad series was written by Georges Rivière, writing in the new journal, *L'Impressioniste*:

> Like a spirited, impatient beast stimulated rather than fatigued by the long journey [the locomotive] has just finished, it shakes its smoky mane that billows against the glass roof of the vast hall. Men swarm around the monster like pygmies at the feet of a giant. . . . We hear the shouts of the workers, the sharp whistles of the engines blasting their cry of alarm, the incessant noise of iron and the formidable and heavy huffing and puffing of the vapor.[18]

Monet has set up the picture to contain the presence of the working classes, even openly invading their work space to do so. The melding of nature and artifice in the alembic of steam, sunlight, smoke, clouds creates a new atmosphere that dissolves key aspects of modern life and history. Rivière gratefully sees the workers reduced to pygmy-like status in the shadow of industrial power, and their shouts are not a call to arms but responses to the overwhelming complexity of the formidable technology.

(The railroad engineer in Zola's *La Bête humaine*, which opens with a panorama of Gare Saint-Lazare and its neighborhood, feels a close emotional attachment to his locomotive which he feminizes in his attempts to control "her"). What Monet graphically accomplishes in his dematerializing studies of humans and machinery is the neutralization of the worker as a threat in the face of industrial progress.

This would mesh well with the republicans' optimistic forecast of the role of railroad technology in the future of France. The railroad introduced the modern corporate system, coordinating on a vast scale the processes of production and distribution and establishing a managerial elite dear to the heart of the utopian capitalists. The railroads also required vast amounts of capital that not only conduced to centralizing industrial technology but also stimulated the growth of the stock exchange for trading and speculating in railroad securities. One ardent republican wrote in 1873 that the coalitions of capital and organizational efforts for railroad expansion furnished a model for large-scale social cooperation. As she noted:

> In this vast organization, wholly analogous to a mechanism ingeniously put together, each employee, each worker, constitutes an indispensable spring, no matter if he is lowly or elevated. There the greaser of the wheels, the engine stoker, and the switchman are as necessary as the engineer and the director. From this results the idea of equality of the services: not that we are pretending that there is an equivalence in the quality and value of the functions, individually considered, but because from the general point of view, there is an equality of indispensability. Aside from this, each employee feels himself as useful, by virtue of his contribution, as the top person in the hierarchy.[19]

Similarly, Monet's indistinguishable workers could be rationalized in the same way as Burty, Mallarmé, and other moderate republicans generally rationalized Impressionist informality and lack of compositional centrality in democratic terms—their painted presence was no less important than any other dab or "cog" in the well-oiled machine.

The French railroad system lost 835 kilometers of rail when the Prussians annexed Alsace and most of Lorraine, and many railway stations and lines were badly damaged during the war and the Commune. These events entailed a drastic shakeup of the rail industry throughout the 1870s.[20] In 1876 and 1877 both the Senate and the Chamber of Deputies appointed commissions to study the railway in relation to the state, culminating with the Freycinet Plan of 1878 that called for the government to take over ailing lines and reorganize the system. Monet's choice of the railroad station owned by the Chemin de Fer de l'Ouest could hardly have been arbitrary, since the Gare Saint-Lazare was the oldest, largest, and most important station serving Paris. It serviced long distance lines to Normandy and Brittany and heavily used commuter lines to Argenteuil and other towns west of Paris and around its periphery. This network embraced the fashionable seaside resorts such as Boulogne, Deauville, and Trouville that early attracted the Impressionists, and included Monet's home town Le Havre. During the Commune, service at Gare Saint-Lazare was either suspended for long periods or interrupted and it served as a bastion of defense for the Communards.[21] Departing from this station was also incommodious because passengers were systematically sub-

ject to searches by the National Guard. Here and at the Place de l'Europe there was a major showdown between the Communards and the Versaillais under General Clinchant.[22] Monet's series of images of a bustling, thriving railway industry (he called one of the series *Train de marchandises* [*Gare Saint-Lazare*])[23] not only recuperates the station for the bourgeoisie and celebrates a national comeback, but may also yield an insight into his own optimistic anticipation of the possibilities of unconstrained mobility.

Manet's *The Railroad (Gare Saint-Lazare)* brings us back to the level of the sidewalk stroller, where he places a fashionably dressed young woman seated with reading materials and a young girl on the edge of a garden overlooking the tracks close to the Pont de l'Europe. Its metal trusswork is visible at the right edge of the picture. Separating the two figures from the railroad yards below is a tall iron grillwork fence which was satirized by cartoonists and journalists as the bars of a prison or madhouse cell. Painted in 1872–1873 and exhibited in the official Salon of 1874, the picture offers an insight into the potential appeal of an "impressionist" sensibility to the bourgeois mindset in the immediate aftermath of civil upheaval. For what is being shown is a serene vision of the industrial world—neatly partitioned off from the upper class realm occupied by the figures.

The ubiquitous Burty had seen this work still unfinished in the studio of the artist in the autumn of 1872, and in his typically allusive style suggested its restorative and veiling character. Burty began his article about recent visits to the ateliers of his artist-friends with an apparent reference to the seasonal change, "The swallows are gone. The artists return," but his conclusion following the discussion of Henry Cros' figurines of passionate demoiselles takes us right into the political: "Why, if this continues, the republic will no longer be so tedious, so ferocious and so hostile." When he turns to Manet's work, he espies a "young woman, wearing the blue twill that was in fashion until autumn . . . seated next to her young daughter, who, dressed in white and standing, observes through the grillwork fence of Batignolles Square the cottony white smoke thrown across the way by a railroad train. . . . Movement, sun, clear air, reflections, all give the impression of nature, but nature subtly grasped, and finely rendered."[24] According to Burty, Manet's "harmonic and sensitive" painting had its analogue in the beautiful black and white engravings of modern life seen in the politically moderate English illustrated journal *Graphic*.

Tabarant claimed that the scene was painted in the triangular garden of the studio of Alphonse Hirsch, whose daughter posed for the young girl in the picture. Located behind the building at 58, rue de Rome, near the corner of the rue de Constantinople radiating out from the Pont de l'Europe, the garden overlooked Gare Saint-Lazare. Manet's non-commital and ambiguous scene has always been read as some cryptic narrative, but what is clear is his sharp separation of the bourgeois world of his colleague and the industrial world below. This is vividly pictured by the iron fence that runs the breadth of the canvas and the long, drawn out trail of smoke that obscures everything in the trainyard. The garden in fact is a safe haven from which bourgeois people may observe the spectacle of the railroad and otherwise indulge in leisure-time pursuits. The older woman, posed by Victorine Meurent, has been reading a book which she has momentarily left off with her fingers still marking the place, and she

also holds a folded journal in her other hand while a puppy snuggles in her lap. The young girl daydreams before the cloud of vapor, and the puppy slumbers undisturbed. Like the "machine in the garden," Manet's work creates an almost pastoral image out of the stuff of industry. The railroad, with all its turbulence, is there as a necessary adjunct of modern life and even momentarily disruptive, but it scarcely interferes with the bourgeois lifestyle.

The need to regulate the supposedly open and shared public spaces is nowhere more evident than in Caillebotte's unabashedly authoritarian *Young Man at His Window* (fig. 61). As in the case of the *Floor-Scrapers*, Caillebotte has marshalled an unusual perspectival scheme to dramatize social and property relations in the post-Commune society. The scene is projected from the viewpoint of a nattily attired male who stands with his back to the spectator inside a luxurious third-story (*deuxième étage*) townhouse interior looking through an open window into the streets below. His feet are set confidently apart, hands thrust in the pockets, gazing through the window at the scattered carriages and passers-by like a military officer surveying the enemy's position from a remote hilltop.

Caillebotte is at pains to ensure that the spectator identify with this sheltered viewpoint, establishing the primacy of the scene in the bourgeois parlor with the massive ballustrade functioning analogously to the iron grill in Manet's *The Railroad*, the inrushing diagonals of the opened window wings, and the plush upholstered armchair located on a line with the dominant compositional movement. The very title—*Jeune homme à sa fenêtre*—signifies private ownership and a spectator's privileged point of view, and the real-time beholder is cued to the commanding position and line of sight of the painting's protagonist.

Thus it is not surprising to learn that the protagonist is René Caillebotte, the artist's younger brother, who is looking out of the window of the sumptuous family home at 77, rue de Miromesnil. From the corner of the building on the rue de Lisbonne, René looks past the rue de Miromesnil into the Boulevard des Malesherbes. Caillebotte's picture records one of the new Haussmannian residential zones built in the previous decade, a status-oriented neighborhood where Henri Rouart, another influential Impressionist painter-collector, resided on the rue de Lisbonne. One of the fiercest episodes of Bloody Week occurred in this area along the Boulevard des Malesherbes, where the Federals built one great barricade extending the width of the boulevard and several smaller barricades nearby attempting to block the way to the Madeleine and the network of defenses extending to the Opera. The Versaillais took over the lower part of the rue de Miromesnil and advanced on the neighboring church of St. Augustin from which to launch their attack on the Communard fortifications of the Boulevard des Malesherbes.[25] The regular army also managed to penetrate some of the buildings of the boulevard and fire down upon the insurgents from the balconies and take them by surprise. By the time the barricade was taken, the Boulevard des Malesherbes was furrowed with shells "like a field ploughed up by gigantic shares."[26] Caillebotte's neat compositional geometries effaces the traces of the Communards and resurrects the Haussmannian authority, reinforced by the commanding position of René who stands guard over the quarter with the authority granted by his social station.

The apparent focus of René's gaze is an unaccompanied well-dressed woman below

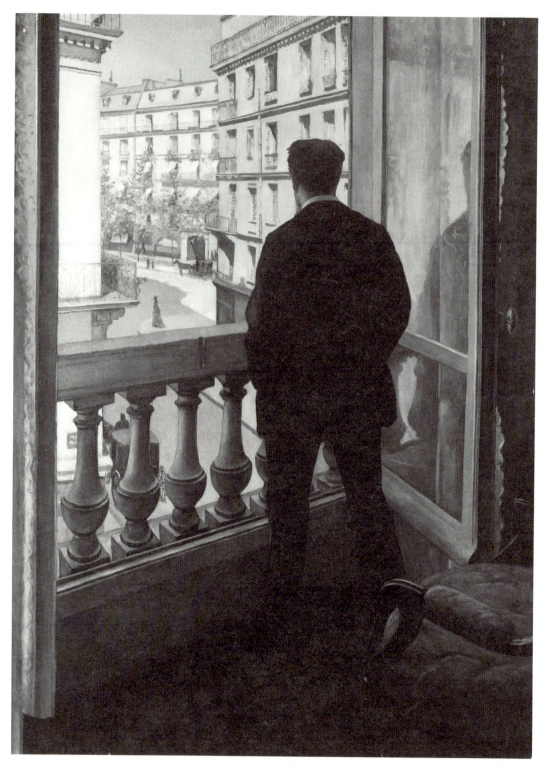

61. Gustave Caillebotte, *Young Man at His Window*, 1876. Private Collection, Paris.

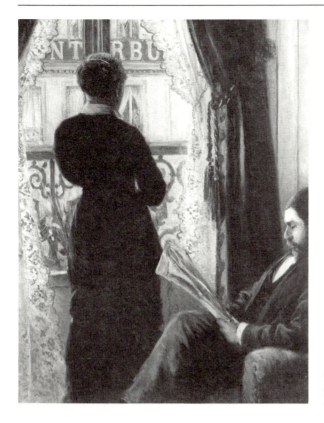

62. Gustave Caillebotte, *Interior, Woman at the Window*, 1880. Private Collection, Paris.

in the process of crossing the intersection. Distant and isolated in the field of vision, she is nevertheless the exciting object of his scrutiny. Being safely under the surveillance of the male watcher, she poses no threat either to herself or to others. In this sense, she is diametrically opposed to the independent women of the Commune, whom Maxime du Camp characterized as "these bellicose viragos" who "possessed a single ambition . . . to outdo the male by exaggerating his vices."[27] Another commentator declared that the so-called French "warrior-woman" is a "coarse, brawny, unwomanly" female whose want of authentic "womanly attributes" forced her to "quit the conventional mode of life."[28] Hence Caillebotte's image not only restores order to the streets of Paris, but a patriarchal order that constructs the passive, objectified female in opposition to the militant female warrior of the Commune. In the public spaces of modernity shaped in the wake of the Commune, the female roaming at will is problematical.

René possesses the outdoor, public space by virtue of his command over private property. Caillebotte expresses this superiority through the lofty vantage point that permits surveillance without being seen in return. The bourgeois woman, however, is denied that same degree of hierarchical control, as is evident from Caillebotte's *Interior, Woman at the Window* which shows a woman seen from the rear looking through the window of her apartment (fig. 62). Her posture is much more tentative than that of

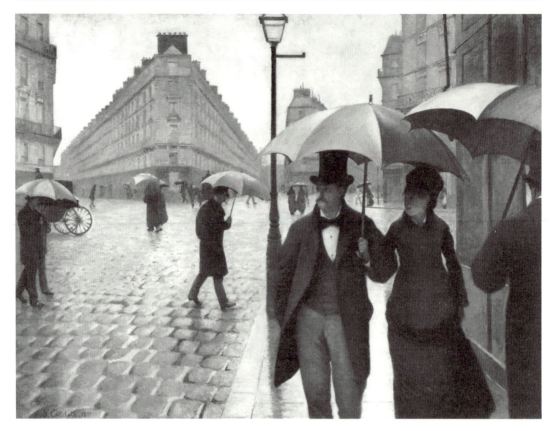

63. Gustave Caillebotte, *Paris Street, Rainy Weather*, 1877. The Art Institute of Chicago, Chicago.

René, and she shares the space with a seated male whose form foregrounds the picture with a strong right angle that stabilizes the vertically oriented composition and pulls the composition away from the window. Furthermore, instead of commanding a public domain outside the interior her view is delimited by another building across the street and it is impossible for the viewer to see what it is that captures her attention. Whereas René's view is open and extended, that of the woman is closed off and there is more emphasis on the interior. She remains confined and subject to the male gaze both within the private and public realms.

Caillebotte's *Paris Street; Rainy Weather* was his most monumental work (approximately seven by ten feet) and plunges us into a vast public space bathed in the cool fresh air of a drizzly day (fig. 63). The scene represents pedestrian traffic at a star-burst intersection formed of the crossing of the rues de Moscou, Turin, St. Petersbourg, and Hambourg in the vicinity of the Pont de l'Europe. For many scholars this work has become the canonical example of modernity, inextricably linked with the depiction of Haussmannian Paris. The district was planned from the start as a residential zone for the grand bourgeoisie and almost entirely constructed within the artist's lifetime.

Here was a microcosm of the impeccably clean, wide, and uniform look imposed by Haussmann's boulevards, countering the unsanitary, crooked, densely packed and dark urban picturesqueness of the old city. At the same time, the sight of the uniformly and impeccably groomed bourgeois pedestrians strolling (either singly or in pairs) isolated from the others also prompts thoughts on the effects of Haussmannization on their behavior and psychology. The scholars seek answers to the question: To what extent are these wandering strangers, regimented yet seemingly unconnected psychologically, the result of their modern environment?

The critics reviewing the Impressionist exhibition of 1877 did not mention the fact of the pedestrians' isolation, suggesting that their comportment seemed entirely consistent with the expected norm of street interaction. They complained about the uniformity of the surface treatment that made secondary details and accessories such as paving stones and umbrellas as important as the main elements of the composition. Despite the methodical perspectival scheme, the picture's consistent all-over handling of the surface lacked the accents of some ordering principle. They observed the modern costume and contemporary physiognomies of the figures in the foreground, for example, who seemed to have taken their umbrellas "from the racks of the Louvre [department store] and the Bon Marché."[29] Thus there is recognition of the new society's bourgeois orientation, with the feeling, however, of an atomized structure that fails to distinguish between paving stones, umbrellas, and the human participants.

At least two critics perceived the rain in metaphorical terms, as a cleansing action. Lepelletier claimed to see the "sidewalks and paving-stones washed by the waters of the sky, like the old bricks of Amsterdam by the Dutch housewives," while Jacques saw "well-built, sumptuous houses" jutting out "on to a pavement that is washed, clean, measured with a patience."[30] The sanitary action of the rain on the paving-stones was a gratifying recollection of the social "cleansing" and purification of the streets once stained by the physical presence as well as by the blood of the Communards. Although the wide Haussmannian boulevards were designed in part to forestall the type of barricade that so effectively blocked off the old narrow streets of semi-medieval Paris, the worker-engineers of the Commune still managed to forge monumental barricades across the boulevards with the Second Empire's own paving stones. Indeed, "les pavés sanglantes" become a pervasive metaphor for both the supporters of the Impressionists and the enraged reactionaries who wanted to scrub Paris clean of Communard traces.[31]

The conspicuous treatment of the paving stones and their rain-drenched and light-reflecting radiance symbolically constitute a Paris restored to its pristine Haussmannian appearance and a Paris recuperated for the bourgeoisie. The even distribution of emphasis on the surface and seemingly random placement of the figures further allows the painter to imagine an egalitarian public space. I have found two working-class types among the pedestrians, both observed within the background space framed by the umbrella of the couple in the right foreground: one is a house painter in a smock carrying a ladder seen just behind the head of the male, and the other is a house-servant just exiting a shop at the right of the woman's head. Caillebotte can theoretically claim to have depicted a public space with no purposeful hierarchy of social content or privi-

leged theme, but in fact the diminutive working-class figures—represented with their specific occupational attributes—do constitute a minor note in this "snapshot" of the modern thoroughfare. Hence whether it be Monet's blurry atmospheric effects or Caillebotte's more methodical treatment of the surface the effect of both is to neutralize the physical presence of the perceived insurgent threat in their midst.

I now want to undertake a more concrete analysis of Impressionist activity by examining the sites they paint in the light of their previous history during the catastrophic events of 1870–1871. Key Impressionist scenes coincide with key locales of conflict and destruction during the Franco-Prussian War and the Commune. Some of this may be merely coincidental in that the Impressionists sought their motifs in the heart of Paris, where the fighting inevitably took place. But even with this reservation, the fact that in both the suburban areas and urban areas these sites so neatly overlap suggests a kind of plan.

After about five and a half weeks of bombardment and skirmishing among the ruins of suburban villages already damaged in the Franco-Prussian conflict, the Versaillais entered Paris on 21 May and in a week of ferocious street fighting put a bloody end to the revolutionary Paris Commune. The squares, boulevards, and parks of the city were strewn with the bodies of thousands of its citizens and the rubble of many of its most famous public buildings. The geography of the capital and the citizens contesting it were inevitably caught between a government bent on crushing permanently the nettlesome revolutionaries of Paris and the revolutionaries themselves intent on destroying an institutional structure that oppressed them.

The recent transformation and modernization of the Paris public space under Napoleon III and Georges Haussmann had made Parisians very much aware of the cultural politics of boulevards, squares, and public buildings. As poorer families were pushed from the center by demolition and rising rents, they moved into settlements on the northern, eastern, and southern edges of the city. One of these districts was Montmartre, where the Commune began on 18 March when the government tried to capture by surprise the artillery of the Paris National Guard, and during "Bloody Week" became a site of some of the fiercest fighting of the civil war.

The Communards returned to the center of the capital to take control, displacing the bourgeoisie who had profited most from Haussmannization. The Commune's seizure of national as well as evacuated private property was predictably characterized by Versailles, in their propaganda to the troops, as the expression of socialist plundering, best seen in the destruction of Thiers' own house and auction of his goods in retaliation for the bombardment of Paris. The most sensational treatment of the Communards was reserved for accounts of the expropriation of private property and the outrage to domestic privacy that was assumed to be the inevitable result of Communard occupation. The pro-Versailles press reported that former slum inhabitants were making themselves at home in evacuated private houses and looting at will. Thus when the Versailles troops confronted the Communards they were fighting in part to regain the sanctity of private property wantonly violated by the Fédérés. The Communards' tight hold on the thoroughfares, squares, parks, and theaters hardly explains the brutal suppression by the Versaillais; it was their symbolic threat to private property and control of public space that made their bloody massacre a necessary part of the retaking of

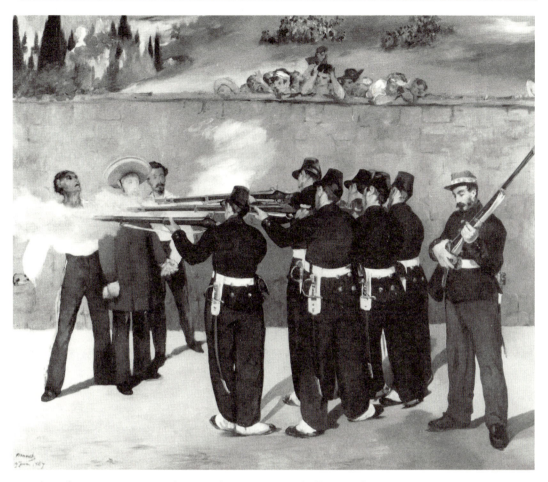

64. Edouard Manet, *Execution of Maximilian*, 1867. Kunsthalle, Mannheim.

Paris. But in the process they recoded Haussmannization for bourgeois Paris and left their indexical imprint on the territories of modernity.

The Fédérés were ensconced in the heart of what would become Impressionland; the main arteries of the city, its squares and parks, with its barricades in the Batignolles near Montmartre, la place de la Concorde, the Tuileries, the place Vendôme, the Hôtel de Ville, Bois de Boulogne, Luxembourg Gardens, the parc Monceau, la place de l'Europe, and the vicinity of Gare Saint-Lazare. The report of MacMahon, commander in chief of the army of Versailles, describes a Draconian sweep of every street, barricade, neighborhood, barrio, ghetto occupied by the working-class Fédérés. Dry as dust, the rapport provides a daily account of the street-by-street, barricade-by-barricade, quartier-by-quartier campaign. The heroic Federals, having no alternative, contested every inch of the ground. Manet's lithographs convey the summary executions of the defeated Communards before their barricades, even quoting his own previous depiction of the *Execution of Maximilian* to make the point about the breakdown of the boundaries between foreign invasion and civil war (figs. 64, 65).

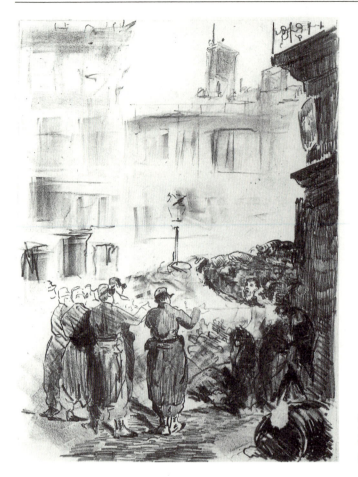

65. Edouard Manet, *The Barricade*,
1871. Lithograph. National Gallery,
Washington, D. C. Rosenwald
Collection.

As shown in the case study of Caillebotte, Impressionists dealt with specific urban
sites and suburban locales so as to recuperate the ground fought over, bloodied, and
wasted. They too went on neighborhood by neighborhood forays, freeing them from the
grim memories of the past and metaphorically establishing social harmony by immers-
ing them in a flood of dazzling sunlight and color. In their scenes of this topography,
bridges are repaired, trees replanted and flourishing, the rubble of ruins removed, and
the pace of life returned to normal.

Both the "polished" Impressionist Caillebotte and the "blurry" Impressionist Monet
painted the Parc Monceau in the eighth arrondissement, located close to the resi-
dential district where Caillebotte and Rouart lived.[32] Although their images of Parc
Monceau and its visitors are tranquil, it had been invested by the Communards as a
base and then became the notorious site of mass executions during Bloody Week.[33]
Nothing could be more remote from this memory than Monet's *Parc Monceau* of 1878,
so intimate a scene of his family that it smacks more of a private garden than a public
park (fig. 66). Monet in fact painted three portraits of the park in the spring of 1876,
each including glimpses of plush residential buildings (fig. 67), and did another series

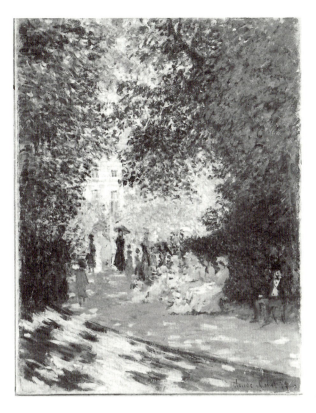

66. Claude Monet, *Parc Monceau*, 1878. Metropolitan Museum of Art, New York.

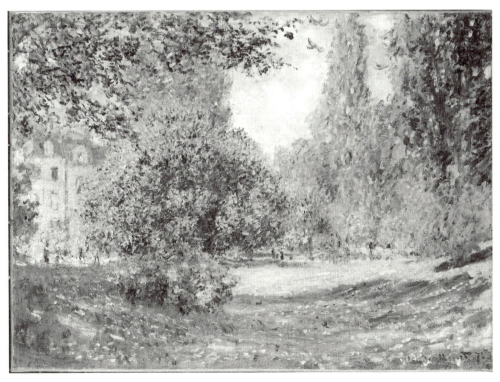

67. Claude Monet, *Parc Monceau*, 1876. Metropolitan Museum of Art, New York.

in 1878, following the group devoted to the Gare Saint-Lazare—attesting perhaps to a sustained effort to reinvest these sites symbolically with bourgeois significance. Not surprisingly, Zola used the vicinity of the Parc Monceau as the setting for the luxurious mansion of the parvenu Saccard and his incestuous wife and son in the1872 novel *La Curée.* This site serves as the stepping-off point for the exploration by Renée and Max-ime of "new Paris," in which every boulevard becomes "an extension [un couloir] of their townhouse." Although set in the period of Haussmannization, Zola's novel was completed after the Commune and the repeated references to "new Paris" carries a double meaning. When the lovers return home after their madcap foray along the tu-multuous boulevards, "they took pleasure in the Parc Monceau, which was the natural border of this new Paris which displayed its luxury in the first warmth of spring."[34]

Mallarmé's description of the Impressionists as people who "find their sub-jects . . . in their own gardens" is an apt description of Caillebotte, Monet, and Re-noir.[35] All three shared a passion for cultivating gardens and in a real sense often created the subject matter for their landscapes. The portrayal of their gardens is in fact a celebration of their privacy and their private ownership of property. Like the balcony overlooking the boulevard or the iron grill overlooking the railroad, the sequestering of the painters within their own gardens after the Commune implies an escape into a certain set of social relations. In December of 1871, Monet rented a house with a garden for his family in the Paris suburb of Argenteuil, where they resided through the autumn of 1874. This was the period of France's recuperation from the two sieges and coincided with the organization of the first Impressionist exhibition. Monet set up for himself an apolitical, no-risk sphere for self-renewal, as well as for territorial and ideo-logical self-definition. Renoir's depiction of *Monet Painting in His Garden* of 1873 shows the artist at home painting a thicket of red and yellow roses in his private sanctuary—a forerunner of the controlled landscape at his Giverny estate (fig. 68). Monet's own representations of his garden are even more enclosed and sheltering than Renoir's; the largest of these is *The Luncheon (Argenteuil)* of 1873, which smacks of bourgeois harmony and self-containment (fig. 69). Here the women and the small child—the seated Jean Monet who builds a tower of blocks in the protective shade of the luncheon table—are walled off in total privacy, and pictured with all the the com-forts of the good life. These are the material values and worldly preoccupations that drew Monet to the suburbs in the post-Commune era, an outcome cherished by his middle-class counterparts in every walk of life and constituting a symbolic rejection of the politics of the late insurgency. Zola wrote to Cézanne on 4 July 1871: "Now I find myself quietly at home again in the Batignolles Quarter as if I'd just woken up from a bad dream. My little garden-house is the same as ever, my garden is untouched . . . and I could almost believe the two sieges were bad jokes invented to scare children."[36]

Renoir's *The Morning Ride* of 1873 was meant to ingratiate him with an upper-class clientele who rode in the Bois de Boulogne, and the flowing tresses of the female eques-trian suggests an exhilarating romp in a zone now wholly restored to its privileged function (fig. 70). Prior to the Commune, popular imagery celebrated the Bois as a place for unaccompanied women to ride.[37] The "Amazon" is accompanied by a male youth on a pony, attesting to the "restored" Bois as a safe haven for both women and children.

68. Auguste Renoir, *Monet Painting in His Garden*, 1873. Wadsworth Atheneum, Hartford.

69. Claude Monet, *The Luncheon (Argenteuil)*, 1873. Musée d'Orsay, Paris.

70. Auguste Renoir, *The Morning Ride*, 1873. Kunsthalle, Hamburg.

71. *La Revue du 29 juin, à Longchamps.* Wood engraving reproduced in *L'Illustration*, 1871.

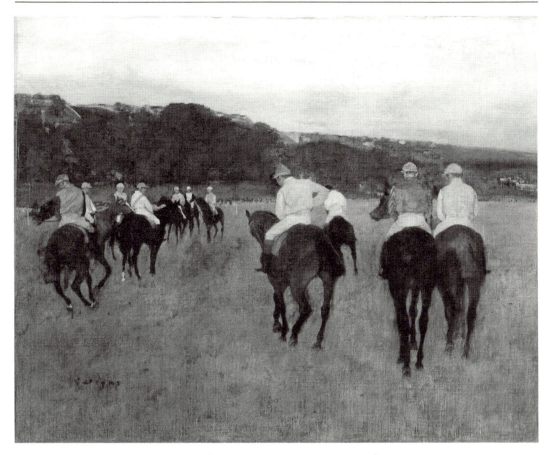

72. Edgar Degas, *Race Horses at Longchamps*, c. 1871–1874. Museum of Fine Arts, Boston. S. A. Denio Collection.

Although refused by the Salon jury of 1873, Henri Rouart, the "grand bourgeois" industrialist, amateur painter, and early patron of the Impressionists purchased the picture for his townhouse in the exclusive residential section of rue de Lisbonne.[38] Manet and Degas returned to depict the racecourse of Longchamps in the Bois, a site chosen for the Versaillese to parade in review on 29 June after the bloodletting of the Commune (figs. 71–73). The review was part of Thiers' plan for the national revival, a show of strength in the face of the Prussians and a celebration of his victory over the Communards. He wrote that the event "was the joy of a happy convalescence on a spring day."[39] The two images by Manet and Degas reveal less of the drama and more of a pastoral vision than that which marked their racing subjects from before the Commune. The spirit of convalescence reveals itself in Berthe Morisot's placid representations of family outings in the large park, her favorite outdoor retreat.[40] Morisot's scene in the Bois, *Lake of the Bois de Boulogne*, may give us a spatial split along gender lines, with a protected feminine sphere in the boat where women can be casual, and another

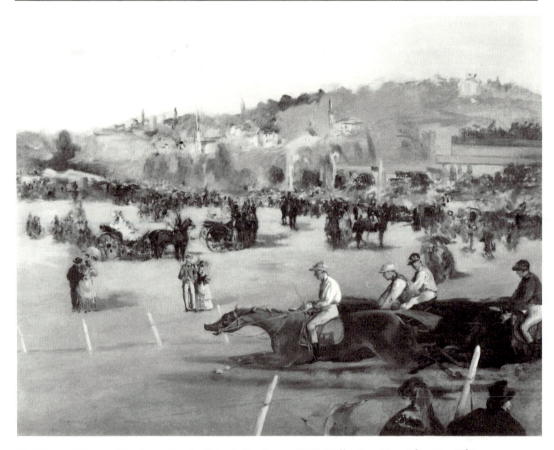

73. Edouard Manet, *The Races in the Bois de Boulogne*, 1872. Collection Mrs. John Hay Whitney.

zone beyond that would have to be negotiated more cautiously, but in a class sense they have taken back the day (fig. 74).

Degas' *Place de la Concorde* of 1875, looking east towards the Tuileries, emphasizes the spaciousness of the extensive intersection and a momentary uncanny absence (fig. 75). The effect of the figures pushed to the extreme edge of the left picture plane, and cropped promenaders in the foreground, gives the effect of a motion picture running backwards. But by so doing, Degas creates a vast empty space cutting across the scene towards the Tuileries. The flâneurs and equestrians who inhabit the periphery of that space belong to the privileged sector of French life. The impeccably attired man wearing the top hat and umbrella is the Bonapartist aristocrat Vicomte Ludovic-Napoléon Lepic (son of an aide-de-camp of the first Napoleon), an amateur printmaker and close friend of the artist who exhibited with the Impressionists. The sharp upward tilt of his cigar and the upturned umbrella establish dynamic vectors for that space while investing his stride with a distinct sense of purpose. His two daughters Janine and Eylau (the latter named for the battle of 1807 in honor of Napoleon) and their greyhound seem to be moving in all directions at once, suggesting the chaos of the street and its unseen

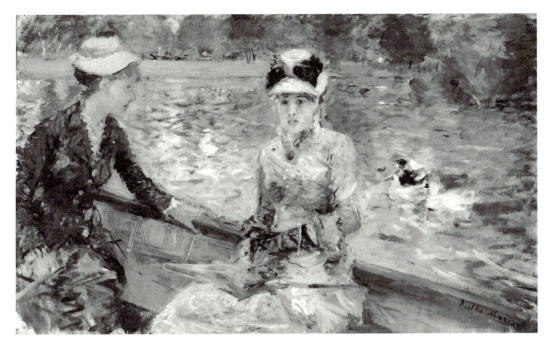

74. Berthe Morisot, *Summer's Day*, 1879. National Gallery, London.

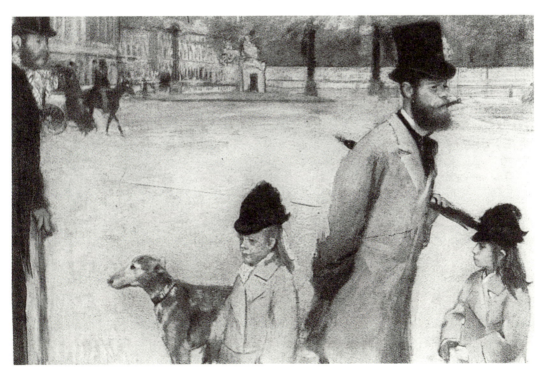

75. Edgar Degas, *Place de la Concorde*, 1875. State Hermitage, St. Petersburg.

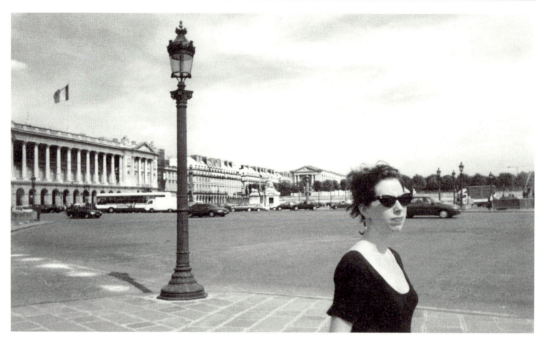

76. Photograph of Place de la Concorde and occluded view of the statue of *Strasbourg*, 1993. Courtesy, Eric Segal.

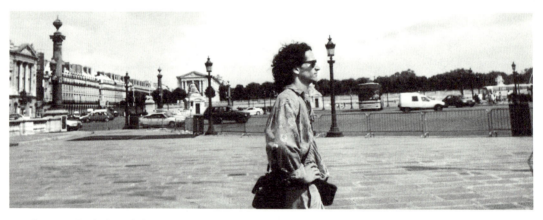

77. Photograph of Place de la Concorde and partial glimpse of the statue of *Strasbourg*, 1993. Courtesy, Eric Segal.

oncoming traffic. The effect of the abrupt sharp-angled movements is a sense of randomness, heightened by the drastic snapshot-like cropping of the figures.

Parisians, breathing free and on the move in the Place de la Concorde, a picturing only conceivable in the aftermath of 1870–71. But "l'année terrible" is there lurking metonymically behind the top hat of Lepic which calculatedly screens it out, where the female personification of Strasbourg stands as a reminder of that fateful year (figs. 76–78).[41] It was a point of assembly for Parisians during the heroic struggle of the town

against the invading Prussians as they cheered the valiant Alsatian general Ulrich (fig. 79). Eloquent orators held forth there on stools haranguing the crowd when the Prussians required the cession of Alsace and Lorraine as a condition of peace, and later, as in a funeral procession, soldiers and civilians lined up to shower it—the face now veiled in crepe—with floral crowns and wreaths when the demand became fact. Parisians continued to throw bouquets at the foot of the statue throughout the century.

Adding insult to injury, in March 1871 the Prussians occupied the Place de la Concorde and the Champs Elysées; next, the Commune celebrated its founding with a nocturnal fête in the Place de la Concorde, and in early April it was the site of demonstrations of more than seven hundred women who organized a march on Versailles in an effort to avoid a bloody clash. Once again, the rallying point was the statue of Strasbourg.[42] But the column of women, carrying a red flag unfurled, were blocked by the National Guard claiming concern for their safety. Some of the women then re-

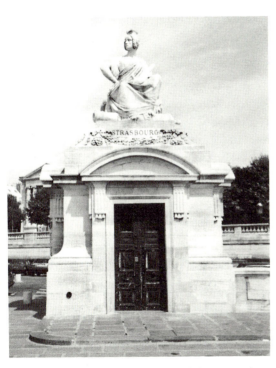

78. The statue of *Strasbourg*, Place de la Concorde.

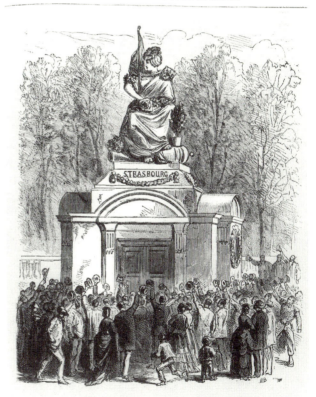

79. *Paris pendant la guerre.—Manifestation devant la statue de Strasbourg, sur la place de la Concorde*, 1871. Wood engraving reproduced in J. Claretie, *Histoire de la Révolution de 1870–1871*, p. 249.

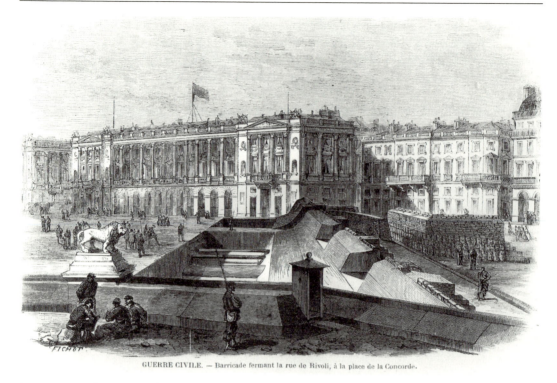

GUERRE CIVILE. — Barricade fermant la rue de Rivoli, à la place de la Concorde.

80. *Guerre civile.—Barricade fermant la rue de Rivoli, à la place de la Concorde*, 1871. Wood engraving reproduced in *L'Illustration*, 1871.

grouped and a week later organized the Union des Femmes pour la Défense de Paris et les Soins aux Blessés—the women's section of the French International.[43] Meanwhile, Communards proceeded to build one of its most spectacular barricades at the end of the rue Royale which commanded the Place. Designated by the Communards as a last line of defense, the Place was the target of heavy shelling by the Versaillais, and in May became the scene of fierce conflicts between the insurgents and the exiled government's troops. Illustrators and photographers of the period marveled at the barricade, ostensibly to suggest the idea of Communard solidity and readiness, but when the fighting began it was quickly run over (fig. 80).

Crossing a street under fire constituted a constant peril for Parisians during the Commune. The openness and spaciousness of the Place de la Concorde made it a specially dangerous zone for the insurgents when Thiers began pounding Paris with shells. Proof of this is the fact that the allegorical statues of the cities received a terrific pounding; Lille was beheaded and Strasbourg was pitted from grapeshot.[44]

Degas' expansive yet agoraphobic space attempts literally and metaphorically to push this history into the background, and to open a passage for the dominant group still confined by the threat of revolution from below. In the case of Lepic, he belonged not only to the privileged minority in power, but also to a political party out of power trying to recuperate its shattered prestige. He had enjoyed the highest status during the Second Empire, fought heroically alongside Napoleon III in the Franco-Prussian con-

flict and was taken prisoner at Sedan. According to the legend, Lepic kept hidden beneath his uniform a Napoleonic eagle and a torn strip of the tricolor it had surmounted.[45] In the early 1870s, the Bonapartists (Degas among them, I suspect) still clung to hopes for a revival; a nostalgia for the glory days of the Second Empire survived among army officers, high ecclesiastics, and recently dispossessed officials, and the death of Napoleon III in 1873 positioned the young Prince Imperial as an appealing representative of the dynasty. If nothing else, the thirty-odd admitted Bonapartists in the National Assembly were making life difficult for both the republicans and the monarchists, separated by a narrow margin of votes, and they played a crucial part in bringing down Thiers in 1873 and Broglie in 1874. Finally, as long as France remained without a constitution, the door remained open to a Bonapartist alternative for keeping order at the expense of the disorderly masses.

Degas depicts the Lepic family on the go but checked in their forward movements at the same time. Although pictorially marginalized, Degas' need to at least pose the threat from below in visual form indicates that the recent experience of the Commune remained as a festering wound despite France's restorative energies. Degas has swept the streets clean of debris and filled in the holes, but the jerky movements of the foreground figures suggest that the crucial signifier of Strasbourg serves as a kind of invisible electric fence beyond which they cannot go. The reminder of failure and potential chaos hovers above them and constrains their mobility.

In this sense, Degas' work provides a greater degree of narrative complexity than that of most of his colleagues. Such images as the *Absinthe* of 1876, however, hardly fit the escapist paradigm I have been constructing here; indeed, his depressing glimpse of trapped working-class existence would seem to contradict my central thesis (fig. 81). What Degas achieves in this painting and in his many studies of the Cafés-Concerts is to create the type of degraded proletarian participant in the Commune (not unlike that of the laundresses), the "other" that helps construct the decent, freedom-loving bourgeoisie strolling in the sunlit streets, just as the savage caricatures of the "Pétroleuses," working-class women accused of setting fire to the buildings, helped construct the patriarchal ideal of female respectability in the aftermath (fig. 82). The flip side of the debonair and energetic Lepic is the frowzy, dazed, and slumped over café habituée in *Absinthe*. It is altogether unsurprising to learn that Degas, according to Ellen Andrée who posed for the work, deliberately staged the scene to put the onus on the female, setting her before the absinthe and the bohemian male next to her (posed by Marcellin Desboutin) before "an innocent beverage." And she concluded, "the world upside down, hey!"[46]

The conservative cartoonist Bertall published a book of caricatures in late 1871 of Communard types with the aim of preserving their memory as a warning for the future. Although he hoped they had passed into oblivion, those actors who "played their parts in that strange and sanguinary drama," may still be lurking behind the scenes waiting their chance to once more reappear on stage. Not coincidentally, Bertall's English translator of 1873 picked up on this thought and declared: "Since Oblivion will not wipe away the Communist stains from our modern Civilization, nor prevent their reappearance or imitation, it were yet better and wiser to paint them as they have been, before a renewal or resuscitation is attempted."[47]

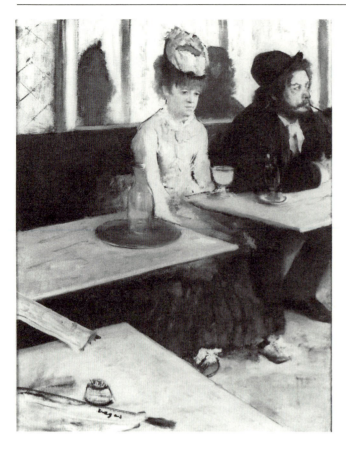

81. Edgar Degas, *L'Absinthe*, 1876.
Musée d'Orsay, Paris.

Bertall's caricatures of female participants are particularly insulting and aggressive, including his view of the women hoping to march to Versailles from the Place de la Concorde (fig. 83). Another caricature shows a seated woman at the desk of the police commissioner smoking and drinking (fig. 84). Most vicious of all, however, is the inevitable image of the "pétroleuses"—the quintessential stereotype of the inebriated female participant in the Commune (fig. 85). The "pétroleuses" were identified with working-class alcoholism, considered by one faction of the right as the source of the "irrational" outbreak of insurgency (fig. 86). The victors could claim that Paris of the Commune was a city given over to drunkards and prostitutes, thus identifying the spaces of modernity transgressed by working men and women as degenerate because not subject to the control of the bourgeoisie.[48]

The propensity to drunkenness became a crucial quality in the construction of the "bad worker" and depraved female. Alcoholism was used as a codeword for working-class agitation and as an overarching explanation for the French defeat. The founder of a temperance society in the wake of the Commune represented an elite that needed to explain the irrational outbreak and especially to prevent it from happening again. The reactionary Maxime Du Camp described the Communards as the "chevaliers of de-

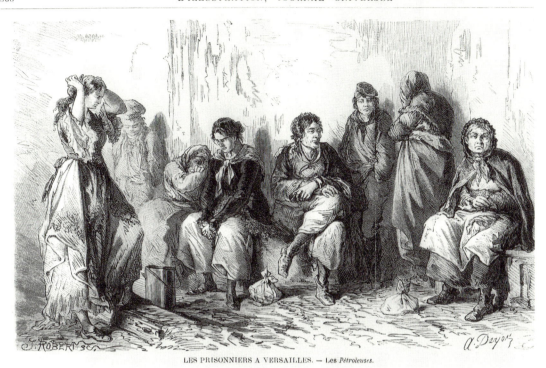

LES PRISONNIERS A VERSAILLES. — Les *Pétroleuses.*

82. *Les prisonniers à Versailles.—Les Petroleuses,* 1871. Wood engraving reproduced in *L'Illustration,*
1871.

bauchery, the apostles of absinthe," and claimed that the Parisian insurgents wallowed
in wine, eau-de-vie, and other poisonous spirits. Medical researchers published ac-
counts purporting to prove the pathology of the Commune, with abundant statistics
on the admissions of alcoholic ex-Communards into mental hospitals. As one of these
physicians wrote:

> Now one can understand the bestial and savage faces of the workers in the
> uprising, the thefts, the massacres, and the arson; the insanity, imbecility
> which affected such a large number of them; their vicious instincts, their lack
> of morality, their laziness, their tendency toward crime, and in the long run,
> their reproductive impotence. In short, it is not surprising to see that each
> new revolution brings an increase of atrocities and degeneration.[49]

By thus equating revolution and alcoholism, the conservatives could dismiss any at-
tempt to explain the insurrection in terms of social and political inequities, that in the
end the vision of a sane society was simply the wild hallucination of a bunch of dip-
somaniacs. Thus the savage suppression could be justified as a necessary surgical oper-
ation to restore the health of the body politic. This myth had now to become

TYPES DE LA COMMUNE

COMMISSAIRE DE POLICE

84. Bertall, *Commissaire de Police*, 1871. Color lithograph reproduced in *Les Communeux*, No. 25.

TYPES DE LA COMMUNE

EN ROUTE POUR VERSAILLES

83. Bertall, *En roûte pour Versailles*, 1871. Color lithograph reproduced in *Les Communeux*, No. 30.

TYPES DE LA COMMUNE

PÉTROLEUSES.

85. Bertall, *Pétroleuses*, 1871. Color lithograph reproduced in *Les Com-muneux*, No. 20.

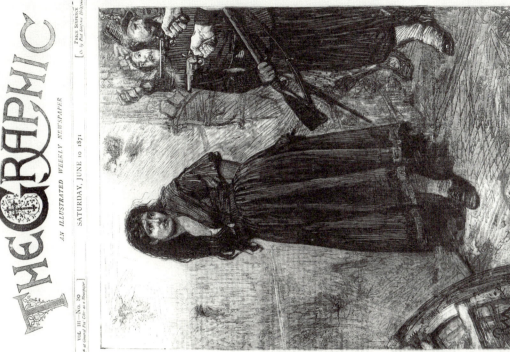

THE END OF THE COMMUNE—EXECUTION OF A PÉTROLEUSE.

86. *The End of the Commune—Execution of a Pétroleuse*. Wood engraving published in *The Graphic*, 10 June 1871.

institutionalized in the form of a temperance movement and realized in an attack on the "public drunk," the scapegoat for the failure of the defense of Paris and the outbreak of the Commune. The law passed by the National Assembly in 1873 extended government surveillance to monitor the lives of working people, implying a need for total control over individual and collective behavior. Zola, an outraged critic of the law wondered if it would equally apply to the clients of the Maison d'Or and the Café Anglais, two of Paris' most elegant cafes. It was in 1876, the year of Degas' picture, that Zola began serializing *l'Assommoir*, based on the degeneration of Gervaise Macquart. Conceived in a drunken encounter, her own abuse of alcohol eventually leads her to abandon her livelihood and sink into prostitution. Ironically, even the conservatives—though they despised the subject matter—felt smug about Zola's ruthless description of the effects of alcoholism on the working class, ignoring its pictures of urban squalor and poverty and ironically seeing it as support for their own assertions.[50] The sudden episode of the Commune in effect gave the conservatives an escape hatch in being able to view the degradation as the cause rather than the result of poverty and exploitation. The painter lacks the range of the novelist, and it seems likely that Degas' choice of focus responds to a conservative paradigm that displaces all responsibility for institutionalized oppression in an industrial system on the backs of its victims.

Immediately after the war, two conservatives published a *Guide à travers les ruines: Paris et ses environs*—a curious guidebook that coincides with the sites selected by the Impressionists.[51] The authors' aim was twofold: to record precise detail for those hungry for such information in the present, and to reconstitute for future generations the "primordial" state of things before totally effaced by restoration. They refer to their planned strolls amid the ruinous quartiers as a "navrante promenade." (They hoped to see a part of the Hôtel de Ville preserved with a commemorative plaque to keep the horrors of the Commune perpetually in view.) The authors never fail to point out the incalculable tragedies of human and property loss due to the fires of the Commune, including the destruction of a bakery that produced unforgettable croissants for the employees of the Ministry of the Navy. Their obsessive detail, down to the bizarre colorations produced on the stone by the flames, is meant to impress the observer with the savage character of the Commune and their wanton demolition of the historical legacy. The guidebook concludes with the satiation of "this continual spectacle of devastation," and ends on this note: "Quand la belle campagne des environs de Paris aura repris ses riants aspects, un éternel souvenir restera de cette double crise, inscrit sur les monticules funéraires où se lisent les noms de tant de morts dont plusieurs furent des héros."

The Impressionists went further in eliminating the traces of the double crisis, attesting to a moderate political viewpoint that would forget the recent past. There may be expressed in their urban- and suburbanscapes a sense of relief from zones once cordoned off and from the thought that danger once lurked in the very motifs under scrutiny, but there is no doubt that they systematically covered the same ground and restored them to their pristine character. Since much fighting took place within confines of houses, courtyards, and alleys, elevated windows suggested the presence of concealed enemies. Impressionists often painted from an upper-story window, a sign of

freedom when we recall that troops on both sides routinely ordered windows to be closed to make sniping more difficult and issued stern warnings to occupants of houses about firing from windows. If the entire length of the Seine once appeared to be a fiery inferno, under the Impressionist gaze it evolved into summer brilliance. It is now in the public spaces, where consumerist spectacle and illusion seduces those who can only afford to look and not buy, that the working classes can rejoin society in the intersections they momentarily commandeered. Analogously, it is in the places of leisure and recreation where the Impressionists can most comfortably display the mingling of the classes without thereby sacrificing social hierarchy.

5. MAPPING THE TERRAIN

MONTMARTRE, the populous eighteenth arrondissement, was a key site of both Communard and Impressionist activity. Because a major portion of the National Guard's artillery was stationed on the hill (Butte de Montmartre), the Commune began here on 18 March when the Government of National Defense tried to seize it. According to the *Guide à travers les ruines*, the Fédérés made the most use of the section near the Moulin de Galette: "La partie de Montmartre qui fut la plus utilisée par les fédérés se trouve entre l'établissement Debray, où se voit encore un vieux moulin à vent qui reste pour enseigne, et le grand cimitière Montmartre."[1] Various images of the period confirm this statement, including a watercolor by Denis-Desroche dated 18 March 1871 showing the Moulin de Galette in the background (fig. 87). During Bloody Week, Montmartre—by now considered the "Citadel of the Commune"—was the first site penetrated by the Versaillais who went straight for the Second Battery, located at the Moulin de Galette with its sights fixed on Versailles.[2] An engraving in the *Illustrated London News* for 4 February 1871 also attests to the importance of this strategic site for mounting a defense of the capital, identified by the conspicuous landmark of the Moulin de la Galette restaurant and dance hall (fig. 88).

Learning that the Versailles soldiers were trying to seize the cannon, men and women of Montmartre swarmed up the Butte in a surprise foray. According to Louise Michel, an active participant in the Commune, the people climbing the hill did not expect to survive the encounter but were prepared to "pay the price." The women covered the cannon with their bodies, and when the officers ordered the troops to fire they refused. At this moment, the troops preferred to give up seizing the cannon rather than fire upon the women. It was a remarkable victory achieved by the working-class women of Montmartre, not yet stigmatized as drunken prostitutes by the propaganda of Versailles.[3]

As the *Guide* mentioned, the mill—one of three remaining of the many windmills that stood on the hill of Montmartre before the erection of the Sacré-Coeur—was owned by père Debray. It was the dance hall in the courtyard that Renoir chose as the subject for his break-through painting of 1876, *Dance at the Moulin de la Galette* (fig. 89). Writers, performers and artists like Renoir—drawn to the heretofore semi-rustic backwater for its low rents—were then transforming the predominantly working-class arrondissement into a center of entertainment and bringing the district within the city

87. Denis-Daroche, *Moulin de la Galette*, 1871. Water color. Present whereabouts unknown.

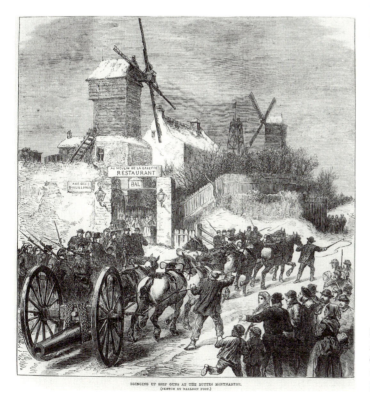

BRINGING UP SHIP GUNS AT THE BUTTES MONTMARTRE.
(SKETCH BY BALLOON POST.)

88. *Bringing up Ship Guns at the Buttes Montmartre*, 1871. Wood engraving reproduced in *The Illustrated London News*, 4 February 1871.

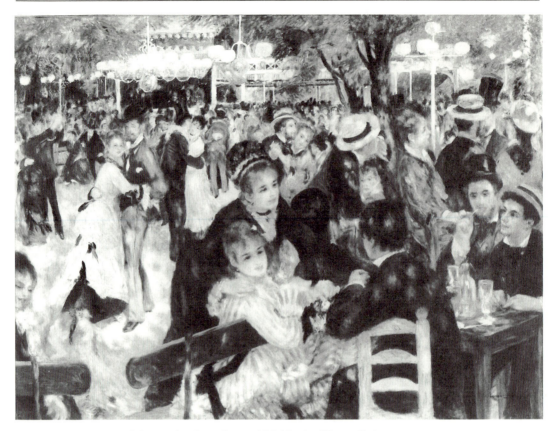

89. Auguste Renoir, *Bal du Moulin de Galette*, 1876. Musée d'Orsay, Paris.

boundary. What had once been exclusively working-class entertainments like the rau-cous dances and music-hall shows were gradually reworked for the consumption of a class of spectators. Georges Rivière, Renoir's friend and biographer, emphasized the working-class origins of the women who posed for Renoir, and who were regulars at the Sunday balls: "These young girls are the same ones with whom we rub elbows every day, and whose prattling fills Paris at certain hours." They are "proud of their light homemade dresses fashioned of inexpensive material and free labor"—hence their ability to pretend to bourgeois status. Above all, Renoir's work is about the "noise, laughter, movement, sunshine, in an atmosphere of youth."[4] The males in the picture are painters and writers in Renoir's circle who came to Montmartre to dance with the young seamstresses, florists, milliners, and daughters of artisans and workers, and to use them as models. Men have access to the public sphere where women play limited roles, and women are there to serve the professional and erotic needs of the male. The gaiety that Paris lost in 1870–71 is brought back but at a high cost: the liberating energies of the Commune have now been repressed into a patriarchal system and social hierarchy, allowing contact between the classes in a more casual manner but still re-

taining the hierarchical norm. Working-class women, in fashionable homemade Sunday dress, and bourgeois men seemingly mingle with an air of equality, but the illusion will vanish by Monday. Renoir veils the contradictions through a glittering visual display of light reflections and sunlit color that simultaneously dissolves and reunifies solid bodies.

The attraction of Montmartre in the post-Commune era is seen also in the new meeting place for the Impressionists and their friends, the Café de la Nouvelle Athènes. Although not far from their former headquarters at the Café Guerbois in the Batignolles district, where the artists and the writers met in the 1860s, after the Commune Manet, Monet, Renoir, Degas, Pissarro, Zola, and Duranty regrouped in the Nouvelle Athènes on the Place Pigalle. Place Pigalle was one of the contested sites during the struggle over the artillery on 18 March that erupted into the Commune. Here a party of the National Guard encountered a company of Chasseurs of the Versailles army, whose commanding officer ordered his troops to fire upon the Guard. The army hesitated to fire at the Guard, who then made their way to the Buttes Montmartre to protect the artillery. It was at this time that General Lecomte was taken prisoner by the insurgents and his own defecting troops who eventually shot him along with General Clément Thomas, giving the Versaillese an ideological pretext to mobilize support for an all-out attack on the Commune. A sketch of the incident in the Place Pigalle clearly shows in the background the Café de la Nouvelle Athènes, again attesting to the intersection of the Impressionist sphere of activity and the ravaged terrain of the Commune (fig. 90). No wonder that sarcastic critics soon designated La Nouvelle Athènes as the self-appointed antithesis of the Ecole de Rome, and described the "New Athenians" who frequented it as the "*intransigeants* de la peinture."[5]

The two views of *Le Pont Neuf* facing the left bank painted by Monet and Renoir in 1872 suggest another dimension to Impressionist recuperation (figs. 91, 92). They depict the Paris throughfares bustling with activity, and in Renoir's version a crowd comprised of street vendors, haute bourgeosie, gendarmes, soldiers, and idle strollers move in easy harmony without interacting. A slightly earlier newspaper engraving of the view of the bridge from the opposite direction, indicating the apartment building at the left where the painter stationed himself to make the picture, demonstrates the parallels between popular imagery and Impressionist painting which analogously distance their street scenes and impersonalize social relations (fig. 93). Renoir's representation of return to normalcy in the public sphere the year following the savage suppression of the Commune is highlighted by the plunging perspective at the right, culminating on the equestrian statue of Henri IV, the metonym for nineteenth-century restoration in French political life. Yet here again, Renoir encompasses topography once under control of the Communards. An engraving of 1871 depicting a view of the monument from the flip side of the bridge, captures the lively maneuvers of the Fédérés as they guide gunboats past the statue up the Seine in the direction of the Hôtel des Monnaies (fig. 94). The reportorial illustrator makes a wry comment on political change in the parallel directions of the equestrian rider and the gunboats carrying artillery for emplacements on the barricades, as if Henri IV were leading them into battle.

Renoir's monarchical symbol signifies the opposite. His brother Edmond confirms

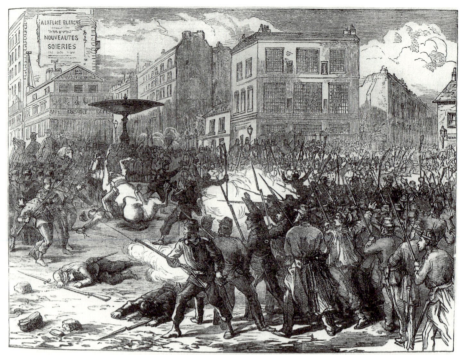

ENCOUNTER ON THE PLACE PIGALLE.

90. *Encounter on the Place Pigalle.* Wood engraving reproduced in *The Illustrated London News*, 1 April 1871.

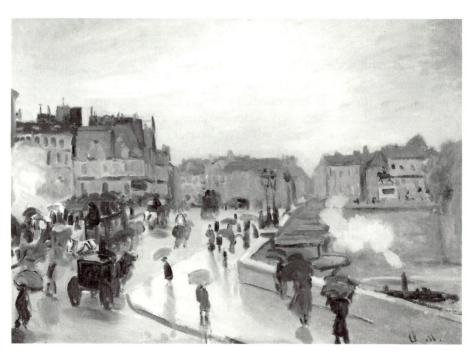

91. Claude Monet, *Le Pont Neuf*, 1872. Dallas Museum of Art, Dallas. The Wendy and Emery Reves Collection.

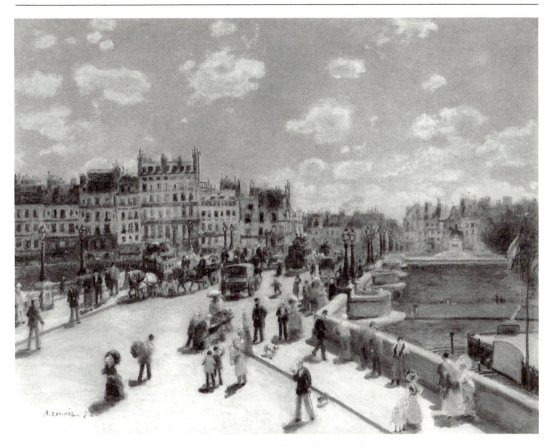

92. Auguste Renoir, *Le Pont Neuf*, 1872. National Gallery of Art, Washington, D. C.

the primacy of the motif in the initial construction of the design, and this is pictorially evident in the way it is framed by the tri-color at the right edge of the picture. Not coincidentally, the Comte de Chambord (the pretender Henri V), the Bourbon heir to the throne, could have received the crown had he not refused to enter any arrangement that would mean rejecting the white Bourbon flag and retaining the tri-color. He proclaimed that under no circumstances would he suffer the standard of Henri IV, François Ier, and Joan of Arc to be torn from his hands. Renoir joins the symbols of French nationalism and the Bourbon dynasty in a hopeful moment, when monarchists still controlled the National Assembly and dreamed of a "fusion" between the Orléanists and Legitimists to prevent the republic from becoming a permanent reality. Significantly, the owner of Renoir's painting, Paul Durand-Ruel, the Impressionists' dealer and an extreme conservative, wrote in *Le Figaro* on 31 October 1873: "Business has been stopped solely by fear of [the country's] falling into the hands of the republicans again; and all of us, as Frenchmen and as tradesmen, long for the restoration of the hereditary monarchy, which alone can put an end to our troubles."[6] Not surprisingly,

93. Auguste Deroy, *Paris nouveau.—Entrée de la rue de la Monnaie et du Pont Neuf: Nouvel Etablissement de la Belle Jardinière*. Wood engraving reproduced in L'*Illustration*, 2 October 1869.

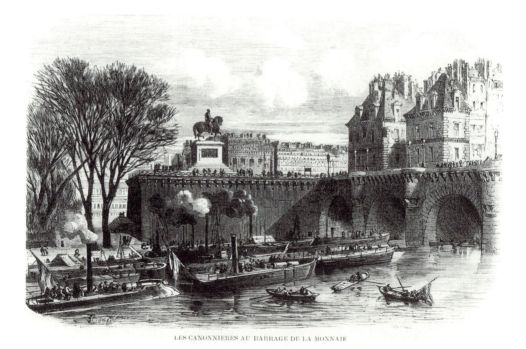

94. *Les Cannonières au barrage de la Monnaie*, 1871. Wood engraving reproduced in L'*Illustration*, 1871.

Durand-Ruel pledged his loyal support to the Comte de Chambord whom he had known personally for years.

In this sense, Renoir's vision of harmonious Paris under the aegis of a monarchical head complements Fremiet's equestrian image of Joan of Arc. Indeed, the statue of Henri IV had been a replacement for the original destroyed during the Revolution of 1789, commissioned after the abdication of Napoleon I and the return of Louis XVIII who seized the occasion for a royal procession across the Pont Neuf on the way to Notre-Dame. Ironically, the toppling of the Vendôme Column and its reconstruction had revived the story that the bronze for Henri IV's horse had been taken from the statue of Napoleon that had been hurled down from Vendôme Column after the Restoration. The bronze founder had hoped to preserve the Chaudet effigy as a national monument and offered to exchange it for an equivalent amount of bronze, but the newly restored Bourbons insisted on melting down the Napoleon in retaliation for the original loss of the statue. If the Joan of Arc looks triumphantly towards the Tuileries and the Meissonier to the ascending victory quadriga, so Renoir's Henri IV metaphorically points to the collapse of the Bonapartist regime and the rise of a new social order.

This hoped for transition is mocked by André Gill in his censored caricature of Thiers for the cover of the 4 August 1872 issue of *L'Eclipse*, where clouds have been deployed to obscure the original recognizable traits of some of the other protagonists (fig. 95). Entitled *La Déliverance*, it depicts Thiers presiding over the successful raising by France of a large indemnity imposed by Prussia as a condition of its victory in 1870–1871. France's surprisingly quick success in paying the indemnity guaranteed an early removal of Prussian troops from French soil and was widely viewed as a triumph for the conservative republican, and the fledgling Third Republic.[7] Thiers, moreover, holds up the pledged money as a new-born infant, whose head surmounts the sack labeled "41 milliards," which he has just delivered from France, shown as the mother (the title "La Déliverance" carries a double meaning as "delivery" and "salvation"). This motif was an ironic take-off of Eugène Devéria's popular painting of the Salon of 1827, *The Birth of Henri IV*—the founder of the Bourbon dynasty (fig. 96). Although we just see their feet in the caricature's censored form, the original version showed Thiers surrounded by the two royalist pretenders, the Comte de Chambord and the Comte de Paris, as well as the deposed Napoleon III clutching a dead eagle, all watching the miraculous birth with evident dissatisfaction.

Ironically, Pissarro included this caricature as a wall decoration in his 1874 portrait of Cézanne, as well as one of Courbet, then in exile to avoid the heavy fine imposed upon him by the government (fig. 97).[8] Although Thiers had resigned the previous year, the confrontation of the ex-Communard and the person responsible for the crushing of the Commune could hardly be coincidental. Pissarro's painting is not only a tribute to his friend and disciple, but also a political portrait corresponding to their close association in the wake of the Commune and their shared debt to Courbet for his role in pointing the way to artistic independence and the establishing of new alliances outside the official network. At the same time, Thiers' triumph in galvanizing the bourgeoisie to finance the indemnity signaled the beginning of the rehabilitation of France and a fresh start for the artists.

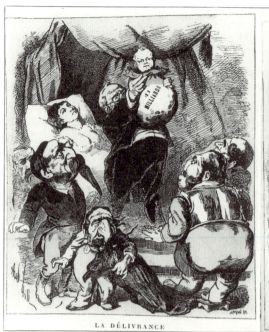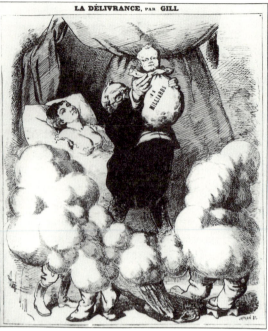

95. André Gill, *La Déliverance*, 1872. Color lithograph reproduced in *L'Eclipse*, 4 August 1872.

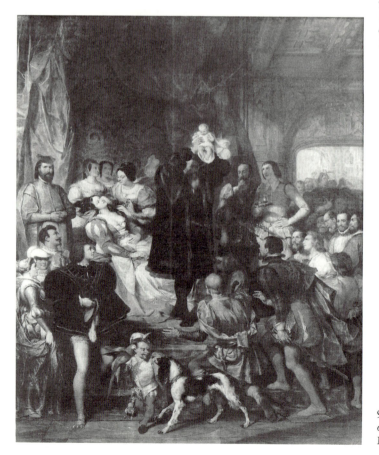

96. Eugène Devéria, *The Birth of Henri IV*, Salon of 1827. Musée du Louvre, Paris.

97. Camille Pissarro, *Portrait of Cézanne*, 1874. Private Collection.

Renoir's attitude towards Pissarro in turn suggests his own social and political conservatism that he shared with his dealer, Durand-Ruel. Renoir refused to participate in the 1882 Impressionist group exhibition because of Pissarro's increasing radicalism. As he wrote to Durand-Ruel:

> To exhibit with Pissarro, Gauguin and Guillaumin is the equivalent of exhibiting with some radical trade-union [*sociale*]. Pretty soon Pissarro will invite the Russian Lavrof [the anarchist Petr Lavrov] or some other revolutionary. The public doesn't like the smell of politics and at my age I do not wish to be a revolutionary. To remain with the Jew [*l'israélite*] Pissarro is the revolution.[9]

Renoir's accusation notwithstanding, there is rarely any explicit political content in Pissarro's painting (although it is overt in his prints). Like his colleagues, his aspirations for a better society took the form of representations of arcadian landscapes with vibrant men and women in cultivated fields, marketing towns, and thriving river scenes.

The destruction of bridges in the outskirts of Paris during both the Franco-Prussian War and the Commune were sources of great anxiety in the period. The destruction of the infrastructure and disruption of communication between the capital and the ban-

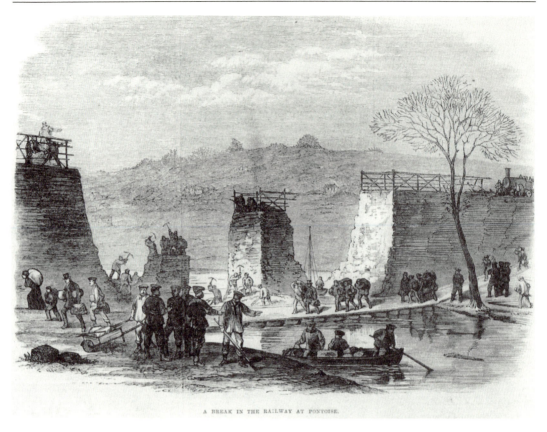

A BREAK IN THE RAILWAY AT PONTOISE.

98. *A Break in the Railway at Pontoise*, 1871. Wood engraving reproduced in *The Illustrated London News*, 11 March 1871.

lieux demoralized the population and cut off vital necessities in a time of scarcity. Vessels en route to the capital carrying food were delayed many days in the Seine by the ruins of the bridges destroyed between Rouen and Paris. Not surprisingly, the work of the Impressionists often tracks these formerly destroyed connecting links and returns them to their critical functions in everyday life.

Areas ultimately falling to the Prussians whose bridges were blown up included Pontoise and Argenteuil, soon to be major sites for the Impressionists. The Prussians occupied these territories in the departments of the Oise and Seine et Marne until they received a one-half billion franc indemnity and the ratification of the definitive peace treaty—a humiliating experience that long after haunted the local inhabitants. French troops destroyed the railway bridge at the market town of Pontoise early in 1871 to intercept the Prussian advance, and thus severed a vital lifeline from Paris to the north (fig. 98).

Camille Pissarro, who was in London during the repression of the Commune, returned to France to witness the rebuilding in the aftermath. He took up residence in Pontoise in August 1872, where he had lived for a time before the war, and there he

painted the banks of the Oise including the restored railway bridge. He painted the same motif before 1871, but the inert horizontal lay of the bridge is static consistent with his rendering of the town as a sleepy rural village (figs. 99, 100). His postwar views of the bridge depict it from an angle, giving it a dynamic character consistent with his animated views of river banks and industrial activity (figs. 101, 102). The bridge has not only been restored, but it is integrated into a thriving economy as the community of Pontoise regains its links with the capital. His river views now generally direct the eye into the landscape, following the movement established by steamboat, barge, and factory smokestacks. The *Railroad Bridge at Pontoise*, painted around 1873, shows the bridge spanning the Oise with a puffing locomotive crossing it from the right end (fig. 103). Although here movement is minimized, the calm may be seen as a sense of harmony attendant upon the reopening of the lines of communication and transportation. Pissarro's work after 1871 demonstrates a special disposition for roadways leading into or out of villages, and of curving embankments that provide a sense of movement suggesting the reinvigorated tempo of life along the river.

Lying between Paris and Pontoise is Argenteuil, the goal of steady suburban flight in this period, where Monet took up residence at the end of 1871. Here Monet became preoccupied with the impressive railway bridge, rebuilt after its demolition during the Franco-Prussian War, as well as the nearby highway bridge that had also been destroyed and reconstructed. Monet would paint these bridges many times in the years 1872 to 1874 (figs. 104, 105). In this instance, what I would call his obsessive interest in the reconstruction of these bridges as a metonym for the regenerative national impulse, predisposes him to even include views of them under repair (figs. 106, 107).[10]

Argenteuil, still tied to the apron strings of Paris, had been going through a rapid growth spurt prior to the war; while parts of it were still quite rural, others had become heavily industrialized. Factories dotted the landscape and polluted the river, but it held its own as a resort for the Parisian bourgeoisie and gained a reputation (since 1867) for its sailing facilities. But it paid dearly for its part in the war. The Prussians, who had used the town as an observation post for their artillery, had extracted a special fine of over 15,000 francs from the inhabitants on leaving. The factories had been shut down and both its bridges destroyed. The pedestrian and highway bridge, which led directly to Paris, had been burned down by the French army in its retreat towards the French capital in the autumn of 1870. The railway bridge, a few hundred meters upstream, had suffered the same fate. It had been blown off its concrete pillars and lay in the water, its cast-iron girders sagging as if made of some soft material (figs. 108, 109). In addition to the damage during the war, the railroad station had been smashed by bombardment from Versailles during the Commune uprising.

Despite this physical destruction, the town quickly began to recover from the upheavals by the time Monet arrived. The two bridges were girded in scaffolding, and Monet's two studies of the roadbridge under repair attest to the continuity of everyday activity although reconstruction is still incomplete. Pedestrians walk to and fro on the bridge, while below a steamboat belching smoke prepares to sail beneath one of the arches. Here the prominent timbers of the scaffolding enveloping the stone piles seem to work as part of the wooden remnants of the old structure and create the effect of

99. Camille Pissarro, *Quay and Bridge at Pontoise*, 1867. Tel Aviv Museum, Tel Aviv.

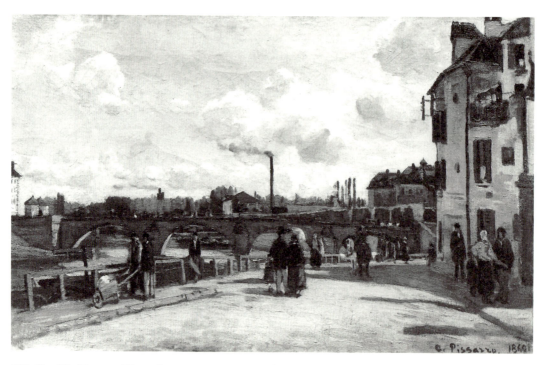

100. Camille Pissarro, *View of Pontoise: Quai au Pothuis*, 1868. Städtische Kunsthalle, Mannheim.

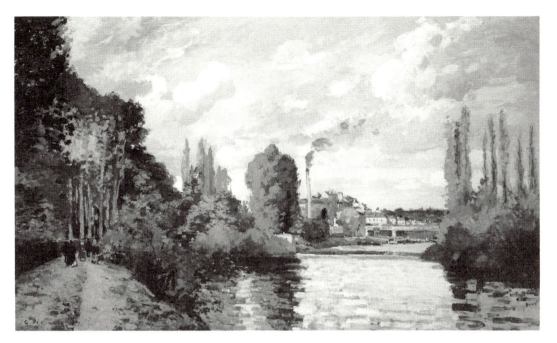

101. Camille Pissarro, *The Banks of the Oise*, 1872. Lent by Lucille Ellis Simon, photo courtesy of Los Angeles County Museum of Art, Los Angeles.

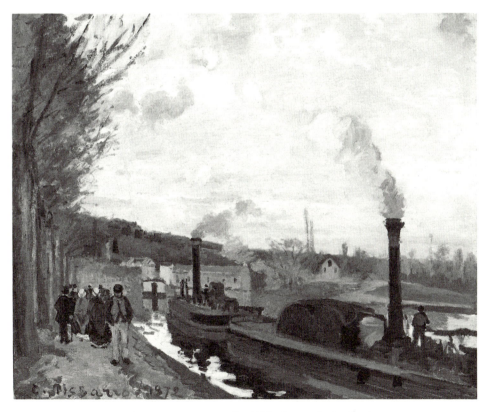

102. Camille Pissarro, *The Seine at Port-Marly*, 1872. Staatsgalerie, Stuttgart.

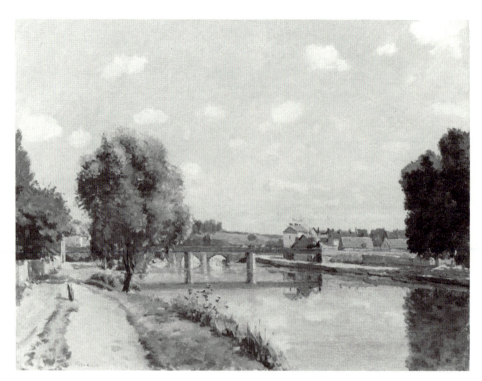

103. Camille Pissarro, *The Railroad Bridge at Pontoise*, c. 1873. Private Collection.

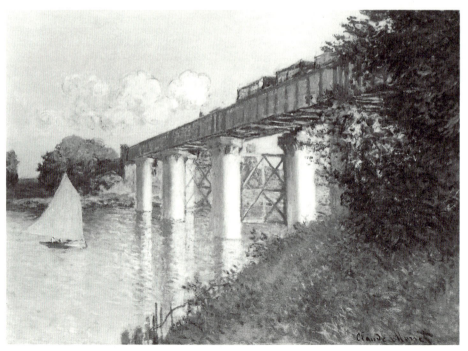

104. Claude Monet, *The Railway Bridge, Argenteuil*, 1874. Philadelphia Museum of Art, Philadelphia. John G. Johnson Collection.

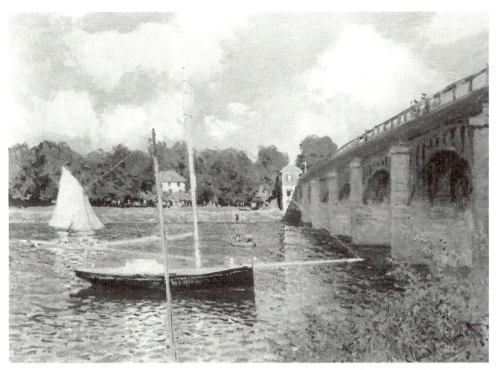

105. Claude Monet, *The Roadbridge at Argenteuil*, 1874. National Gallery of Art, Washington, D. C. Collection of Mr. and Mrs. Paul Mellon, 1983.

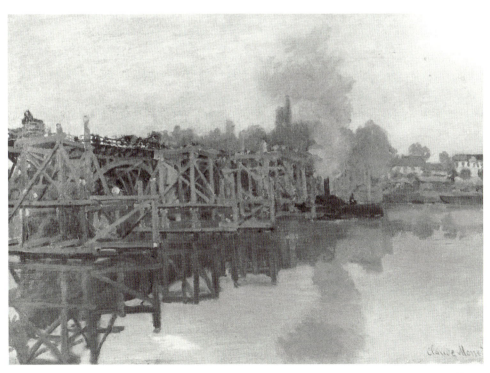

106. Claude Monet, *Roadbridge Under Repair*, 1872. Fitzwilliam Museum, Cambridge. Collection Late Lord Butler of Saffron Walden.

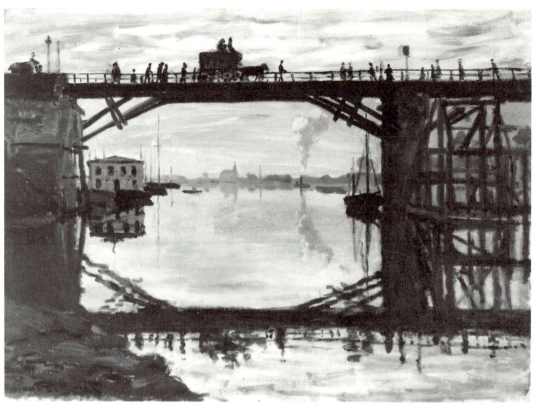

107. Claude Monet, *The Wooden Bridge at Argenteuil*, 1872. Private Collection. Photo courtesy of Christie's, London.

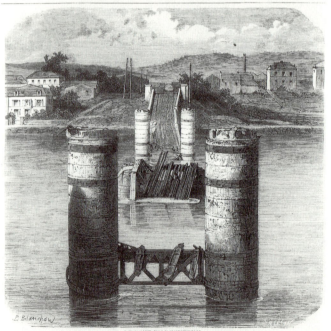

L'ILLUSTRATION, JOURNAL UNIVERSEL

L. Blanchard

LE PONT D'ARGENTEUIL.
Vue prise de la berge de Gennevilliers. — D'après la photographie de M. Andrieu.

108. *Le Pont d'Argenteuil*, 1871. Wood engraving reproduced in *L'Illustration*, 1871.

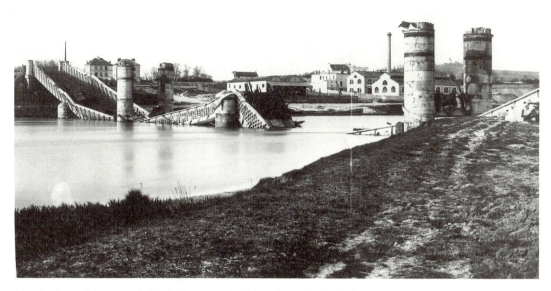

109. *Le Pont d'Argenteuil*, 1871. Photograph. Collection Viollet, Paris.

pontoons. Monet thus integrates the scaffolding with the bridge itself and minimizes the appearance of ruin and repair. This is seen even more strikingly in a second study of the unfinished bridge in 1872, this time looking through the opening of a single arch. Monet's high viewpoint and muted, almost silhouetted, framework of the scaffolding and its reflection in the water, frame the distant view of the river rather than call attention to the scaffolding itself. This framing function is further reinforced by the stark simplicity and symmetry of the design. Through the opening we see signs of activity and progress, and high on the roadbridge we see a bustling traffic of pedestrians and a rolling horse-drawn carriage.

Monet's 1873 painting of the new railroad bridge, *The Railroad Bridge Viewed from the Port*, is an unmistakable paean to French industrial and spiritual recovery (fig. 110). The gleaming iron trestle rests on elegant columns of poured concrete and spans the river from a height and vantage point that dominates the landscape. Trains hurtle across the bridge in both directions, while below sailboats cavort in pleasure, thus reassuring the spectator that commercial and leisure pursuits proceed apace and are inseparable from modern living. The topos of the admiring spectators in the picture spells it out more directly, recalling those inside cover illustrations of school texts imaging the bright future with two white adolescents watching a parade of technological marvels. But Monet's unprecedented bright color and daring brushwork imbue the modernist content with the look of modernity, and divest the scene of its anecdotal and sentimental potential.

Monet's reactive optimism, that he packaged and sold to middle-class buyers who shared it, reached a crescendo in 1878. Even foreign observers fell into line, as in the case of the English journalist, George Sala, who, as previously mentioned, entitled his

110. Claude Monet, *The Railroad Bridge Viewed from the Port*, 1873. Private Collection, London.

book of reportage that year *Paris Herself Again in 1878–9*.[11] Two paintings inspired by the festivities for the first national holiday celebrated by the Third Republic, *Rue Montorgeuil, fête de 30 juin 1878* and *Rue Saint-Denis, fête de 30 juin 1878*, extend the mood of renewal that we have observed in early Impressionist landscape (figs. 111, 112). Both depict the explosive outburst of enthusiasm that marked the *Fête de la Paix*, and it is not fortuitous that Monet's two street scenes depict working-class quartiers, just to the north of Les Halles, that were sites of fierce struggle during Bloody Week.[12] The year 1878 was a turning point in the fortunes of the conservative Republic, coinciding with the inauguration of the first Exposition Universelle of the government since the Franco-Prussian War and Commune. It was organized to celebrate France's regeneration, to demonstrate through its industrial. commercial, and cultural productions its complete recovery, Phoenix-like, from the effects of those twin catastrophes. Contemporary popular imagery, which in 1871 had played on the familiar boat on the arms of Paris as a broken, dismasted vessel, now portrayed the upright Ship of State supporting the festivities at the entrance of the Bois de Boulogne and thus metaphorically alluding to the rejuvenated nation (figs. 113, 114). At the inauguration of the exposition, the president of the French parliament, Jules Grévy, who had supported the crushing of the Commune, declaimed that "France has restored itself," and that its resurrection is visible in the current spectacle: "The Exposition is now opened and all the world may admire the marvellous vitality, the astonishing resources of that France, formerly so humiliated and crushed, now thrusting ahead to the admiration of all."[13] The 1878 Exposition Universelle was an ambitious spectacle designed to dazzle the foreigner and

112. Claude Monet, *Rue Saint-Denis, fête de 30 juin 1878*, 1878. Musée des Beaux-Arts, Rouen.

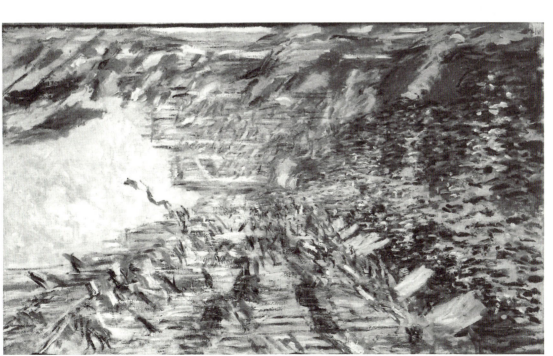

111. Claude Monet, *Rue Montorgeuil, fête de 30 juin 1878*, 1878. Musée d'Orsay, Paris

113. Edmond Morin, *1er Mars 1871.—Paris en deuil.—Ecusson allégorique.*
Wood engraving reproduced in *Le Monde Illustré*, 4 March 1871.

114. M. Scott, *Paris le 30 Juin 1878.—La fête de nuit.—L'entrée du Bois
de Boulogne par la porte Dauphine.* Wood engraving reproduced in *Le
Monde Illustré*, 6 July 1878.

bewitch the native, in effect to wipe the slate clean of any lingering effects of "l'année terrible." The brilliant effect of the colorfully arranged banners, garlands, and flags flying from buildings in every quarter of Paris in preparation for, and to mark, the fair's opening on 1 May was likened to a "fairyland"—a term often used to describe Monet's array of colorations (fig. 115).

The fair had been promoted by the republicans, but the popularity of the event cut across party lines. Republicans seized the occasion to boast of the unity and consensus that they were achieving, a healing of the divisions that had warped the national spirit since the beginning of the decade. Nationalism had replaced politics as the republican press boasted that France had become a single family and the hearts of all French people "vibrated in unison." The enthusiasm of the populace thronging the boulevards was contrasted with the nightmarish street scenes of the years of 1870–71, and the once threatening "crowd" was re-presented as a benign homogeneous entity.

The huge success of the celebration inspired the suggestion for the organization of the Third Republic's first official national holiday. But this immediately incited bad blood between the monarchists and republicans; whereas everyone could see something positive in this expression of spiritual renewal and national recovery, choosing a national holiday threatened to reveal specific ideological sympathies. This became evident when the predominantly radical Municipal Council of Paris called for a large-scale celebration of the coming 14 juillet. Until then, the government of MacMahon had outlawed Bastille Day, whose commemoration of insurrection now carried with it memories of the Commune and the issue of amnesty for those Communards still imprisoned or exiled. It was during this controversy over the national holiday that the republicans and monarchists sniped at each other in the private celebrations of Voltaire and Joan of Arc, already referred to in my discussion of Fremiet's statue. On 30 May Victor Hugo presided over the centenary celebration of Voltaire, using it as an opportunity to speak on behalf of amnesty for the Communards.

Eventually, the republicans and monarchists agreed to a compromise, deciding to celebrate the first official national holiday on the politically neutral and insignificant date of 30 June. Thus it would be a totally meaningless holiday designed exclusively to sustain the momentum of unity and consensus achieved the month before. How closely related this was to the earlier events is seen on the eve of the festival when the subject of displaying the Phrygian bonnet came up. The royalist *Gazette de France* claimed that for radicals "the holiday would be authentic only if the red flag and the phrygian bonnet could be deployed emblematically throughout, and if they could proceed to the execution of their radical program in reestablishing the Commune."[14]

As in the case of the festivities of 1 May, the descriptions of the celebration of 30 June operated, propagandistically, in favor of the notion of unity (fig. 116). The tri-color banners once again blazed throughout the city, and the crowds once again poured out in the streets. The *Journal officiel* stressed the public space of the celebrations that took place in every arrondissement, every neighborhood, "even the poorest," and noted that the mood of public confidence had Parisians and foreigners alike acting as "one great family."[15] The year before, when the funeral procession of Thiers proceeded along the Boulevard Saint-Denis, the conservative press interpreted the solidarity of the

LA FÊTE NATIONALE. — Quelques croquis à la plume des rues de Paris pendant la journée du 30 juin. — (Dessin de M. Oms.)

116. V. Oms, *La fête nationale.—Quelques croquis à la plume des rues de Paris pendant la journée du 30 juin.* Wood engraving reproduced in *Le Monde Illustrée,* 13 July 1878.

LE 1er MAI A PARIS. — Décoration spontanée de la rue d'Aboukir à l'occasion de l'ouverture de l'Exposition. — (Dessin de M. Scott.)

115. M. Scott, *Le 1er Mai à Paris.—Décoration spontanée de la rue d'Aboukir à l'occasion de l'ouverture de l'Exposition.* Wood engraving reproduced in *Le Monde Illustrée,* 11 May 1878.

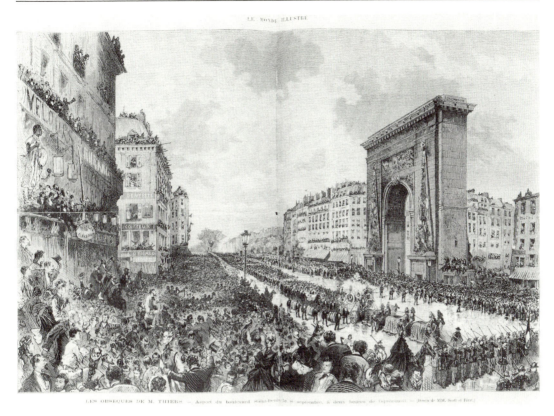

117. Férat, *Les obsèques de M. Thiers.—Aspect du boulevard Saint-Denis, le 8 Septembre, à deux heures de l'après-midi.* Wood engraving reproduced in *Le Monde illustré*, 15 Septembre 1877.

French turnout as a sign of support for the "vanquisher of the Commune and liberator of the land" (fig. 117).[16]

Monet's two representations of the empty holiday of 30 June correspond to its seeming ideological neutrality, emphasizing in his exuberant bouquet of buildings, people, and banners the national euphoria that swept all before it, even in the "poorest" neighborhoods. No hint of political protest or sinister machinations lurk in the corners of these Impressionist pictures whose surfaces reveal its structure and hide nothing. Monet's reading of the holiday is filled with the same sense of buoyant optimism that marks most of his work of the 1870s and for which he found a number of buyers including the virulent anti-Communard dealer, Durand-Ruel. Indeed, both works went to anti-Communard patrons: *La rue Montorgueil* sold to Georges de Bellio and *La rue Saint-Denis* to Hoschedé. Monet's two works read out the past just as the very holiday itself is empty of all historical signification. It commemorated no thing, as if France began its history that day like a "Big Bang" of blue, white, and red fragments shooting everywhere in space. The almost-vaporous banner stretching across the rue Saint-Denis emblazoned with the slogan "VIVE LA FRANCE" functions as a subliminal

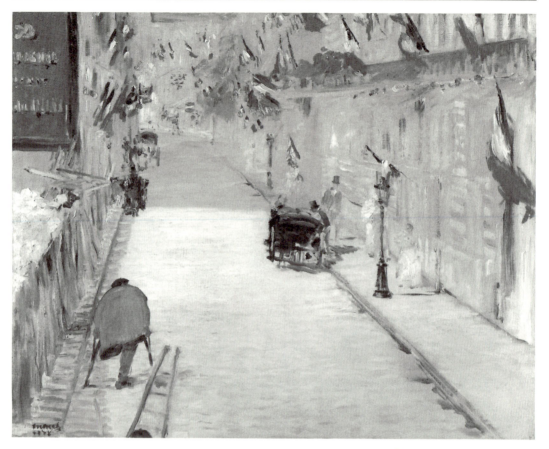

118. Edouard Manet, *The Rue Mosnier with Flags*, 1878. Collection of Mr. and Mrs. Paul Mellon, Upperville, Virginia.

message for the rapturous crowd and exhibition spectator. In the end, he is hardly politically neutral since he only gives the illusion of unity and consensus. Here we see quite clearly that the idea of the impression, with its emphasis on opticality and the fleeting moment, perfectly suited the selective thought processes necessary to sustaining the illusion.

Ironically, it was Manet who deconstructed this fabric of deception with his *Rue Mosnier with Flags*, done during the same period (fig. 118). Manet, however, differs from the densely woven fabric of street theater in the Monet by opposing the fullness of the decorations draped from the buildings with the near-empty street below. The emptiness of the street adumbrates the hollowness and sham of the celebration, and this is brought home sharply by the lone one-legged worker wearing the laborer's blue smock and familiar *casquette* trudging the street.[17] A regular veteran of either the war or the Commune (it's not likely that he is an ex-Communard), he is a signifier of that history and of the toilers who shaped it. These veterans had been the forgotten heroes

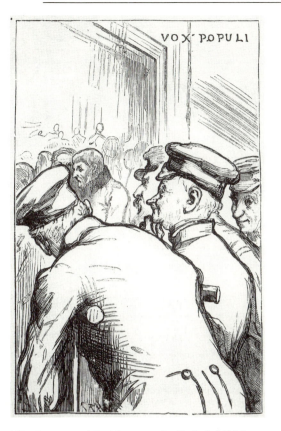

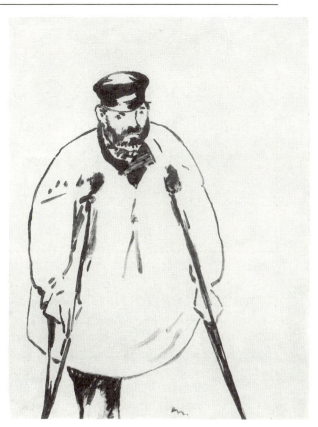

119. *Scenes and Incidents at the Paris Exhibition, Vox Populi*. Wood engraving reproduced in Supplement *Harper's Weekly*, 5 October 1878.

120. Edouard Manet, *A Man with Crutches*, 1878. Brush and ink drawing on paper. The Metropolitan Museum of Art, New York City. Harris Brisbane Dick Fund, 1948.

until 1878, when they were incorporated into the festivities of the universal exposition (fig. 119). Manet, who never failed to champion the underdog, does not neglect to pay homage to them (fig. 120). Given this position, it is unsurprising to learn that when amnesty was finally declared for the Communards Manet commemorated the moment with a watercolor of festive banners inscribed "Vive l"amnistie."[18]

Yet Manet's overt politicizing of Impressionism stands as an exception, itself tempered by his need to be accepted in the official Salon. He remains more the scholar's favorite, while the broad mass of museum goers prefer to flock to the hard-core Impressionists. Perhaps the excitement of looking at Impressionist works is related to a sense of relief from the same urban pressures and looming catastrophes that Monet and his colleagues worked so hard to elide. After all, the ideological issues of the world they painted are still very much alive in the advanced industrial states, except that in this country, for example, the terms "ghetto" and "barrio" substitute for *quartier*. In this sense, the initial occluding function of Impressionist landscapes has yet to lose its vitality.

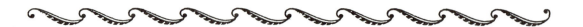

Epilogue: Georges Seurat's *Un Dimanche à La Grande-Jatte* and Post-Commune Utopianism

THE GENERATION that followed the Impressionists experienced the Commune and its repression as a childhood trauma and their attempt to achieve a more monumental expression of modernity represents not only a cyclical or aesthetic response but a social and political riposte growing out of radical energies stimulated by its haunting memories. To test this hypothesis I have chosen the canonical work of Post-Impressionism, Seurat's *La Grande-Jatte*. This painting has become enshrined as one of the most ambiguously popular icons of the movement, examined from every perspective and in every context, yet distinguished in the art historical literature for its apparent imperviousness to systematic criticism and interpretation (fig. 121).[1] Nevertheless, I believe that by studying it as a complex iconographical response to the social instability of post-Commune France many of its paradoxical qualities may be comprehended as part of Seurat's deliberate program to make system out of social as well as aesthetic disorder.

Seurat's painting depicts a peculiar social geography and public encounter in one of the popular parks in a suburb of northwest Paris. It is a moment of recreation and leisure, and this is conveyed to us by the diverse positions and actions of the crowd; individuals promenade, rest, fish, boat, play, rehearse their musical lessons, and otherwise bask in the radiant light of the river. For all the seeming informality, however, the puzzling features of light and perspective that give it a Hogarthian twist, the complex arrangement of the figures in space, their distinctive shapes and poses, and the compositional emphases all demonstrate that the work had been carefully programmed in advance.

It is common knowledge that Seurat painstakingly prepared for the execution of this work, producing sketch after sketch in working out the details.[2] It took nearly two years to construct, requiring approximately seventy preliminary drawings and painted sketches. The technique itself sustains this methodical process: upon an *ébauche*-like layer of elongated, parallel brushstrokes Seurat applied a network of prismatically col-

121. Georges Seurat, *Sunday on the Isle of La Grande-Jatte (1884)*, 1884–1886. The Art Institute of Chicago, Chicago.

ored points of almost uniform size which produce an appearance of a mechanically ordered screen.

When the work exhibited at the Salon des Indépendants in 1886 no observer could doubt that the artist had asserted his method against the improvised canvases of the Impressionists. But if its audience understood La Grande-Jatte as an example of the fresh assertion of system, they were not yet ready to include its eccentric qualities within the framework of academic practice. Only later, when it became evident from Seurat's sustained efforts to deal systematically with the Impressionist technique and content, did critics perceive the traditional basis of the painter's methods.

Seurat's period of training at the industrial art school of Justin Lequien and at the Ecole des Beaux-Arts under Henri Lehmann, a disciple of Ingres, coincided with the change in the critical reception of the Impressionists. While the attack on the formlessness and sketchiness of the group continued, there developed a greater tolerance and even respect for their dynamic features. As a latecomer to this movement, Seurat's training in the academic curriculum and his exposure to the Ecole's rich resources predisposed him to the conception of a fresh synthesis which would reconcile the modernist energy of the independents with the narrative depth and formal structure of the old masters whom he studied and copied as a student.

One of the major sources for Seurat's projected synthesis was Charles Blanc, whose *Grammaire des arts de dessin* Seurat had read at the Ecole.[3] Blanc wrote the book in reaction to what he perceived to be the falling away in France from the noble principles of the high art of the past. He praised continued English enthusiasm for Hogarth's *Analysis of Beauty* and Reynolds' *Discourses* and the widespread teaching in German schools of Baumgarten's aesthetics, but deplored ignorance of the knowledge of art in France, which in this respect was "one of the most backward nations in Europe."[4] Daily in the so-called "new Athens," one can see eminent citizens and millionaires vying at the Hôtel Drouot for worthless objects by seventh-rate painters, while the "great masters are shamefully cheapened."

Blanc's *Grammaire* aimed to rectify this deplorable state by presenting in a single volume the elementary principles of high art. He stressed both the form and content of magisterial art to clarify the nature of triviality in new as well as older works. He warned that "composition is not improvised," and quoted Delacroix on the need for careful arrangement of the parts to release intellectual energies. Only detailed preparations in black and white and color enable the painter "to speak the language of the gods."[5] Blanc believed that art elevated the outlook of nations and could even reform behavior by the dignity of its representations:

> Without being either a missionary of religion, a teacher of ethics, or a means of government, painting improves our morals, because it touches us and can awake in us noble aspirations or salutary remorse. Its figures, in their eternal science, speak more loudly and emphatically to us than could the living philosopher or moralist—people like ourselves. Their immobility sets our mind in motion. More persuasive than the painter who has created them, they lose the character of a human work because they seem to live a loftier life and to belong to another, to an ideal world.

For Blanc the key to the effectiveness of all great history painting is "unity." Unity signifies the dominance of a certain characteristic linear rhythm; the human craving for order dictates the need to bring all the lines of a work into relationship with a dominant. We see in everyday life that "the straight lines correspond to a sentiment of austerity and force, and give to a composition in which they are repeated a grave, imposing, rigid aspect." The painter should be especially mindful of:

> The horizontals, which express, in nature, the calmness of the sea, the majesty of far-off horizons, the vegetal tranquility of the strong, resisting trees, the quietude of the globe, after the catastrophes that have upheaved it, motionless, eternal duration—the horizontals in painting express analogous sentiments, the same character of eternal repose, of peace, of duration. If such are the sentiments the painter wishes to stamp upon his work, the horizontal lines should dominate in it, and the contrast of the other lines, instead of attenuating the accent of horizontality will render it still more striking.

In the end, nature appears in complex forms of conspicuous disorder and it is only the human mind that can extrapolate from it the germs of beauty contained within it, thus

recreating them for the second time "by bringing them into order, proportion, and harmony,—that is to say, unity."[6]

In these statements we glimpse the didactic and political implications of Blanc's arguments and their applications to high art on the eve of the Franco-Prussian War and the Commune.[7]

Four years after publishing the *Grammaire*, Blanc resumed the directorship under the newly formed Third Republic, and his major action was the formation of the Musée des Copies to inspire art students with a taste for monumental art.[8] Rather than use the meager funds at his disposal for purchasing works by living painters, he employed mainly hack copyists to reproduce the frescoes and magisterial pictures of Renaissance and Baroque masters. The next administration, however, loathed the scheme, and dismantled the Museum of Copies and sent the best examples to the Ecole des Beaux-Arts. The two after Piero della Francesca had an undoubted influence on the style of Seurat, who would shortly act on Blanc's precepts.[9]

Seurat's assimilation of these precepts is seen in his letter to Maurice Beaubourg of 28 August 1890, which summarized his theories:

> Art is Harmony.
> Harmony is the analogy of opposites, the analogy of similar elements, of *value*, *hue*, and *line*, considered according to their dominants and under the influence of lighting, in gay, calm, or sad combinations.

Seurat's practice as well as his cryptic references to previous history painting and classic sculpture to elucidate it demonstrated his preoccupation with the tradition characterized by Blanc. Seurat's close associate, Signac, recalled Seurat saying in regard to the picture: "I would have painted equally well in another key, the struggle of the Horatii and the Curatii."[10] While Signac meant to suggest the painter's indifference to abstruse iconographical programs, he contradicts himself with another statement in the same passage, that Seurat "only chose a naturalist subject in order to tease the Impressionists, all of whose paintings he was planning to redo in his own way." Gustave Kahn quoted Seurat in 1888: "The Pan-Athenaic Frieze of Phidias was a procession. I want to make the moderns file past like the figures on that frieze, in their essential form; to place them in compositions arranged harmoniously by virtue of the direction of the colors and lines, line and color arranged in accordance with one another."[11]

The problem of order and harmony is central to Seurat's conception, exactly as in Blanc's formulation of history painting. Applying to this concept the model of the physical sciences, Seurat hoped to emancipate his work from bourgeois convention and give it a measure of objectivity. The picture represents his ambitious attempt to show how this model could resolve and reconcile the contradictions of modern society and its cultural practice.

Central to Seurat's formulation is his calculated choice of time and place: Sunday, the Christian day of rest, on the small island of La Grande Jatte, a public recreation site. As the day of leisure for all classes, or semi-leisure for many workers who had to work part-time including those in the leisure industry itself, the normal differentia-

tion of the classes in terms of dress and routine could be obscured. We know they are there thanks to the observations of Seurat's friend, Jules Christophe:

> Monsieur Georges Seurat, finally, with the temperament of a Calvinist mar-
> tyr, who has planted, with the faith of a Jan Hus, fifty people, lifesize, on the
> bank of the Seine at La Grande Jatte, one Sunday in the year 1884, and tries to
> seize the diverse attitudes of age, sex, and social class: elegant men and ele-
> gant ladies, soldiers, wetnurses, bourgeois, workers, It is a brave effort.[12]

Yet clearly it is difficult to distinguish one group from another, since all are *"endimanchés"*—dressed in their Sunday best. Seurat's friends, Coquiot and Beaubourg, recalled this mixture of the classes, and the sharing of the leisure activities such as boating and swimming.[13] Although Beaubourg owned his own skiff which he kept moored at the island of La Grande Jatte, those less fortunate rented a rowboat or canoe. Seurat's exaggerated emphasis on fashion deliberately plays on the idea of the "Sunday best" to conceal social differences, including even the casual but fashionable sportswear of the reclining male at the left who is often singled out as the working-class type. It was not uncommon to come upon workers wearing tophats either on Sundays in the park or on other leisure occasions (as is clear from Renoir's *Moulin de la Galette* as well as reportorial images of the time [Fig. 122]), and one can single out several such types in Seurat's picture who rest on the grass, against a tree, and promenade in their shirtsleeves. In short, working-class people are present in the picture but it is not possible to distinguish them from clerks and professionals.

The mass production of clothing, and the use of mass-production design by tailors and seamstresses, enabled the diverse sectors of the cosmopolitan public to assume a similar appearance. Writers of etiquette manuals during the Third Republic continued to stress the formulas of public conduct, but the mystification of social differences made them more anxious about the encounter with strangers.[14] The emerging confusion over social identity was heightened by the uncertainty of the formulas of decorum to be applied. One could no longer distinguish the social position of men or women on the basis of their public appearance. As Louis Ulbach wrote in 1878: "A Paris, sur le trottoir, tous les hommes sont égaux."[15] In the case of women, male commentators had the added complication of distinguishing prostitutes from honest women by costume. For example, the umbrella—once the exclusive accessory of the aristocracy—now "se trouve . . . entre toutes les mains."[16]

But it was particularly on Sundays, when Parisians of every social group took to the suburbs, that the distinctions were most blurred. The popular commentator, Grand-Carteret, observed that on this day even at the Jardin des Tuileries "toutes les classes y sont confondues, ou plutôt une seule y domine." This pertained to all the parks, however, because Sundays high society permits itself the liberty of mixing with "that part of the public which is unable to promenade the other days; indeed, those who participate in the total fusion of the classes, will see, side by side, the kind of people who, in ordinary times, would blush to be seen in such mixed company."[17]

This restructuring of the visual code of social decorum was inevitably bound up with the breakdown of the line drawn between the exclusive and plebeian, private and pub-

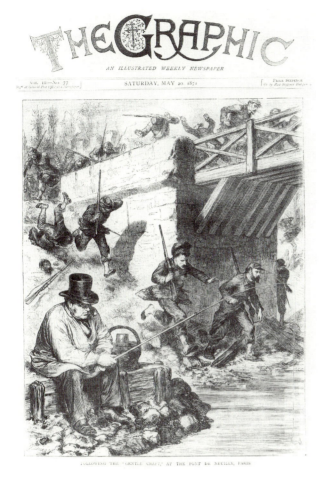

122. G. Durand, *Following the "Gentle Craft," at the Pont de Neuilly*, Paris. Wood engraving reproduced in *The Graphic*, 20 May 1871.

lic life. One instance of the new cosmopolitan interaction of bourgeois public behavior and public geography was the transformation of private estates and gardens into municipal parks. There is no need to rehearse here the full impact of Haussmannization on French public life and culture, except to recall the importance Napoleon III's Préfet de la Seine placed on open verdured spaces and public gardens.[18] Haussmann and his collaborator, the engineer Adolphe Alphand who became chief of Park Service, not only converted the state forests of the Bois de Boulogne and Bois de Vincennes into public gardens but also planned and constructed several other great parks and public squares such as Monceau and the Buttes-Chaumont. Their pretext for doing so centered on the call for respiration, ventilation, recreation and relaxation of the masses.[19] In actuality, these newly planted areas, promenades, squares, public gardens, and suburban parks aimed at the distanced social intercourse of the various classes—increasingly separated physically east and west by Haussmann's work—as a vent for unrest or antisocial views.[20]

The Third Republic, in its efforts to enhance the quality of urban life and stave off social unrest, extended the park construction begun under the Second Empire. Alphand survived both the fall of Haussmann and the fall of Napoleon III, and under the Republic he more or less assumed the functions of his former boss. In this capacity he expanded the parks program, including the completion of the city park on the hill of Montsouris on the Left Bank in 1878. As in his previous constructions, Alphand excavated a large lake and created islets. Here he emulated the gardens of the private estates, ultimately his model for public parks. Invariably, these estates in and around Paris included a lake with an islet for the diversion of pleasure-seeking guests and as a setting for promenades (figs. 123, 124).[21]

The island of La Grande Jatte belongs to this category of park scenery and itself represents a clinical case study of the shift from the private to the public realm. Situated in the Seine where the river loops around Paris to the northwest, the island originally formed part of the estate of the Orleans family at Neuilly-sur-Seine.[22] The estate comprised the eighteenth-century château, used as a summer residence by the future king Louis-Philippe and his family, and a vast park of 222 hectares extending from Paris to the Seine which included the island of La Grande Jatte. Louis-Philippe's son, the Prince de Joinville, recalled the island in his memories of childhood:

> Neuilly! I can never write the word without feeling moved, for it is bound up with all the happiest memories of my childhood, and I salute that name with respect akin to that which I would show a dead man! Those who never knew the Neuilly of which I would speak must imagine to themselves a very large country house . . . standing in the middle of a very large park which stretched from the fortifications to the Seine, just where the Avenue Bineau now runs. Within the park walls there were fields and woods and orchards, and even islands, the chief of which was called the Island of the Grande- Jatte, enclosing an entire arm of the Seine.

The Prince de Joinville makes clear the privileged use of this land for the children of the noble family:

> At five o'clock in the morning, before lessons or school began, we were galloping about in the big park. In play hours, and on the Thursday and Sunday holidays, the whole troop of children roamed the fields, almost unaccompanied, the oldest ones looking after the youngest. . . . There were flowers everywhere, fields of roses, where we gathered splendid bouquets every day, and they were never missed. Then we used to go boating and swimming. Boys and girls, equally good swimmers all, would plunge in turn into the little arm of the Seine enclosed within the park. Nothing more delicious can be imagined than to cast oneself into deep water near the bridge at Neuilly, and to let oneself drift down almost as far as Asnières, under the great willows, returning afterwards on foot by the Island of the Grande-Jatte.

In this revealing passage we learn that all the "public" pleasures later indulged in and around the Grande-Jatte by Seurat and his contemporaries had once been the ex-

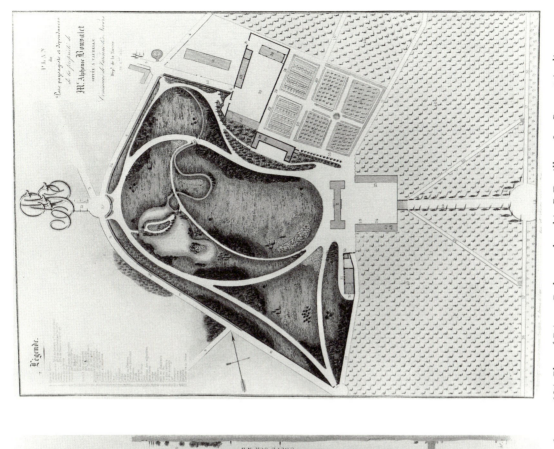

123. Plan of Private Park reproduced in F. Duvillers, *Les Parcs et jardins*, opp. p. 6.

124. Plan of Private Park reproduced in F. Duvillers, *Les Parcs et jardins*, opp. p. 46.

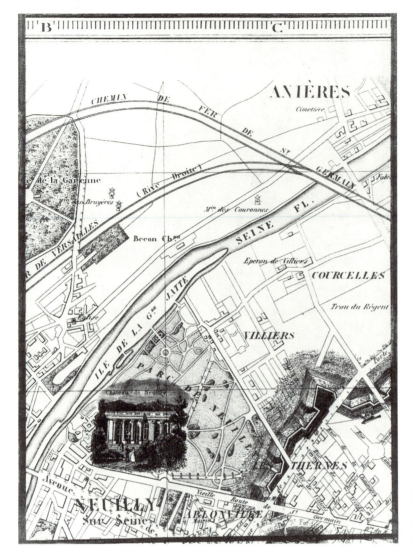

125. Detail of map showing Neuilly and the Isle of La Grande-Jatte. From A. Vuillemin, *Nouveau plan illustré de la ville de Paris*, 1848.

clusive privileges of an aristocratic class. Indeed, after this joyous description of his childhood the Prince's memories turn bitter: he recalled how the grounds had been confiscated by Napoleon III, cut up in part for speculation and in part for transference to the municipal domain.[23]

A local oral tradition maintains that the island underwent Haussmannisation around the time of the expansion of the neighboring Bois de Boulogne.[24] A look at a map of the area in 1848, showing the chateau still intact, reveals that the island had a somewhat different configuration than at the time Seurat painted his picture, including a small well-defined islet—the "Petite-Jatte"?—on its Right Bank which according to the legend was fused by Haussmann with the larger body (figs. 125, 126). Hence the site chosen by Seurat for his magnum opus was a park that had undergone a transformation analogous to other properties belonging to the state.

126. Detail of map showing Neuilly and the Isle of La Grande-Jatte. From Maison Andriveau-Goujon, *Plan géométral de Paris*, 1898.

Seurat's choice of setting had a profoundly personal meaning for him dating from childhood and was inextricably tied to his experience with Haussmann's urbanization and townplanning. When Seurat was only three years old the family moved to the tenth arrondissement in northeast Paris on 110, Boulevard Magenta, one of the major diagonal boulevards cut by Haussmann through working-class quarters and extending all the way to what is now the Place de la République. Due east of the family apartment Alphand constructed the working-class version of the Bois de Boulogne on the high ground of Belleville, the singular park of the Buttes-Chaumont, which was literally carved out of the limestone quarries. It offered the spectacle of a working-class paradise, complete with lakes and islets, suspension bridges, grottoes, temples, and a cascade falling from a height of one hundred feet into an artificial stalactite grotto (fig. 127). Seurat's mother, deserted most of the week by her reclusive husband, promenaded frequently in the park with her children.[25] Seurat was eight years old when Alphand opened the park in conjunction with the opening of the Exposition Universelle, and something of its impact on him is gleaned from Coquiot's description of Buttes-

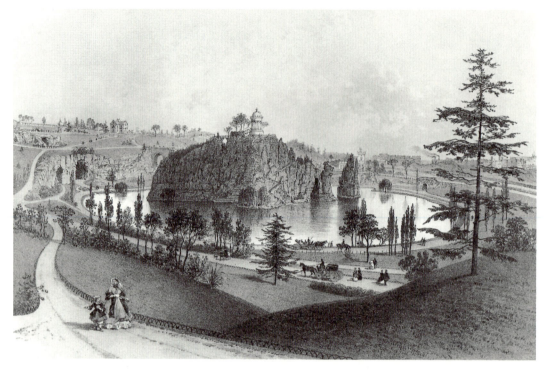

127. F. Benoît, *Square des Buttes-Chaumont*. Lithograph reproduced in V. Fournel, *Paris et ses ruines*, 1872, opp. p. 5.

Chaumont as "une image du paradis terrestre." The Buttes-Chaumont appeared to the children as an oasis in the midst of the depressing neighborhood, and not surprisingly, Seurat's friends similarly described La Grande-Jatte as an Eden-like paradise formed out of the squalid suburbs.

Seurat's absentee father also reserved to himself an analogous paradise in the suburban countryside. Antoine-Crysostome Seurat, who had served as huissier (bailiff) at the Public Tribunal of the Seine at La Villette, retired in 1856 and purchased a house at Le Raincy, a village northeast of Paris. His property also had belonged to the House of Orleans, and like the one at Neuilly had a chateau surrounded by a vast park. Louis-Philippe's father, Philippe-Egalité, had embellished the grounds and transformed them into "une sorte de jardin anglais," with a variety of artificial effects and accessories. The ostentatious grounds were confiscated by the government in 1852, divided into lots and sold to Parisians. A look at maps of the region during the time of the reign of Louis-Philippe and the Second Empire shows the changes to the original estate and the parceling up of the territory (figs. 128, 129). The elder Seurat created his own garden around the property and hired a gardener to maintain it, giving a good deal of his own spare time to raising flowers.[26] Seurat's painting of *The Watering Can* in the Garden at Le Raincy provides us a glimpse of the walled-off privacy of the plot, and the disproportionate emphasis on the watering can in the right foreground with its phallic spout suggests the claustrophobic environment of his father (fig. 130).

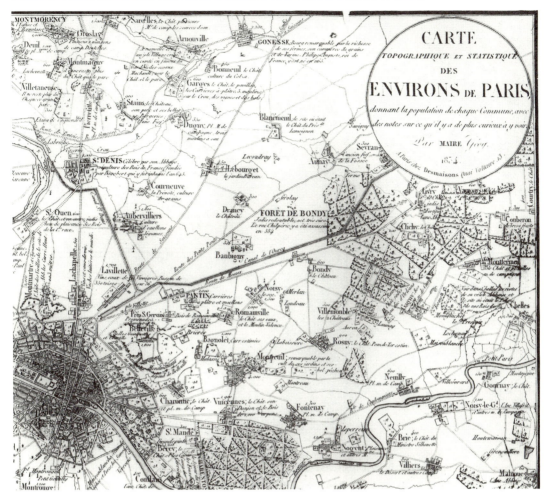

128. Map of vicinity of Le Raincy, c. 1830.

Here Antoine-Crysostome lived most of the week, visiting his family at the apartment of the Boulevard Magenta only on Tuesdays.[27] His curious behavior was heightened further by his insistence that he be addressed as "Monsieur l'officier ministriel" out of respect for his previous official position. This had involved delivering eviction notices and seizing property of insolvent or bankrupt citizens, typical functions of the despised huissiers described by Coquiot as "ces bas valets de la Force!" Thus Seurat's childhood would have unfolded against the backdrop of real estate speculations, land development, a preoccupation with property rights, and relentless exposure to an unstable, physical environment in which entire neighborhoods, buildings, and familiar topographical features were continually subjected to confiscation, rehabilitation, demolition, and new construction.

The successive evolutions of French noble lands and ex-crown possessions into real estate and city parks developed primarily within the context of urban expansion into

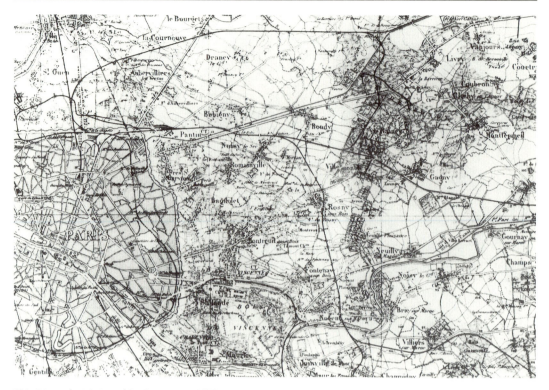

129. Map of vicinity of Le Raincy, c. 1870.

the suburbs and surrounding countryside. The instant creation of public gardens, or ersatz landscape, as an antidote/complement to urban squalor and lifestyle demonstrated the ability of the new entrepreneurs to control physical phenomena: mature trees were uprooted and replanted, new lakes and artificial waterfalls created, and a thriving ancient metropolis totally transformed to conform to a centralized scheme.

One of the most astute critics of Haussmannization, Victor Fournel, ridiculed the pretentions of the city's engineers and lamented the wholesale destruction of historic sites. But he admired the creation of the new parks and promenades which could now be created "at least as quickly as a house." He saw it as ironic that engineers and architects were involved in the creation of the parks and public gardens, and that the "natural" look was achieved through the intervention of industrial processes. Except for the soil and the trees, everything in the new parks was fabricated and artificial including lakes, islands, and hills.

Fournel recognized that they were not designed for the comparatively few who pine for rural seclusion and the beauty of nature, but for those who enjoy solitude in crowds and to whom any work is artistic in proportion to its artificiality (figs. 131–133). For the true Parisian male the country has become "only an affair of custom and of genre." The potted geranium on the balcony amply satisfies his bucolic instincts:

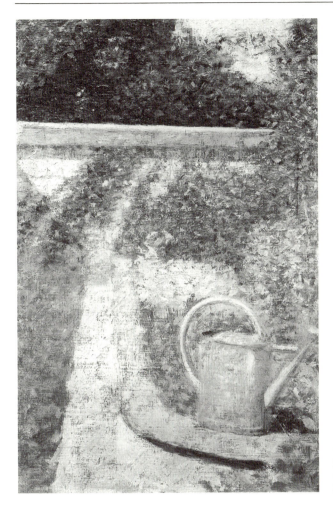

130. Georges Seurat, *The Watering Can (The Garden at Le Raincy)*, oil on panel, c. 1883. Collection of Mr. and Mrs. Paul Mellon, Upperville, Virginia.

He needs the nature in the suburbs of Paris, the fried fish [*fritures*] of Asnières, the dust of Romainville, the mirlitons of Saint-Cloud, the Swiss chalets of Auteuil, and the three-story trees of Robinson Crusoe, where one can dine on mutton from Madeira and creamy meringues, in the midst of the warbling of the modistes on the rue Vivienne and the ingenuous prattle of the florists of the Palais Royal. What he seeks and enjoys in the wilting fields of the suburb is a demi-Paris, with shade trees that recall those of the boulevards. . . . His ideal is to eat melon on the grass, in the Bois de Meudon, in the midst of a crowd. He detests the empty spaces where no one is to be seen, where there are no pubs, where one encounters while promenading only water, grass, trees, flowers, and swarms of tiny insects; where one does not know how to kill time. If he rents a villa, he takes care to choose a fashionable location, not far from the railroad. . . . In showing you his garden, he boasts with pride:

Bois de Vincennes. — Vue de la Route des Buttes.

131. Bois de Vincennes. Lithograph reproduced in Ernouf, *L'Art des jardins*, p. vii.

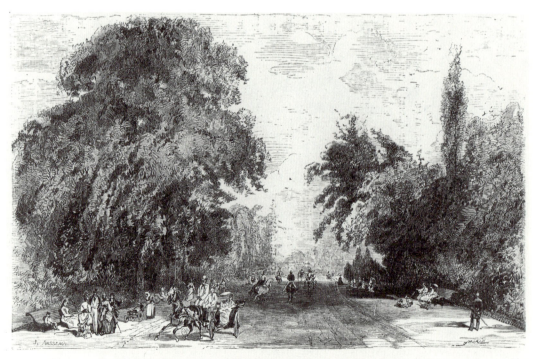

Fig. 310. — Grande Allée traversant le Parc de Monceaux, à droite et à gauche pour Piétons, au milieu Voie carrossable.
(*Voyez* page 224.)

132. Parc de Monceaux. Lithograph reproduced in Ernouf, *L'Art des jardins*, p. 221.

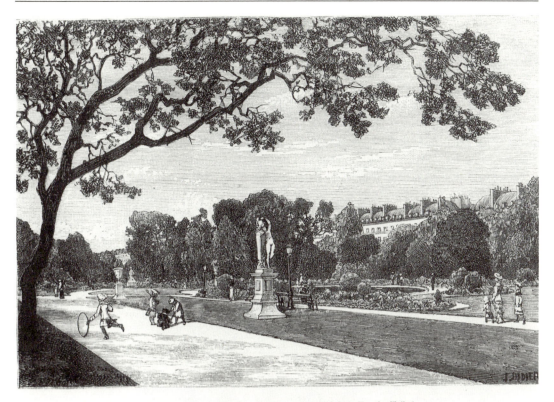

Fig. 454. — Les Tuileries. — Jardin paysager ; côté de la Rue des Tuileries.

133. Jardin des Tuileries. Lithograph reproduced in Ernouf, *L'Art des jardins*, p. 322.

"The railroad runs past only two steps away and I hear all the trains." His ultimate dream would be the constructions of cities in the country, or the shifting of the country to Paris. The public gardens have been created to respond to this fantasy.[28]

It is precisely this lifestyle that Seurat père chose for himself in purchasing the land in Le Raincy directly on the line of the Gare de l'Est situated in walking distance from the apartment on the Boulevard Magenta. For the less privileged as well the park became essential to metropolitan attainment and diversion which accommodated manifold leisure pursuits. The informal public use of heretofore private lands represented the positive side of the government's attempt to channel off potential revolutionary energy and foster a greater sense of community and social coherence.

Seurat's park setting is consistent with his model of science and industry serving him as the basis of his technique and structure. It was also fundamental to his new brand of history painting: Fournel noted wryly that the actual countryside had declined in the eyes of the worldly Parisian to a state of genre, while the new parks,

reconstituted and almost totally fabricated, appeared as an updated form of historical landscape.[29] Horticulturalists and landscape gardeners all compared the modern parks to an all-embracing synthesis of the arts including architecture, sculpture, and painting which furnished the models for the topographic layouts.[30]

Seurat's formal organization of the informal public recreation site was in the best tradition of the historical landscapist as well as of the civic engineers of the Second Empire and Third Republic. (We know that during the time he made preparative studies for the picture he and a friend cut the grass on the island to make it conform to his projected ideal.) Closely associated with the precision of the organization was his ceremonial and processional theme of the Sunday strollers. As elsewhere in nineteenth-century Europe and the United States, the Sunday promenade had become a ritual among Parisians within the realm of urban leisure. These promenades were defined as much by a characteristic set of social ideals and practices as by the distinctive landscape plans. Sundays the city's residents, many sporting their parasols and walking sticks, departed home and church for the broader world of the public park. They set out "to see and be seen," establishing within a seemingly random and heterogeneous crowd an order of gesture, decorum, and body language. Within the closed container of the structured landscape the strollers, barely linked socially the other six days, became a unified body of leisure, enjoyment, and refinement.[31]

The heterogeneous assembly itself constituted an attractive and diverting spectacle for park visitors, but specialized park areas like La Grande-Jatte had the added advantage of being able to accommodate diverse leisure pursuits. It not only stood for formal recognition of the strolling custom but its "regulars" vaunted the benefits of improved physical, mental, and civic health. One could observe at leisure examples of the latest fashions and other reminders of city life and commerce while participating in the bustling outdoor concourse. Seurat clearly took pains to break down the dense crowd into individual strollers occupied with his or her private recreation. They do not know one another and have gathered independently, but collectively they provide one another with an element of curiosity and entertainment.

In a society given over more to competition than to collective effort, the creation of areas for common recreation offered a benign solution for fostering social coherence and civic loyalty. The encounter took place only once a week when each participant pursued their own objects of pleasure, minimizing the potential for hostility. The casual association permitted the temporary abandonment of exclusive pretentions and a meeting on equal terms, thereby encouraging unity of the social classes. The park setting literally reconstituted the Sunday crowd by divesting it of narrow commercial preoccupations and neutralizing the social collisions of the street. Seurat's "modernizing Puvis"—as the critic Félix Fénéon called *La Grande-Jatte*—interprets the park as an idyllic backdrop for the harmonious integration of the urban multitude.

This democratizing encounter of the classes on a common property occurred on Sundays, the Christian Sabbath, the Day of Rest. As we have seen, the daily differentiation of the classes was less conspicuous on Sundays in the park by virtue of special attire and common participation in recreation.[32] Traditionally, the common religious devotion on that day predisposed bourgeois writers to see it

as the most *democratic* feature in the whole Christian religion. On the sabbath all aristocratic distinctions of rank and fortune are to be forgotten. The powerful are to be humbled before the Lord, and the meanest of mankind exalted to a momentary equality with the highest of their fellow beings, by worshipping the Father of all, in the common capacity of His children.[33]

The ultramontane Montalembert went further in stressing the importance of Sunday for demonstrating the alliance of all persons with one another and with God: "Le repos du septième jour est la base de cette alliance auguste: il en est le signe, le symbole et la condition fondamentale."[34]

Montalembert's statement formed part of a popular discourse in the post-1848 period bearing on the problem of leisure time for the working classes. Although a French law of 1814 stipulated that employers had to give their employees time off to attend church on Sundays, its lack of any binding legal injunction had resulted in its wholesale violation. But following the uprisings of 1848, moderates sought to find safe solutions to working-class unrest, and the institution of Sunday rest assumed a central place in parliamentary debates. The influence of the social movement is clearly seen in Montalembert's declaration that "if it remains a day of recreation for the rich, too often Sunday is for the poor, the worker, only a day of exhaustion or disorder." The profanation of Sunday constituted an attack on the laborer's "liberty, equality, and human dignity." Sunday repose offers workers an escape from dehumanizing routine, a chance to restore physical vitality, and above all permits them once a week to feel and see themselves "the equal of the rich, involved in the same leisure pursuits, and gathered around the same altars." The aristocratic priest blamed the continuing violation of the Sunday rest on capitalist greed and socialist intransigence; to those proclaiming slogans like "liberty of work," and "right to work," he opposed "the law of God who created the right to rest."[35]

Montalembert was attacked by the Left, most notably by the radical and atheist Félix Pyat, who called his proposals for a "Sunday Law" duplicitous and diabolical. Pyat insisted that the right to recreation on Sunday presupposed work for all during the previous six days. Without the freedom to work and secure employment a mandated day of rest makes no sense. Workers were at the mercy of their employers who decreed unemployment at will during slack seasons or dead seasons and set their wages arbitrarily according to the number of bodies available. It is hypocritical, on the one hand, to demand that workers take unpaid leave when sickness, unemployment, and work hazards, could at any time result in the loss of their daily bread, and then, on the other, to condemn them for working Sundays. If Montalembert is genuinely serious about Sunday rest, he will endeavor to see that the poor are guaranteed work all week at decent wages. The right to work lies at the base of the right to repose.[36]

Both Montalembert and Pyat depended for their arguments on the most significant discussion of the issue, Pierre-Joseph Proudhon's pamphlet of 1850 which went through several editions its first year of publication.[37] Both a political radical and devout Catholic, Proudhon addressed the issue from the view of public health, morale, and family relations. He stressed the importance of the day for social stability and

harmony. Like Pyat, Proudhon began with the preconditions of guaranteed job security and a decent standard of living as the basis of a Sunday law. The intention of the Mosaic commandment remains relevant for modern society in its tacit call for a "solidarity of destinies" and "a genuinely fraternal society." The heart of any debate on the institution of Sunday rest—indeed, the basic problem of contemporary society—is the "achievement of a state of social equality which will not be communism, despotism, factionalization, or anarchy, but liberty with order and independence with unity."

Proudhon amplified the discussion by envisioning a public meeting ground for all the social classes "inaccessible aux gendarmes" but preserving without coercive authority the spirit of "order and liberty."[38] Inspired by Fourier and other utopian socialists whom he professed to despise, Proudhon projected a future similar to Etienne Cabet's popular 1840 novel *Voyage en Icarie*. Cabet opens with a picture of serene world which he calls "a second *Promised Land*, an *Eden*, an *Elysium*, a new *Earthly Paradise*." Here the inhabitants live out their lives in supreme contentment, in a land where private property has been abolished and people spend much of their daily afternoons in leisurely pursuits on wide promenades or in spacious parks open to all. The public spaces epitomize the salubrious and free environment of Icaria: in the symbolic heart of the capital, Icara (a thinly disguised Paris), the river divides itself in two to form a vast circular island covered with trees, promenades, and gardens. Sunday, the tenth day of the Icarian week, is a day of repose for all and is celebrated with excursions and picnics in the parks—whose shrubberies, lawns, and fountains exhibit a perfect synthesis of art and nature—where one sees everywhere "certain groups dining on the grass, singing, laughing, jumping, running, dancing, and enjoying a thousand games." The people are all properly and elegantly clad in similar clothing, which eliminates envy and coquettishness. All of the charming locations where Icaria's population spends its abundant leisure time had "formerly served only the pleasures of a few noblemen who shut them in by the walls or moats of their castles and their parks."

Sunday in the park is central to Cabet's visionary organization of the physical environment to establish a community of natural equality by the elimination of private property. A forerunner of environmental determinism, Cabet's parks and promenades anticipate Haussmann and Alphand in their throughly planned and structured walkways, vast lawns, grottoes, artificial hills covered by birds, and sheets of water from brooks, waterfalls, fountains, and sprinklers. "All that the fertile imagination of the skilled designer could imagine was found gathered together there, even birds and animals of all kinds on the water and the lawns."

Icarian Sunday—when every gathering and special event is signaled by the blast of the trumpet—thus anticipates the concept of Seurat's *La Grande-Jatte* which is inseparable from the discourse on dominical repose and radical utopianism.[39] Icarianism represented one of Europe's most significant pre-Marxian socialist developments as well as one of the more fascinating secular experiments in the United States. Although it was forced to go underground after 1848, its ideas retained enough of a hold on the radical imagination to be revived again during the Third Republic.[40]

The polemic centering on working-class leisure never completely vanished in the ensuing years. During the time of the Second Empire societies throughout Europe

began to crop up advocating a weekly day of rest for working classes.[41] One of the most active groups, the *Comité de la Fédération internationale pour l'observation du dimanche* of Geneva, began a national formation in 1866 and ten years later expanded as an international umbrella organization embracing several French societies alone at Paris, Marseilles, Toulouse, Montauban, and Strasbourg. The first international congress of weekly repose met in Geneva in 1876, followed by congresses at Berne in 1879, Paris in 1881, and Brussels in 1885.

This expansion and stepped-up activity was stimulated by the advent of the Commune, analogous to the feverish debates generated by the uprisings of 1848. The repression of the Left permitted the initiative to pass to the bourgeoisie who comprised most of these organizations and continued the work of their predecessors in the 1850s. A key document in the discussions of the 1880s is the publication of the *Congrès International du Repos Hebdomadaire* organized at the Paris Exposition Universelle of 1889.[42] Although taking place some five years after Seurat began his painting, most of the participating societies had been in existence since the 1870s and their delegates articulated arguments similar to those heard in the debate of the 1850s. The main purpose of the elite group of economists, physicians, liberal clerics, and entrepreneurs in 1889 was to persuade business and government to unite on the issue to keep control of labor-capitalist relations, but like their predecessors they had no intention of providing workers with compensation that would induce them to take off Sundays.

Several new factors, however, invigorated the discussion: the inevitable specter of the Commune, the economic crisis sparked by the crash of the Union Générale in January 1882, the recent threat of Boulangism, and the vivid expression of growing socialist and anarchist appeal to the workers as manifested in such strikes as the one at Décazeville at the beginning of 1886. While the old arguments on the restorative and recuperative aspects of Sunday rest were trotted out and buttressed with more scientific and statistical data, there was a new urgency in favor of the dominical day off to maintain "la paix sociale."

Members of the congress picked up on the old argument that it was absolutely indispensable to the worker's dignity to have a periodic rest day on which to move freely and experience independence in the society of other free people. Raoul Allier, professor of philosophy at Montauban, declared that "social hatreds will fall the day when workers will see before them, not a bourgeoisie infatuated with, or proud of its charity, but a bourgeoisie intent on guaranteeing human solidarity with justice and liberty."[43]

In addition to periodic independence, the members of the congress stressed the importance of time off for contemplation of ideas and cultural activities to counter the animal-machine state identified with brutalizing labor. The ideal day for uniting with the family was Sunday, when children were at home and the working male was obligated to participate in family outings. For this reason they condemned the alternative off day of Monday, when the worker was inclined to join his comrades at a cabaret.[44]

This distinction had already been represented in Salon painting a decade earlier by Roger Jourdain, whose pair of pictures, *Le Dimanche* and *Le Lundi*, depicted familiar scenes on the island of La Grande-Jatte (figs. 134, 135).[45] Reproduced in *L'Illustration* with a revealing text, the first shows fashionable shop clerks enjoying a picnic near the

LE DIMANCHE

134. Roger Jourdain, *Le Dimanche*, 1878. Wood engraving after painting reproduced in *L'Illustration*, 15 June 1878.

LE LUNDI

135. Roger Jourdain, *Le Lundi*, 1878. Wood engraving after painting reproduced in *L'Illustration*, 15 June 1878.

water's edge, while its pendant shows depressed artisans drinking cheap wine in a low tavern. Clark and House see this confrontation as an example of class struggle on the island, when in fact it represents contrasting uses of the day off as the accompanying text makes clear.[46] Pitting shop clerks against artisans hardly makes for a dramatic instance of the class struggle, and Clark's argument that workers refrained from going out on Sundays because they could not afford a special outfit rests on a reference to the 1860s and is not relevant to the circumstances of the later Third Republic. What is important about Jourdain's pendants is the association of La Grande-Jatte with the dominical ideal of bourgeois social reformers.

The Garden of Eden every Sunday; paradise once a week. Seurat's *La Grande-Jatte* does more: it fixes the weekly holiday in monumental perpetuity while yet keeping to the logic of Sunday. The power of Seurat's eternal moment resides in its affirmative links with those utopian visions that posited the ideals associated with Sunday as the basis of daily life experience. Fénéon identified Seurat with anarcho-communist circles to which most of his closest friends belonged.[47] While this influence has been suggested on many occasions as a source of inspiration for his painting, it has never received the careful consideration it deserves.

Signac once summed up the anarchist artist's credo: "Justice en sociologie, harmonie en art: même chose." The painter's visual enactment of this idea is his *Au temps d'Harmonie*, originally entitled *Au temps d'Anarchie* (fig. 136).[48] It is very revealing to juxtapose this work with Seurat's *La Grande-Jatte*, since I believe they spring from the same ideological wellsprings. Less subtle than Seurat's representation, Signac's nevertheless similarly projects an Eden-like setting in which the various social types disport themselves according to their intellectual or recreational preferences. Signac's change of title does not dissociate the concept from his political philosophy, since "harmony" was a catchword of anarchism and indeed, of every utopian movement in the nineteenth century.

Seurat explained his theory to Beaubourg with the opening lines: "Art is Harmony. Harmony is the analogy of opposites." Of course, Chevreul, Henry, and other sources of Seurat's color theory said a good deal about harmony achieved through analogy and contrast, but it would be erroneous to conclude that their studies—and Seurat's—refer exclusively to the aesthetic domain.[49] *La Grande-Jatte* aims at a reconciliation of the antinomies of existence itself: freedom and order, the subjective and objective, spontaneity and control, the artificial and the natural, the individual and the collective, the micro and the macro. Thus Signac's association of social justice and aesthetic harmony bears directly on Seurat's theory. The three chief anarchists writing in French, Pjotr Aleksejevich Kropotkin, Elisée Reclus, and Jean Graves consistently use the term "harmony" to express the condition of society after the elimination of private property and exploitation. In his popular exposition of the doctrine in *Paroles d'un révolté* (1885), a collection of pieces first published in *La Révolte* in the years 1880–1882, Kropotkin defended the use of a label that conjured up for its critics a social state opposed to that of the "harmony" he envisaged. Turning the tables on them, he challenged the critics to define the "order" they held up as the ideal:

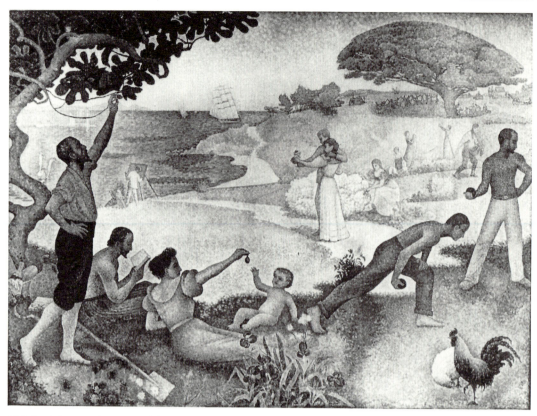

136. Paul Signac, *Au temps d'harmonie*, 1894. Marie de Montreuil, Montreuil. Photo M. Philippe Dele-
porte.

> Is it the harmony that we anarchists dream of? The harmony that will estab-
> lish involuntarily in human relationships, when humanity will cease to be
> divided into two classes, one of which was sacrificed to the profit of the other?
> The harmony which will surge spontaneously from the solidarity of interests
> when all peoples will form a single family, when each one will work for the
> well-being of all, and all for the well-being of each? Evidently not! Those who
> reproach anarchy as the negation of order do not speak of this future harmony;
> they speak of order in its application to contemporary society. Therefore it is
> this order that anarchy wishes to destroy.

Reclus, Kropotkin's collaborator and the editor of *Paroles d'un révolté*, writes of "cette
douce oasis de paix et d'harmonie entre hommes qui se sentent égaux et travaillent de
concert à l'avènement de la justice." In his seminal statement on anarchy published in
an English review in 1884, Reclus invoked Alfred R. Wallace's view of civilization as
"the harmony of individual liberty with the collective will." Jean Grave proclaimed
"the progressive march towards harmony" in his writings, and in an article entitled
"L'Harmonie" he reiterated the anarchist prediction of the voluntary solidarity of au-
tonomous beings in the new society.[50]

All three interpreted anarchy as a theory of life and conduct in which social harmony is obtained without centralized government or any coercive authority by free agreements between diverse groups, territorial or professional, voluntarily constituted for the sake of production and consumption. They emphasized individual liberty, self-activity, and non-hierarchical forms of organization as the basis of anarchist harmony. Anarchists viewed human relationships as essentially one of compatibility of contrasting initiatives, a harmonizing of differences achieved through the satisfaction of each individual's needs and creative potential. While accepting modern science and industry as absolutely indispensable to the new society, both Kropotkin and Reclus—world class geographers—insisted on an ecologically salubrious environment for the free play of the individual's personality similar to the type envisaged by Cabet in the *Voyage en Icarie*.[51] Kropotkin wrote in his famous *Conquète du pain* that anarchist society is already heralded in the "parks and gardens open to all."[52] Public parks were a model of a humanly scaled natural environment for balanced, wholesome communities enjoying the advantages of both town and countryside.

Like the utopian socialists who had preached self-actualization of individuals in a state of community, anarchists insisted on the liberty of the individual to choose his or her vocation as the basis of self-fulfillment and social equality. Whatever the differences of the systems of Saint-Simon, Fourier, and Owen, they united in their recognition of the problem of their contemporaries in finding satisfaction in work and in their relationships with others. Among Saint-Simon's last words to his disciple Olinde Rodrigues was a restatement of his life's goal "to afford all members of society the greatest possible opportunity for the development of their faculties."[53] The signification of his famous slogan which began "From each according to his capacity," turned on society's responsibility to allot each of its members an appropriate function. The realization of this goal would diminish class antagonisms and stimulate the gravitation of all humanity to *"universal association."* This development engendered a state of society designated as "harmony"—the name Owen gave to his experimental community in Indiana and the title of the all-embracing phalanstery of Fourier.

While Kropotkin rejected the phalanstery as a delimiting concept, he warmly embraced Fourier's call for congenial work for all its members.[54] Here Kropotkin alluded to Fourier's theory of the passions that furnished the basis to his social system. It implied an organization capable of giving each member the power to choose and vary his or her own destiny and life pursuits untrammeled by social restrictions. The era of Harmony consisted of a social order in which men and women freely obeyed the dictates of their passions. Fourier claimed that work could become appealing and that conflicting tendencies harmonized when particular personality types were united into groups and series of groups where differences in age, wealth, character, and education were carefully screened and contrasted. He named the instinctual drives that motivated each type "passionate attraction" and the organization and nuancing of these diverse personalities the "passionate series." There were twelve basic passions and approximately 810 possible combinations that would play a role in promoting social harmony within the phalanstery.[55]

Fourier's ideal association was not a grouping together of like-minded people, but

one in which differences were maximized and capable of many novel combinations. Indeed, contrast and antipathy were essential to the successful operation of a series, and the potential for social conflict channeled into activities for the realization of the common good. He called the art of creating passionate ties between members of classes that appear to be essentially antagonistic his theory of *ralliements*. This was facilitated by his allowing former class distinctions to be preserved in Harmony, although these counted for very little in the everyday life of the community.[56]

Fourier claimed to have invented a new science known as "Analogy" which would aid in the discovery of new medecines, explain the laws of outer space, and solve complex problems in physics.[57] This science facilitated his own insight into "cette grande énigme du mécanisme d'harmonie des passions." Harmony is passionate attraction discovered by the science of Analogy: "Now if Attraction is God's agent for the direction of the material harmonies of the universe, it must, according to analogy and the unity of system, be the agent for good for the direction of social harmonies." Fourier's theory of analogy sprang from his belief that everything in the material universe was a hieroglyph of, or had a correspondance in, the passionate universe. Each of the twelve passions, for example, had its own color, musical note, geometrical form, and celestial body. Similarly, every life form and mineral species had its analogue in a human character trait, institution, or social relationship. For examples, Dogs represent friendship, cats self-centeredness, the rooster the worldly male, the flower of the hydrangea coquettery, and the iris marriage. All of the differences and antipathies in the passionate universe are united through analogy, hence Fourier's definition of his system as the "emploi harmonique des discords."[58]

Here is a primary source of Seurat's famous theoretical formulation: "Art is Harmony. Harmony is the analogy of contraries." This helps clarify the combination of the various social types, age groups, and activities, as well as the geometries of the wet-nurse and her companion in the middleground and the clear analogy between the curve of the monkey's back and the woman's bustle. In addition, the butterfly, rarely mentioned in the literature but occupying a key location, may also allude to Fourier. One of the three key distributive passions, mainsprings for the operation of the other nine, was the *papillonne*.[59] The order of the phalanstery took cognizance of the reality that many of its members, like butterflies, would, given the opportunity, flit from one occupation to another to escape boredom. This *"papillonne"* drive would be satisfied by allowing for frequent changes of tasks and of relationships.[60] In Seurat's painting the butterfly hovers near a woman seated in the grass with an array of accessories—novels, newspaper and fan—to keep herself variously occupied all afternoon.

In Fourier's Harmony women were to enjoy full and equal rights, and to enjoy perfect freedom and self-expression. Fourier laid down as a general proposition: "Social advances and changes of periods are brought about by virtue of the progress of women towards liberty, and the decadences of the social order are brought about by virtue of the decrease of liberty of women."[61] His program appealed to strong intellectual women such as Flora Tristan—Gauguin's grandmother and a militant feminist—and George Sand. Consistent with Fourier's system of passional attraction, he did not defend his feminist position on the basis of women's similarity to men; instead he

stressed the variety of psychological and physical gradations, tastes, and inclinations that female freedom will contribute to the synthesis of the passionate series.[62]

Like Fourier, the anarchists championed the cause of women in the nineteenth century and enjoyed the affiliation of Louise Michel, the outspoken feminist hero of the Commune, and Séverine (Caroline Rémy Guebhard), who in 1884 assumed editorship of the independent radical newspaper *Le Cri du Peuple*. The later theoreticians of anarchism also held out to women the opportunity of participating actively in a movement for gender equality and universal solidarity. Although there was one strain of anarchist misogyny stemming from the influential writings of Pierre-Joseph Proudhon, many of his successors bracketed off this aspect of his work.[63] Naturally, actual anarchist practice in fin-de-siècle France was not always consistent with anarchist theory, but as a matter of principle the movement endorsed equality for women.[64] In 1886 Grave wrote that "in anarchy there are neither men nor women, but only human beings each enjoying the fullness of their rights."[65] He went on to amplify his position in his *L'Individu et la société* (1897): "Woman is the equal of man; woman is a human being who has a right to satisfy fully all of her singular mental and physical needs; the absolute right to dispose of her being as she wishes, to develop it to its fullest potential; that is the right and duty of every being, male or female."[66] Signac was critical of Strindberg's drama, *The Father*, because of what he perceived to be its anti-anarchist bias regarding women. Marriage, according to this intimate friend of Seurat, should consist of two equals, the paradigm of anarchist society.[67]

In Seurat's *La Grande-Jatte* the presence of many unchaperoned women engaged in a variety of activites attests to the influence of feminism on his thought. Although the absence of males is explained by the fact that some had to work that day, it is noteworthy that even when women are shown next to men they occupy a space apart, as with the seated reader. Especially striking is the pair fishing at the water's edge, unmistakably working-class women engaged in a pastime that might net them supper. This detail is seen as all the more impressive when we compare it with an official Salon painting of the period treating the theme of fishing, in which the female is the passive participant doting on the male's skills (fig. 137). Recently, Richard Thomson identified the women fishing and the wetnurse with standard erotic humor of the period; but although it was commonplace to juxtapose buxom wetnurses with flirting soldiers and pun on *pêcher* (to fish) and *pécher* (to sin) none of this seems to me to be relevant to the Seurat.[68] Nothing in the actual relations of the park crowd suggests prostitution: the dignified bearing of the woman with the monkey, the stolid geometry of the wetnurse, and the fisherwoman are totally self-contained in their own mental and recreational space. The military cadets of Saint-Cyr remain a goodly distance from the nurse, and no male approaches or gazes at the woman holding the fishing rod. Seurat's preliminary studies for the painting show that he did in fact see such a figure on the shore of the island, but she is represented alone and absorbed in her own world. If anything, Seurat has de-eroticized the afternoon encounter in the park to stress the self-enclosed character of each figural activity.

Thus several essential principles of anarchism, the accentuation of individual differences, feminism, the absence of authoritarian control, an organization of society based

137. *La Pêche*. Wood engraving reproduced in *L'Illustration*, 1875.

on mutual agreement, were all to be found, as Kropotkin himself claimed, in Fourier.[69] The anarchist's revival of his precepts as well as those of other early social reformers was stimulated by the most decisive event in their lives: the Commune. Every March 18th anarchists in France and throughout the world commemorated it. Despite its failure, the principles it stood for and its fusion of multiple ideological strains became a model of revolutionary change for Kropotkin, Grave, Reclus, and of course, for Marx, whose *Civil War in France* drew different conclusions but similarly vindicated it as a revolutionary model.[70] All understood the Commune as a world historically significant moment in the history of civil change. For all four again it resurrected positive

memories of 1848 and the June uprising of the militant working classes of Paris. In 1871 the theoretical ideals underlying the class struggles of 1834 and 1848 revived, just as the pioneer social reformers—Saint-Simon, Owen, and Fourier—had themselves been impelled to their investigations of the contradictions of bourgeois society and the transitory nature of this society under the impact of the French Revolution of 1789 and the Napoleonic wars.

No matter where Kropotkin, Reclus, and Grave begin in their writing they almost inevitably recall June 1848 and March 1871. (Kropotkin's memoirs even close on a note of prayer for a revolution as widespread as in 1848.) Kropotkin recalled that the whole-sale destruction of June workers effaced socialist literature and ideas so that the names of the reformers, once so familiar before 1848, vanished without trace. Ideas that were commonplace of socialists before 1848 "were so wiped out as to be taken, later on, by our generation, for new discoveries." These ideas revived at the end of the Second Empire, and while the brutal repression of the Commune again thwarted the "free development of socialism in France" the theories of the French forty-eighters took a step forward. The Commune demonstrated to the working classes after 1871 that "free agro-industrial communes, of which so much was spoken in England and France before 1848, need not be small phalansteries, or small communities of 2000 persons. They must be vast agglomerations like Paris, or, still better, small territories."[71] When control of the Republic passed to a parliamentary majority of republicans in the late 1870s, socialist activity stepped up, and, invigorated by the return of the exiled communards stimulated renewed interest in the theories and heroes of 1848.[72]

The social and political context in which Seurat came to define his life work was decisively affected when he was eleven years old by the crushing defeat of France by Prussia in 1870 and the devastating civil war in the spring of 1871. For French people generally the accumulated impact of these successive traumas and the abrupt end of the Second Empire left a permanent scar on the national psyche. The massive destruction of the environment and the rapid succession of unstable governments could not have failed to leave their impress on Seurat's generation and their developing sense of calling. His friend, Jean Ajalbert, poet, lawyer, and anarchist, was seven years old at the time of the siege and the Commune, and he remembered the famine and the nightmarish horror:

> The Commune is, for me—when I hear "Revolution," hear of civil war always happening, in Russia, in Spain—the ineradicable image of a red night when I am screaming in horror, terrorized; soldiers in front of my bed, pushing my mother, dressed only in petticoat and camisole, her legs naked, jabbing a bayonet into my mattress by the light of stable lamps.[73]

The Versaillais had been looking for his father (who had escaped in time), a peasant from Auvergne who owned some livestock that he slaughtered for food at the behest of the Communards, and this made him suspect to the Versaillais.

When Ajalbert reviewed Seurat's *La Grande-Jatte* he was attracted to its stripped down qualities, lauding its elimination of the superfluous: "he leaves out the affectations, the accessories, and the frills, and gives us a schema—a very suggestive one." It

138. Walter Crane, *To the Memory of the Paris Commune, 1871*. Engraving, 1871. By Courtesy of the Board of Trustees of the Victoria & Albert Museum, London.

was its feeling of salubriousness, its sense of well-being that appealed to him, giving "the impression of the intense life that flows out, on Sundays in summer, from Paris to the outskirts of the city." Ajalbert responds to Seurat's restructuring of human society and the picture's utopianism that emerges unexpectedly out of "the dots of color."[74]

The political and aesthetic imagination of their mutual friend Fénéon, who saw in *La Grande-Jatte* a "modernizing Puvis" (that is, a rethinking of Puvis de Chavannes' pastoral utopianism in the light of modern science and progressive social insight), also had been shaped in part by the experience of the Commune. When he was being arraigned on charges of anarchist activities in 1894, his mother placed Walter Crane's print dedicated to the Paris Commune at the head of a dossier she kept on the unfolding anarchist conspiracy trial (Trial of the Thirty) in which her son was one of the defendants (fig. 138).[75] In 1897, to commemorate the twenty-sixth anniversary of the founding of the Commune, Fénéon published in the *Revue Blanche* a series of responses by surviving witnesses to, and participants in, the Commune to a questionnaire that he drew up (illustrated with Crane's print among others). His third question attests to his sense of the impact of that event: "What in your opinion has been the influence of the Commune, then and since, on events and ideas?"[76] Several of those surveyed answered that it definitely saved or made possible the Republic, while permanently discrediting bourgeois society as a force for progressive social change. Jean Grave answered that the Commune "synthesized all the proletarian aspirations and

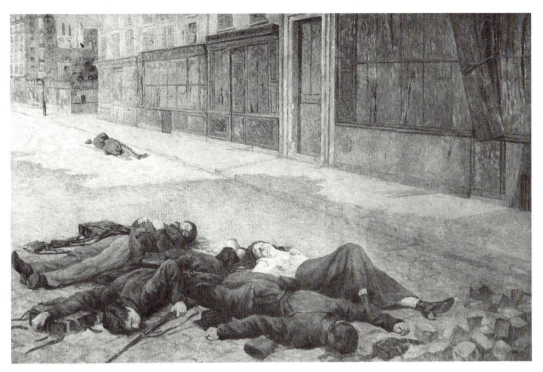

139. Maximilien Luce, *A Paris Street in 1871*, 1904–1905. Musée d'Orsay, Paris.

gave a stimulus to the movement of ideas of which the present generation is the ulti-
mate product."[77]

Grave's friend, Maximilien Luce, another affiliate of the Neo-Impressionist move-
ment and a radical political activist who contributed his talents to the anarchist news-
papers including *La Révolte*, was thirteen years old when the Versaillais launched their
brutal reprisals in the working-class district behind the Gare Montparnasse where his
family lived. His adolescent imagination was indelibly scarred with the memory of
these episodes which haunted his entire adult life. He conceived of painting a series of
images consecrated to the theme, but it was not until many years later that he could
finally put on canvas the nightmarish scenes that haunted him. He exhibited his mon-
umental (five by seven feet) *A Paris Street in 1871* at the Salon des Indépendants of
1905, an eerily deserted street scene in which several Communard corpses, including
one woman, are shown fallen behind their barricade (fig. 139). Although based on re-
portorial illustration from the period (figs. 140, 141), Luce's treatment of the street
with its long plunging perspective, shuttered anonymous store-fronts and absence of
life seems to freeze the scene into a silent dream-like vision. The fallen insurgents
appear in a state of suspended animation, more asleep than dead, and as illumined by
Luce's vivid light and colorations seem ready to awake from their temporary state of
immobility and rise again to take their place behind the barricade.[78]

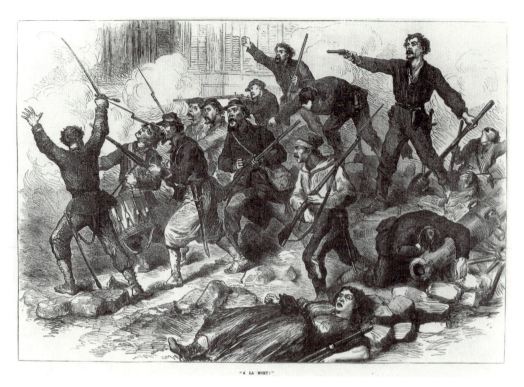

140. "A la Mort." Wood engraving reproduced in *The Illustrated London News*, 10 June 1871.

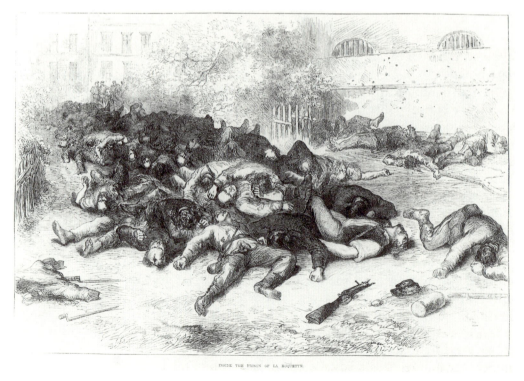

141. *Inside the Prison of La Roquette.* Wood engraving reproduced in *The Illustrated London News*, 17 June 1871.

There is no doubt of the traumatic effect of the Commune on Seurat and his family. During this period, his family fled the apartment on the Boulevard Magenta and sought refuge in Fontainebleau.[79] They returned only to find that the street had been the site of some of the most bitter fighting of Bloody Week and had sustained heavy damage. Barricades had been erected along the boulevard at the intersections of the rue de Chabrol and the Boulevard de Strasbourg.[80] The park of the Buttes-Chaumont was in a shambles; like all the parks of Paris, it had been stripped of its trees for scarce firewood by the desperate working-class inhabitants of nearby Belleville. In addition, its limestone grottoes had served as magazines for arms and supplies, and its hills for the emplacement of the communards' artillery. During the Prussian siege one grotto storing oil and other inflammable substance ignited and sent a roaring fire sweeping through the park. Finally, the Buttes-Chaumont was the scene of summary executions of communards by the troops of Versailles and the victims remained in a ditch for sometime after the Commune had been thoroughly crushed.[81] The irony of the destruction of the Boulevard Magenta and its vicinity after Haussmannization a decade before would have been staggering for the family and their neighbors.

The keen torment of bourgeois Parisians in the face of the abrupt cessation of prosperity and the rebuilding of Paris is seen most vividly in the publication of Victor Fournel's *Paris et ses ruines en mai 1871* (1872). The cynical critic of Haussmannization before 1870 now lamented the passing of the old order and cursed the vandals of the Commune who crumbled into dust the "splendor" of the monuments and boulevards created by the Second Empire (figs. 142, 143). Fournel glimpsed the tragic irony in the dismantling of Haussmannian Paris and the laying waste to its urban renewal by the pestilential onslaught of bombardment, siege, and finally civil war. For him it was retribution for the corruption of Napoleon III, but while he believed that Bismarck and Moltke had aimed from the start at destroying Haussmann's Paris, he had worse things to write about the "depraved professors of civil war and anarchy" who brought Paris to its disastrous end with the "now dishonored name of the Commune." They took up where the Prussians left off, continuing the "brutal and systematic destruction" and leaving in their incendiary wake a city in ashes.[82]

The previous chapters have already shown to what extent these social and political attitudes affected the initial reception of the Impressionists. There was a widespead appeal for order and reconstruction, to restore things as they were before and get back to normal. This is the message of Fournel's book. After retracing the devastation, Fournel tried to recapture the image of Paris when it was the envy of the entire world at the time of the Exposition Universelle of 1867. He lauds the administration of Thiers for rebuilding even Bonapartist monuments such as the Vendôme Column. Seeing the stirrings of a marvellous resurrection, he adds: "Now it remains only to wash away the blood, to erase the traces of battle, to dress the wounded, to bury the dead, to raise up the ruins, to bring about a rebirth of order, security, work, to repair the disasters of the two sieges."

Fournel was especially distressed by the devastation caused by the Commune to the parks and the promenades that Parisians visited Sundays in the northwestern suburbs especially Asnières, Levallois-Perret, Courbevoie, and Neuilly-sur-Seine—all sites that

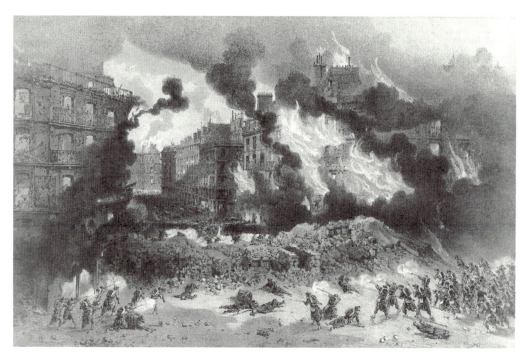

142. Sabatier, *Rue de Rivoli*. Lithograph reproduced in Fournel, opp. p. 75.

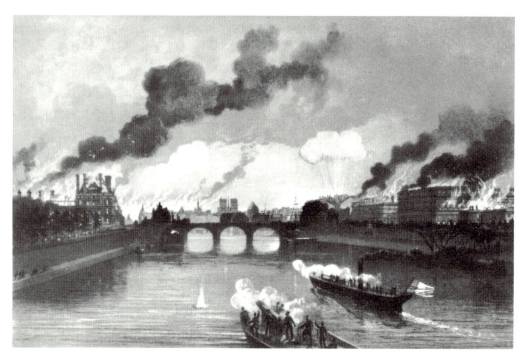

143. Sabatier, *Paris Burning*. Lithograph reproduced in Fournel.

retained the scars of this event and were to be incorporated into Seurat's major works.[83] Although Fournel does not refer specifically to the Grande-Jatte within this zone, it served as a strategic site for both the Communards and the counter-insurgency and was violently contested during the Commune.[84] Ironically, "This agglomeration of small towns which border each other and seem to form one city, had enjoyed complete security during the Prussian siege: but they became the arena of the fiercest struggle of the Commune. Ruins upon ruins,—here in two words sums up the state in which one came upon them after the battle." For the inhabitants of Neuilly, especially, forced to hide in the cellars and reduced to famine, the war between French people "went beyond even the rigors of the Prussian siege" (figs. 144, 145).[84]

Seurat's *Une Baignade* of 1883–1884, representing newly reconstructed factories and bridge, would seem to be complicit with the early Third Republic obsession with the restoration of the old environment (figs. 146–148). The view in the picture is northeast along the left bank of the Seine towards the railway bridge (spared during the two sieges) which just allows for a glimpse of the piers of the new pedestrian bridge (destroyed in 1871) paralleling it, with the chimneys of the huge nearby gasworks (also damaged during the Commune) of Clichy in the distance and the edge of the Ile de la Grande-Jatte just glimpsed at the right. The monumental figures resting on the bank or bathing are workers from the local factories on their lunchbreak. This unprecedented focus on the recreation of working-class persons not only foreshadows some of Seurat's thematic concerns in *La Grande-Jatte*, but also attests to his anarchist projections and his departure from the ideological predisposition of the Impressionists.[85]

Unlike the Impressionists, Seurat confronted the ruins of the Commune with the same sense of reconfiguration. His study of the remnant of the Tuileries in 1882 gives it a stateliness and order that would have been anathema to Fournel and the Impressionists (fig. 149).[86] It may be recalled that Monet's *The Tuileries* deliberately occults the ruined parts of the palace to make it blend harmoniously with his image of restoration and regeneration.[87] The older generation wished to efface the memory of the past and get on with their lives, while the younger generation wanted to aid in the formation of a new order on the ruins of the old. The Post-Impressionist edifice meant more than simply supplying a rational foundation to the aesthetic improvisation of their predecessors, but also implied a different set of social and political objectives as exemplified in Seurat's *La Grande-Jatte*. Hence Pissarro, a much older man but a deeply committed anarchist, joined the circle around Seurat and converted to Pointillism in the 1880s. Impressionism had reached a dead end with the contemporary social and economic crisis and Pissarro needed the input of the younger, more politically active, generation.[88]

The desire to contribute to the regeneration of society was prevalent among intellectuals of Seurat's generation. They reached maturity in the first years of the Third Republic, at a time when that fragile government was beset by a variety of tensions and crises, and they hoped to contribute to the reestablishment of a profoundly shaken social order. This is most striking in the case of a thinker who was almost Seurat's exact contemporary: Emile Durkheim, the founder of modern sociology and preeminent student of social structure. Durkheim was born in 1858, one year earlier than

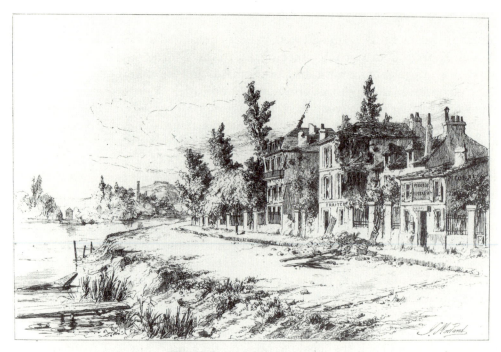

LES BORDS DE LA SEINE A ASNIÈRES

144. V. A. Morland, *Les bords de la Seine à Asnières*, 1871. Lithograph reproduced in Morland, *Les environs de Paris après le siège et la guerre civile*, Plate 27.

LA GARE D'ASNIÈRES

145. V. A. Morland, *La Gare d'Asnières*, 1871. Lithograph reproduced in Morland, Plate 24.

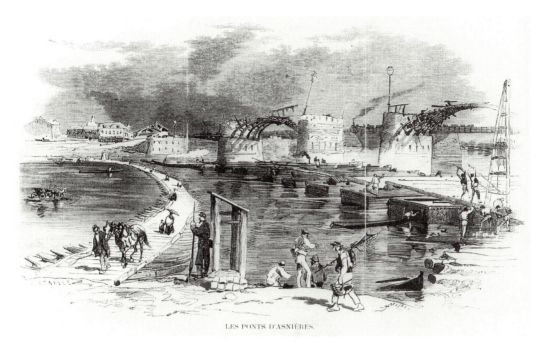

146. *Les Ponts d'Asnières*. Wood engraving reproduced in *L'Illustration*, 1871.

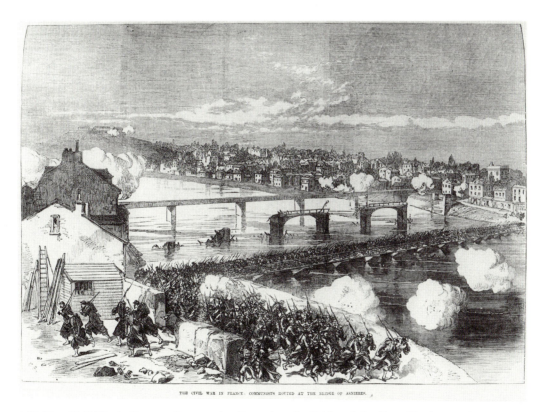

147. *The Civil War in France: Communists Routed at the Bridge of Asnières*. Wood engraving reproduced in *The Illustrated London News*, April 29, 1871.

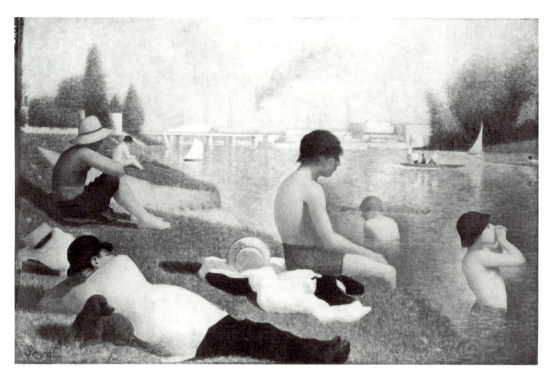

148. Georges Seurat, *Une Baignade, 1883–1884.* National Gallery, London.

149. George Seurat, *Les Ruines des Tuileries*, c. 1882. Private Collection, Switzerland.

Seurat, and exhibits several interesting parallels with the painter. He experienced directly the impact of the Franco-Prussian War when his hometown Epinal was occupied by Prussian troops. The event left an indelible impression on his evolving sensibility. As an adult, Durkheim dreamed of rebuilding a sense of community disoriented in the wake of the Franco-Prussian War and Commune. He wanted to teach "a doctrine, have disciples and not just students, play a role in the social reconstitution of a France wounded in defeat." While rejecting anarchism and socialism for himself, Durkheim was preoccupied throughout his life with major reforms of the social and economic order.[89]

At the Ecole normale in 1879, when Seurat was studying at the Ecole des Beaux-Arts, Durkheim explored the writings of Fourier, Proudhon, Saint-Simon and his disciple Auguste Comte, the founder of positivism and the inventor of the term "sociology." Although he published his most important work, *De la division du travail social*, only in 1893 he planned it and completed the first draft of it between the years 1884–1886 when Seurat was working on *La Grande-Jatte*. Largely optimistic and deterministic, the work centers on the problem of social order and assumes that the division of labor—here conceived as the specialization of individual talent rather than the breakdown of the work process itself—always involves a proportionate increase in social solidarity. Social solidarity "is characterized by a co-operation which is automatically produced through the pursuit by each individual of his own interests."[90]

Durkheim distinguished between mechanical solidarity and organic solidarity. The first stems from acceptance of a common set of beliefs and customs, while the latter arises from functional interdependence in the division of labor. Mechanical solidarity presumes identity between individuals in a society where the pressure to conform is powerful, whereas the higher form of organic solidarity presupposes differences between individuals in their beliefs and actions. Hence organic solidarity—based on the increasing division of labor—promotes a social cohesion of individual units exhibiting the kind of symbiotic relationship that the organs of the body have to one another. As he put it in his study of Saint-Simon and socialism: "humanity must strive towards a state in which all its members, cooperating harmoniously, unite in order to exploit the globe together."[91] While he believed in the state institution to protect individual rights, his solution to the danger of a repressive state also resembled anarchist doctrine. It is not the division of labor as such but the *forced* division of labor that generates social tensions and a condition of *anomie*. People must not be pushed into occupations at variance with their natural talents. Social harmony results from a cooperation that is automatically produced through the pursuit by each individual of his or her interests. Arguing against state control which led to atomization, he advocated decentralization through the formation of communal associations with a high degree of autonomy organized around occupations and industries. They would resolve conflicts both within their own membership and in relationship to other occupational groups; and they would be the focus for a variety of educational and recreational activities. Finally, they would play a direct role in the political system and stand between the coercive state and the individual.[92]

This brings us to a consideration of Durkheim's concept of *anomie* , a condition resulting from the atomizing effects on society of modern life, and Seurat's seemingly detached figures which many critics perceive as robotic and depersonalized. The most outrageous critique in this category comes from Ernst Bloch of the Frankfurt school, who refers to the painting in several places in *Das Prinzip Hoffnung* as a kind of inauthentic utopia. Denouncing Seurat's "Puppen aus der Spielzeugschachtel," Bloch explains:

> Dies Bild ist ein einziges Mosaik von Langeweile, ein Meisterstück des Sehnsüchtig-Ungelungenen und Abstandhaften im dolce far niente. Das Bild schildert bürgerlichen Sonntagmorgen auf einer Seine-Insel in der Nähe von Paris, und eben: es schildert nur noch auf höhnische Weise. Leeren Gesichts ruhen Figuren im Vordergrund, die Gruppe der übrigen bildet in der Hauptzahl hölzerne Vertikalen, gleich Puppen aus der Spielzeugschachtel, intensiv mit starrem Lustwandel beschäftigt. Dazu der bleiche Fluss, mit Segelbooten, Ruderregatta, Vergnügungsdampfern, ein Hintergrund, der trotz seines Vergnügens eher dem Hades als der Sonne anzugehören scheint. Lauter glückloses Nichtstun ist in dem Bild, in seinem hellmattwässrigen Raum, in dem ausdruckslosen Sinnens. Schlaraffenland auch hier, doch so, dass mit der Arbeitswelt jede Welt, ja jedes Objekt ins Wässrig-Laue zu schwinden scheint. Die Folge ist bodenlose Langeweile, kleinbürgerlich-höllische Abstands-Utopie vom Sabbat im Sabbat selbst; der Sonntag gerät nur noch als gequälte Forderung, nicht mehr als kurzes Geschenk aus Gelobtem Land. Solch bürgerlicher Sonntagnachmittag ist die Landschaft des gemalten Selbstmords, der nur deshalb keiner wird, weil ihm auch noch die Entschiedenheit zu sich selber fehlt.[93]

The picture is an entire mosaic of boredom, a masterpiece of unsuccessful yearning and the paradoxical distancing inherent in dolce far niente. The picture represents a middle-class Sunday morning on an island in the Seine River near Paris, and this is just the point: it represents it in a merely mocking manner. Empty-faced people relax in the foreground; the majority of the others have been pressed into wooden verticals, looking like dolls from the toybox, intensely caught up in a transfixed promenade. Add to this the pallid river with sailboats, a scull regatta, pleasure boats—a background that, despite the apparent good time had by all, may be assigned to Hades rather than to the sunlit world. Sheer joyless idleness is the content of the picture, in its bright matt watery atmosphere, its expressionless contemplation. Although appearing in the guise of Utopia, it is presented in such a way that the work-a-day-world, all the world, even every object, seems to fade away into the watery indifference. The result, then, is bottomless boredom, petty bourgeois hellish distancing Utopia from Sabbath on the very Sabbath; Sunday becomes mainly an imposition, a burdensome requirement, nothing more than a brief gift from the Promised Land. This kind of middle-class Sunday afternoon is the landscape of painted suicide which actually never comes off because, to put it simply, it lacks the resolve to do so.

This astonishing assessment seems to have been inspired by a Durkheimian night-mare, a description of the visualization of an anomic state that Bloch would be tempted to call "the landscape of painted suicide" were it not for the picture's lack of decisiveness.

Bloch's intriguing analysis, which drags in all the right terms only to pulverize the subject, thoroughly missed the point. Karl Werckmeister has shown that Bloch's ideo-logical predisposition got in the way of a historical decoding of the picture. Bloch ne-glected Seurat's scientific and classicizing approach to Impressionist themes, and failed to grasp that the figures were deliberately stylized in an antique mode to create a "timeless" image of modern life. Bloch reads the hieratic stylization erroneously as symptomatic of the incapacity of the bourgeois to act spontaneously and to genuinely enjoy their Sunday promenade. Bloch used the criterion of social realism to judge the work, inappropriate for the experimental character and synthetic stylization of Seurat's composition.[94]

Werckmeister, however, goes too far in rejecting Bloch's content analysis and de-scribing the monumental painting as "ein perfektes Beispiel des symbolischen *l'art pour l'art*." Bloch is closer to the mark in seeing it as a representation of an elaborate iconographical program, although he inverts the original signification of the painting. Here Meyer Schapiro's trenchant description sets the work in its proper perspective:

> The space is endlessly peopled, without that closed hierarchy of figures set off on a narrow stage of the foreground which is so common in the tradition of French classicism. In the Grande Jatte the dominant figures of the foreground are not superior to, or different in kind from the more distant and accessory persons. The rigidity of their individual postures does not entail or follow from their submission to a transcending formal scheme, like symmetry or triangulation. They are an aimless assembly, people who have come together independently, each occupied with his own private recreation or repose in a common sunlight or shadow.[95]

I disagree with Schapiro, however, when he writes that the figures on the island "do not know or see each other, and have their unity of movement or of being only in the common site and the common relaxation." The experience in the park comprises com-munication through ritual gestures, a coding of behavior that is generally non-verbal. Each character in the painting conveys through his or her gesture bits of information about his or her self-conception. These social attributes are there because they were meant to be witnessed, and if there seems to be a sense that people are not quite conscious of the communication they are receiving, what is more important is that none of the figures acts as if something is amiss or that something uncustomary is being played out. Even the outrageous monkey on a leash is accepted in a deadpan way. Seurat's park permits personal disinvolvement, engagement, or self-involvement, whatever is appropriate for the strollers at that moment. It is preeminently a scene of tolerance, non-competitiveness, and absence of conflict, the opposite of the key re-quired to represent "the struggle between the Horatii and the Curiatii." Seurat depicts the realm of an unfocused interaction where no single participant occupies the official center of attention and where every viewpoint, orientation, and preference is tolerated.

In *La Grande-Jatte* the autonomy of the figures is derived from the physical structure of the canvas itself. They are constituted out of the units of pigment, determined by the laws of the physical universe they inhabit. Its sociological justice and aesthetic harmony are, to paraphrase Signac, one and the same. This integration of theme and execution represents the core of Seurat's methodology, based as it is on the model of the natural sciences to ensure a degree of objectivity and independence from bourgeois convention and thus make a permanent contribution to the regeneration of society.

Here again the aims of Seurat and Durkheim parallel one another. Their models were drawn from 19th-century physics, chemistry, and biology—especially evolution. For Durkheim human beings could not improve their society unless they took themselves as objects of science. The sociologist had to treat social facts as material things, assimilating to the realities of the empirical world those of the social world. To treat social phenomena as things was to treat them as *data*, and this constituted the starting point for the science of sociology.[96] Since statistical techniques were barely developed at the time, Durkheim had to invent them as he went along. His approach was analogous to Seurat's methodology which both tested in their research. That their work would have to be added to and revised they understood very well, since they saw what they were doing as a collective undertaking whose findings would be handed on to successive generations.

They were encouraged in their undertaking by the aims of the anticlerical Third Republic which sought secular substitutes for religious authority and looked to science as an instrument to bring the unruly elements of society into harmony with the dominant ideology.[97] Major scientists such as the organic chemist Marcelin Berthelot and the physiologist Paul Bert were appointed to key administrative posts. Bert quit his work on respiration for the government post and became a leading spokesperson for the secularization of the state and of social life. Bert also actively supported colonization and ended his life as governor of Indo-China. Like his colleagues, he saw laicization and colonialisation as related components of the wish to regenerate France on the basis of modern science. Charles Henry, the mathematician whose ideas were to exercise a profound influence on Seurat's later work, had been a disciple of Bert and Bert's teacher Claude Bernard. Indeed, it was under the auspices of the Ministry of Commerce, Industry, and the Colonies that Henry published his *Instruction sur les harmonies de lumière, de couleur, et de forme* in 1891 for use in technical drawing schools.

Recently, Seurat's pseudo-scientific methodology has been called into question by John Gage and Alan Lee.[98] Their questioning of Seurat's theory and attempt to disentangle the erroneous assumptions of Seurat and the misunderstandings of the critics from the facts as we now know them is a valuable addition to the literature. But if Seurat did indeed fail to grasp some of the more abstruse principles of physics, there can be no doubt that he attempted to develop a scientific method of painting. Both Gage and Lee agree that his paintings were "experiments," but Gage wants to remove them from the "positivist and materialistic" temper of the time and attribute them to an "imaginative leap," while Lee claims that Seurat failed to see his paintings as "experiments, and that as such they stood to refute his theories."

These are clues to the hidden agenda of the two writers: Gage wishes to divest

Seurat's work of the stigma of "scientific" thinking; Lee wants to free science from the stigma of Seurat's painting. Seurat's own response to a misinterpretation of his work contradicts them both: "They see poetry in what I have done. No, I apply my method and that is all there is to it." And he continually tested and developed his method, as demonstrated in his application of Henry's principles on expression and harmony in paintings subsequent to 1887. His process exemplifies the theoretical extrapolation of the scientific method from individual sciences by making extensive use of the principles of analogy and comparison.

The most important source of Seurat's interest in science and its primacy in his work is anarchistic philosophy. The success of Marx's "scientific socialism" has tended to relegate the anarchists to the utopian category which seriously distorts the extent of their commitment to a scientific understanding of social transformation. Yet the leading theoreticians of the movement, Kropotkin and Reclus, were trained scientists and made critical contributions to geography and geology.

Reclus wrote Bakunin in 1875 that even if the spirit of French civilization were to disappear there would remain something better than that in "Darwinian evolution, the study of the conservation of energy, and comparative sociology."[99] Darwin profoundly influenced the thinking of the anarchists who labored hard to rescue it from the clutches of the Social Darwinists and the Spencerians. Kropotkin's *Mutual Aid: A Factor of Evolution*, supported by voluminous documentation based on biological observations, contradicted the "struggle for existence" thesis in showing that the instinct for cooperation within a given species is far more decisive for its survival. Kropotkin pointed out that in the *Descent of Man* Darwin recorded that in numberless animal societies where there are sufficient resources the struggle between individuals disappears and is replaced by cooperation. In such cases, the fittest are not the physically strongest or the cunningest, but those who learn to combine for the mutual support of all for the welfare of the community. Thus anarchism proves to be in accordance with the conclusions arrived at by the theory of evolution.[100]

The great appreciation of the anarchists for animal life derives from their understanding of Darwinian theory as well as from Fourier's theories of analogy. Reclus wrote to his friend Richard Heath in 1884 that he did not exclude animals from the anarchist community, that he "embraced also animals in my affection for socialist solidarity." And in a letter to Heath the following year he reiterated the statement and admitting that he thoroughly believed that "dog and cat are my brothers."[101] Kropotkin often invoked as models for his ideal society the communities of certain animals and insects.

Here I believe is the explanation of the presence of the animals in Seurat's painting including the striking monkey on the leash.[102] The Darwinian thesis had furnished contemporary cartoonists with a rich repertoire of satire, and no doubt there is a comical element in Seurat's visual rhyme of the animal's back and the woman's bustle (fig. 150).[103] But the monkey is there as well to evoke the Darwinian connection to anarchist philosophy. One French translator of Darwin's Origin of the Species ridiculed outraged critics for identifying "perfected monkeys with degenerate Adams," but Seurat depicts the primate very much at home in Eden.[104]

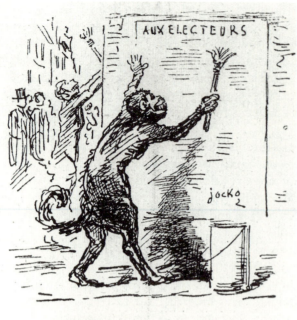

CONSÉQUENCE DU SYSTÉME DARWIN
Les singes se portant aux prochaines élections.

150. Cham, *Conséquence du système Darwin. Les singes se portant aux prochaines élections.* Wood engraving reproduced in *Le Monde illustré*, 1878.

Seurat knew Darwin at first hand from his studies with Mathias Duval, a disciple of Claude Bernard who taught anatomy at the Ecole des Beaux-Arts.[105] A follower of Duchenne and Darwin, Duval carefully analyzed physiognomic expression in humans and animals with the aid of Duchenne's photograph collection at the Ecole.[106] Darwin himself had used Duchenne's illustrations of facial expression to make his case, a fact that Duval noted with Gallic pride. Darwin wished to show in his *Expression of the Emotions in Man and Animals* of 1872 (translated into French 1874) that animals have an emotional life akin to that of humans, a similarity explainable by evolution. In his section on monkeys Darwin noted that their expressive actions are "closely analogous to those of man." And he cited a case related to him by Duchenne:

> Dr. Duchenne—and I cannot quote a better authority—informs me that he kept a very tame monkey in his house for a year; and when he gave it during meal-times some choice delicacy, he observed that the corners of its mouth were slightly raised; thus an expression of satisfaction, partaking of the nature of an incipient smile, and resembling that often seen on the face of man, could be plainly perceived in this animal.[107]

Anarchists believed they not only followed a course traced by evolution but that they followed the method of induction in such natural sciences as physics, chemistry, physiology, anthropology, and sociology. They especially loved to invoke the metaphor of the molecule and cell in relationship to the body, each of which had independent exis-

tences and yet were simultaneously dependent upon each other. In an era swept away by the discoveries in natural science, Durkheim could refer to the "social molecule," and elsewhere write: "The living cell contains nothing save chemical particles, just as society is made up of nothing except individuals." But anarchists went further in emphasizing the "sociability" of autonomous cells and molecules in making up the aggregate.[108]

Kropotkin described the shift in scientific thinking as an advance from the study of "the great sums" to "the infinitely small ones—the individuals of which those sums are composed and in which it now recognizes independence and individuality at the same time as this intimate aggregation." For example, when a physiologist

> speaks now of the life of a plant or of an animal, he sees an agglomeration, a colony of millions of separate individuals rather than a personality, one and invisible. He speaks of a federation of digestive, sensual nervous organs, all very intimately connected with one another, each feeling the consequence of the well-being or indisposition of each, but each living its own life. Each organ, each part of an organ in its turn is composed of independent cellules which associate to struggle against conditions unfavorable to their existence. The individual is quite a world of federations, a whole universe to himself.[109]

Closely related to this view of science was the development of atomic theory in France.[110] The atomic idea had an ancient history—matter had to have some corpuscular condition—but it remained to be expressed in purely scientific terms. While the first foundations of modern atomic theory were laid by the English chemist Dalton, the distinction between atoms and molecules was made only in the 1830s by Gaudin , a disciple of Ampère. Gaudin defined the atom as a little homogeneous spherical body, essentially indivisible, and molecule as an isolated group of atoms of whatever number and nature—a distinction not officially accepted by chemists until their international congress met at Karlsruhe in 1860 to settle questions of chemical nomenclature. But far more controversial were the theories of Antoine Laurent and Charles Gerhardt, the champions and originators of the atomic theory, and whose works became the starting point for modern organic chemistry. Gerhardt's experiments showed that all matter is comprised of molecules whose atoms are disposed in a determinate order. He based his atomic weights on the principle that the molecules of all elements in the vapor state are composed of two atoms, and while this was not true of certain metals it represented a major advance in the systematization of chemistry.

Gerhardt's adversaries argued that his theory was a metaphysical one; science—in the Comtean sense—should aim at equations connecting observable phenomena. Reality for them was hidden and inaccessible and they saw their task as one of classification. But Gerhardt's supporters (both Gerhardt and Laurent died before the Karlsruhe congress) believed that they could describe reality itself, that atoms and molecules were not mental abstractions but material objects which constituted veritable blueprints of nature. Their equations of composition were extended to the three dimensions of space in 1874 by the formulations of Van t'Hoff in Holland and Le Bel in France on the structure of the carbon atom.

Kroptokin wrote in *Modern Science and Anarchism* that the takeoff of modern science could be traced to the liberating impulses of the revolution of 1848. This is certainly true in the case of Laurent and Gerhardt who became staunch socialists in 1848 and supported the cause of the workers in June. Gerhardt wrote in 1850 that "republicans and socialists make one"—a unitary concept (*système unitaire*) identical to the one he had developed for organic chemistry and published the month the revolution broke out. He then associated this unitary movement with progress and compared its opponents to the old guard in science still tied to the classical theories of Lavoisier. In both the political and scientific realms there are two parties in France, "the past and the future." Gerhardt himself affiliated with the radical disciples of Fourier, Saint-Simon, and Comte, including painters and writers such as Chenavard, Couture, Toussenel, and Sue. He addressed them on the great possibilities of organic chemistry for future society, including the synthetic production of quinine, the recycling of tree bark for food, and other substances that would be synthesized in the lab.[111]

Ironically, those chemists who actively agitated against the conclusions of Gerhardt and Laurent were also political conservatives. J.-B. Dumas accepted the post of Minister of Agriculture and Commerce under the Second Empire and exercised an authoritative influence in the administration, while another adversary, Marcelin Berthelot, became a powerful figure in the Third Republic and proclaimed: "C'est le socialisme qui sera notre Némésis."[112] The opposition of Berthelot to atomic theory prevented it from being taught in elementary instruction until about 1890. Nevertheless, the association of political conservatism with opposition to the theory allowed political progressives to espouse it in the name of both scientific and social progress. One radical follower of Gerhardt, Edouard Grimaux, taught chemistry at the Ecole Polytechnique in the early 1880s, and was one of the most fervent adepts of atomic theory. His popular *Théories et notations chimiques* of 1883 prepared the educated public for the general acceptance of the theory and stimulated the work of a younger generation.

The notion that all matter is constituted of individuated particles that potentially are reconstitutable into new forms may be seen metaphorically as the micro complement of the concept of Haussmannization. The arrangement and rearrangement of the building blocks of matter could be seen as having a more fundamental impact on the material universe than the restructuring of the Bois de Boulogne. Seurat would have been exposed to these theories through his studies at the Ecole (where Louis Pasteur had taught for a time), and through his contact with Chevreul and Henry. It is not generally recognized, but Chevreul's main claim to fame related to his work in the field of organic chemistry. His most important work involved the study of fats and their general division into fatty acids and glycerin.[113] Gerhardt's close friend at the Sorbonne, Auguste Cahours, was a favorite disciple of Chevreul, and the two students collaborated on a paper on fats under Chevreul's direction at the chemist's lab in the Jardin des Plantes.[114] Although the distinguished Chevreul eventually identified himself with the opponents of atomic theory, his ongoing opposition guaranteed it a hearing and relegated him to the category of the conservatives.

The growing French acceptance of atomic theory may be seen in the translation of Hermann von Helmholtz's famous essay on the relation of optics to painting. It was

reproduced in Ernst Wilhelm Brücke's *Principes scientifiques des Beaux-Arts* of 1878 and was certainly known to Seurat.[115] In Helmholtz's discussion of atmospheric perspective and the effect of air on the light the physicist used various terms indiscriminately to describe the suspended particles of the air. He called them "feine durchsichtige Theilchen," "die trübenden Partikelchen," and "die Molekeln der Luft."[116] But the French translator consistently used "molecule" in every case: "des molécules fines," "les molécules de l'air," and "molécules flottantes."[117] Thus this seminal discussion of the relation between optics and painting would have informed Seurat of the concept of the molecular composition of the atmosphere.

Schapiro wrote that the "substance" of the figures in *La Grande-Jatte* "is perceived as a dense granular atomic matter like the total field with its particles of light."[118] Somehow this acute insight got lost in the voluminous literature subsequently devoted to the picture. Schapiro further noted that the individuated paint units, rather than create a fusion at a certain distance, have their own distinct character that draws attention to the painter's method. Thus the separate points hold their own within the general scheme analogous to the individual figures in their self-enclosed space—the visual equivalent of one of the central metaphors of anarchist philosophy. At the same time, Seurat discovered his own brand of "unified field theory" in which he harmonizes the potential macro reconstruction of Haussmann with the potential micro reconstitution projected by Gerhardt. And this he makes clear and accessible to spectators within the context of a narrative drawn from their own familiar experience.

Seurat's attempt to redo history painting on the basis of modern life involved his awareness of new political, sociological, and scientific possibilities to simultaneously develop unique human identities and mutual bonds. In this way he could realize Baudelaire's definition of the painter of modern life as someone who concentrates on "the passing moment and all the suggestions of eternity that it contains." Building on the fugitive scene of the Impressionists and the genre tradition, Seurat gave the whole the substratum of solemnity gleaned from the monumental tradition of history painting. The world envisaged by the anarchists, a world that was not utopian but could be realized immediately, was equal in grandeur to the great civilizations of the past. This was made possible by the immense transformations of matter and energy that modern science and industry was bringing about. Seurat makes his own painting, on both the micro and macro level, a paradigm of this possible future, thus fulfilling Kropotkin's Saint-Simonist- and Fourierist-inspired plea to artists to "tell us what a rational life would have been, if it had not been blocked at each step by the ineptitudes and ignominies of the present social order."[119]

Appendix: On Olin Levi Warner's Draft of a Speech in Defense of the Paris Commune

THE ORIGINS, evolution, improvisations, and final collapse of the Commune were observed with keen fascination by the international community. The memorable images of women and children neutralizing armed troops, of women, many of whom had sustained the worst hardships of the nightmarish Prussian siege, assuming a militant voice in all bureaucratic and political discussions, and even more astonishing, of theretofore powerless workers and petty bourgeois in a major metropolitan center taking control of administrative and institutional functions normally reserved for traditional elites, made the incident a compelling event in the development of modern society.

For the first time in the history of advanced industrial society working men and women, together with petty tradespeople, found themselves in command of the crucial decisions that affected the pattern of their daily lives and of their community. It was as if the American government and its minions, besieged by a foreign power, suddenly abandoned all of its official posts in Washington, D. C. and left the workers, the poor, and the disadvantaged to run things for themselves. Next imagine this harried, inexperienced body of men and women frantically operating the machinery of state while having to confront the displaced officialdom, now reconstituted as its sworn enemy in Alexandria, Virginia, with military resources stocked to capacity by the foreign power anxious to cut a deal with the old regime. In this novel scenario it might be expected that the energies of the beleaguered community would be almost entirely absorbed in their self-defense and physical survival. Astonishingly, however, the Paris Commune somehow found the time to elect committees to take up the issues of cultural survival as well, including basic educational reform, socially redeeming community entertainment and public art, and the preservation of the national treasures.

Almost anything accomplished under such unrelenting pressure and stress would seem to merit at least some praise and marvel from the contemporaries and later historians of all political persuasions, yet this has not been the case. With rare exception, the moderate liberal intellectuals of France and elsewhere almost unanimously identi-

fied with the "law and order" conservatives exiled in Versailles and the harsh suppression of their fellow citizens.[1] There was no end to the combinations of formerly incompatible bedfellows suddenly united by this perceived threat to their privilege and self-esteem. Bonapartists, monarchists, and republicans in France, Republicans, and Democrats in the United States, all officially recognized parties around the globe condemned the experiment. The French moderates who conceived the idea of the Statue of Liberty for the United States and the American moderates who received it recoiled in horror from the Commune.[2] The moderate *Harper's Weekly* kept up a steady attack on the Communards, especially the females, identifying them as savages and justifying to its readers the ultimately random overkill on the part of the Versaillais.[3] Herman Melville could hardly contain his disgust for the Communards which shows itself repeatedly in the verses of his dense four-part poem *Clarel*.[4]

Not surprisingly, American newspapers followed the line that the whole thing had been plotted by Karl Marx and the International Working Men's Association.[5] But as Marx himself showed in an interview at the time, although many members of the Commune belonged to the International his sprawling group had never been a secret body organized for conspiratorial purposes, and each branch responded to the peculiar political and social conditions of its local context.[6] This was confirmed by the Paris emissary of the International's General Council, who reported total disorder among the members of the French branch as late as 28 February 1871.[7] Nevertheless, some members of the Commune did belong to the International which stood loyally by the insurrection, and for this it was easily made a scapegoat in the aftermath.[8]

The chorus of abuse in the American press quickly mounted as the Commune unfolded, and after its destruction it was frequently used to epitomize all the horrors of "communist" philosophy. Not only the press, but the Sunday sermon, the political oration, and the popular pamphlet depicted the Communards as the most depraved specimens of the human race. American newspapers and periodicals almost unanimously took the side of Versailles and systematically denigrated Paris as an inferno of diabolical creatures. The Commune became a kind of Rorschach test for the conservatives and moderates, bringing out their worst fears about the family, religion, property, and social order. They constructed a demonic image of the Communard activists, and thus excused every atrocity by the Versaillese.[9] *Harper's Weekly* wrote that "in the interest of civilization [the Commune] must be suppressed," and on the eve of the all-out attack on the Commune by the Versailles armies, it declaimed that "popular madness . . . rules the hour in Paris," and with the Reds in control no one can guess "how soon the thirst for blood may be aroused." Finally, the crushing of the Commune—which outraged "every instinct of religion and humanity"—was a great victory for France: "The effort of the Commune ends, therefore, without the least sympathy or respect."[10]

The obsession of the American press with the Commune is seen in the fact that it commanded a major share of the headlines during the early 1870s. Major newspapers gave their readers the impression that anarchy ruled the streets in Paris, with bloodthirsty mobs sweeping the streets in search of innocent victims. Visceral images of the revolution of 1789 were recalled, suggesting a return to the Terror, mob rule, and the

guillotine. This time, however, the victims were to be drawn not from the aristocracy but from the ranks of the wealthy middle class. The press emphasized that the working people had revealed their incapacity for governing by their resort to thievery and murder, and so in the end demonstrated the intimate connection between socialism and violence. Like those who calculatedly raised the cry of Marxism-Leninism in more recent times, the press persistently equated the Commune with "Communism" and therefore identified it with the destruction of private property. They warned further that the Commune was not just native to France but could be exported to America as part of an international conspiracy. As late as 1873, the *New York Times*, with the Commune in mind, could write:

> If the time ever came—which we earnestly hope will not—when the socialists of the cities would combine to strike at the wealth heaped up around them, the native American [i.e., socialists are mainly "foreign agitators"] would be as ready to take the rifle to put down the rebellion against property, as he was to put down the rebellion against freedom.[11]

The dire example of the Commune could therefore be used to keep domestic dissidents in line. One paper labeled a coal miners' strike in Pennsylvania as "The Commune of Pennsylvania," and the strikers were identified with Communards.[12] On 20 January 1874 the *New York Times* ran an editorial entitled "The Communists" that tried to placate rural fears of "Communistic riots and socialistic outbreaks in this City." It admitted the existence of "a dangerous class" of "ruffianly, brutal, and uncontrolled" types such as inhabited Paris, who only needed an incentive "to spread abroad the anarchy and ruin of the French Commune."[13] But it insisted that these potential rioters were only pawns, and that the hardcore communists were either French or German radicals who had fled undemocratic societies and still kept up their old ways. Working people generally ignored them, and only "a general calamity . . . would increase them to the surges which presage storm." Although the panic over the Commune now appeared over, it becomes clear from subsequent articles that the *Times* was warning against a storm of its own making.

It is certain that the press' systematic abuse did much to shape the American public opinion on the Commune. Several popular novels of the late nineteenth century treated the Commune as a type of authoritarian state against which Anglo-Americans and their aristocratic French allies heroically pitted themselves.[14] Although the Commune had its defenders in the United States, they tended to be radicals painted by the press as would-be Communards themselves. Those moderates who refused to join the chorus of unqualified denunciation, like the vehemently antisocialist, *Nation*, acknowledged that the Commune could hardly have administered itself for any length of time if there had been only a gang of "lunatics and loafers" at the helm as other members of the press claimed. Indeed, the *Nation*'s main worry was that it would provide a model for other attempts at "labor reform."[15]

Even more positive was the impressive, authoritative report of John Russell Young for the *New York Standard*, which had been in the forefront of the denunciators. By chance, Young was sent by the State Department on a secret mission to Europe in May

1871, and he seized the opportunity to investigate the situation in Paris. He visited the barricades, attended club meetings, entered churches, and roamed the streets of Montmartre. He soon discovered that the Communards and their experiment had been viciously libeled and slandered. The city was operating in an orderly manner and there was no looting or mob action despite the apparent absence of the police. He observed one enormous crowd of at least thirty thousand men and women, but it conducted itself with the greatest decorum. He had expected churches to have been converted to some nefarious use, but instead he found the Church of the Madeleine to be a quiet place of worship. Finally, he learned that it was not the Communards but the Versaillais soldiers who had begun the shooting of prisoners and unarmed civilians in cold blood, and that during the combat they did more damage to property than the Communards.[16]

Young recognized that his report ran counter to the popular version, and he stated that it would have been easier for him to have seconded the wild accounts: "The newspapers do little more than scream, and you wade through column after column with much of the feeling of stumbling through a morass or a field of briers." But, like a dedicated journalist, he resisted the "exaggeration and falsehood" of his fellow correspondents and insisted on confining himself "simply to what I saw, or to such facts as come upon the responsibility of some trusty eye-witness."[17]

In this context the legacy by a notable American sculptor, Olin Levi Warner (1844–1896), of a manuscript defending the Commune is of the utmost historical importance.[18] Warner was surely a "trusty eyewitness" to the events, and it was probably the persistent calumny on the part of the U.S. press that prompted him to write his paper. Ironically, Warner's own work rarely showed traces of his passionate political ideals; although far more radical in his convictions than the Impressionists, his work is far more conservative in expression. It is testimony, however, that interests us here—a testimony that reveals the range of possible political thought in the period. Significantly, Warner's view of the Commune coincides with the contemporary leftist interpretations. It is not simply the fact that he defended it that positions him among the radicals—after all, any defense of this event would have placed him on the left—but that his exposition focuses on those very issues singled out by radical proponents as the basis of their revolutionary hypotheses. For Marx the key to understanding the contribution of the Commune to socialist evolution was not simply the momentary "dictatorship of the proletariat," but that it replaced long entrenched hierarchic and bureaucratic structures with democratic systems at every level.[19] Here is Warner characterizing the actions of the Communards:

> After completing its own organization in whole and in part, the first thing done by the Commune was to issue decrees abolishing certain wrongs so long inflicted upon the people by governments that had existed and establishing certain rights and privileges they were justly entitled to, but which had been so long denied them; in fact, the whole tenor of the Commune pointed to reform in all departments of the government and in all directions, and all of these reforms were perfectly just and natural.

Having been a wage earner most of his adult life, Warner inclined to a sympathetic understanding of the events of the Commune. In addition, he directly observed and participated in the events leading up to its formation. He joined the crowd celebrating the establishment of a republic on 4 September 1870, and although most foreigners fled Paris during the Prussian advance Warner decided to stick it out because his sympathies were "with the people." When the Prussians began their siege, Warner enlisted in the corps of the Légion des amis de la France organized to supplement the regular forces. As the siege persisted month after month, he suffered with them the deprivations of fear, hunger, and cold. During the days of the Commune, Warner bore witness to the savage vindictiveness of the Versaillais as they bombarded and slaughtered innocent men, women, and children. He shared in danger faced by all Parisians in the poorer quarters as shells and bullets whistled all around him day and night. On the positive side, he profited from the Commune's cancellation of rents owing for the period of the siege and worried that the decree would be revoked should the Versaillais resume power. Undoubtedly, it was the Commune's social reforms supportive of the laboring classes that most deeply appealed to Warner.[20]

Warner's manuscript was prepared as the draft for a speech, perhaps meant to be delivered before the group that centered on the official U. S. organ of the International, *Le Socialiste,* founded in New York on 7 October 1871, which circulated mainly among the French community. Warner was especially close to this community of émigrés in New York City and eventually married the daughter of Dr. Elie Auguste Eugene Martinache, whose portrait he modeled in 1876, the year before he prepared his address on the Commune. Martinache had been a regimental surgeon in the French army until the advent of the Second Empire, when he emigrated to America and allied himself with other anti-Bonapartist exiles.[21]

Warner's manuscript strikes at some of the most cherished conservative illusions concerning the Commune. He begins by stating his aim to discredit the mistaken notion "regarding the meaning, motives, and final results of the Paris Commune of 1871." Like John Russell Young, he emphasized that what he had to say was not derived from previous historical or popular accounts, but would be based "upon facts and incidents of my own personal experience." He counts himself fortunate to have been on the spot during the final years of the Empire, during the Prussian siege of Paris, the establishment of the Commune, and then the founding of the Third Republic. His reason for emphasizing his own participation and rejecting historical accounts is that thus far history had been "one-sided" in dealing with the lives of the oppressed: "History . . . speaks of the crimes of the Commune! When she speaks of the ten fold darker crimes of Versailles then she will have dealt justly with the subject and not until then." Warner's outrage at the way the story has been told is seen in his rhetorical questions near the end of the manuscript:

> Why is it that [Communards] are still reviled and held in such contempt by even the thinking and intelligent and their deeds looked upon with such horror and their memories covered with such infamy while the Government of Versailles with her black hearted assassins escapes the censure of the world?

> Why are the crimes of the Army of Versailles dragged out of sight and hidden
> from the gaze of civilization when those crimes are black and infamous as any
> that stain the pages of history.

Surprisingly, Warner answers with a class analysis, although he simplistically divides the antagonists into "labor" and "aristocracy." When he uses the latter term again, he identifies it more generally with "conservatism" and exploitation and hence as an inclusive term for all the enemies of the Commune.[22]

Warner was disturbed to "find that most people in America have but a vague and in many cases an entirely mistaken idea regarding the real meaning of the term "Commune," which the press had deliberately identified as synonymous with communism and socialism. By so doing, they linked the Commune to the International and to ideas of worldwide conspiracy and revolutionary violence, including the United States. Warner, however, points out that the term "commune" in France was used for the municipal governments in all the smaller towns and cities and implied a certain degree of regional autonomy. During the Second Empire, the major metropolitan centers such as Paris, Lyons, and Marseilles—also the most likely to have radical or republican politics—were denied the right to elect municipal officers and were governed by appointed officials. Thus the declaration of the Communal form of government at Paris in the wake of the French capitulation to the Prussians signified a renewed commitment to democratic politics in the actual and symbolic center of France.[23]

Warner next tries to dispel the popular image of the Commune as a rogue operation by tracing its origin to the logic of the circumstances. The people of Paris heroically held out against the invader long after the French armies had surrendered at Sedan, and this in the face of inaction on the part of the army officers based in Paris and the majority of the provisional government established after the capitulation of Napoleon III.[24] The tense situation reached a boiling point two months after Paris yielded, when the anxious government—now transferred to Versailles—tried to seize the artillery of the Paris National Guard. This group, organized under emergency conditions, comprised mainly artisans and laborers who forged the pieces of light artillery with their own subscription money. The cannons did not belong to the government, and the guardsmen did not relish them falling into the hands of the Prussians together with the other arms and war munitions surrendered with the fall of Paris. They thereupon moved the artillery to the heights of Montmartre and kept close watch over them. When on 18 March the Versailles government sent a body of troops to capture the artillery, the National Guard fought back and drove the Versaillais from the city. In effect, a state of war existed between Versailles and Paris and it was under these exceptional conditions that the Commune was proclaimed. As Warner stated: "There was nothing unnatural about this. Any of us if [we] had belonged to the National Guard would have done likewise if we had been men of principle and willing to defend those principles."

Warner repeatedly points to the Versaillais as the aggressors and insists that most of the actions taken by the Commune were defensive. The Versailles government continually bombarded Paris and sent forays led by gendarmes (line troops often fraternized

with the populace whereas the police had less compunction about charging their fellow citizens) around the walls of the city. Warner witnessed daily funeral processions for national guardsmen slain by the Versaillais, and recounts one story after another about the latter's atrocities. At the same time, Warner insisted on the "perfectly honorable and just" motives and intentions of the founders of the Commune, and in his footnote to this statement dismisses the common notion "that the Communists were nothing more or less than band of cut-throats and incendiaries with theft their object," a conclusion derived from the fearsome idea "that Communism meant equality of fortune as well as equality of position in the body politic."

Indeed, the first acts of the Commune included the publishing of a decree separating Church and State and several other political and social reforms that moved it closer to a democratic society, but they proved to be too radical even for those who had the most to gain from them. Warner blamed this on the basic conservatism of contemporary society. He also reminded his audience that the Commune declared its "good and peaceful intentions" by decreeing the burning of the public guillotine, thus demonstrating before all the world that the Commune had no intention of repeating 1793 and 1848. Here again Warner acted to dispel the malicious associations of the Commune with the Terror of the French Revolution and the relentless allusions to the guillotine, Marat, and Robespierre.

Warner, however, is weak when it comes to defending the "crimes" of the Commune. One senses that he is on the defensive here, and seems to have confused his chronology, suggesting that the Communards took the initiative in shooting sixty-four hostages that in turn led to reprisals by the Versailles troops. The policy of shooting prisoners (even those who had surrendered) and unarmed citizens in cold blood had in fact been inaugurated in April, long before the bloody climax of the conflict, the *semaine sanglante* of 22–28 May, and it was rigorously administered by the Versaillais all along. The shooting of the archbishop of Paris, Monseigneur Georges Darboy, and five others, an action that was carried out reluctantly by the Communards in retaliation, did not take place until 24 May, during the final days of the Commune. Several efforts were made to exchange Darboy and other clergy for the veteran revolutionary Blanqui, but Thiers declined the offers.[25] While the American press reacted in horror to the shooting of Archbishop Darboy and the other hostages, it passed in muted judgment over the systematic execution of the Communards since April and which decisively intensified during Bloody Week. Whenever a barricade was taken every prisoner was shot on the spot, an act captured in the famous lithograph by Edouard Manet. Any citizen caught with a weapon—loosely defined as a claspknife, razor, and even rock—was executed. When a citizen was found inside with Communard literature or was identified as a Communard on the street, he or she was lined up against a wall and shot. Thiers had clearly given the order not to show quarter, and the result was the most vindictive massacre in French history. Warner himself does not hesitate to recount several grisly stories of the bestial behavior of the Versailles troops.

Warner nevertheless feels the need to justify the Commune's crimes, and he goes into the long history of the church's support of tyranny and its role in the suppression of French people. Warner is unmistakably anticlerical—that perhaps is the subtext of

his address—and proceeds to denounce the tyrant who owes his power to the priestly clan "as they keep the masses degraded for him." The "poor laboring man" recognizes at last "that he is the slave of these vampires of humanity and longs to free himself from their vile clutches." When granted their sovereignty at the moment of the Commune the people sought first of all to rid themselves of this huge incubus, and here Warner reiterates (incorrectly) that the initial act of the new government was to declare the separation of Church and State.[26] Warner's impassioned construction here of the motivations of the Communards suggests that he closely identified with them on this issue.

Warner claims that the shooting of the Archbishop and other priests took place "soon after" as an act of "vengeance" for the accumulated suffering and deprivation, an egregious error in chronology that compels an apology more in line with the explanations of the enemies of the Commune than with the actual historical circumstances. Similarly, he uses the same excuse for the early executions of General Claude-Martin Lecomte (who on 18 March led the main attack against the heights of the Butte Montmartre to capture the guns and ordered his troops several times to fire on unarmed civilians thrusting themselves between the hostile troops and the National Guard), and ex-General Clément Thomas (who was detested for the role he played in the repression after the Blanquist revolt of May 1848 and again during the workers' insurrection of June 1848, and who as officer for the Government of National Defense during the siege again betrayed his hostility to the working class in trying to prevent the general arming of the Paris National Guard and by pitting the bourgeois battalions against the proletarian ones). The assassination of these two generals by mainly military personnel, although to be sure encouraged by an infuriated crowd, was carried out by mainly military personnel and took place amid the wild disorder occasioned by the initial attempt of Thiers' army to disarm the citizens of Paris on 18 March.

Warner fails to mention the attack of the National Guardsmen on the Friends of Order, a group composed predominantly of the upper classes who hoped to intimidate the Commune with a show of strength on 21–22 March. Their demonstrations culminated at the Place Vendôme, where the National Guard headquarters were located. The first day the square was cleared peaceably, but on the second, the Friends of Order returned in a hostile mood with concealed weapons to contest the Central Committee's control of Paris and their call for elections on 26 March. They pressed up against the Guard who fired first into the air and then into the crowd, leaving a dozen people dead and a dozen more wounded. Although the shooting was not authorized beforehand by the government, the event gave a nasty twist to the Commune and betrayed some of its contradictory forces.[27] Nevertheless, this was the last manifestation of violence on the part of the Communards until Bloody Week. Communard violence took place early on, at the height of confusion and anxiety about the actions of Versailles and the Prussians.

Surprisingly, Warner also fails to provide an adequate defense of the pulling down of the Vendôme Column, one of the most notorious acts of the Commune (figs. 151, 152). Warner dismisses accusations of vandalism, but instead attempts to justify its destruction on the basis of aesthetic judgment. He claimed that the Vendôme Column "was

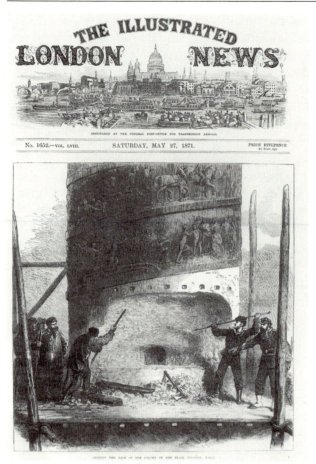

151. *Cutting the Base of the Vendôme Column, Paris.* Wood engraving reproduced in *The Illustrated London News,* 27 May 1871.

no great work of art," and no great loss to the world of art. It was "merely a pretentious copy of the Trajan Column at Rome," and the bas-reliefs running spirally around the column represented "the worst kind of sculpture." As a sculptor himself, Warner may have felt that his credentials allowed him to speak out authoritatively on the destruction of the column, but he lost sight of the fact that it was primarily a political act rather than one based on an aesthetic evaluation.

Curiously, Warner owned a copy of the decree that ordered its destruction as "a monument of barbarianism, a symbol of brute force and of false glory, a confirmation of military rule contrary to the international rights of mankind." Young was another American eyewitness who appreciated the Communards' destruction of the Column—which he called "a monument to assassination and misery and woe." It symbolized the type of militarism that sent out the children of France "to murder and devastation." And he went on:

> But the thought that to-day a people have been brave enough to root out a monument to murder; to say that there is a higher mission for nations of

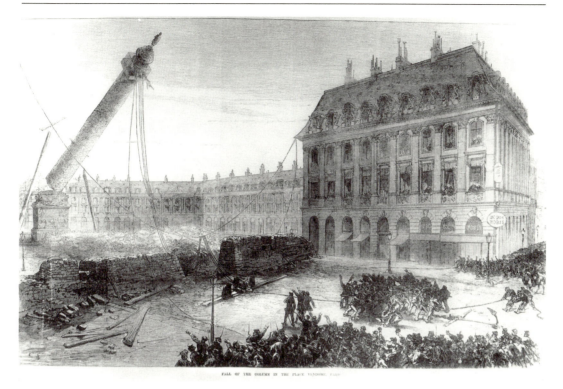

152. *Fall of the Column.* Wood engraving reproduced in *The Illustrated London News*, 27 May 1871.

valiant people than Republicanism; that the time has come for people to do what statecraft has failed to do as yet, namely, to make peace and courtesy and living in the world which God sent them to occupy, without, of necessity, cutting their neighbor's throat; the thought that this poor Commune, with all its recorded knaveries has been wise enough to do this, and brave enough to bear witness to it, will live for ages as its best contribution to humanity and brotherhood. The falling of this column will be heard throughout the world.

Here the writer provides the political motivation underlying the demolition of the Napoleonic monument celebrating the victories of French armies at Austerlitz and its significance as a bellicose rallying point for the Bonapartist forces that led French people to their recent defeat at the hands of the Prussians.[28]

When Warner discusses the burning of Paris during the retreat of the Communards, he uses a similar argument for justifying what appeared to be acts of random violation and vandalism. Although he understood them as acts of desperation, he also saw a symbolic and tactical logic to them. The Tuileries had been the residence and headquarters of Napoleon III and the Hôtel de Ville had been the central organ of his control over Paris, while the Palais de Justice had been the site of innumerable cases of injustice and the Préfecture de Police had been associated with all "the murderous plots and

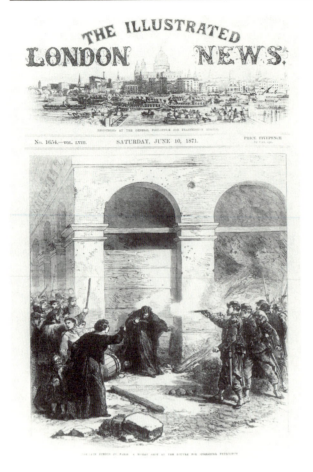

153. *The Late Events in Paris: A Woman Shot at the Louvre for Spreading Petroleum*. Wood engraving published in *The Illustrated London News*, 10 June 1871.

intrigues against the people." Warner also correctly notes that the Commune never issued an official decree or edict calling for the destruction of these buildings, and the burning was done by groups acting upon their own initiative in the face of an advancing enemy. Strategically, it served to cover the retreat of the desperate Communards who knew that capture meant death.

The question of the burning of the buildings immediately invokes the case of the women known as the *pétroleuses*—those who supposedly hurled the petroleum or kerosene oil on to the fireproof structures (fig. 153). Warner insists that the horrific image of the female petroleum thrower was "nothing more or less than a scare gotten up by the Versailles Government to excuse wholesale massacre of women and children after the Commune had ceased to exist." He points out that none of the women accused of incendiarism were found in the areas of the burnt buildings (actually, some were), but were invariably drawn from working-class districts remote from the site of incendiary activity. But were the "pétroleuses" myth or reality? Here is what Marx declared on the subject:

This story is one of the most abominable schemes that has ever been invented in a civilized country. I am certain that not one woman, not one child, could be accused with the slightest semblance of proof of having poured kerosene in houses or of having tried to set anything on fire; and yet hundreds were shot for that, and thousands were deported to Cayenne. Anything that might have been burned was burned by men.[29]

Warner was absolutely right about the myth of the "pétroleuses," a notion sparked by mass hysteria during the panic days of May, and then exploited by the Versaillais. This is not to say that women did not play a role in the incendiarism: the Paris fires were lit during the fighting, and it is likely that women who were defending the barricades also had a hand in them. But what was never proven was a systematic plan to destroy the buildings by a select team of women designated for that purpose.[30]

Warner's discussion of the pétroleuses leads to his recognition of the pervasive contribution of women to the Commune (figs. 154, 155). Contemporaries were struck by the extent of female participation in the 1871 revolution. Never before in French history had women taken such an extraordinary role in all aspects of governmental and institutional life. Women like Louise Michel and Elizabeth Dmitrieff organized unions, clubs, and committees (such as the Union des Femmes pour la Défense de Paris et les Soins aux Blessés and The Women's Vigilance Committee of the Eighteenth Arrondissement) that were involved in a whole range of issues including the reorganization of work, education, and female soldiering.[31] Warner inadvertently distorts this contribution by claiming that the women acted out of desperation, taking up arms only when they witnessed "their husbands and fathers struggling and dying behind the barricades." At this moment, they repelled the invader by dropping paving stones and whatever else they could find from their windows and even rushed into the barricades to take up the arms of their fallen male comrades. Warner notes that women were arrested en masse and summarily shot by the Versaillais, and yet, as he reminded his audience, "we who are so civilized and so enlightened allow ourselves to be taught to look upon [these women] with a sort of horror."

Here Warner touched on one of the central points of the phobic response to the Commune, whose threat to the privileged classes extended to their gender structures. Thus it is not surprising that the role of women in the Commune was attacked more viciously in the American press than any other aspect of its history. After noting the frequent sight of bodies of women killed by the Versaillais troops, *Harper's Weekly* wrote that the "unsexed women" of the Commune are "ten times more cruel and unreasonable than the men," and that the malcontent would be "almost safer in the hands of a tribe of red Indians than in the power of these infuriated Paris women."[32] Later, discussing a group of female prisoners, its reporter wrote:

These are the Amazons of the Commune, and give us an idea of what the warrior-woman really is—coarse, brawny, unwomanly, and degraded; . . . We generally endow [women] with those womanly qualities which we admire, forgetting that it may be the very want of those attributes which has induced them to quit the conventional mode of life. The *vivandière* of our imagina-

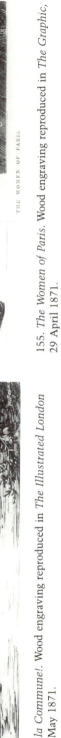

THE WOMEN OF PARIS

155. *The Women of Paris.* Wood engraving reproduced in *The Graphic,* 29 April 1871.

154. *Vive la Commune!.* Wood engraving reproduced in *The Illustrated London News,* 20 May 1871.

tion is always young and pretty and innocent, a gay young creature amidst the regiment of rough, kindly men, and our feelings receive a shock when we see the reality.[33]

This denunciation of Communard women was part of the general condemnation of the "degraded" types participating in the Commune, while at the same time served as a warning to the men and women at home to stay in line or risk degeneration of the species. As would be the case in post-Commune France, the negative discourse surrounding the female participants would be used to help construct the positive image of the "respectable" type of womanhood.

Warner's contribution to our understanding of the Commune lies not only in his historical labors and recollection of the facts. It is perhaps even more significant and compelling for its expression of empathy with the victims. What stood out with piercing clarity in his mind was the painful cry of the victims and the vicious brutality of their oppressors. It was this memory that rose above every other detail of its history. Unlike most of the early accounts, Warner's narrative places less emphasis on the Communards' execution of the prominent hostages than on the thousands of nameless murders of working men and women perpetrated by the representatives of "law and order." Indeed, Warner deliberately brought home the personal and human side of the events to his American audience to demonstrate the callous disregard and calculated lies of previous histories that submerged the brutal massacre of tens of thousands of unknown persons (figs. 156, 157). After abruptly leaving off the telling of specific atrocities, "so horrifying that I do not care to go into further detail," Warner observed: "I would not have related even these few incidents had I not deemed it necessary in order to give you [a] more complete and perfect idea of the manner in which the spirit of the Commune was crushed out by the French Government and strange to say that Government taking upon itself the name and title of a Republic."

Warner could also empathize with the thousands of suspected Communards deported and banished to the prison colonies on New Caledonia and Cayenne. Homes were broken, families divided, and spirits crushed merely because the Communards "dared to assert their manhood and strike for what they believed to be their rights and the rights of their children." In the most impassioned section of the manuscript, Warner rhetorically advances towards his audience to explain the motives of the Versailles government:

> Why is it that these men are still reviled and held in such contempt even by the thinking and intelligent and their deeds looked upon with such horror and their memories covered with such infamy while the Government of Versailles with her black hearted assassins escapes the censure of the world? Why are the crimes of the Army of Versailles dragged out of sight and hidden from the gaze of civilization when those crimes are black and infamous as any that stain the pages of history, while a band of poor unfortunate men struggling for what they knew to be right are crushed out of existence and held up to the world as infamous and despisable? I'll tell you why! It is because the one side in this melancholy affair represented aristocracy and the other labor. Aristoc-

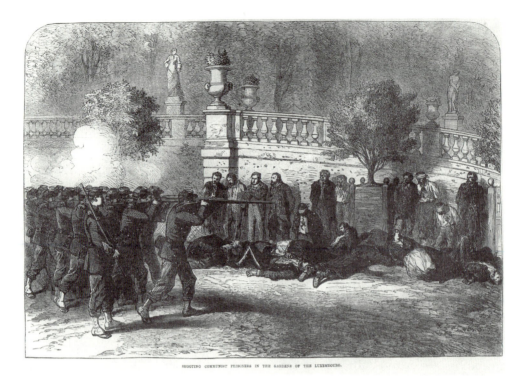

SHOOTING COMMUNIST PRISONERS IN THE GARDENS OF THE LUXEMBOURG.

156. *Shooting Communist Prisoners in the Garden of the Luxembourg.* Wood engraving reproduced in *The Illustrated London News*, 17 June 1871.

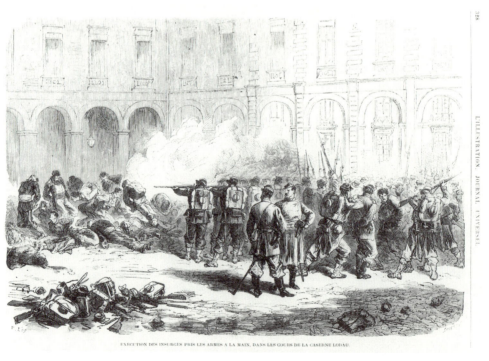

EXÉCUTION DES INSURGÉS PRIS LES ARMES A LA MAIN, DANS LES COURS DE LA CASERNE LOBAU.

157. *Exécution des insurgés pris les armes à la main, dans les cours de la caserne Lobau.* Wood engraving reproduced in *L'Illustration*, 1871.

racy being more popular and consquently more powerful was enabled to crush out labor and make the men who represented it unpopular and with her power make them even more infamous. In order to crush out the Commune entirely and kill it root and branch the Versailles government was obliged to . . . resort to crimes that would blacken the darkest page of history and when those crimes were once committed resort to the most villainous and tyrannical means to hush them up and keep them from the world. There was no longer any freedom of the press, no more freedom of speech. Newspapers with any character whatever were gagged or struck out of existence and those who write or those who speak for the masses were thrown into prison and even exiled if they dare tell the truth.

Warner's acute analysis of the suppression of the Commune could stand as a paradigm for the behavior of authoritarian regimes in the modern period. It helps explain the perennial fascination with the Commune on the part of both the right and the left. In his speech Warner contrasts the freedom of the United States with the unfreedom in France, admonishing his audience to "see and appreciate the liberties we enjoy." Yet it is clear that he is concerned above all that the distorted view of the Commune—all too easily accepted by the American community—portends an ominous future for the basic freedoms currently taken for granted by that community. The malicious reporting on the Commune and the glee with which the press received the news of the Commune's demise aroused his deepest anxieties. As he declared:

Here in America we are supposed to be a freedom loving people. This is regarded as the great home of freedom. Then why is it that we who are such a liberty loving, freedom adoring people are so willing, as we seem to be, to decry and brand as assassins and incendiaries a band of men who fought for the sovereignty of the people, but not being as fortunate as we were when we struck for our liberties, they lost their cause?

Warner stresses that the Communards fought for the "sovereignty of the people" exactly as the American rebels, for "the common cause of suffering humanity." Here Warner experienced the contradictions of the deep forms of American bourgeois society, the persistent acceptance of conquest and murder in the name of order and progress. Embedded in Warner's cry of alarm are the conflicts of interest that ultimately expressed themselves in such Cold War episodes as the destruction of Nicaraguans in the name of the "Founding Fathers" of freedom.

What could have motivated Warner's insights at the time he wrote the manuscript? While the manuscript itself is undated, Warner's correspondence and internal evidence confirms a date of 1877; a letter to his brother Melville of 2 September 1877 gushingly declares: "The lecture was a success. They tell me I had a big house. Good many Communists. Applauded vociferously. Discussion after lecture was very interesting. One woman, a 'petroleum thrower' of the Commune, spoke after me and all corroborated what I said. One man, a lawyer, undertook to tear my argument to pieces and he was completely hissed down. . . . After lecture was over, lots of friends grasped me by

the hand and congratulated me."[35] (Since a previous letter of 6 August to his brother states that he was preparing the lecture, it may be concluded that Warner delivered it in late August or 1 September.[36])

Marginal notes to himself are further revealing of the time of conception; on the back of sheet 41 Warner began doodling his signature and we can make out among the brief inscriptions the words "Washington," his first name "Olin, " and his signature and date, "O. L. Warner 77." On the recto of page 41 Warner had described the atrocities of the Versailles troops. At one point, he states, he went into the street to inspect the "havoc and traces of carnage." He observed "piles of dead" in all directions, and close examination revealed that many of the corpses had been shot point blank in the head—proving that they had been killed after capture. We can still hear Warner's mournful intonation in his recollection, "my head bled for those poor men." It may have been the need to pause momentarily from these painful memories and to return to the safety of his present social space that he began doodling on the back of this page.

Yet it may not be coincidental that his free associations embrace the macro and the micro of his existence as a citizen of a national space, the capital of the nation and the signature of his subjective being. Warner here works through the tension between the bureaucratic state and the individual, between authority and personal identity, at the very moment when he forces himself to remember the shattering of identities in the name of the state. On the next page Warner picks up the thread of his narrative, recalling a lone corpse on the sidewalk. He then took out his sketchbook to portray this man, that is, he wanted to give him identity and a memorial (fig. 158). Reminiscent of Manet's scene of *Civil War*, it nevertheless avoids the convention and drama of the French painter's image based also in part on popular reportorial illustration (fig. 159).[37] As Warner sketched the fallen victim, an old man hobbled up to him and told Warner about the bravery of the dead man who held at bay a whole company of troops, and concluded with the statement, "I tell you, Sir, that man well merits the esteem of his country." Warner than affirmed this to his audience: "Ladies and Gentlemen, that man did merit the esteem of his country, but because he struck for his liberties his country killed him like a dog." Warner's outrage here must involve his heightened sense of concern about his own relation to a state that branded his heroes with the stamp of contempt.

The very year he prepared this manuscript Warner joined a group of dissident artists who eventually called themselves the Society of American Artists.[38] After his return from France in 1872 through 1877, Warner had not fared well in his career and at one point had almost given up as a sculptor. He received few commissions between the years 1872 and 1876 and just managed to eke out a living working in industry ornamenting silver and bronze ware.[39] (He had even hoped to take his lecture on the road to "make money" from it.[40]) His alliance with an organization of progressive artists in the 1870s may have been prompted by his experience of the Commune and his understanding of the need for collective action to survive. The object of the association was to hold annual exhibitions of modernist artists rejected by the National Academy of Design juries. Although the first exhibition did not take place until the following year, the group's rebellious position put them into confrontation with the establishment

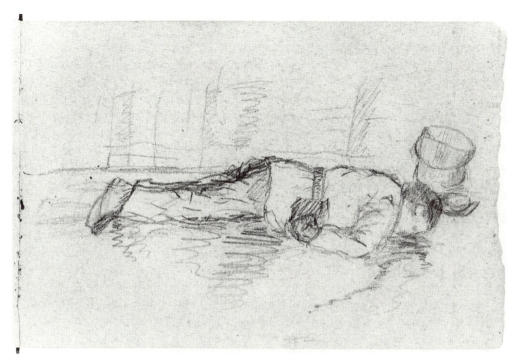

158. Olin Levi Warner, *Dead Communard* (leaf from sketchbook), 1871. Pencil on paper. National Museum of American Art, Smithsonian Institution, Washington, D. C. Gift of Mrs. Carlyle Jones.

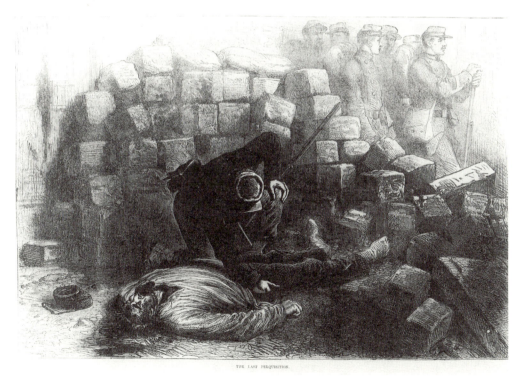

159. *The Last Perquisition*. Wood engraving reproduced in *The Illustrated London News*, 17 June 1871.

institution. Warner may have identified with the group of artists that formed them-selves into the Fédération des Artistes de Paris organized during the Commune at the instigation of Gustave Courbet.[41] The committee selected to draw up the statutes was to include painters, sculptors, architects, engravers, lithographers, and decorative artists—part of a conscious attempt to create ties of solidarity with the artisanate. (Coincidentally, the Society of American Artists included artists who also carried out designs for manufactured objects including Warner and his friend Albert Pinkham Ryder, who worked for the decorative workshop of Daniel Cottier & Co.) The program of the organization called for the free expression of art, the elimination of all govern-ment control and privileges, equality among all members, and rotating committees elected and/or recalled by open elections of all the artists. Regular and open exhibi-tions of new work were to be arranged with no prizes to be awarded, with the aim of encouraging "the development of the arts, the moral or intellectual emancipation of artists, and the improvement of their material status."[42] In this sense, the Society of American Artists could be seen as a collateral offshoot of the artists of the Commune.

At the same time, Warner's repeated emphasis on the class conflict between labor and aristocracy may have been stimulated by the domestic turbulence in 1877. His own manifold experience as a wage earner—as a laborer in a glove factory, as a telegra-pher in New York and Georgia, and as an industrial designer—predisposed him to identify with the working classes who at that moment felt themselves in a state of siege. The United States was in the depths of a Depression that had been touched off in 1873 by the failure of the banking house of Jay Cooke and would continue through the rest of the decade. Widespread homelessness and unemployment in 1877 led to labor marches and strikes in the textile mills of Fall River, Massachusetts, and the coal min-ing districts of Pennsylvania. In the same year a series of riotous strikes by railroad laborers—representing a response to wage cuts, death and injuries on the job, and kick-backs and profiteering by the railroad firms—occurred in a dozen cities, shaking the nation as no previous labor conflict had done. Ironically, newspapers at the time of the railroad strike frequently invoked the Commune in such captions as "Commune in Pittsburgh," "Commune in St. Louis," "Commune in Chicago," Commune in Phila-delphia," and the "Reign of the Commune."[43]

During this period, the government protected business interests and called often on the U.S. Army to join with local police and the National Guard to supress strike activ-ity. Also in 1877 President Rutherford Hayes began withdrawing the remaining Federal troops from South Carolina and Louisiana (in part to provide the backbone of an army to oppose the striking workers of the North and resisting Native Americans in the far West), thus ending the commitment of the nation to ensuring equal rights to newly enfranchised African American citizens. The year 1877 could be seen as the threshold moment signaling the government's commitment to the prevention of blacks and white workers from full participation in the American Dream. Hence Warner's speech on the Commune was written in a climate charged by his own government's battle against the "poor laboring man."

One other factor may have predisposed Warner to a sympathetic reading of the Com-mune, his Masonic affiliation. Warner had belonged to the Freemasons since the 1860s,

and advanced to Master Mason of the Third Degree.[44] In France, Masonry had been generally supportive of revolutions, and during the Commune it took an active role in trying to mediate a peace between Versailles and the Commune (fig. 160). When their efforts did not succeed, a major segment of Parisian Freemasons espoused the principles of the Commune and acted to preserve it from destruction (figs. 161, 162). Prominent Communards such as Jules Vallès, Henri Rochefort, Jules Allix, Gustave Lefrançaise, and a host of others were affiliated with Masonry. The Masonic intervention culminated 29 April in a spectacular demonstration, capped by a mass meeting that voted an overwhelming endorsement of the Commune. Since the first week of the month, the Masonic Order had become increasingly radicalized. On 7 April, the lodge Les Disciples du progrès held a meeting to discuss a plan of conciliation to end the bloodshed. The next evening the *vénérables* (masters) of the majority of lodges of Paris assembled at the headquarters of the Grand Orient on the rue Cadet to draft a statement against civil war. It summoned the belligerents to achieve peace, and a delegation proceeded to the Hôtel de Ville where they were warmly received. On 10 April the Masonic delegation traveled to Versailles and met with Thiers the following day. As one brother recalled, Thiers received them "with contempt, refusing to recognize the legality of its mandate." That they were not taken seriously induced them to take a more political line of action, joining with other conciliator organizations. But in every case it met with benevolence from the Commune, hardheadedness from Versailles. At the second meeting with Thiers on 22 April, Thiers not only dealt with them with "cold politeness," but actually reproached them for not taking up arms against Paris. The Masons protested that they were a pacific organization, but wondered in return how it was possible for Thiers to bombard his own people with such ferocity. Thiers rejoined: "A few buildings will be damaged, a few people killed, but the law will prevail." Now an angered Masonry gathered on 26 April to challenge Versailles and to defend the Commune, and at least two thousand marched to the Hôtel de Ville where they were greeted by Mason Communards. Allix drew a parallel between the construction of the temple in the ancient world and the Commune's plans for the modern reorganization of labor. A mass rally in the Louvre courtyard was called for 29 April, and although the leadership disavowed it the rank-and-file of Parisian Masonry lined up behind the banners of their lodges and voted an overwhelming endorsement of the Commune.[45] Thus it may have been the experiences of Parisian Masonry that reinforced Warner's sympathetic reading of the events of the Commune.

Writing to his father from Paris on 21 February 1872, Warner debated returning to his native country despite the horrors that he had recently witnessed. He understood the need to earn a living, but his heart was then in France, for "I find everything that surrounds me is more congenial to my nature."[46] And he confessed:

> I find those I can understand and who can understand me and who know my feelings better than my own country me can: I go to America to make money. It is contrary to my nature. I return to France to live. It is according to my nature. I would like to arrange it so I could go to America and return to France once a year. I think I could lead a contented life which is all I ask in this world.

161. *The French Siege of Paris: Masonic Deputation to Versailles Going out at the Porte Maillot.* Wood engraving reproduced in *The London Illustrated News*, 13 May 1871.

160. Moloch, *La Franc-Maçonnerie et la Commune*, 1871. Color lithograph.

FREEMASONRY IN PARIS

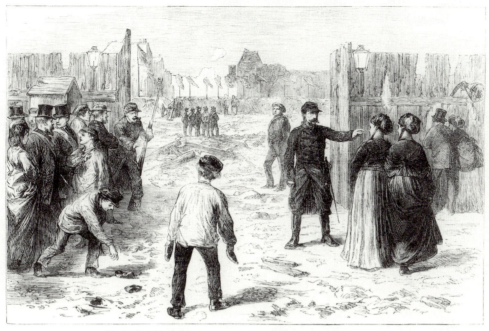

THE OCTROI GATE AT THE PORTE MAILLOT—THE MASONIC BANNERS ON THE RAMPARTS

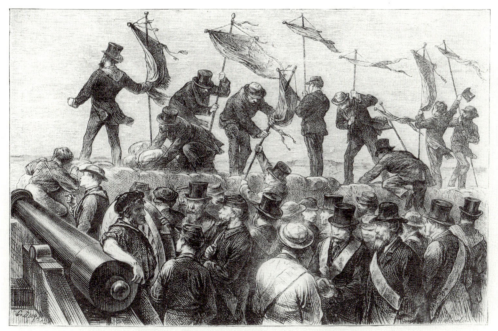

FREEMASONS PLANTING THEIR BANNERS IN FRONT OF PORTE MAILLOT

162. *Freemasonry in Paris.* Wood engraving reproduced in *The Graphic*, 20 May 1871.

I have no other ambition. I look at life, society and the world differently from what I once did. I think freer and broader and am less trammeled by the infernal conventionalisms of society that abase men and keep their minds small.

Prior to the Commune, Warner's correspondence indicated that his main purpose for residing in France was to secure the skills necessary to earn a living as a sculptor in America.[47] This letter provides evidence that the Commune was a decisive *rite de passage* for Warner which profoundly transformed his outlook on life, and it was with this sense of self-understanding, as well as the desire to set the record straight, that he was moved to set down his thoughts on the subject for an American audience.

NOTES

CHAPTER 1

1. T. J. Clark, *The Painting of Modern Life*, New York, 1985, p. 23.

2. Arnold Hauser, *The Social History of Art*, vol. 4, New York, 1959, p. 166.

3. Quoted in R. Greeman, "The Permanence of the Commune," *The Massachusetts Review*, vol. 12, Summer 1971, p. 392.

4. K. Marx and V. I. Lenin, *The Civil War in France: The Paris Commune*, New York, 1988, pp. 77–78.

5. M. Davis, "The L.A. Inferno," *Socialist Review*, vol. 22, January–March 1992, p. 57. Elsewhere he presciently used the metaphor of the Commune to characterize the cultural and political conditions in Los Angeles centering on the Watts Rebellion. See *City of Quartz*, New York, 1992, pp. 62–70.

6. E. Scarry, *The Body in Pain: The Making and Unmaking of the World*, New York and Oxford, 1985, p. 177.

7. T. Duret, *Histoire de Edouard Manet et de son oeuvre*, Paris, 1906, p. 125.

8. T. Duret, *Histoire de France de 1870 à 1873*, 2 vols., Paris, 1893, II:105. Here Duret attacks socialism and declares his sympathy with a gradualist, reformist position. The book was published by Georges Charpentier, Zola's publisher and Renoir's patron, and attests to his alignment with Duret's position. Four years later, however, Duret was more favorable to the left and suggested that the socialist minority acted most responsibly during the Commune. See F. Fénéon, "La Commune," *La Revue Blanche*, vol. 12, 1897, pp. 284–285.

9. J.-P. Bouillon, "Les lettres de Manet à Bracquemond," *Gazette des Beaux-Arts*, 6e. per., vol. 101, April 1983, pp. 151–152.

10. Another corrective to this situation will be the forthcoming study by Holly Clayson entitled "Visual Representation and Parisian Women in the 'Terrible Year' (1870–71)."

11. This is especially surprising in the case of Clark, whose thesis on the modern spectacle was admittedly inspired by the Situationist International. This group published a highly original interpretation of the Commune (in the form of fourteen "theses") as a contribution to the clarification of revolutionary ideas and could be understood as part of the process of political and philosophical preparation for the May–June 1968 rebellion in France. See T. J. Clark, *The Painting of Modern Life*, New York, 1985, p. 9; R. Greeman, "The Permanence of the Commune," *The Massachusetts Review*, pp. 391–395. Mention should be made of Theodore Reff's short but incisive catalogue section, "The Street as Battleground," in *Manet and Modern Paris*, National Gallery of Art, Washington, 1982, pp. 201–231. Other studies that should be noted are J. Lacambre, "Les expositions à l'occasion du contenaire de la Commune de Paris," *Revue de l'Art* No. 18, 1972, pp. 68–71; J. Kaplow, "The Paris Commune and the Arts," in *Revolution and Reaction: The Paris Commune 1871*, eds. J. Hicks and Robert Tucker, Amherst, 1973, pp. 144–167; J. A. Leith, "The War of Images surrounding the Commune," in *Images of the Commune*, ed. J. A. Leith, Montreal and London, 1978, pp. 101–150; A. Rifkin, "Cultural Movement and the Paris Commune," *Art History* 106, vol. 2, 1979, pp. 201–220; J. Péridier, *La Commune et des artistes*, Paris, 1980.

12. R. L. Herbert, *Impressionism: Art, Leisure, and Parisian Society*, New Haven and London, 1991, pp. 13, 30, 74, 202, 227, 234 and *passim*.

13. S. F. Eisenman, *Nineteenth Century Art: A Critical History*, London, 1994, pp. 238, 244.

14. H. Loyrette and G. Tinterow, eds., *The Origins of Impressionism 1859–1869*, The Metropolitan Museum of Art, New York, 1994.

15. M. R. Brown, "Art, the Commune, and Modernism: the Example of Manet," *Arts Magazine*, vol. 58, December 1983, pp. 101–107. See also her "Manet, Nodier, and 'Polichinelle,'" *Art Journal*, vol. 44, Spring 1985, pp. 43–48.

16. P. Tucker, "The First Impressionist Exhibition in Context," *The New Painting: Impressionism 1874–1886*, The Fine Arts Museums of San Francisco, 1986, pp. 93–117.

17. V. Spate, *The Colour of Time: Claude Monet*, London, 1992, pp. 73–80, 92–95, 127–128.

18. Although still a controversial idea, my own researches have revealed the possibility of a *flâneuse* in this period: see A. Boime, "Manet's *Bar at the Folies-Bergère* as an Allegory of Nostalgia," *Zeitschrift für Kunstgeschichte*, vol. 57, No. 2, 1993, pp. 234–248.

19. G. Pollock, *Vision and Difference*, London and New York, 1990, pp. 51–54.

20. For Braquehais, see J. C. Gautrand, "1870–1871: Les photographes et la Commune," *Photo-Ciné-Revue*, February 1972, pp. 52–63.

21. Talk by J. M. Przyblyski, "Photographing the Paris Commune, 1871," Eighteenth Annual Colloquium in Nineteenth-Century French Studies, Binghamton University, 23 October 1992.

22. Ibid., p. 61; J. Wiener, "Paris Commune Photos at a New York Gallery: An Interview with Linda Nochlin," *Radical History Review* 32, March 1985, pp. 59–70.

23. D. Harvey, *Consciousness and the Urban Experience*, Baltimore, 1985, p. 217.

24. *Letters of Gustave Courbet*, ed. P. ten-Doesschate Chu, Chicago and London, 1992, p. 416. For Courbet's role in the organization of the Commune-sponsored Fédération des Artistes, see J. Péridier, *La Commune et les artistes*, Paris, 1980, pp. 63–65.

25. A. de Balathier Bragelonne, *Paris insurgé: Histoire illustrée des événements accomplis du 18 mars au 28 mai 1871*, Paris, 1872, pp. 85, 125, 211, 243, 244–245, 279, 342, 389, 414–415, 423.

26. P. Louis, *Histoire du socialisme en France*, Paris, 1950, p. 237. See also G. Tersen, "L'Opinion publique et la Commune de Paris (1871–1879)," *Bulletin de la Société d'études historiques, géographiques et scientifiques de la région parisienne*, vol. 34, Nos. 106, 107–108, 109, 1960, pp. 15–27, 26–36, 25–30; vol. 36, Nos. 114–115, 1962, pp. 24–33.

27. *The 60s Without Apology*, ed. S. Sayres, A. Stephanson, S. Aronowitz, and F. D. Jameson, Minneapolis, 1984, pp. 2–3.

28. J. and E. de Goncourt, *Paris Under Siege, 1870–1871: From the Goncourt Journal*, ed. G. J. Becker, Ithaca and London, 1969, p. 312.

29. F. Bourgeat, "Paris vivant," *Le Siècle*, 22 June 1889.

30. C. Monselet, "Courrier de Paris," *Le Monde illustré*, vol. 28, 10 June 1871, p. 354.

31. Petit-Jean, "Courrier de Paris," *Le Monde illustré*, vol. 29, 19 July 1871, p. 42.

32. P. Véron, "Courrier de Paris," *Le Monde illustré*, vol. 29, 15 July 1871, p. 34.

33. H. Lazerges, *Etude sur la réorganisation des Beaux-Arts et sur l'enseignement du dessin dans les écoles communales*, Montpellier, 1871, pp. 3–9.

34. "Translation des cendres des généraux Lecomte et Clément Thomas"; "Restauration de la colonne Vendôme. Mise en place de la statue de Napoléon ler," *Le Monde illustré*, vol. 38, 8 January 1876, p. 22.

35. De Goncourt, *Paris under Siege*, p. 316.

36. Burty's reviews appeared in English in *The Academy*, vol. 9, 15 April 1876, p. 364; *La République française*, 25 April 1874; in J. Lethève, *Impressionnistes et symbolistes devant la presse*, Paris, 1959, pp. 67–68.

37. A. Vollard, *Renoir*, Paris, 1920, p. 62.

38. L. Venturi, *Les archives de l'impressionnisme*, 2 vols., Paris and New York, 1939, II:285.

39. Venturi, *Les archives de l'impressionnisme*, 1:10; H. Adhémar, "Ernest Hoschedé," *Aspects of Monet*, ed. J. Rewald and F. Weitzenhoffer, New York, 1984, p. 56; A. Callen, "Faure et Manet," *Gazette des Beaux-Arts*, 6e pér., vol. 83, March 1974, p. 160. Charpentier belonged to an upper-class intellectual circle calling themselves "Les Tracqueurs," all of whom avoided the Commune save one, who joined the insurrection as a lark, according to Dreyfous (Charpentier's close associate), in order to subvert it. During the siege of Paris, Charpentier served in the staff headquarters editing the reports of General Jules Trochu for the *Journal officiel*. Charpentier was a moderate Republican, identified later with the Opportunists Gambetta, Lockroy, and Floquet; they rejected the Commune, but decried the repression and later voted for amnesty. M. Dreyfous, *Ce que je tiens à dire*, Paris, 1912, pp. 257, 277–280; *Ce qu'il me reste à dire*, Paris, 1913, pp. 158, 166; C. Becker, *Trente années d'amitié 1872–1902; Lettres de l'éditeur Georges Charpentier à Emile Zola*, Paris, 1980, pp. 68–69. Rouart, the "grand bourgeois français," was a captain of artillery during the Prussian siege and evidently followed Degas, who served under him, in studiously avoiding the Commune. A. Alexandre, *La collection Henri Rouart*, Paris, 1912, p. 18. For Maître, see F. Daulte, "A True Friendship: Edmond Maître and Frédéric Bazille," in *Frederic Bazille and Early Impressionism*, The Art Institute of Chicago, Chicago, 1978, p. 29. Georges de Bellio descended from an old Romanian family and was related to Prince Georges Bibesco, an ordnance officer in the French army serving under General du Barail, whose cavalry formed part of Thiers' plan of

attack against the Commune. Bibesco offered to use his influence to find Renoir a comfortable position in the military, and it was Bibesco who helped the artist again after he left Paris during the Commune and ran afoul of the Versailles military authority. Evidently, Bibesco introduced de Bellio to the painter. R. Nicolescu, "Georges de Bellio, l'ami des impressionistes," *Revue roumaine d'histoire de l'art*, vol. 1, No. 2, 1964, p. 213; G. Rivière, *Renoir et ses amis*, Paris, 1921, pp. 13–14; Vollard, *Renoir*, pp. 62–63. Although Renoir's testimony, as recorded by Renoir, differs from Rivière's on the identity of the officer who offered assistance, the painter confirms Bibesco's early influence in behalf of his career. For du Barail's role in suppressing the Commune, see *Rapport du maréchal Mac-Mahon sur les opérations de l'armée de Versailles depuis de 11 avril, époque de sa formation, jusqu'au moment de la pacification de Paris, le 28 mai*, Paris, 1871, p. 4.

40. Goncourt, *Paris Under Siege*, pp. 258–259, 279, 295.

41. G. A. Sala, *Paris Herself Again in 1878–9*, London, 1882, pp. 76–77.

42. A. Silvestre, *Au pays des souvenirs*, Paris, 1887, pp. 152–153.

CHAPTER 2

1. M. Guérin, *Degas Letters*, tr. M. Kay, Oxford, n. d., p. 39.

2. See A. Alexandre, "Durand-Ruel: Bild und Geschichte eines Kunsthändlers," *Pan Halbmonatsschrift*, vol. 2, 16 November 1911, p. 120.

3. E. Cardon, "L'Exposition des révoltés," *La Presse*, 29 April 1874.

4. S. Eisenman, "The Intransigent Artist or How the Impressionists Got Their Name," in C. S. Moffett et al., *The New Painting: Impressionism 1874–1886*, San Francisco, 1986, pp. 51–57.

5. E. Daudet, *L'agonie de la Commune: Paris à feu et à sang (21–29 Mai 1871)*, Paris, 1871, p. 148.

6. E. Zola, *Oeuvres complètes*, ed. H. Mitterand, Paris, 1966, XII: 970–971.

7. Monet's earnings, for example, show a dramatic increase in the 1870s; in 1872 he made 12,100 francs, and the following year 24,800. Between the years 1872–1877, his income totalled 84,429 francs, an average of 14,000 francs per year—quite astonishing when we learn that a top worker's salary averaged around 2,000 francs per annum. See Tucker, *Monet at Argenteuil*, pp. 47, 194–195, Note 33.

8. M. Deraismes, "Une exposition particulière. De l'école réaliste," *L'Avenir des femmes*, 5 July 1874. For a full analysis of this review see A. Boime, "Maria Deraismes and Eva Gonzalès: A Feminist

Critique of *Une Loge au Théâtre des Italiens*," *Woman's Art Journal*, vol. 15/2, Fall 1994–Winter 1995, pp. 31–37.

9. M. Deraismes, *France et Progrès* in *Oeuvres complètes*, 2 vols., Paris, 1895–1896, I:3–11, 146, 176–181, 186, 189–191, 224–248.

10. M. Deraismes, "La régénération de la France," *L'Avenir des femmes*, 5 November 1871; "Soyons Francs," *L'Avenir des femmes*, 6 July 1873; P. K. Bidelman, *Pariahs Stand Up!: The Founding of the Liberal Feminist Movement in France, 1858–1889*, Westport, Connecticut, 1982, pp. 57, 73–88, 99–105; T. Garb, *Sisters of the Brush: Women's Artistic Culture in Nineteenth-Century Paris*, New Haven and London, 1994, pp. 50–53, 65–66.

11. L. Richer, "Silence aux femmes!," *L'Avenir des femmes*, 16 March 1873.

12. For the "pétroleuse," see E. Thomas, *Les Pétroleuses*, Paris, 1963; G. L. Gullickson, "La Pétroleuse: Representing Revolution," *Feminist Studies*, vol. 17, Summer 1991, pp. 241–265. Alexandre Dumas *fils* referred to Communard women as female animals who resembled decent women only when dead. In 1872 he published a defense of a man who summarily killed his adulterous wife entitled *Tue-la* (Kill Her). See Bidelman, *Pariahs Stand Up!*, p. 79.

13. P. Burty, "Fine Art. The Exhibition of the 'Intransigeants,'" *The Academy*, vol. 94, 15 April 1876, pp. 363–364.

14. The paper argued against amnesty as late as 1876: see "Echos de Paris," *Le Gaulois*, 10 April 1876.

15. L. de Lora, "Petites nouvelles artistiques. Exposition libre des peintres," *Le Gaulois*, 18 April 1874.

16. E. Blavet, "Avant le Salon. L'Exposition des réalistes," *Le Gaulois*, 31 March 1876.

17. J. Lethève, *Impressionnistes et Symbolistes devant la presse*, Paris, 1959, p. 78.

18. V. Cherbuliez, "Le Salon de 1876," *Revue des deux mondes*, pér. 3, vol. 15, May–June 1876, pp. 515–517.

19. V. Cherbuliez, *L'Art et la nature*, Paris, 1892, pp. 311–312, 317–319.

20. M. Deraismes, "Les pick-pockets politiques," *L'Avenir des femmes*, vol. 8, 4 June 1876, pp. 81–83.

21. See the translation of *La Nouvelle peinture* in C. S. Moffett et al., *The New Painting: Impressionism 1874–1886*, San Francisco, 1986, pp. 37–47. See also H. Clayson, "The Second Exhibition 1876: A Failed Attempt," *The New Painting*, pp. 145–159.

22. Duranty, *Le pays des arts*, Paris, 1881, p. 3.

23. This was the famous bon mot [*lichettes noires*] of Louis Leroy, critic for *Le Charivari*, whose satirical review of the show also baptized the artists as "impressionnistes." See J. Rewald,

Histoire de l'Impressionnisme, 2 vols., Paris, 1955, I:365.

24. P. Burty, "The Paris Exhibitions. Les Impressionistes—Chintreuil," *The Academy*, vol. 5, 30 May 1874, p. 616.

25. P. Burty, *Grave imprudence*, Paris, 1880, pp. 12, 52–53, 65, 91.

26. Burty, "The Paris Exhibitions," p. 616.

27. "Exposition de la Société anonyme des artistes," *La République Française*, 25 April 1874.

28. S. Mallarmé, "The Impressionists and Edouard Manet," *The Art Monthly Review and Photographic Portfolio, a Magazine Devoted to the Fine and Industrial Arts and Illustrated by Photography*, vol. 1, 30 September 1876, pp. 117–122; reprinted in C. P. Barbier, *Documents Stéphane Mallarmé*, 5 vols., Paris, 1968–1976, I:79–81, 84.

29. Barbier, *Documents*, pp. 85–86.

30. S. Mallarmé, *Correspondance*, ed. H. Mondor, J.-P. Richard, and L. J. Austin, 15 vols., Paris, 1959–1986, I:346, II:312, 312n. During this period, Mallarmé was reading *Le Gaulois*, the newspaper of Versailles. Ibid. I:351.

31. "Exposition de la Société anonyme des artistes," *La République Française*, 25 April 1874.

32. C. Mendès, *Les 73 journées de la Commune*, Paris, 1871, pp. 152–153.

33. Tucker, "The First Impressionist Exhibition in Context," p. 110.

34. L. Michel, *La Commune*, Paris, 1898, p. 346.

35. J. Vallès, *La Commune de Paris*, ed. M.-C. Bancquart and L. Scheler, Paris, 1970, p. 350n.

36. A. Darcel, "Les Musées, les arts et les artistes pendant la Commune," *Gazette des Beaux-Arts*, pér. 2, vol. 5, 1872, pp. 50–51.

37. Lissagaray, *History of the Commune*, p. 335.

38. R. Greaves, *Nadar, ou le paradoxe vital*, Paris, 1980, pp. 303–310.

39. P. Burty, "The Paris Exhibitions. Les Impressionistes—Chintreuil," *The Academy*, vol. 5, 30 May 1874, p. 616. In his review in the French press he likened the illuminated site of Nadar's to "the passage of a fireball" [le passage d'un bolide]. See "Exposition de la Société des artistes," *La République Française*, 25 April 1874.

40. G. Le Bon, *The Crowd, A Study of the Popular Mind*, Marietta, GA, 1982, pp. 96, 108n., 169.

41. Quoted in B. Denvir, ed., *The Impressionists at First Hand*, London, 1987, p. 85.

42. L. de Bernard, "Les femmes de Paris pendant le siège," *Le Monde illustré*, vol. 28, 11 February 1871, pp. 87, 89–90; V.-F.-M., "Les incendiaires," ibid., 3 June 1871, pp. 342–343.

43. V. Fournel, *Paris et ses ruines en mai 1871*, Paris, 1872, pp. i–vi.

44. For Zola and the Commune, see R. Ripoll, "Zola et les Communards," *Europe*, vol. 46, April–May 1968, pp. 16–26.

45. J. Rewald, *Cézanne, A Biography*, New York, 1986, p. 91. See also Zola's attitude in *Le Corsair*, 3 December 1872, quoted in J. Rewald, *The History of Impressionism*, New York, 1973, pp. 265–266.

CHAPTER 3

1. D. Rouart, ed., *Berthe Morisot: The Correspondence*, trans. B. W. Hubbard, London, 1987, p. 73. Actually, Mme Morisot thought that the Manet in question was his brother Eugène, and it was only a few days later that she learned that Tiburce had referred to Edouard.

2. Herbert, *Impressionism*, p. 164. The date of *At the Races in the Country* is a contested one, with speculation ranging from as early as 1869 to as late as 1873. Henri Loyrette bases the earlier dating—also accepted by Reff (letter of 5 August 1994)—on the baby's date of birth, 11 January 1869. But there is no need to assume that Degas painted it directly on the spot, as Herbert pointed out (note of 25 July 1994), and it could have been done from a sketch or from memory during his long stay with the family in 1871. Although Degas visited the coasts of Normandy in 1869, we do not know for certain that he visited Valpinçon at that time. It is also noticeable that the baby is somewhat large for six months, and the style and angle of the cropping in the lower right-hand corner strikes me as too advanced for the earlier date. It is more reminiscent of *Portraits in an Office (New Orleans)*. Finally, however, what is most important about the picture in terms of my argument is that it displays the lifestyle preferred by Degas in the moment of social crisis. See Editions de la Réunion des Musées Nationaux, *Degas*, Paris, 1988, No. 95, pp. 157–158.

3. J. P. Bouillon, "Les lettres de Manet à Bracquemond," *Gazette des Beaux-Arts*, 6e. pér., vol. 101, April 1983, pp. 151–152.

4. P. Nord, "Manet and Radical Politics," *The Journal of Interdisciplinary History*, vol. 19, Winter 1989, pp. 447–480.

5. Ibid., p. 448n.2.

6. F. Jellinek, *The Paris Commune of 1871*, London, 1937, p. 330.

7. Ranc resigned from the Commune on 6 April but had to flee to Belgium during the repression.

8. L. Fiaux, *Histoire de la guerre civile de 1871*, Paris, 1879, pp. 525–526.

9. R. E. Shikes and P. Harper, *Pissarro, His Life and Work*, New York, 1980, pp. 87–88.

10. He wrote Piette in 1871 angrily denouncing "these assassins of socialists": see J. Bailly-Herzberg, ed., *Correspondance de Camille Pissarro*, 5 vols., Paris, 1980–1991, I:67–68.

11. Pissarro to his son Lucien, 2 May 1887 in ibid., II:157.

12. F. Daulte, *Alfred Sisley*, Milan, 1988, p. 22.

13. R. Shone, *Sisley*, New York, 1992, pp. 46–47.

14. Cited in J. Lindsay, *Cézanne, His Life and Art*, New York, 1969, p. 168.

15. Barbara Ehrlich White states that he was drafted into a regiment of cuirassiers (armored troops on horseback), but Vollard recorded in his interview with the artist "le 10e chasseurs à cheval." See B. E. White, *Renoir, His Life, Art and Letters*, New York, 1988, p. 37; A. Vollard, *Renoir*, Paris, 1920, p. 55.

16. White, *Renoir*, p. 39.

17. G. Coquiot, *Renoir*, Paris, 1925, p. 57; Vollard, *Renoir*, pp. 57–58.

18. S. Monneret, *Renoir*, New York, 1990, p. 9.

19. "Rebuilding. By a Member of the Rookery," *The Illustrated London News*, vol. 58, 8 April 1871, pp. 348, 350.

20. Bertall, "Le Docteur Tant-Pis et le Docteur Tant-Mieux," *L'Illustration*, vol. 58, 1871, p. 424.

21. *Letters of Gustave Courbet*, p. 415.

22. A. Boime, "Thomas Nast and French Art," *The American Art Journal*, vol. 4, Spring 1972, pp. 61–62.

23. M. Guérin, ed., *Letters de Degas*, Paris, 1931, pp. 5, 8.

24. Ibid., pp. 11, 13.

25. M. Guérin, *Degas Letters*, tr. M. Kay, Oxford, n.d., pp. 29–32. The English edition contains several letters, including this one, not published in the original French edition.

26. I had reached my conclusions prior to the appearance of Marilyn R. Brown's fascinating monograph on the picture, whose interpretation coincides on many points with my own. I can hardly do justice here to her probing and passionate analysis, but she demonstrates that already by the time of the picture's completion the market, audience, and even the message had shifted within dynamically unfolding economic and cultural conditions. To my mind, Degas' insistence on guarding his "first impression" attests to his ongoing complicity with Thiers' program which accorded with his own. Although, as Brown points out, their financial situation deteriorated rapidly soon afterwards, both Musson and Rene DeGas proved to be resilient types in the "American" grain. See M. R. Brown, *Degas and the Business of Art: A Cotton Office in New Orleans*, University Park, PA, 1994, pp. 1–58; *Soard's New Orleans City Directory for 1878*, New Orleans, 1878, pp. 231, 512. Both Rene DeGas and Musson are shown sharing a business address at r. 372 Esplanade, the former a partner in Leisy & Co., and the latter listed as president of the New Orleans Insurance Association.

27. *Degas Letters*, pp. 17–19.

28. Ibid., pp. 70–71.

29. Boime, "Thomas Nast," pp. 161–164; E. Zola, "Deux Expositions d'art au mois de mai: Salon de 1876 et deuxième exposition impressionniste," *Le Messager de l'Europe* (Saint Petersburg), excerpted in English translation in *The New Painting*, p. 171.

30. In the New Orleans labor structure, the blue collar force was further broken down into white and black. It was noted that in the Louisiana Cotton Manufacturing Company, "The operatives are all white, being chiefly creoles from Third District." See "Louisiana Cotton Manufactory," in E. L. Jewell, *Jewell's Crescent City Illustrated*, New Orleans, 1873, n.p.

31. *Degas Letters*, p. 18.

32. See E. Lipton, *Looking into Degas: Uneasy Images of Women and Modern Life*, Berkeley and Los Angeles, 1988, pp. 116–150.

33. E. Thomas, *The Women Incendiaries*, New York, 1966, pp. 176–177.

34. This also seems to be the case in the female representation of women's labor in Impressionism: see L. Nochlin, "Morisot's *Wet Nurse*: The Construction of Work and Leisure in Impressionist Painting," in *Women, Art, and Power and Other Essays*, New York, 1988, pp. 37–56.

35. Brown, *Degas and the Business of Art*, pp. 83–116.

36. M. Chaumelin, *La Gazette [des étrangers]*, 8 April 1876; cited in *The New Painting*, p. 171.

37. Lissagaray, *History of the Commune of 1871*, p 347.

38. A. Boime, "Entrepreneurial Patronage in Nineteenth-Century France," in *Enterprise and Entrepreneurs in Nineteenth- and Twentieth-Century France*, ed. E. C. Carter II, R. Forster, and J. N. Moody, Baltimore and London, 1976, p. 154; H. Adhémar, "Ernest Hoschedé," in *Aspects of Monet*, ed. J. Rewald and F. Weitzenhoffer, New York, 1984, p. 55; Brown, *Degas and the Business of Art*, p. 84.

39. Alexander, *La Collection Henri Rouart*, p. 42.

40. L. d'Argencourt and J. Foucart, *Puvis de Chavannes 1824–1898*, Grand Palais, Paris, Editions des Musés Nationaux, 1976, pp. 114–115, Nos. 91, 92. In the same Salon, Feyen-Perrin (a former member of the Fédération des artistes) exhibited a similar theme; entitled *Le Printemps de 1872*, it shows a young woman strolling dreamily through a meadow carpeted with a bright array of spring blossoms, barely concealing a piece of shrapnel at her foot. Not surprisingly, the verses of Silvestre serve as the epigraph for the Salon entry: "Everything revives. Upon our dead, so long without burial,/The fragrant shroud of flowers closes

over,/And spring returns, sweet, charming, perfumed;/How light are our sorrows to your conscience, O Nature!" See *Salon de 1872*, No. 625. For an illustration of Feyen-Perrin's picture and commentary see P. Mantz, "Salon de 1872," *Gazette des Beaux-Arts*, per. 2, vol. 5, 1872, pp. 466–467.

41. Zola, *Oeuvres complètes*, xii, pp. 907, 909. During the critical years 1872–1874, the Commune entered the official Salon mostly by way of representations of the ravaged buildings like the Tuileries, as well as projects for its restoration. The term "Commune," however, does not enter the Salon titles until 1874; the two cases are *Souvenir de la Commune;—Neuilly, 1871* by the American painter, Edward Harrison May, and *Les Tuileries après la Commune*, a watercolor by Jules Richomme. See *Salon de 1874*, Nos. 1283, 2512.

42. See the discussion of P. Mainardi, *The End of the Salon: Art and the State in the Early Third Republic*, New York, 1993, pp. 99, 101, 104.

43. V. C. O. Gréard, *Meissonier, His Life and His Art*, London, 1897, pp. 266–267.

44. M. Vauvert, "Les Tuileries," *Le Monde illustré*, vol. 29, 1 July 1871, p. 6.

45. K. Varnedoe, "The Tuileries Museum and the Uses of Art History in the Early Third Republic," *Saloni, gallerie, musei e loro influenza sullo sviluppo dell'arte dei secoli XIX e XX*, ed. F. Haskell, Atti del XXIV Congresso Internazionale di Storia dell'Arte, 1981, pp. 63–68. Coincidentally, Meissonier exhibited his *Ruins of the Tuileries* in 1883 when the last remnant of the palace had been demolished. See Mainardi, *The End of the Salon*, pp. 99, 101, 104.

46. T. Gautier, *Tableaux du Siège, Paris, 1870–1871*, Paris, 1872, pp. 372–373.

47. S. Barrows, *Distorting Mirrors: Visions of the Crowd in Late Nineteenth-Century France*, New Haven and London, 1981, pp. 73–92, 100–104.

48. M. de Villemessant, "Enterprise générale de balayage parisien," *Le Figaro*, 8 June 1871.

49. L. M. Tisserand, "La nouvelle statue de Jeanne d'Arc," *Le Monde illustré*, vol. 34, 28 February 1874, p. 135.

50. P. H. Tucker, *Monet at Argenteuil*, New Haven and London, 1982, p. 163.

51. M. Vauvert, "Le jardin des Tuileries transformé en parc d'artillerie," *Le Monde illustré*, vol. 28, 8 April 1871, p. 218.

Chapter 4

1. M. Berhaut, *Caillebotte, sa vie et son oeuvre*, Paris, 1978, p. 7.

2. R. Tombs, *The War Against Paris 1871*, Cambridge, 1981, pp. 17–18.

3. J. Claretie, *Peintres & sculpteurs contemporains*, 2 vols., Paris, 1883–1884, II: 134.

4. Ibid., p. 151; Berhaut, *Caillebotte*, p. 7.

5. Claretie, *Peintres & sculpteurs contemporaines*, pp. 147–150.

6. "Nos gravures," *Le Monde illustré*, vol. 41, 1877, p. 166.

7. K. Varnedoe, *Gustave Caillebotte*, New Haven and London, 1987, pp. 3, 185. Caillebotte's rejection had been noted by a critic for *Le Rappel*: see E. Blémont, "Les Impressionistes," *Le Rappel*, 9 April 1876.

8. Varnedoe, *Gustave Caillebotte*, p. 187.

9. Ibid., p. 54.

10. Burty, "Fine Art. Exhibition of the 'Intransigeants,'" p. 364.

11. Varnedoe, *Gustave Caillebotte*, p. 186.

12. Burty, "L'Exposition des Impressionistes," *La République française*, 25 April 1877.

13. C. P. D., "Le Pont Métallique de la Place de l'Europe," *L'Illustration*, vol. 5, 11 April 1868, p. 236.

14. *Rapport du Maréchal Mac-Mahon*, p. 16; *Paris Under Siege, 1870–1871: From the Goncourt Journal*, p. 135; M. du Camp, *Les Convulsions de Paris*, 4 vols., Paris, 1878–1880, II:347–348; E. A. Viztelly, *My Adventures in the Commune*, London, 1914, p. 318.

15. V. Fournel, *Paris et ses ruines en Mai 1871*, Paris, 1872, p. 4.

16. Herbert, *Impressionism*, pp. 23–24.

17. *The New Painting*, p. 224.

18. Venturi, *Les Archives de l'impressionisme*, II:312.

19. Deraismes, *France et progrès*, pp. 162–164.

20. See J.-J. Rovel, *Etude sur les chemins de fer envisagés au point de vue militaire*, Constantine, 1874; and the review of the book, "Les Chemins de fer au point de vue militaire," *La République Française*, 22 June 1874.

21. *Paris insurgé*, pp. 87, 158; M. Vauvert, "Les engagements sous Paris," *Le Monde illustré*, vol. 28, 22 April 1871, p. 263.

22. *Rapport du Maréchal Mac-Mahon*, p. 16; Viztelly, *My Adventures in the Commune*, p. 318.

23. *Claude Monet-Auguste Rodin: Centenaire de l'exposition de 1889*, Musée Rodin, Paris, 1989, p. 214.

24. Burty, "Les Ateliers," *La renaissance littéraire et artistique*, vol. 1, 1872, pp. 220–221.

25. E. King, *Descriptive Portraiture of Europe in Storm and Calm*, Springfield, MA, 1890, pp. 475–481. An American journalist, King actually holed up in an upper-story appartment on the Boulevard des Malesherbes and was an eye-witness to this episode during Bloody Week.

26. P.-O. Lissagaray, *History of the Commune of 1871*, New York, 1898, p. 334.

27. Du Camp, *Les Convulsions de Paris*, II:87, 89.

28. "Women of Montmartre," *The Graphic*, vol. 3, 10 June 1871, p. 542.

29. E. Lepelletier, "Les Impressionnistes," *Le Radical*, 8 April 1877, reprinted in Varnedoe, *Gustave Caillebotte*, p. 188.

30. Lepelletier, "Les Impressionnistes," *Le Radical*, 8 April 1877; Jacques, "Menu Propos," *L'Homme Libre*, 12 April 1877; in Varnedoe, *Gustave Caillebotte*, p. 189.

31. Silvestre, *Au Pays des souvenirs*, p. 152; King, *Descriptive Portraiture of Europe*, pp. 490–491.

32. Berhaut, *Caillebotte*, Nos. 58, 111; D. Wildenstein, *Claude Monet, Biographie et catalogue raisonné*, 4 vols., Lausanne and Paris, 1974, Nos. 398–400, 466–468.

33. G. Soria, *Grande histoire de la Commune*, 5 vols., Milan, 1970, IV:196; P. de Lano, *Journal d'un vaincu*, Paris, 1892, p. 46.

34. E. Zola, La Curée in *Oeuvres complètes*, 50 vols., Paris, 1928, XIII:199.

35. Tucker, *Monet at Argenteuil*, pp. 125–153; P. Wittmer, *Caillebotte and His Garden at Yerres*, New York, 1991.

36. Cited in J. Lindsay, *Cézanne, His Life and Art*, New York, 1969, p. 148.

37. See Edmond Morin's cover illustration, "Un temps de galop au Bois de Boulogne," *L'Esprit follet*, 29 May 1869. Reproduced in J. Isaacson, "Impressionism and Journalistic Illustration, *Arts Magazine*, vol. 56, 1982, pp. 104–105.

38. Alexandre, *La Collection Henri Rouart*, p. 23.

39. Jellinek, *The Paris Commune*, pp. 372–373.

40. A. Higonnet, *Berthe Morisot's Images of Women*, Cambridge, MA, 1992, pp. 64–65.

41. Clark, *The Painting of Modern Life*, p. 75.

42. "Physionomie de Paris," *Paris insurgé*, p. 264.

43. E. Thomas, *The Women Incendiaries*, New York, 1966, pp. 58–62, 74.

44. Lissagaray, *History of the Commune*, p. 334.

45. A. M. de Belina, *Nos peintres dessinés par eux-mêmes*, Paris, 1883, pp. 341–342.

46. Editions de la Rèunion des musèes nationaux, *Degas*, No. 172, pp. 286–288.

47. Bertall, *Les Communeux 1871, Types—Caractères—Costumes*, 3rd ed., Paris, 1880, "Avant-Propos," n.p.; Bertall, *The Communists of Paris 1871: Types—Physiognomies—Characters*, Paris, 1873, "Introduction," "Artist's Preface," n.p.

48. Rumors about the drunken prostitutes setting fire to the municipal buildings were exploited by the police des moeurs in the period after the Commune to justify stepped up powers of surveillance and arrest. See C. Bernheimer, *Figures of Ill Repute: Representing Prostitution in Nineteenth-Century France*, Cambridge, MA, 1989, pp. 209–210.

49. Quoted in S. Barrows, "After the Commune: Alcoholism, Temperance, and Literature in the Early Third Republic," *Consciousness and Class Experience in Nineteenth-Century Europe*, ed. J. M. Merriman, New York and London, 1979, p. 209.

50. C. Richet, "Les poisons de l'intelligence. I. L'Alcool.—Le Chloroforme," *Revue des deux mondes*, vol. 19, 15 February 1877, p. 829n.

51. L. Hans and J.-J. Blanc, *Guide à travers les ruines: Paris et ses environs*, Paris, 1871.

CHAPTER 5

1. Hans and Blanc, *Guide à travers*, pp. 46–47.

2. B. Noël, *Dictionnaire de la Commune*, Paris, 1971, p. 264; E. Daudet, *L'agonie de la Commune*, Paris, 1871, p. 61.

3. L. Michel, *Mémoires de Louise Michel, écrits par elle-même*, 2 vols., Paris, 1886, I:174–176.

4. Cited in Venturi, *Archives de l'impressionnisme*, II:308–309.

5. Perdican, "Courrier de Paris," *L'Illustration*, 7 January 1882.

6. A. Distel, *Impressionism: The First Collectors*, New York, 1990, pp. 25, 175.

7. R. J. Goldstein, *Censorship of Political Caricature in Nineteenth-Century France*, Kent, OH, 1989, pp. 54–56.

8. T. Reff, "Pissarro's Portrait of Cézanne," *Burlington Magazine*, vol. 109, November 1967, pp. 627–633.

9. L. Venturi, *Les archives de l'impressionnisme*, 2 vols., Paris and New York, 1939, I:122.

10. Tucker, *Monet at Argenteuil*, pp. 57–87; Herbert, *Impressionism*, pp. 220, 222–226.

11. G. A. Sala, *Paris Herself Again in 1878–9*, 6th ed., 2 vols., London, 1882.

12. Lissagaray, *History of the Commune*, pp. 347, 350, 356.

13. Walker, "Ouverture officielle de l'Exposition, *Le Monde illustré*, vol. 42, 11 May 1878, pp. 302–303.

14. *La Gazette de France*, 29 June 1878.

15. *Journal officiel*, 2 July 1878, p. 7542.

16. "Nos gravures," *Le Monde illustré*, vol. 41, 15 September 1877, pp. 168–169.

17. R. Kasl, "Edouard Manet's 'Rue Mosnier': 'Le Pauvre a-t-il une patrie?,'" *Art Journal*, vol. 44, Spring 1985, pp. 49–58.

18. The Metropolitan Museum of Art, *Manet 1832–1883*, ed. F. Cachin, C. S. Moffett, and M. Melot, New York, 1983, No. 205.

EPILOGUE

1. There is a voluminous literature on the work. See especially J. House, "Meaning in Seurat's Figure Paintings," *Art History*, vol. 3, September 1980, pp. 345–356; T. J. Clark, *The Painting of Modern Life*, New York, 1984, pp. 261–267; R. Thomson, *Seurat*, London, 1985, pp. 97–126; R. L. Herbert, *Georges Seurat 1859–1891*, The Metropolitan Museum of Art, New York, 1991, pp. 170–219; M. F. Zimmermann, *Seurat and the Art Theory of His Time*, Antwerp, 1991, pp. 171–195. There is also the special issue of *The Art Institute of Chicago Museum Studies* devoted to "The Grande-Jatte at 100," vol. 14, No. 2, 1989.

2. The standard study here is D. C. Rich, *Seurat and the Evolution of "La Grande Jatte,'* Chicago, 1935.

3. W. I. Homer, *Seurat and the Science of Painting*, Cambridge, Mass., 1964, pp. 17, 29–36.

4. C. Blanc, *Grammaire des arts du dessin*, Paris, 1867. I am using the English translation by K. N. Doggett, *The Grammar of Painting and Engraving*, Chicago, 1891, pp. xvi–xvii.

5. Ibid., pp. 68–69.

6. Blanc, *Grammaire*, pp. 37–38, 40, 97.

7. Blanc, whose political sense of art had been shaped by 1848, dreamed of a monumental public art to elevate the taste of the masses. His elitist ideal remained Paul Chenavard's universal history and palingenesis of humanity which he had commissioned for the Pantheon during his short-lived tenure as Director of Beaux-Arts in 1848. Here a painter managed to give effective visual form to complicated philosophical and political themes: "It is impossible to relate history more clearly and vividly by the figurative language of art, mute language that engraves itself upon the memory of peoples in ineffaceable lines, like the eloquence of the Athenian orator which left its needles in the heart." Ibid., pp. 7, 9, 29–30.

8. A. Boime, "Le Musée des Copies," *Gazette des Beaux-Arts*, 6e. pér., vol. 64, October 1964, pp. 237–247.

9. Boime, "Seurat and Piero della Francesca, *Art Bulletin*, vol. 47, June 1965, pp. 265–271.

10. Quoted in J. Rewald, *Georges Seurat*, New York, 1943, p. 26.

11. N. Broude, ed., *Seurat in Perspective*, Englewood Cliffs, N. J., 1978, p. 20.

12. *Le journal des artistes*, 13 June 1886, quoted in Clark, *The Painting of Modern Life*, p. 263.

13. G. Coquiot, *Seurat*, Paris, 1924, pp. 45–46, 55–57, 60, 65–72. Art students from the Ecole learned to scull near the island in the 1880s, rowing down the "narrower portion of the river on the south side of the island." See J. Shirley, *Shirley Fox.*

An Art Student's Reminiscences of Paris in the Eighties, London, 1909, pp. 217–219. Marie Bashkirtseff, who exhibited with Seurat at the Salon des Independants in 1886, also worked at La Grande-Jatte in the early 1880s and noted the various types on holidays. See M. Bashkirtseff, *Journal*, tr. A. D. Hall, 2 vols., Chicago and New York, 1913, II:200, 295.

14. L. d'Alq, *Le savoir-vivre dans toutes les circonstances de la vie*, 3 vols., Paris, 1883–1885, I:3, 31, 207, 211, 216 ff. ("Le savoir-vivre du cigare"), II: 47–48, 199–200; A. Babeau, *Les bourgeois d'autrefois*, Paris, 1886, pp. 365, 368.

15. L. Ulbach, *Guide sentimentale de l'étranger dans Paris*, Paris, 1878, p. 54.

16. O. Uzanne, *L'ombrelle, le gant-le manchon*, Paris, 1883, p. 61.

17. J. Grand-Carteret, *XIXe siècle (En France)*, Paris, 1893, pp. 488–489. The author also added that "everything returned to normal on Monday!" See also the discussion of Sunday in the Bois de Boulogne in L. Barron, *Les environs de Paris*, Paris, 1886, p. 2, where the author states that the park becomes "abruptly democratized."

18. D. H. Pinkney, *Napoleon III and the Rebuilding of Paris*, Princeton, 1972, pp. 93–104; G. F. Chadwick, *The Park and the Town*, London, 1966, pp. 152–162.

19. V. Fournel, *Paris nouveau et Paris futur*, Paris, 1865, p. 17; A. Alphand, *Les promenades de Paris*, 3 vols., Paris, 1868, I:LVIII–LIX; Baron Ernouf, *L'Art des jardins. Parcs—jardins—Promenades*, Paris, n.d., pp. 352–353 (Alphand collaborated on the production of this work); E. Deny, *Jardins et parcs publics*, Paris, 1893, pp. 9–10, 61–82.

20. In his *Les Promenades de Paris* of 1868, Alphand stated the need for surveillance in the parks "to avoid the vandalism of children or of unscrupulous persons." Alphand, *Les promenades*, p. LVIII.

21. F. Duvillers, *Les parcs et jardins*, Paris, 1871, opposite pp. 2, 6, 10, 16, 46, 56.

22. J. Bertaut, *Le roi bourgeois*, Paris, 1936, pp. 58–63; P. Coulomb, *Histoires de Neuilly*, Neuilly, 1946, pp. 131–132.

23. Prince de Joinville, *Vieux souvenirs 1818–1848*, Paris, 1894, pp. 22–24. Louis-Philippe's properties, including other parklands like Monceau, were absorbed into the public domain by Louis-Napoleon's decree of 22 January 1852. See *Bulletin des lois de la république française*, Xe série, Paris, 1852, IX:92–93; Barron, *Les environs de Paris*, p. 32; P. Coulomb, *Neuilly des origines à nos jours*, Neuilly, 1966, p. 213; R. Lécuyer, "Un paysage des bords de la Seine en péril," *L'Illustration*, vol. 169, 22 January 1927, pp. 85–87.

24. "Voyage à l'isle de la Grande Jatte," *Neuilly, Journal Indépendant*, No. 858, June 1979. Accord-

ing to the story, there were two islands joined to-gether by Haussmann.

25. Coquiot, *Seurat*, pp. 18, 21–22.

26. Ibid., pp. 12–16.

27. For the father's house at Le Raincy, see J. J. A. Bougon, "Le peintre Georges Seurat et Le Raincy," *En Aulnoye Jadis*, No. 17, 1988, pp. 78–79. The reclusive retiree indulged in some curious religious rituals, apparently conducting private masses in the basement of his country house in which his gardener functioned as choir boy. His bizarre piety may explain his son's personal need to secularize Sunday.

28. Fournel, *Paris nouveau*, pp. 78–79, 85–86, 90–92, 115.

29. Ibid., p. 114.

30. According to the landscaping specialist Ernouf this is implied in the notion of creating scenes in the "style paysager." But in public spaces, as in every other branch of art, "unity" must govern the layout, whether of a vast park or a modest landscape-garden. Ernouf, *L'Art des jardins*, pp. x, 124–125, 127, 129, 283–285, 297. Charles Blanc also accorded a prominent place in his *Grammaire* to parks and gardens, whose object, he claimed, was to introduce order into the free creations of nature. Indeed, this section uses many of the terms he previously applied to his definition of history painting. See Blanc, *Grammaire des arts du dessin*, 1876 ed., pp. 306–328.

31. Grand-Carteret, *XIXe siècle*, pp. 473–491; F. L. Olmsted, "Public Parks and the Enlargement of Towns," *Journal of Social Science*, No. 3, 1871, pp. 18–22, 28, 32, 34; D. Bluestone, "From Promenade to Park: the Gregarious Origins of Brooklyn's Park Movement," *American Quarterly*, vol. 39, Winter 1987, pp. 529–550.

32. This was true elsewhere in the world as well: see the unpublished paper by E. Blackmar and R. Rosenzweig, "The Park and the People: Central Park and Its Publics, 1850–1914," presented to the Joint Hungarian-American Conference on New York and Budapest in the Era of Metropolitan Transformation, 14–19 August 1988, p. 16.

33. F. J. Grund, *The Americans, in their Moral, Social, and Political Relations*, Boston, 1837, p. 47. Grund was a German writer devoted to making comparative studies of the various nationalities in the 19th century.

34. C. Montalembert, *Rapport de M. de Montalembert. De l'observation des dimanches et jours fériés*, Paris, 1850, p. 17.

35. Ibid., pp. 28–29, 36, 49.

36. F. Pyat, *Loisirs d'un proscrit*, 2 vols., Paris, 1851, I: 45, 67–68, 70, 73–75.

37. P.-J. Proudhon, *De la célébration du dimanche considérée sous les rapports de l'hygiène pub-lique, de la morale, des relations de famille et de cité*, Paris, 1850; Montalembert, *Rapport*, p. 9n.

38. Proudhon, *De la célébration du dimanche*, pp. viii–ix, 18–19, 41–42, 80.

39. E. Cabet, *Voyage en Icarie*, Paris, 1848, pp. 21, 49–51, 58, 282–283.

40. C. H. Johnson, *Utopian Communism in France: Cabet and the Icarians, 1839–1851*, Ithaca and London, 1974, pp. 65–66.

41. F. Schwerin, *Der Sonntag. Erste gekrönte Preisschrift unter 76 eingelieferten Arbeiten des Volksschullehrerstandes Deutschlands*, Leipzig, n.d. [1850s]; J. Miller, *Physiology in Harmony with the Bible Respecting the Value and Right Observance of the Sabbath*, Edinburgh, 1855; *De Rustdag en de werkende Stand*, Amsterdam, 1859; *Om Söndagens firande enligt Guds Ords*, Stockholm, 1864.

42. *Exposition universelle internationale de 1889. Congrès international du repos hebdomadaire au point de vue hygiénique et social*, Paris and Geneva, 1890. The International Socialist Congress also met in 1889 and advocated an eight-hour day and a day off—with compensation.

43. Ibid., pp. 47, 85–86, 106, 107, 127, 178, 190, 387.

44. Ibid., pp. 61, 135. One participant declared: "Le dimanche, c'est la famille, le lundi, c'est le cabaret," while another (a factory owner) called Monday "le dimanche du diable."

45. *L'Illustration*, vol. 71, 15 June 1878, pp. 390–391.

46. Clark, *The Painting of Modern Life*, pp. 261–263; House, "Meaning in Seurat's Figure Paintings," p. 348.

47. Rewald, *Georges Seurat*, p. 47. For studies of this milieu, see E. W. Herbert, *The Artist and Social Reform*, New Haven, 1961; R. L. and E. W. Herbert, "Artists and Anarchism: Unpublished Letters of Pissarro, Signac and Others," *Burlington Magazine*, vol. 102, November–December 1960, pp. 473–482, 517–522.

48. F. Cachin, *Paul Signac*, Greenwich, Conn., 1971, pp. 69, 73.

49. I am convinced that Chevreul, whose *De la loi du contraste simultané*, first published in 1839 and addressed specifically to industrial designers, was influenced by the utopian strains of the later July Monarchy. Chevreul's own development had been conditioned by frightful memories of the Terror, and his search for unity and harmony in garden design cannot be separated from his attempt to establish order in the real world. See M. E. Chevreul, *The Laws of Contrast of Colour and their Application to the Arts*, tr. J. Spanton, London, n.d., pp. 179–197; Chevreul, *Histoire des connaissances chimiques*, Paris, 1866, pp. 411–416, 436;

A. B. Costa, *Michel Eugène Chevreul, Pioneer of Organic Chemistry*, Madison, 1962, p. 1. (The elder Seurat's obsession with landscape gardening may have led him first to Chevreul's important manual for its important section on horticulture.) In the case of Henry, who read Charles Fourier, the relationship between aesthetic theory and society is even clearer: the tendency of the species towards "dynamogeny"—towards continuity and unity of action—results in individuality moving in the direction of the collectivity and collectivity in the direction of the individual being. "The realization of this double goal will be an era of absolute harmony." See C. Henry, *Cercle chromatique présentant tous les compléments et toutes les harmonies de couleurs*, Paris, 1888, pp. 147–148. Finally, Henry concludes his *Rapporteur esthétique* with the statement that aesthetic harmony ultimately conduces to the realization of society's higher destiny, "the creation of universal harmony" (*Rapporteur esthétique*, Paris, 1888, p. 22).

50. P. Kropotkin, *Paroles d'un révolté*, Paris, 1978, p. 89; E. Reclus, *Correspondance*, 3 vols., Paris, 1911, II: 325, 327; Reclus, "Anarchy: By an Anarchist," *The Contemporary Review*, vol. 45, January–June 1884, p. 628; Reclus's preface to Kropotkin's *Conquête du pain*, quoted in J. Ishill, ed., *Peter Kropotkin, the Rebel, Thinker and Humanitarian*, Berkeley Heights, N. J., 1923, p. 76; J. Grave, *L'Anarchie, son but—ses moyens*, Paris, 1899, p. 316; "L'Harmonie," *La révolte*, 28 December– 10 January 1890–1891.

51. S. Osofsky, *Peter Kropotkin*, Boston, 1979, p. 62.

52. P. Kropotkin, *Conquest of Bread*, New York and London, 1968, p. 36.

53. Quoted in F. E. and F. P. Manuel, *Utopian Thought in the Western World*, Cambridge, Mass., 1982, p. 602.

54. P. Kropotkin, "Anarchism: Its Philosophy and Ideal," in *Kropotkin's Revolutionary Pamphlets*, ed. R. N. Baldwin, New York, 1970, pp. 117–118; Kropotkin, *Memoirs of a Revolutionist*, Boston and New York, 1899, pp. 402, 404–405; Kropotkin, "Le travail agréable," *La révolte*, 8–15 February 1890.

55. The most thorough exposition of Fourier's system is found in *Théorie des quatre mouvements et des destinées générales*, 2 vols., and *Théorie de l'unité universelle*, 4 vols., in *Oeuvres complètes*, 12 vols., Paris (Editions Anthropos), 1966, vols. I–V.

56. Fourier, *Oeuvres*, III:297, IV:509, VI:323– 334.

57. Ibid., II:212–216.

58. Fourier, *De l'anarchie industrielle et scientifique*, Paris, 1847, pp. 14–15, 17, 36, 38, 61.

59. Fourier, *Oeuvres*, III:162, IV:409–411, VI:66.

60. Jean Grave used Fourier's metaphor in his article "L'Harmonie" to characterize the magnetic pull of association and the pooling of autonomous talents in a constantly rotating series corresponding to the variability of the human passions. J. Grave, "L'Harmonie, *La révolte*, 28 December–10 January 1890–1891.

61. Charles Fourier, *Design for Utopia: Selected Writings of Charles Fourier*, tr. J. Franklin, New York, 1976, p. 77.

62. For this reason feminism occupied a central place in his teaching which proclaimed that emancipation of society had to begin with the emancipation of women. See E. Dessignole, *Le féminisme d'après la doctrine socialiste de Charles Fourier*, Lyon, 1903; N. V. Riasanovsky, *The Teaching of Charles Fourier*, Berkeley and Los Angeles, 1969, pp. 208–210.

63. Proudhon's major statements on women's social role are found in *De la Justice dans la révolution et dans l'église*, 3 vols., Paris, 1858, III: 335– 486; *La pornocratie ou les femmes dans les temps modernes*, Paris, 1875. Louise Michel, a radical feminist attached to anarcho-communism, simply separated Proudhon the political and social philosopher from Proudhon the anti-feminist. See L. Michel, *The Red Virgin: Memoirs of Louise Michel*, ed. and trans. B. Lowry and E. E. Gunter, University, AL, 1981, pp. 110–111, 142, 167.

64. For an excellent discussion of this contradiction in anarchist rhetoric and practice, see J. Hutton, "Camile [sic] Pissarro's *Turpitudes Sociales* and Late Nineteenth-Century French Anarchist Anti-Feminism," *History Workshop*, No. 24, Autumn 1987, pp. 32–61.

65. Grave's comment was a footnote to an unsigned article by a feminist: "Un cri de femme révoltée," *La révolte*, 18–24 September 1886.

66. Grave, *L'Individu et la société*, Paris, 1897, p. 294.

67. J. Rewald, "Extraits du Journal inédit de Paul Signac: I (1894–1895)," *Gazette des Beaux-Arts*, 6e. pér., vol. 36, July–September 1949, p. 113.

68. Thomson, *Seurat*, pp. 122–124.

69. P. Kropotkin, *Modern Science and Anarchism*, London, 1923, pp. 57–59; Kropotkin, *Memoirs of a Revolutionist*, p. 405. See also E. S. Mason, "Fourier and Anarchism," *The Quarterly Journal of Economics*, vol. 42, February 1928, pp. 228–262.

70. Kropotkin, *Paroles d'un révolté*, pp. 93–118; "L'Anarchie dans l'évolution socialiste," *Le Révolté*, 9–15 May 1886; *Conquest of Bread*, pp. xiii– xiv; "Anarchist Communism," *Revolutionary Pamphlets*, p. 51; Grave, *L'Anarchie, son but—ses moyens*, pp. 91, 193, 197; *Quarante ans de propagande anarchiste*, pref. J. Maitron, Paris, 1973, pp. 106–122; "Echos du 18 Mars," *Le révolté*, 25

April–8 May 1886; K. Marx, "The Civil War in France," in *The First International and After*, ed. D. Fernbach, New York, 1974, pp. 187–268. For Reclus, who, with his brother Elie, actually participated in the Commune and was captured by the troops of Versailles, see M. Nettlau, *Elisée Reclus, Anarchist und Gelehrter (1830–1905)*, Berlin, 1928, pp. 138–170.

71. Kropotkin, *Memoirs*, pp. 270–271; *Conquest of Bread*, pp. xii–xiv.

72. As early as 1872, a congress of Phalansterians organized to celebrate the centenary of Fourier's: see G. Weill, *Histoire du mouvement social en France 1852–1902*, Paris, 1904, pp. 205–206, 271, 378, 380.

73. J. Ajalbert, *Mémoires en vrac au temps du symbolisme,1880–1890*, Paris, 1938, pp. 26, 43; J. U. Halperin, *Félix Fénéon Aesthete & Anarchist in Fin-de-Siècle Paris*, New Haven and London, 1988, p. 26.

74. Quoted in Clark, *The Painting of Modern Life*, p. 264.

75. Halperin, *Félix Fénéon*, p. 28.

76. F. Fénéon, "La Commune," *La Revue blanche*, vol. 12, 1897, pp. 249–305, 356–388.

77. Ibid., p. 300.

78. A. Tabarant, *Maximilien Luce*, Paris, 1928, pp. 9–10, 12, 51–52; T. Reff, *Manet and Modern Paris*, National Gallery of Art, Washington, D. C., 1982, pp. 230–231.

79. Coquiot, *Seurat*, p. 28.

80. *Rapport du Maréchal Mac-Mahon sur les opérations de l'armée de Versailles depuis le 11 avril, époque de sa formation, jusqu'au moment de la pacification de Paris, le 28 Mai*, Paris, 1871, p. 22; P.-O. Lissagaray, *History of the Commune of 1871*, New York, 1898, p. 347; G. Soria, *Grande histoire de la Commune, Edition centenaire 1871–1971*, 5 vols., Milan, 1970, IV: 194.

81. V. Fournel, *Paris et ses ruines en mai 1871*, Paris, 1872, pp. 73, 78.

82. Ibid., pp. I–VI.

83. For the devastation in these areas, see also Barron, *Les environs de Paris*, p. 30: "Neuilly, where we are now entering, is covered with these gardens, these basins, infinitely proper and lovely appendages of houses equally proper and lovely. But here, at the approaches of La Grande-Jatte, the civil war of 1871 had devastated it; here we see only enclosed fallow plots, standing ruins, heaps of rubbish, twisted rails, gaping holes in the walls which served as embrasures for the rifles and artillery of the Versailles troops and the Communards. For fifteen years the traces of bitter street by street, foot to foot, hand to hand combat seemed to beg for repairs that no one cared to accord them." Also V. Morland, *Les environs de Paris après le*

siège et la guerre civile, Paris, 1871, plates 24, 27.

84. *Rapport du Maréchal Mac-Mahon*, p. 11; A. de Balathier Bragelonne, *Paris insurgé: Histoire illustrée des événements accomp.is du 18 Mars au 28 Mai 1871*, Paris, 1872, pp. 406, 441, 455.

84. Fournel, *Paris et ses ruines*, pp. 80, 84.

85. For *Une Baignade*, see Thomson, *Seurat*, pp. 75–96; Herbert, *Seurat*, pp. 147–169.

86. H. Dorra and J. Rewald, *Seurat*, Paris, 1959, p. 57, No. 60.

87. P. Tucker, *Monet at Argenteuil*, New Haven and London, 1982, p. 163.

88. M. Melot, "Camille Pissarro in 1880: An Anarchist Artist in Bourgeois Society," *Marxist Perspectives*, vol. 2, No. 4, Winter 1979–1980, pp. 36–37.

89. G. Davy, "Emile Durkheim," *Revue de métaphysique et de morale*, vol. 6, 1920, p. 183; J. Duvignaud, *Durkheim, sa vie, son oeuvre*, Paris, 1965, pp. 4, 9; J.-C. Filloux, *Durkheim et le socialisme*, Geneva, 1977, p. 8; S. Lukes, *Emile Durkheim, His Life and Work*, Harmondsworth, 1975, pp. 41–42.

90. E. Durkheim, *The Division of Labor in Society*, tr. G. Simpson, New York, 1964, pp. 37–38, 41, 200.

91. Durkheim, *Socialism and Saint-Simon (Le Socialisme)*, ed. A. W. Gouldner, Yellow Springs, Ohio, 1958, pp. 6, 10, 211.

92. Ibid., p. xii; Durkheim, *Suicide: A Study in Sociology*, Glencoe, 1951, pp. 373–374, 389–390.

93. E. Bloch, *Das Prinzip Hoffnung*, 3 vols., Berlin, 1954, II:393–394, 495, 507.

94. O. K. Werckmeister, *Ende der Aesthetik*, Frankfurt am Main, 1971, pp. 50–52.

95. M. Schapiro, "Seurat and 'La Grande Jatte,'" *Columbia Review*, November 1935, p. 13.

96. Durkheim, *The Rules of Sociological Method*, New York, 1982, pp. 3, 35, 69; *Suicide*, pp. 9–10.

97. I. Hofmann, *Bürgerliches Denken: Zur Soziologie Emile Durkheim*, Frankfurt am Main, 1973, pp. 71–72, 163 ff., 196. The French bourgeois feminist, Maria Deraismes, an ardent republican, wrote that the fundamental law in both the physical and social world was "solidarity," and stressed the interdependence of all matter in the universe. The wise interpretation of the concept of solidarity will yield to society "order and harmony." See M. Deraismes, *France et progrès* [originally published 1873], in *Oeuvres complètes*, 2 vols., Paris, 1895–1896, I: 177–178.

98. A. Lee, "Seurat and Science," *Art History*, vol. 10, June 1987, pp. 203–226; J. Gage, The Technique of Seurat: A Reappraisal," *Art Bulletin*, vol. 69, September 1987, pp. 448–454.

99. Reclus, *Correspondance*, II:170. For Reclus,

anarchism, and science, see M. Fleming, *The Anarchist Way to Socialism*, London, 1979, pp. 144 ff.

100. Kropotkin, *Mutual Aid*, pp. vii–xvi, 2–4; *Revolutionary Pamphlets*, pp. 53–54; *Modern Science*, p. 26; Reclus, *Evolution and Révolution*, Paris, 1891, pp. 8, 35; Grave, *Quarante ans*, p. 169; "La lutte pour l'existence," *Le Révolté*, 3–16 January 1886.

101. Reclus, *Correspondance*, II: 325, 336.

102. Boime, "Studies of the Monkey by Seurat and Pisanello," *Burlington Magazine*, vol. 111, February 1968, pp. 79–81.

103. In Kropotkin's famous essay "Aux jeunes gens" (first published in 1880), he puts down those "fops, sad products of a society in decay, who promenade on the sidewalks with their Mexican trousers and their monkey faces." In *Paroles d'un révolté*, p. 51.

104. C.-A. Royer, introduction to *De l'origine des espèces*, Paris, 1862, p. xxxviii. Indeed, it was commonplace in the 1880s for families to maintain monkey pets, but Seurat's singular role for the animal grabbed the attention of his contemporaries. According to George Moore, rumors spread that the tail of the primate was "three yards long." See E. G. Boulenger, *Apes and Monkeys*, New York, 1937, p. 147; G. Moore, *Confessions of a Young Man*, London, 1907, pp. 28–29.

105. Boime, "The Teaching of Fine Arts and the Avant-Garde in France During the Second Half of the Nineteenth Century," *Arts Magazine*, vol. 60, December 1985, pp. 50–51.

106. For Seurat and Duchenne, see R. L. Herbert, "'Parade de cirque' de Seurat et l'esthètique scientifique de Charles Henry," *Revue de l'art*, No. 53, 1981, pp. 9–23.

107. C. Darwin, *The Expression of the Emotions in Man and Animals*, London, 1872, pp. 5–6, 133.

108. See R. S. Roslak, "Organicism and the Construction of a Utopian Geography: The Role of the Landscape in Anarcho-Communism and Neo-Impressionism," *Utopian Studies* (n.s.), vol. 1, No. 2, 1990, pp. 96–114; "The Politics of Aesthetic Harmony: Neo-Impressionism, Science, and Anarchism," *Art Bulletin*, vol. 73, September 1991, pp. 381–390.

109. Durkheim, *De la division du travail social*, Paris, 1967, p. 100; Kropotkin, "Anarchism: its Philosophy and Ideal," *Revolutionary Pamphlets*, pp. 118–119; Grave, *L'Individu et la société*, pp. 16–17, 20–21, 59, 61–65; "L'Harmonie," *La Révolte*, 28 December–10 January 1890; Reclus, *Correspondance*, II:144–145.

110. M. Caullery, *French Science and its Principal Discoveries Since the Seventeenth Century*, New York, 1975, pp. 133,136–141. See also R.

Taton, ed., *Science in the Nineteenth Century*, New York, 1965, pp. 268–302.

111. E. Grimaux and C. Gerhardt, *Charles Gerhardt, sa vie, son oeuvre, sa correspondance*, Paris, 1900, pp. 183–185, 192–194, 205–207, 224–225. His politics cost him the prestigious chair at the Collège de France.

112. M.-P.-E. Berthelot, *Science et morale*, Paris, 1909, p. 299. For his position on atomic theory and his opposition to Gerhardt, see Berthelot, *La synthèse chimique*, Paris, 1876, pp. 154–155, 157, 159–160, 167.

113. Caullery, *French Science*, pp. 101–102.

114. Grimaux and Gerhardt, *Charles Gerhardt*, pp. 33–34, 39, 46 and 46n., 314.

115. E. W. Brücke, *Principes scientifiques des Beaux-Arts*, Paris, 1878, pp. 169–223.

116. H. L. F. von Helmholtz, *Populäre wissenschaftliche Vorträge*, 3 vols., Braunschweig, 1865–1876, III: 65–66.

117. Brücke, *Principes scientifiques*, pp. 181–182. See also J. Jamin, "L'Optique et la peinture," *Revue des deux mondes*, vol. 7, January–February 1857, p. 628. Rood's textbook on color (used by Seurat) uses terms such as the "molecular constitution of crystals" and the "atoms in the air": O. N. Rood, *Students' Text-Book of Color; or, Modern Chromatics, with Application to Art and Industry*, New York and London, 1916. This edition was identical to the one of 1881.

118. Schapiro, "Seurat," p. 13.

119. Kropotkin, "Aux jeunes gens," p. 67. Yet from the perspective of history we can see to what extent La Grande-Jatte also meshes with the Third Republic's attempt to secularize French society and displace the rival authority of the church with the aid of the burgeoning scientific disciplines. The physical and the social sciences, including Durkheimian sociology, were pressed, voluntarily, into the service of the Third Republic in its efforts at national integration. They were used to reconstruct society with a civic and laic form to replace the outmoded religious morality. *La Grande-Jatte* fits into this scheme through its application of scientism to the secularization of Sunday. Sunday is not seen as a day of religious observance, but as a day of recreation and play among an integrated populace organized by the state. This use of La Grande-Jatte, once the private property of the Orleans family, also signifies the Third Republic's final destruction of the feudalistic order. On this last point, see J. Grave, "Les Orléans," *Le Révolté*, 3–11 June 1886. Grave attacks the Comte de Paris, the brother of the Prince de Joinville for his pretensions to the throne of France. He recalled that the prince's father, Louis-Philippe, had deprived the workers on 1830 of the Republic, but he also recog-

nized that his regime inspired resistance in the form of the secret societies and the great revolts of 1831, 1834, and 1848.

Appendix

1. E. Daudet, *L'agonie de la Commune*, Paris, 1871; P. Lidsky, *Les écrivains contre la Commune*, Paris, 1982.

2. A. Boime, *Hollow Icons: The Politics of Sculpture in Nineteenth-Century France*, Kent, Ohio, 1987, pp. 120–124. It should be recalled that radicals in the United States celebrated the Paris Commune every March 18th by parades and demonstrations.

3. "Paris and France," *Harper's Weekly*, vol. 15, 8 April 1871, p. 306; "Versailles and Paris," ibid., 22 April 1871, pp. 354–355; "A Club of Paris Reds," ibid., p. 363 (the pictorial journalist noted the Reds' "excessively dirty hands"); "The Communists in Paris," ibid., 6 May 1871, pp. 412–413; "Women of Paris," ibid., 27 May 1871, p. 485; "Women of Montmartre," ibid., 8 July 1871, p. 620.

4. H. Melville, *Clarel, A Poem and Pilgrimage in the Holy Land*, ed. W. E. Bezanson, New York, 1960, p. 227, part II, xxv, lines 110–111, p. 479, Part IV, xx, lines 128–136. First published in 1876, the character Ungar often speaks the antidemocratic sentiments. One exception to the antagonism of American intellectuals was Walt Whitman, whose "O Star of France," written shortly after the Commune, bemoans its failure and praises its attempt.

5. S. Bernstein, "The Impact of the Paris Commune in the United States," in *Revolution & Reaction*, pp. 59–60.

6. P. S. Foner, ed., "Interview with Karl Marx," ibid., pp. 71–79. The original was published in the New York *World* of 18 July 1871.

7. Bernstein, "The Impact of the Paris Commune," p. 59.

8. *The Nation*, vol. 13, No. 314, 6 July 1871, pp. 2–3, referring to the International's public show of sympathy for the Commune, accused it of wanting credit for "all its atrocities and desperation."

9. "The Lesson of Paris," *The New York Times*, 26 May 1871, referring to "This rabble, this crowd of fanatical, revolutionary, socialistic laborers."

10. "Paris and France"; "Paris under the Red Flag," *Harper's Weekly*, vol. 15, 20 May 1871, p. 458; "The Victory of France," ibid., 10 June 1871, p. 523.

11. "Communism in America," *The New York Times*, 28 December 1873.

12. Bernstein, "The Impact of the Paris Commune in the United States," p. 61; "Mob Law in Pennsylvania," *The New York Times*, 8 April 1871. The *Times* editorial began: "We keep wondering at the spectacle of one of the world's greatest capitals given up to the unbridled license of a rabble, when at our very doors we see the law defied by a handful of trades-union rioters." On the same day the *Tribune* ran back-to-back editorials on the "state of disorder and excitement" in Pennsylvania and the need for "the restoration of order" in Paris. *New-York Daily Tribune*, 8 April 1871.

13. "The Communists," *The New York Times*, 20 January 1874.

14. E. King, *Under the Red Flag or The Adventures of Two American Boys in the Days of the Commune*, Philadelphia, 1895; G. A Henty, *A Girl of the Commune*, New York, 1895; R. W. Chambers, *The Red Republic: A Romance of the Commune*, New York, 1895. Edward King's book, particularly vicious, praises the Versaillese Maréchal MacMahon, future president of the French Republic, "to whose energy and skill was due the suppression of the greatest insurrection of modern times" (p. 550), while Chambers relishes his description of "maddened women" including an "old hag" who beat out the brains of one of the line troops with her wooden shoe (p. 88). It is interesting to speculate on the date 1895 for all three novels, the height of Populist agitation and the depletion of the gold reserves.

15. "'The Commune' and the Labor Question," *The Nation*, vol. 12, No. 307, 18 May 1871, pp. 333–334; "The Future of Capital," ibid., No. 312, 22 June 1871, p. 429. The lack of real sympathy for the Communards is seen in the *Nation*'s condemnation of the shooting of Archbishop Darboy and the priests as "the most horrible incident of the struggle," and its characterization of the mass deportation of Communard suspects as good "for their mental and moral health." Ibid., No. 309, 1 June 1871, p. 375; No. 311, 15 June 1871, p. 411.

16. The entire series was published in J. R. Young, *Men and Memories*, ed. M. D. R. Young, 2 vols., New York, 1901, pp. 164–207.

17. Ibid., pp. 171–172.

18. Archives of American Art, O. L. Warner: Draft of Speech on the Paris Commune.

19. Marx's letter to Kugelmann, 12 April 1871 in K. Marx and V. I. Lenin, *The Civil War in France: The Paris Commune*, pp. 86–87.

20. G. Gurney, "Olin Levi Warner (1844–1896): A Catalogue Raisonné of His Sculpture and Graphic Works," Ph.D. Diss., University of Delaware, 1978, pp. 7, 10, 29–30, 32, 35. A revealing glimpse of Warner's class consciousness is found in a letter to his relatives written shortly after his arrival in France describing English society: "One striking peculiarity of English society is the aristocratic feeling the people (those who are not common laborers) always seem to have. Their airs, and their

old foolish customs which are as unchangeable as the sun, are disgusting to an American. . . . The Houses of Lords & Commons would be mere ciphers if the members were not clothed in their robes & wigs. Little boys six & eight years of age must wear high hats & kid gloves or they are not of the 'respectable youth.' . . . In France it is far different. Society is freer & more Republican." (Warner would soon change his opinion on imperial France after settling there). Collection of Mrs. Ralph F. Warner, Alexandria, Virginia, Letter M4, 9 August 1869.

21. Gurney, "Olin Levi Warner," pp. 63, 137.

22. This was not uncommon in Leftist terminology at the time for describing middle-class ascendancy: In his socialist novel *The Iron Heel*, Jack London characterizes the tyrannical "Oligarchy" of capitalist trusts as embodying "the aristocratic ethic or the master ethic." J. London, *The Iron Heel*, New York, 1908, p. 66.

23. Warner's definition was overlooked by Marx who claimed a mistaken link between the old and the new: "It is generally the fate of completely new historical creations to be mistaken for the counterpart of older and even defunct forms of social life, to which they may bear a certain likeness. Thus the new Commune, which breaks the modern state power, has been mistaken for a reproduction of the mediaeval Communes, which first preceded, and afterwards became the substratum of, that very state power" (*The Civil War in France: The Paris Commune*, p. 59).

24. Here Warner contributes to the prevalent view of the Commune as an offspring of circumstances brought on by the Franco-Prussian War; a more recent thesis traces its origins to the heightened labor awareness of the late, "liberalized" Second Empire, following the passage of a law in 1868 permitting public assembly. See A. Dalotel, A. Faure, J.-C. Freiermuth, *Aux origines de la Commune: Le mouvement des réunions publiques à Paris 1868–1870*, Paris, 1980.

25. Young, *Men and Memories*, p. 190.

26. The separation of Church and State, though embedded in the Commune's program from the start, was not announced in its first decree of 29 March 1871 but was included in a general declaration on 19 April 1871.

27. Marx, *The Civil War in France: The Paris Commune*, pp. 48–51, claims that the demonstrators "ill treated and disarmed the the detached patrols and sentries of the National Guard they met with on their progress, and . . . attempted to break through the line drawn up there, and thus to carry by surprise the headquarters of the National Guard in the Place Vendôme." According to Marx, the "Friends of Order" began firing first and when

shots into the air proved ineffective for halting the violence fire was commanded by the officer of the National Guard.

28. Ibid., pp. 201–202. The power of this antihierarchical gesture is seen in the response of the reactionary Catulle Mendès to the same decree preserved by Warner which Mendès included in his private journal. Addressing the members of the Commune, he writes: "It was not enough for you . . . to have destroyed the present and compromised the future, you still want to annihilate the past! . . . Do not think that demolishing the Vendôme Column is just toppling over a bronze column with an emperor's statue on top; it is unearthing your fathers in order to slap the fleshless cheeks of their skeletons and to say to them: You were wrong to be brave, to be proud, to be grand! You were wrong to conquer cities, to win battles. You were wrong to make the world marvel at the vision of a dazzling France." C. Mendès, *Les 73 journées de la Commune*, Paris, 1871, pp. 149–150. The Communard Louis Barron's interpretation of the event approaches more closely the reading of Young: "This colossal symbol of the Grand Army—how it was fragile, empty, miserable! It seemed to have been eaten out from the middle by a multitude of rats, like France itself, like its tarnished glory." L. Barron, *Sous le drapeau rouge*, Paris, 1889, p. 167. Except for slight changes, I have made use of the translations in Ross, *The Emergence of Social Space*, pp. 5–8. For an insightful discussion of the demolition of the Vendôme Column, see J. Weiner, "Paris Commune Photos at a New York Gallery: An Interview with Linda Nochlin," *Radical History Review*, No. 32, 1985, pp. 59–70.

29. Marx's interview for *The New York Herald*, 3 August 1871, quoted in E. Thomas, *The Women Incendiaries*, New York, 1966, p. 168. The reporter agreed, stating that he has yet to meet with a single person who actually saw a woman with kerosene.

30. Thomas, *The Women Incendiaries*, pp. 165–216. Thomas' book, originally titled in the French, *Les Pétroleuses*, focuses on the full range of women's contributions to the Commune.

31. Ibid., pp. 70–75, 147–149.

32. "Women of Paris," *Harper's Weekly*, vol. 15, 27 May 1871, p. 485.

33. "Women of Montmartre," *Harper's Weekly*, vol. 15, 8 July 1871, p. 620.

34. Warner's passionate rhetoric here approximates Marx's in this typical passage from *The Civil War in France: The Paris Commune*:

In all its bloody triumphs over the self-sacrificing champions of a new and better society, that nefarious civilisation, based upon the enslavement of labour, drowns the moans

of its victims in a hue-and-cry of calumny, reverberated by a world-wide echo. The serene working men's Paris of the Commune is suddenly changed into a pandemonium by the bloodhounds of "order." And what does this tremendous change prove to the bourgeois mind of all countries? Why, that the Commune has conspired against civilisation! The Paris people die enthusiastically for the Commune in numbers unequalled in any battle known to history. What does that prove? Why, that the Commune was not the people's own government but the usurpation of a handful of criminals! The women of Paris joyfully give up their lives at the barricades and on the place of execution. What does that prove? Why, that the demon of the Commune has changed them into Megaeras and Hecates! The moderation of the Commune during two months of undisputed sway is equalled only by the heroism of its defence. What does that prove? Why, that for months the Commune carefully hid, under a mask of moderation and humanity, the blood-thirstiness of its fiendish instincts, to be let loose in the hour of its agony! (p. 76.)

35. Warner Papers, National Museum of American Art, Smithsonian Institution, Washington, D.C.

36. Warner Papers.

37. See J. Baas, "Edouard Manet and *Civil War*," *Art Journal*, vol. 44, Spring 1985, pp. 38, 40.

38. For a discussion of the formation of this group and its aims, see E. Broun, *Albert Pinkham Ryder*, The National Museum of Art, Washington, D.C., 1989, pp. 30–41; W. I. Homer, *Albert Pinkham Ryder: Painter of Dreams*, New York, 1989, pp. 25–29, 31–33.

39. Gurney, "Olin Levi Warner," p. 56.

40. Warner Papers, letter to brother dated 6 August 1877.

41. For the organization of the arts under the Commune, see J. Kaplow, "The Paris Commune and the Artists," *Revolution & Reaction*, pp. 144–167; A. Rifkin, "Cultural Movement and the Paris Commune," *Art History*, vol. 2, 1979, pp. 214–216.

42. S. Edwards, ed., *The Communards of Paris*, 1871, Ithaca, 1973, p. 157.

43. Bernstein, "The Impact of the Paris Commune in the United States," pp. 68–69.

44. Gurney, "Olin Levi Warner," p. 11.

45. For the role of freemasons in the Commune, see Lissagaray, *History of the Commune*, pp. 236–239; P. G. Nord, "The Party of Conciliation and the Paris Commune," *French Historical Studies*, vol. 15, Spring 1987, pp. 20–27.

46. Collection of Mrs. Ralph F. Warner, Alexandria, Virginia, Letter from Warner to his father, M24, 21 February 1872.

47. Ibid., to relatives and special section to father, Letter M6, 28 September 1869; to brother, Letters M8, 29 November 1869, M9, 27 February 1870.

POSTSCRIPT

Elizabeth Anne McCauley's *Industrial Madness: Commercial Photography in Paris 1848–1871*, New Haven, 1994, contains a major chapter on the photographer Auguste Bruno Braquehais (pp. 149–194), where she notes that his 109 views of the Commune constitute "his largest body of work" dedicated to a single theme. She also observes that whereas most of the other photographic images of the Commune by his competitors were taken after the defeat of the Communards and focus on death and destruction, Braquehais recorded the activities of the Communards during their short-lived control of the urban space. And she concludes: "Braquehais undoubtedly intended to sell these works as souvenirs to the Communards depicted; they certainly could have served as damning evidence after the Commune's defeat" (pp. 187–191).

In 1994 a major retrospective of Caillebotte's paintings was held at the Grand Palais (*Gustave Caillebotte 1848–1894*, Réunion des Musées Nationaux/Musée d'Orsay, Paris 1994). The show then traveled to the Art Institute of Chicago, where it opened in February 1995. It is intriguing to find that the American version of the catalogue (*Gustave Caillebotte: Urban Impressionist*, 1995) carries several references to the Commune in the excellent essay "The Street" by Julia Sagraves, some of whose ideas coincide with mine (see especially pp. 92–93, 96). This would suggest that the end of the Cold War has perhaps encouraged a younger generation of American art historians to explore this heretofore marginalized episode. Yet these references to the Commune are absent in the French version of her essay ("La Rue"). Evidently, the author was advised by the French organizers to delete these references which she subsequently restored in the American version. Although some

French scholars feel that some Americans tend to overinterpret, and read too much into, French pictures, in this case I have no doubt that the real reason for the request of the removal of the references was strictly political, demonstrating, to me at least, that the Commune is still very much alive and unwelcome in the imaginations of the current crop of French conservatives.

INDEX